A Mahzor from Worms

A MAHZOR FROM WORMS

Art and Religion in a Medieval Jewish Community

KATRIN KOGMAN-APPEL

HARVARD UNIVERSITY PRESS
Cambridge, Massachusetts
London, England
2012

Library of Congress Cataloging-in-Publication Data
Kogman-Appel, Katrin.
A mahzor from Worms : art and religion in a medieval Jewish community /
Katrin Kogman-Appel.
p. cm. — (Introduction — Facts about the Leipzig Mahzor — Worms: community, society,
and scholarship — A Passover sermon by Eleazar ben Judah of Worms — Halakhah
and minhag: religious law and custom — Musar: pietist ethics — Sod: mystical
dimensions — Epilogue.)
Includes bibliographical references and index.
ISBN 978-0-674-06454-6 (alk. paper)
1. Leipzig Mahzor. 2. Mahzor (Ms. Leipzig Mahzor) 3. Manuscripts,
Hebrew—Germany—Leipzig. 4. Jews—Germany—Worms—History. 5. Jews—
Germany—History—1096–1800. 6. Judaism—History—Medieval and early
modern period, 425–1789. I. Title.
BM674.59.K64 2012
296.4'53—dc23 2011041321

In Memoriam

Hans-Georg Appel
1926–2008

Contents

Preface

W HEN I FIRST CONSIDERED approaching the Ashkenazi mahzorim, a long list of questions and issues piled up on my desk. In comparison to the medieval haggadot, which had been the focus of my earlier work, the mahzorim are less well known and their imagery is much less straightforward. Some of the mahzorim manuscripts had been published in lavish and very expensive facsimile editions. and most of them are mentioned in all the major surveys on medieval Jewish Art. However, the specifics of their decoration programs, of the relation between text and image in these books, and of the way they must have been used were generally cast in shadow. My initial project proposal, which grew out of my long catalogue of questions, received generous funding from the Israel Science Foundation (Grant no. 756/03) from 2004 to 2006.

I addressed some of my questions in a few separate, earlier studies: the sudden comeback of Jewish figural art, of which the mahzorim are a part, in the early thirteenth century after a hiatus of 700 years; the hanging of Haman imaged on a tree that took the shape of the Christian Tree of Jesse; and several other related studies. Soon, however, it was the mahzor in the Universitätsbibliothek in Leipzig, a unique and intriguing, particularly beautiful and elegant manuscript, that caught my full attention. In 2009 I published a short study on one of the images ("The Scales in the Leipzig Mahzor: Penance and Eschatology in Fourteenth-Century Germany," in *Between Judaism and Christianity: Art Historical Essays in Honor of*

Elisheva (Elisabeth) Revel-Neher [Leiden: E. J. Brill], 307–318), which I elaborate here in Chapter 5.

The first time I visited the Universitätsbibliothek in Leipzig, the mahzor was in a very poor state, with its colors flaking, and I was allowed only a few brief glimpses at some of the pages. I am grateful to Christoph Mackert, the director of the manuscript section of that library, for his help in every possible way, not only during that visit, but in every other respect. The manuscript was subsequently restored, and I was able to revisit Leipzig and undertake a full, highly detailed examination.

I am also indebted to the staff of the National Library of Israel in Jerusalem: to Yael Okun at the Institute of Microfilmed Manuscripts; to the former director of the Department of Manuscripts at the National Library, Rivka Plesser; and to Edna Angel from the Hebrew Paleography Project. My thanks also go to Doris Nicholson and Rahel Fronda, keepers of Oriental Manuscripts at the Bodleian Library at Oxford; Ilana Tahan, keeper of Hebrew manuscripts at the British Library in London; and Silvia Uhlemann, director of the manuscript section at the Universitäts- und Landesbibliothek Darmstadt.

Several colleagues have shared their thoughts with me, read parts of the manuscript, and helped in numerous other ways: Daniel Abrams, Rainer Barzen, Elisheva Baumgarten, Matania J. Ben-Ghedalia, Jeremy Cohen, Uri Ehrlich, Jonah Fraenkel, Judah Galinsky, Amos Geula, Zeev Gries, Joachim Hahn, Boaz Huss, Shulamit Laderman, Ruth Langer, Ivan Marcus, Lucia Raspe, Elisheva Revel-Neher, Shmuel Shepkaru, Ephraim Shoham-Steiner, Jeffrey Woolf, Joseph Yahalom, and the anonymous readers for Harvard University Press. I thank all these individuals for their insights, their critique, and their encouragement at various stages of my work.

The very last phase of editing my text and polishing it took place at the Princeton Institute for Advanced Study during a year-long leave of absence from my home institution, the Ben-Gurion University of the Negev. Once this book had evolved, it still relied on the patience, efficiency, and professionalism of several other individuals: Evelyn Grossberg, who safely guided the text through my struggles with the English language, and Sharmila Sen and her staff at Harvard University Press, who accompanied the project during its last phases.

My family's encounters with the Leipzig Mahzor and my dealings with it were of a different kind: Menachem is to be thanked for sharing my enthusiasm and for his enduring support over all these years we've spent together; Yuval, Tamar, and Michal gracefully coped with my absences, my deadline-related panic attacks, and other irregularities in their lives. This volume is dedicated to the memory of my father, the first book-lover I knew, and his unfulfilled dream of becoming a bookseller.

A Mahzor from Worms

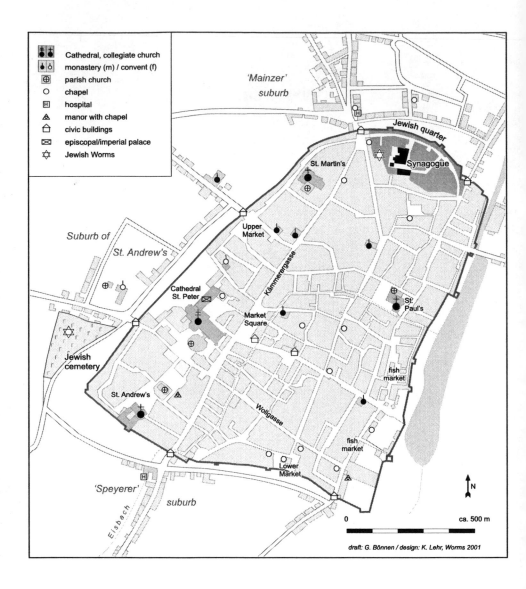

Cathedral, collegiate church
monastery (m) / convent (f)
parish church
chapel
hospital
manor with chapel
civic buildings
episcopal/imperial palace
Jewish Worms

'Mainzer' suburb

Jewish quarter

Synagogue

St. Martin's

Suburb of St. Andrew's

Upper Market

Kämmerergasse

Cathedral St. Peter

Market Square

St. Paul's

Jewish cemetery

St. Andrew's

fish market

Wollgasse

fish market

'Speyerer' suburb

Eisbach

Lower Market

N

0 ca. 500 m

draft: G. Bönnen / design: K. Lehr, Worms 2001

Introduction

OPENING THE LEIPZIG MAHZOR (Leipzig, Universitätsbibliothek, MS Voller 1002/I–II) takes one's breath away, even the breath of an expert with many years of experience and wide exposure to medieval illuminated manuscripts. The solemn dignity of the two large volumes; the quiet language of the images—not very many, and the viewer is somewhat taken by surprise each time one appears, as most of the pages remain undecorated; the impeccable layout with the beautiful scribal work all elicit even a modern viewer's amazement and awe. Paging through the hundreds of folios, one soon realizes that the somewhat stiff little figures with their bird-like profiles are still lively enough to give the modern reader an insight into the mentality of the people who created them some 700 years ago.

The present study is designed to reach an understanding of this mentality and to shed new light on the community that produced and used the book. In an interdisciplinary approach to several of the miniatures in the Leipzig Mahzor, which was produced in Worms around 1310, it shows how this Mahzor adds a particular aspect to the whole of our apprehension of how medieval Jews in that community "made sense of the world."[1] Medieval Ashkenazi mahzorim contain a collection of liturgical hymns *(piyyutim)*—commonly recited optional poetic embellishments to the regular holiday prayers—but the prayers themselves are not included in these volumes. Unlike many other illuminated manuscripts from the Middle Ages, Ashkenazi mahzorim were used within the context of a social entity, a community.

Although they may have been commissioned by individual wealthy patrons and kept in private households on ordinary days, these books were designed for the use of the community as a whole. During holiday services they were used by the prayer-leader, an esteemed member of the community, carefully elected, who was considered capable of representing the entire public before God. As will be observed throughout the chapters that follow, the religious symbols and themes expressed in the imagery of the Leipzig Mahzor appear, not as the product of an individual mind communicated to a private owner's perception, but as reflections of a collective weave of a community's cultural associations. We do not know how exactly this imagery was conceived and who stood behind its messages. An individual patron? A group of scholars, communal leaders, who were concerned with the community's spiritual well-being? Neither do we know how these peoples' concepts were communicated to the artist or artists who drew the lines of the images and filled them with color; what exactly may have been the scribe's role in this scenario? When I refer here to the designer(s) of the decoration, I mean those who authored its imagery, those who conceived it as what it stands for—a portrait of the communal, ritual, and religious concerns of the people who orchestrated the services in the "sacred community" of Worms in the fourteenth century and those who attended them.

A large book of splendid appearance, written in elegant, large square script, lavishly decorated with colored initial panels and marginal illustrations, the Leipzig Mahzor comprises two volumes: the first begins with the services for the Sabbath during the week of Hanukah, the Festival of Lights commemorating the reconsecration of the Temple after its destruction by the Seleucids in the second century, the special Sabbaths between Purim and Pesah, and contains the liturgical poems for the spring and summer holidays. On Purim the deliverance of the Jews of Persia from persecution is celebrated, on Pesah (Passover) the Departure of the Israelites from Egypt, and on Shavuot (the Festival of Weeks) the giving of the law. The second volume was used during the high holidays in autumn: Rosh Hashanah (New Year), Yom Kippur (Day of Atonement), and Sukkot (Festival of Tabernacles).[2] The illuminated mahzor is a typical Ashkenazi phenomenon of the thirteenth and early fourteenth centuries, and the Leipzig Mahzor is among the most outstanding examples produced in this cultural realm. The genre of poetic embellishment of prayers—*piyyut*—was especially favored among Ashkenazi Jews, and several illuminated mahzorim were produced from c. 1230 to c. 1350 in various parts of the German lands.

Art historical considerations attribute the style of the images to the Upper Rhine region and date it to c. 1310. The only in-depth study of this

manuscript was published in 1964 by Elias Katz and Bezalel Narkiss as a commentary to a facsimile edition of the illuminated pages.[3] Narkiss described the pages and offered a stylistic analysis together with a basic iconographical treatment that identified the scenes and provided the relevant biblical and rabbinic backgrounds. From that time on the Leipzig Mahzor was thought to be a typical example of upper-class Jewish culture from southern Germany or, specifically, the Upper Rhine region, and as such it is mentioned occasionally in surveys of Jewish art in general and manuscript painting in particular.[4] However, not only has the art of the Leipzig Mahzor not been studied in detail since the 1960s, but scholars of medieval Ashkenazi liturgy have also neglected its text.

Although the style of the Leipzig Mahzor images seems to indicate that its origins were in the Upper Rhine region (perhaps the work of migrating artists), the textual analysis I discuss in Chapter 1 reveals that the manuscript was produced for and used by the community of Worms in the Middle Rhine region, one of the most celebrated Jewish communities of the Middle Ages and the early modern period.[5] The Jewish community of this particular town can thus be approached as a social realm, a *sozialer Raum* in the terms of Hans Belting, in which the book with its pictures was produced and used.[6] How the community of Worms—its religious culture, its customs, its scholarship, and its history—shines through the imagery and how those features determined the overall appearance of the Leipzig Mahzor make up the central concern of the present work. This is of particular concern, because, in comparison to earlier periods, our knowledge on the community of Worms in the fourteenth century is regrettably scarce, and the imagery of the Leipzig Mahzor thus offers an extra dimension.

The chapters of this book excavate the layers of some of the Leipzig Mahzor's imagery and establish a network of cultural links to those who lived within the framework of the Jewish community of Worms. The manuscript's decoration program reveals itself as a multifaceted mirror of Jewish life in early fourteenth-century Worms. This does not mean that I approach the miniatures descriptively by using them as genre vignettes illustrating medieval life, even though several of the marginal images seem to encourage such an approach.[7] This book is not about realia and everyday life. Rather, it is about religious concepts, ideas and thoughts, values and norms, and religious rituals and cultural symbols. By means of the various methodological points of view I employ throughout the study, the context behind the images is elucidated to suggest an insight into matters that, beyond their presence in written records, take on a visual dimension and thus add to the overall understanding of late medieval religious life in Jewish Worms. The imagery in the Leipzig Mahzor is embedded in a whole

web of practices, beliefs, and values that shaped the mentality of the medieval Jewish community of Worms and the cultural tastes and fashions of its members. The Leipzig Mahzor will thus be approached not solely as a series of images, but as a whole, a liturgical book and a ritual object of communal character. It will be presented here as a particularly interesting chapter of Jewish book culture, and a witness of Jewish communal life. The following pages are not aimed at an interpretation of the imagery *per se*, but are an attempt to embed it in its context in the largest possible sense. They will thus delve into issues beyond the basic reading of the iconography. The liturgical, communal, historical, and religious matters that will be revealed behind the pictures under question, will be discussed in depth and beyond their mere relevance in terms of their pictorial contents.

At the time the Leipzig Mahzor was produced, Jewish book art was quite young, with a history of only about eighty years, a form of cultural expression that Jews adapted from the societies within which they lived. On the other hand, Jewish figural art was an older phenomenon, known since the third century in wall paintings and floor mosaics of ancient synagogues, their style and imagery having been influenced by late-Roman culture. These forms of figural art were abandoned around the middle of the sixth century and then reintroduced into Jewish culture in Central Europe around 1230. Figural art and book illumination were thus adopted by the Jews as a by-product of their contacts with their surrounding cultures. Their abandonment of figural art in the sixth century was apparently a reaction to the full development of the Christian cult of icons, as the Jews became aware that this cultic use of images no longer fit their own conceptions. When Ashkenazi Jews returned to the use of images during the 1230s, they did so, as I suggested elsewhere, again in reaction to their observations concerning Christian culture, as they realized that the cult of icons did not apply to Western Christians of the period.[8]

The birth of Jewish book art was thus the outcome of intercultural relationships or, in other words, the degree of acculturation of Jews in their non-Jewish environment. Belting offers a theoretical framework for the ways intercultural meetings affected the approach to images in different cultures that came into contact with one another.[9] How Jews became aware of the changes in attitude toward images among Western Christians and how this awareness encouraged the production of Hebrew illuminated manuscripts is certainly an example of such a process. Moreover, the way that some of this art appears, from both the formal and the thematic point of view, can only be understood in terms of cultural interaction, a phenomenon that has been studied both from anthropological-historical perspectives and by literary historians.

Even though I consider and analyze aspects of cultural interaction here, they are not at the core of the present study. The images of the Leipzig Mahzor are visual references to cultural phenomena and can, among other approaches, also be studied via the theoretical framework created by anthropologists of culture.[10] When looked at as part of the fabric that people create in order to organize their lives, these images can be interpreted as communicators of religious symbols, concepts, rituals, and other cultural phenomena.

The Leipzig Mahzor is approached here integratively as a ritual object. Religion as a human experience expresses itself in both action (ritual) and thought, and scholars who tackle ritual theory struggle with questions about the relationship between the two. Early scholarship tended to differentiate between the two aspects and to approach them in a clear hierarchy: thought as the primary aspect of the religious experience and ritual as the secondary, subordinate to the realm of religious ideas. Catherine Bell in her critically important survey of theories of ritual approached the history of these ideas as a constant struggle between "differentiation and reintegration of thought and action."[11] Not only can the Mahzor—as any other Ashkenazi mahzor—be understood as a ritual object, but much of its imagery addresses either rituals or religious thought. Hence, whether differentiated or integrated, both religious ideas and ritual action make up the essence of the Leipzig Mahzor's content and its imagery. It is thus the book itself that integrates the two.

Whereas phenomenological approaches focus on rituals as particular modes of religious behavior and on religion as such as representing the sacred, social scientists and cultural anthropologists discuss the social and cultural dimensions of rituals.[12] Some of their thoughts guided me in preparing several of the discussions in the following pages, especially from the point of view of the function of ritual in shaping communal identity and providing cohesion. The Leipzig Mahzor not only contains the rite that was commonly followed in Worms, but also reveals a rich and multifaceted imagery through which the community of that town presented itself. This imagery thus functions as a sort of self-portrait of the community of Worms in the early fourteenth century.

The chapters that follow are the result of attempts to explicate the whole range of associations those who conceived the images and those who used the Mahzor would have experienced while viewing its pictorial contents. The discussions here were not designed to provide a basic understanding of the imagery against the background of textual equivalents of these contents or other scholarly views. Rather, they link the ideas behind the imagery first to a particular intellectual circle and the worldview that lies behind

it and then to the full complex of connotations and associations of the people who identified—closely or loosely—with that worldview. On the one hand, the images are the products of such connotations with religious symbols and cultural phenomena, and, on the other, viewing them and imbuing them with meaning depended on the spectator's having similar associations. Some literary theorists look at cultural history in what is defined as an intertextual approach, according to which a text can be understood only against the background of a whole network of related and associated textual materials. This kind of study can also involve nonverbal materials. In some sense the upcoming discussions create such networks, which refer to both texts and nonverbal cultural elements.[13]

Yet, who exactly were the people who viewed these images? Although the pictures in the Leipzig Mahzor—and any other mahzor for that matter—were part of a public document, they were physically remote from most members of the community, who could only listen while the *piyyutim* were recited. The community had, for the most part, no immediate access to the decoration of the mahzor in all its detail. Theoretically, the viewers of the images can be imagined as scholars—as the prayer-leader using the mahzor during service—who had full knowledge of the profound and controversial issues in contemporary religious life, or, on other occasions, perhaps viewers who had only loose associations with the same issues at a different level.

However, the question of a socially diverse viewing group—diverse in terms of intellectual levels rather than of social strata—is less crucial in the case of a Jewish mahzor than, say, a cathedral tympanum. It is true that the mahzor was a public object associated with the entire community. But its contents were not necessarily *seen* by many; perhaps they did not *have* to be seen by everybody. Those who used the mahzor when reciting the poems certainly had full access—intellectually speaking—to the visually presented contents and the full range of associations linked to them.

However, the images also represented other people, less-educated individuals who were part of the congregation. Theirs was a different set of associations, not necessarily linked to firsthand scholarship, but based on sermons and other modes of communication. How this may have functioned practically, we do not know. We have no precise knowledge about who, apart from the prayer-leader, may have actually had the opportunity to view the images. It is possible that for the duration of the holidays, often two days or more, the mahzor would have been displayed on the lectern and could be viewed by members of the congregation. But referring to the mahzor as a public document does not necessarily mean that it was fully viewed in public. The size of its images certainly put a limit to the public

character of the act of viewing. Still, the example of an image that actually shows a composition similar to that of a cathedral tympanum (fig. 7) might actually indicate that the members of the community had a notion that the book's imagery represented their culture, similar to the way a tympanum would represent the religious culture of its manifold viewers.

The Leipzig Mahzor thus represents specifically the cultural profile of the Jewish community of Worms, and the discussions to follow make no attempt to apply conclusions grounded in "microscopic" observations toward generalizing about the views of a society as a whole.[14] The interpretations to follow indeed say nothing about Ashkenazi religious life in general or about the use of art within the religious context of Ashkenazi Jewry. Rather, they describe the religious life of a particular Jewish community in medieval Ashkenaz at a particular moment in history. Not only do anthropologists warn us away from such generalizations, but even more so, an understanding of the diversity of medieval art makes such generalizations impossible. The medieval Ashkenazi mahzorim are far too diverse in their overall appearance and imagery to be taken as paradigms for any broad cultural phenomenon.

More specifically, finally, the analysis of the Leipzig Mahzor's illustration program often leads to the worldview of the Ashkenazi Pietists and to some of the norms, values, and practices associated with this group of scholars, who were active during the late twelfth and the early thirteenth century. The imagery seems to preserve several central aspects of the Pietist legacy. Modern scholars are uncertain to what extent the Pietists were the center of a "movement" that attracted wider circles of the population or were, rather, only a small, seclusive group—or perhaps several distinct groups—of eccentric ascetics and mystics. Several of their values, however, had a significant impact on later generations of Ashkenazi Jews.

One of the central figures of Ashkenazi Pietism, Eleazar ben Judah (died c. 1232) lived in Worms for most of his scholarly life. A student of Judah the Pious, the dominant figure of Pietism, Eleazar was a particularly prolific writer whose teachings were influential for decades, making an impact even after his death. Centuries later the early modern community of Worms still cherished his memory. Both Judah the Pious and Eleazar belonged to the Qalonymide family, a clan that was instrumental in shaping the stances and customs of Ashkenazi culture. Several years ago Ivan G. Marcus argued that Eleazar "translated" the somewhat sectarian and often demanding views of his teacher into a more popular idiom and thus opened up the world of the Pietists to wider circles of the society.[15] It is in this sense, in the broadest possible way, that the chapters to follow approach Ashkenazi Pietism, or rather elements of its legacy.

The Qalonymide Pietists left a large oeuvre of writings. They engaged in issues of law and custom and established a large corpus of ethical and moral values with a complex system of penitence at its core. They had a particularly keen interest in mystical teachings, which evolved into one of the early roots of later Kabbalah. It appears that, to a significant degree, the visual language used in the Leipzig Mahzor reflects elements of their worldview as it is accessible to us through the body of texts they left behind. The images are not an outcome of translating a textual language into a visual one, and the texts are certainly not used in this way. Rather, these texts, many of which are attributed to Eleazar of Worms, others to his disciples, enable us not only to tackle the question of how images function as message carriers, but to examine the complex of associations a medieval viewer would have experienced while looking at them, thus revealing various layers of Pietist mentality. Vice versa, the images add a whole new dimension to our understanding of the Pietist legacy beyond what texts are able to offer.

Owing to the dominance of Eleazar of Worms's teachings and several other Pietist elements in the imagery of the Leipzig Mahzor, I decided to structure the present study along the three foci of Pietist teaching. This does not mean that the designers of the decoration program envisioned their work in such a way. Rather, it is simply an aid to help us to come to terms with the Pietist worldview. First I revisit the question of attribution by means of textual analysis and offer a short introduction to the history of the community of Worms. Then in Chapters 3 to 6 I discuss a selection of images against the background of what I refer to here in the broadest possible sense as Qalonymide-Pietist legacy: law and custom (halakhah and minhag), ethics and moral issues (musar), and mystical teachings (sod). Each chapter presents a group of images that create a complex network of connections to this worldview, or rather, what had by 1310 become part of a more general system in which the Jews of Worms would shape their cultural and religious identity within the context of Ashkenazi Judaism as a whole.

The Leipzig Mahzor is certainly not a product of this culture in the sense that (post-)Pietist scholars are thought to have designed its iconographic program, to have commissioned the book, or to have made it part of their religious lives. Not only was it produced some eighty years after Eleazar of Worms, the last of the Qalonymide Pietists had died, but it is highly unlikely that they would at all have favored the idea of an illuminated mahzor. The early fourteenth-century community of Worms is certainly not to be defined as a "Pietist community" in the purest sense of the word. It will be shown here, however, that this community's concern with its scholarly

heritage, and in particular that of Eleazar ben Judah, finds its expression in an imagery that relies on Pietist concepts. It is that heritage that mattered rather than a full set of norms and values that a Pietist way of life would have implied. The concluding section of the present book thus places the observations about cultural links between the Leipzig imagery and the Qalonymide-Pietist mentality into a broader context, addressing the question of the Pietist legacy around 1300 in Worms and beyond.

Some of the cultural phenomena evoked in the Leipzig Mahzor also became part of the cultural repertoire of Ashkenazi Jews in general. These aspects of the Leipzig imagery can open windows that allow us to look beyond the microscopic view of the community of Worms. These elements, however, are not the result of unconscious diffusion. It appears, rather, that those who designed the Mahzor's illustration program had a keen sense that their culture had some of its roots in the teachings of Eleazar of Worms and thus in the Pietist value system. In some sense, thus, the analyses presented here can shed further light on modern conceptions of the role Pietist legacy, in its broadest sense, played in post-Pietist Ashkenazi Jewry.

A short note about the definition of "Ashkenaz" is in place here before I proceed. In medieval Jewish understanding, Ashkenaz meant the entire area between Bohemia in the east and England and northern France in the west. To the south it reached the Loire River, the Upper Rhine, and the Alps. However, medieval Jews were also aware of the geocultural landscapes within this vast area and differentiated among Bohemia, Austria, the Rhineland, and France (by which they meant the region north of the Loire). The cultural border between the German lands and France also had a far-reaching impact on Jewish culture, but it did not necessarily parallel the political border. Whereas Metz, for example, was culturally and linguistically a French town, politically it belonged to the German Empire. The term "Ashkenaz" as I use it here refers to Jewish culture in the German lands in contrast to northern French Jewry. Even though I am aware that this is not entirely accurate, as the term originally embraced a larger area, it is used here because the term "German" would be misleading in connection with books not written in the German language and in reference to a culture that cannot be defined as a German culture. An Ashkenazi mahzor is thus a Jewish prayer book from the German lands to the east of the Rhine.

Facts about the Leipzig Mahzor

IMAGINE YOURSELF seated at a table in the manuscript reading room of the Leipzig Universitätsbibliothek, a pleasant, well-lit, quiet room on one of the upper floors of the library. A cart with two large boxes arrives at your table while an improvised lectern made of pieces of foam rubber is being arranged in front of you. You are asked to put on a pair of white cotton gloves. One of the boxes is opened, the protective paper wrapping is removed, and you lift the heavy first volume of the Leipzig Mahzor, which is more than 19 inches high, almost 15 inches wide, and more than 3 inches thick, and place it on the foam-rubber lectern.[1] There is something of a ceremony involved in these actions even before the moment you first open the book (fig. 1) and are carried 700 years back in history. In those days the two volumes of the Mahzor were kept in a wealthy patron's house, and on the eve of every holiday one of the enormous tomes was carried into the synagogue to be placed carefully on a lectern near the Torah shrine. This was also the common practice in other medieval Ashkenazi communities.[2] An engraving by Albrecht Altdorfer from 1519 depicts the medieval synagogue of Regensburg (fig. 2) and shows a man in the narthex walking toward the main hall carrying a huge mahzor. The congregation is assembled, the men in the main hall and the women in the adjacent women's section. The prayer-leader "goes down near the shrine," accompanied by two prominent members of the congregation. He wraps himself in his *talit*, a rectangular liturgical garment, covering his head,

with two of the *talit*'s corners over his shoulders (fig. 10). He then opens the book and begins to recite the texts for the service.

The visitor to the Leipzig reading room begins to leaf carefully through the pages of the first volume. It starts out with a selection of biblical texts, the portions to be read for the holidays. Changing scripts, marginal additions, and sudden interruptions of certain text portions throughout the initial section suggest that at some stage the original order of these sections was altered. It is only after folio 26 that the layout of the pages and the organization of the book begin to make full sense.

The liturgy begins on folio 26. Somewhat unexpectedly, this part opens with a section that belongs to the statutory prayer to be recited during the morning service (*shokhen ad marom*—He who dwells on high). As this is the first prayer to require a quorum of at least ten men, it marks the beginning of the communal service. Statutory prayers are normally not included in medieval Ashkenazi mahzorim. The text is accompanied by an image of the prayer-leader (fig. 10). By focusing on a section that requires the quorum, the designers of the book apparently intended to underscore its communal character. The pages that follow include the optional poems that were recited according to the Ashkenazi liturgical rites.

After the initial Hanukah section, the liturgy for the special Sabbaths before Pesah begins. Looking more closely at the text, the reader familiar with the medieval prayer rites notes several *piyyutim* that were recited specifically in the medieval and early modern community of Worms, such as the poem *adir wena'eh* (Great and Beautiful) for the second day of Shavuot. As stylistic analyses by earlier art historians attributed the book to the Upper Rhine region, the appearance of this poem, which is associated with Worms in the Middle Rhine, calls for attention and for a detailed analysis of the text and its rite. The visitor continues to leaf through the volume and notes that the opening section for each holiday is decorated with an elaborate initial panel, whereas other pages have small marginal images. The former are of a distinct symbolic character and tend to use an allegorical idiom, whereas the latter are narrative and quite lively. Let us take a closer look, then, at the codicology of the volumes, the page layout, the text, and the decoration program.

THE FIRST TWENTY to twenty-five pages of each volume are devoted to biblical texts. Unlike the rest of the pages with their impeccable layout, these initial sections are marked by differing parchment types, different scripts, somewhat crowded marginal additions, and missing portions of text. Codicological evidence suggests that these pages suffered some rearrangement at a later stage (tables 1 and 2). It appears that originally the first volume

most likely started out with the whole set of Torah readings for all the holidays, which must have taken twenty folios, of which only seventeen are still extant. This section was followed by fourteen folios containing the three of the Five Scrolls—the Song of Songs to be read on Pesah, Ruth on Shavuot, and Ecclesiastes on Sukkot. At some later stage, but close to the time of the production of the Mahzor, these sections were divided between the two volumes, leaving the pericopes and *megillot* for the spring holidays in the first volume and moving those for the autumn festivals to the second. The omission of some parts of the Torah readings for Rosh Hashanah and Yom Kippur and codicological evidence concerning the arrangement of the quires indicate that three of the original pages are now missing, that six leaves were inserted in the first volume, and that twelve were added to the second. The added pages are easily recognizable by their parchment quality and their script, both of which are slightly different. The text on these pages is the work of several hands at different periods. They contain the hagiographical readings for the holidays, a set of texts from the Prophets and other biblical books to be recited after the Torah portion *(haftarot)*, and, in the second volume, in especially large script, a short version of the *shir hayihud* (Hymn of divine unity) associated with the Ashkenazi Pietists, perhaps composed by Samuel the Pious. At some point during the late Middle Ages or the early modern period the *shir hayihud* became an integral part of Ashkenazi liturgy.[3] These texts—the *haftarot* and the hymn of divine unity— were added by a fourteenth-century hand.[4]

The Pentateuch portions appear now on folios 1–12 of the first volume (Pesah to Shavuot and the beginning of the Rosh Hashanah pericope on folio 12v) and on folios 1–5 of the second. Several pages that must have contained parts of the Rosh Hashanah and Yom Kippur readings have disappeared. Originally, the first volume would thus have contained folios 1–12 and the two missing folios, followed by what are now folios 1–5 of the second volume. The current folios 13–18 of the first volume are insertions that contain the *haftarot,* written, as noted, in a different script. The *haftarot* cover not only folios 13–18, but also 19r, which apparently had remained empty in the original arrangement. The text of the *haftarah* for Shavuot (Ez 1 and 3:12) is cut off at the end of folio 19r. On folio 19v the original script reappears, opening the Song of Songs. It is from here that we can conclude that folio 19r, which appeared after the last Pentateuch pericope, was originally blank. Today folio 19r contains not only the *haftarah* for the first day of Shavuot, but also a particularly lavish image of Samson rending the lion. Folios 19–25 of the present first volume include the Song of Songs and most of Ruth. The end of Ruth was later removed and bound with the second volume (now folio 18r), followed immediately

by Ecclesiastes. The last is also missing its final page, that folio having been left in the first volume because its verso contains the beginning of the liturgy (folio 26r).

Thus it is clear that the original first volume contained the Torah portions, but no *haftarot*. The former covered two quires of eight folios each and one additional double page. The next folio would have had an empty recto, with the Song of Song beginning on its verso.[5] The latter would have been followed by Ruth and Ecclesiastes, covering the fourth quire and six and a half leaves of the fifth. Apparently, shortly after the Leipzig Mahzor was finished, and perhaps even before it was bound, this arrangement was changed: the readings were taken apart and those for the spring and autumn holidays were bound, respectively, with the first and the second volume. The *haftarot,* which were written by another scribe, who can, however, also be identified as a fourteenth-century hand, were added at the same time. The image of Samson, which is the only illustration that appears together with the Torah readings, must also have been added at that point, as it is hard to believe that it would have painted on an otherwise completely empty page. Moreover, not only does its layout differ from the rest of the decoration program, but it also reflects the hand of a different artist. It is possible that the same artist was also responsible for the marginal depictions for Rosh Hashanah, which show the ram from the Binding of Isaac in the second volume (vol. 2, folio 26v; see fig. 3) and the full scene of the Binding of Isaac (vol. 2, folio 66r; see fig. 4). As will be explained in Chapter 5, it is possible that these two scenes were also afterthoughts to the original program.

Bezalel Narkiss observed and commented on the different style of these images, as compared to the rest of the illustrations, and believed that they were painted by what he called the "master artist."[6] Indeed, these images do exhibit a rather sophisticated shading technique, and the figure proportions as well as the entire compositional perception are much bolder than the somewhat more simplistic, isocephalic images in the rest of the book. What the three images by this "master artist" do have in common with the rest of the decoration program is the design of the birds' heads for the figures. Moreover, the colors are the same, as is the overall artistic language. These observations suggest that these three images were added somewhat later, probably shortly after the major part of the manuscript was completed and while the rearrangement of the biblical texts was being decided upon. It is possible that the original artists were no longer available at that point and the additions were entrusted into the hands of another, perhaps Christian, painter with a similar artistic background. Recent research by Sarit Shalev-Eyni and Dalia-Ruth Halperin has revealed the existence of various patterns of collaboration between Christian and Jewish professionals

in late medieval European workshops, which may account for these observations.[7]

The later changes, together with extensive restoration and rebinding, make a full codicological examination of the manuscript quite difficult. It is primarily with the aid of the catchwords that we can reconstruct the original quire arrangement at the beginning of the volumes (tables 1 and 2). Observations regarding the catchwords can be correlated with the sequence of the texts of the original Torah portions, their lacunae, and the *haftarot* added at the later stage by a different scribe. Catchwords are still readable on folios 8 and 27 of the first volume and on folios 3 and 18 of the second. The latter are hardly discernible and only traces of the script are still visible. If my reconstruction is correct, the two volumes would also have been more balanced in their numbers of folios. Currently, the first volume contains 179 leaves and the second has 225. I suggest that originally the first volume contained 186 and the second 201 (including the missing page in the first volume, but not including, of course, the additional pages with the *haftarot*).

One's initial impression of the Leipzig Mahzor thus comes primarily from the outcome of an afterthought and some changes in the decoration program. It is strange to realize that its outstandingly impeccable layout was altered in a way that somewhat brutally violated the careful considerations of the original design. Apparently the book as planned was not practical. In its original form, the first volume contained the biblical pericopes and *megillot,* but the *haftarot* were not included, which meant that an extra book with the *haftarot* had to be provided for all the services. But this was not the main problem. More of an issue must have been the fact that for the autumn holidays both volumes of the Mahzor would have to be carried into the synagogue. The biblical pericopes for Rosh Hashanah, Yom Kippur, and Sukkot would have been read from the first volume and the liturgy from the second. After one or two seasons—or perhaps even before the volumes were bound—it might have seemed that this was an unnecessary complication and that it would make more sense to rearrange the pages to facilitate the book's use, even at the cost of its appearance. The outcome of these modifications also affects our impression of the paintings themselves. The lavish technique of the Samson image is not representative of the rest of the scenes, and we have to leaf further through the pages to realize that the book's visual language is generally quite different from what one would have thought at first glance.

I NOTED above that earlier art-historical scholarship tended to attribute the style of these images to the Upper Rhine school of manuscript painting. However, this attribution is challenged by the inclusion of *piyyutim*

Table 1 Current Quire Arrangement (Leipzig, Universitätsbibliothek, MS Voller 1102/I–II)

Volume One

II

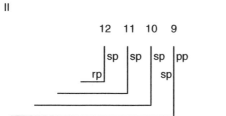

I

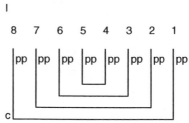

IV

18 17

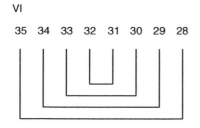

III

16 15 14 13

VI

35 34 33 32 31 30 29 28

V

27 26 25 24 23 22 21 20 19

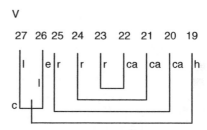

Quires VII to XXV follow the same scheme

Volume Two

II

5 4

I

3 2 1

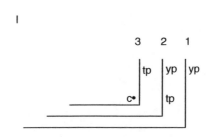

Table 1 (continued)

IV

13 12 11 10 9 8

sh sl sl h h h
 sl

III

7 6

h h

VI

18

e | r e

c

V

17 16 15 14

sh sh sh sh

VIII

32 31 30 29 28 27 26 25

I

VII

24 23 22 21 20 19

e e e e e e

IX

40 39 38 37 36 35 34 33

Key to abbreviations

Technical terms
c: catchword (c•: catchword later added in brown ink)
m: missing

Original parts

pp: Reading portions for Passover
sp: Reading portions for Shavuot
rp: Reading portions for Rosh Hashanah
yp: Reading portions for Yom Kippur
tp: Reading portions for Sukkot and Simhat Torah
ca: Song of Songs
r: Ruth
e: Ecclesiastes
l: liturgical section

Later added parts
h: *haftarot*
sl: *selihot*
sh: *shir hayihud*

Quires X–XXXIII follow the same scheme

XXXIV

225

Table 2 Suggested Original Quire Arrangement of Volume One (Leipzig, Universitätsbibliothek, MS Voller 1102/I–II)

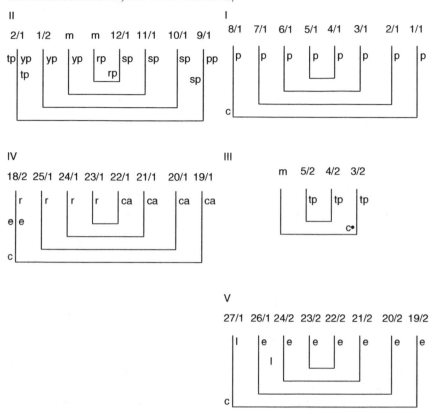

specific to the Worms rite, which is an indication that the Leipzig Mahzor was used in the Middle Rhine region rather than in the Upper Rhine. This means that the question of attribution has to be revisited in terms of the included texts.

The attribution to the Upper Rhine was first suggested by Karl Vollers in 1906, based on a stylistic comparison with the most celebrated example of the late medieval Upper Rhine school, the Heidelberg Manesse Codex.[8] Voller's suggestion held sway in most later discussions of the Leipzig Mahzor: the 1964 facsimile edition of the illuminated pages of the Leipzig Mahzor with introductions by Elias Katz and Bezalel Narkiss;[9] several surveys published during the second half of the twentieth century;[10] in a discussion of a Cistercian breviary from Freiburg im Breisgau, which Judith Raebler compared to the Leipzig Mahzor;[11] and by the curator of manuscripts in the Leipzig Universitätsbibliothek, Christoph Mackert, who compared the

Mahzor with the *Weltchronik* in St. Gall attributed to Zurich.[12] Thoughts about stylistic affinities between the Bird's Head Haggadah, for which both a Franconian and a Middle Rhenish provenance were suggested, and the Worms Mahzor created some confusion about the Mahzor's provenance, but did not lead to any revisitation of the issue.[13] The Bird's Head Haggadah and the Leipzig Mahzor may have been written by the same scribe, a certain Menahem; in both manuscripts, words with the grammatical root *nun-het-mem*, as in *Menahem*, are decorated.[14]

All these discussions are based exclusively on stylistic evidence and focus primarily on comparisons with Christian manuscripts from the Upper Rhine region. The text version was not considered a parameter for attribution, nor was any attempt made to correlate the imagery of the decoration program and its cultural, intellectual, and historical background with the stylistic evidence. The imagery as it was devised in the intellectual ambience of medieval Jewish Worms is the subject of this book, but it is by means of the text that we can draw a clear conclusion regarding the attribution of the Leipzig Mahzor to that community.

Artists, like scribes, traveled from one city to another, and this might have been especially true for the urban setting of the production of Jewish manuscripts. However, the imagery in the Leipzig Mahzor is, as I hope to show, a reflection of the members of the community it was designed to serve. It is possible that the painting was done by an artist trained in an Upper Rhenish style, but that does not necessarily mean that the work was carried out in the same region, that the imagery was designed there, or that it served an Upper Rhenish community. Looking at the Mahzor as a whole, the painting style and technique are relatively minor factors in understanding the decoration program and determining its provenance. Although artists and scribes often traveled about from place to place, the ideas as they are communicated in the illustration program of a particular book, their intellectual ambience, and specific characteristics of rabbinic scholarship and prayer rites were bound to the particular texture of the society in which they were working at the time.

In the following, I shall reassess the attribution of the Leipzig Mahzor in an attempt not simply to determine its place in a certain region that housed a certain workshop that adhered to a certain stylistic school, but to take further pieces of evidence together in an attempt to embed it in the very community that used it. The textual evidence points to Worms as the place where the Leipzig Mahzor was commissioned, written, and used. However, the textual rite preserved in its pages is far more than merely a tool by which to attribute the manuscript as accurately as possible.[15] The observation of the Worms prayer rite and other local rites can lead well beyond the basic issue of attribution to questions about the function of

these rites in the lives of medieval Jews and the patterns of communal religious practice. The attitude toward both prayer and the recitation of liturgical poetry among Ashkenazi Jews mandates that these religious practices, with their fixed and repetitive forms, be approached as rituals.[16] Hence, the mahzor is a ritual object. If we bear in mind what anthropologists say about rituals, an analysis of the Leipzig Mahzor can us lead to an understanding of the role ritual played in the way one particular community shaped its identity. Worms was the home of the individual(s) who designed the decoration program and determined the content of its miniatures. The Leipzig Mahzor plays a dual role in coming to terms with this identity: first, it is in itself a ritual object, and second, its iconographic program includes references to rituals together with other religious themes and symbols embedded in the worldview of its makers.

Lawrence Hoffman has pointed out that liturgists and anthropologists understand two different things when they use the term "rite." A liturgist refers to a rite as a particular liturgical tradition. Anthropologists "use the word to describe a discrete item of human behavior."[17] I consider both notions in the following chapters, distinguishing between "rite," by which I mean a particular liturgical tradition or order, and "ritual," by which I mean certain acts of worship. I am well aware that ritual is much more than that, but within the framework of this book that is the way that it should be understood.[18] In fact, the traditional Hebrew usage distinguishes between two forms of religious behavior: *minhag* for rite, as the rite of Worms, for example, and *seder,* which translates into "order." The former means literally "custom," and Chapter 4 addresses this way of understanding a "rite." The latter encompasses many of those aspects that modern anthropologists attach to rituals. Whereas some social scientists seek distinctive definitions for "rites" and "rituals" (apart from the one noted above), some use the terms broadly as synonyms.[19] Therefore, and for practical reasons, I take the liberty of using these terms in the way they are outlined here.

Before we look more closely at the Leipzig Mahzor's text version, a few general remarks about medieval Jewish liturgies should serve both as an introduction and as a guide through some of the ensuing discussions of the decoration scheme.[20]

The basic form of Hebrew liturgy was already well developed in the late antique period.[21] It consists of an evening prayer *(aravit);* a morning service *(shaharit),* with a special additional prayer *(musaf)* for Sabbaths and holidays; and an afternoon service *(minhah).* Apart from the Bible readings on Sabbaths and holidays during the morning prayer, these services consist of the recitation of *shma yisrael* (not for the *minhah)* and the *amidah.* These two prayers are the core elements of the liturgy. The *shma yisrael* (Hear, o Israel: the Lord is our God, the Lord is one) is based on Deuteronomy 6:4

and is the most essential statement of Jewish monotheism. The *amidah* ("standing") consists of a series of eighteen benedictions (only seven on Sabbaths and holidays), and medieval sources refer to it as *the* Prayer, often referred to simply as *tefillah* (prayer). From the beginning, a clear preference was given to communal prayer, and prayers that address the Divine require the presence of at least ten men. A prayer-leader was chosen "to fulfill the obligation of many," that is, to recite the prayers, and the members of the community, presumed to be less familiar with the precise wording, answered "Amen."[22]

Modern scholars disagree as to when the statutory prayers were finalized.[23] The main difficulty in dealing with the canonization of prayer is the fact that the culture that produced these formulae was basically an oral one. Full textualization of the prayers took place much later and continued for several centuries. Israel Ta-Shma discussed several sources that show that in twelfth-century Rhineland, prayers were still recited from memory.[24] Owing to the nature of the canonization of prayer as an ongoing process, the rites that emerged in Palestine and Babylonia differed to some degree.[25] As a by-product of the ever-increasing Babylonian dominance in matters of religious law, the Babylonian prayer formulae became increasingly ubiquitous in most parts of the Jewish world. Nevertheless, the Palestinian tradition continued to influence local rites in Europe, especially in the German lands, even though in their basic form the rites commonly used in Ashkenaz followed the Babylonian guidelines.[26] The Palestinian heritage spread to Syria, Byzantium, and Italy, and via the last reached the Rhineland, where it became a crucial element in the emergence of Ashkenazi custom and prayer. In contrast, the Sephardi rites developed almost exclusively from the Babylonian tradition, as did the French rite, although at some point the latter opened up to a limited influence from the Rhineland with its Palestinian overtones.[27]

The most striking aspect of the Palestinian tradition is the emergence of liturgical poetry. As early as the late antique period the Jews of Palestine began to elaborate on the core elements of the statutory prayer by means of poetic embellishments known as *piyyutim*.[28] The basic genres were established at that time, a chapter in the history of Hebrew poetry that is associated with Yossi ben Yossi in the fourth or fifth century and Eleazar Qallir and Yannai probably in the sixth.[29] Babylonian scholars expressed reservations—at times with open criticism—regarding this Palestinian tradition of liturgical poetry. In the realms that came to be dominated by Babylonian scholars, *piyyut* never took root to the same degree as in the German lands, where the Palestinian tradition continued to be the determining influence. Liturgical poetry never played the same role in Iberia,

for example, as in Ashkenaz; neither was the recitation of *piyyut* a central feature of synagogue worship in the Sephardi communities. But in the German regions *piyyut* turned into one of the major aspects of local custom, and Ashkenazi Jews also made a point of dwelling on the continuity of this custom from the Palestinian tradition up to Rhenish poetry.[30]

The statutory prayers are found in the siddur, the Jewish prayer book, and often worshippers knew them by heart. The typical Ashkenazi mahzor contains only *piyyutim*, which, in effect, delineate the principal differences among the various local rites in Central Europe.

The poetic embellishments of the recitation of *shma Yisrael* and the *amidah* follow a defined structure and specific poetic forms. The *shma* is preceded and followed by a set of blessings in God's praise. These blessings contain certain words after which the *piyyutim* are named. The following excerpt of these blessings marks the relevant words in Hebrew: "God, who forms *(yotser)* and creates darkness . . . and the Wheels *(ofanim)* and the Holy Beasts raise themselves with great noise toward the Seraphim. Facing them they give praise, saying: blessed is the glory of God from his place. . . . blessed are you, God, who forms the luminaries *(me'orot)*. . . . With great love *(ahavah)* have you loved us, God. . . . There is no God but you *(zulatkha)*. . . . Blessed are you, God, who redeemed *(ga'al)* Israel." Hence, the principal *piyyut* attached to the recitation of the *shma* for the morning prayer is known as *yotser*. It is followed by several other *piyyutim*, forming what is normally referred to as the "*yotser* complex." It consists of the *yotser* itself, followed by the *ofan*, the *me'orah*, the *ahavah*, the *zulat*, and the *ge'ulah*, with the *shma* itself being recited after the *ahavah* section. A similar complex developed for the evening service, the *ma'ariv*.

The liturgical embellishment added to the *amidah* prayer is called *qerovah*, which can take different forms: either the more common *qedushta'ot* (sanctity), or the *shivatot* (seven—for the seven blessings recited on the Sabbath instead of the usual eighteen). Like the *yotser*, the *qerovah* complex generally includes several different *piyyutim*.

The Central European prayer rite evolved in three main versions. The differences are discernible primarily in the poetic embellishments, hardly ever in the fixed structure of the statutory prayer. The French rite, *minhag tsarfat*, developed in the school of Rashi and ceased to exist with the expulsion of the Jews from Capetian France in the early fourteenth century.[31] The Western Ashkenazi rite, referred to in medieval Jewish sources as *minhag reinus*, prevailed along the Rhine, first reaching the line that can be drawn from Nuremberg via Rothenburg to Regensburg and later the Elbe River. The Eastern rite, known as *minhag beheim*, or *minhag ostreich*, was in use to the east of the Nuremberg-Regensburg line, in Austria, and in Bohemia.[32]

Apart from this basic distinction between East and West, we are also aware of several regional variants, and the most distinctive of these developed in the medieval community of Worms. In its early form this variant goes back to Meir ben Isaac, who was known to be in Worms during the second half of the eleventh century, a period during which rabbinic activity there flourished.[33] The second scholar instrumental in developing the rite was Eleazar ben Judah of Worms in the early thirteenth century (d. c. 1232), author of several later *piyyutim*, an authority on matters related to custom, and, as I noted earlier, one of the leading figures of Ashkenazi Pietism. Scholarly attempts to reconstruct the medieval rite of Worms focused on several early modern compilations of customs from Worms extant in manuscript form and a small group of medieval mahzorim.[34]

Attributing medieval manuscripts that lack colophons to the Worms rite faced two main difficulties. First, it was not clear to what extent the rite had developed and undergone change since the Middle Ages. Second, a certain degree of confusion was created by the Worms Mahzor, now in Jerusalem (National Library of Israel, cod. 4°781), which owes its name to the fact that it was kept in that community at least from 1565 until 1938 when the synagogue of Worms burned down. The Worms Mahzor was saved from destruction, rediscovered in 1943, and hidden from the Nazi regime.[35] Today we know that its two volumes have separate origins, that they were put together at some later stage, and that the first volume was most likely produced in Würzburg. However, little is known about the second volume, as its text version has never been examined and there is no colophon. Moreover, we do not know when it was joined with the first.

Until the question of the first volume's origin in Würzburg was settled, it was very uncertain to what degree the Worms Mahzor can, should, and may or may not be related to the medieval rite of Worms. It was observed, for example, that the early modern sources for the Worms rite do not rely on the Worms Mahzor.[36] Moreover, it contains numerous marginal notes that refer to the Worms rite, a feature that led to further doubts about the origin of the book in Worms, as they imply that it was actually not produced in that community and needed later amendments to adjust it to the Worms rite. Malachi Beit-Arié, however, observed that the first volume contains many more such marginal notes than the second.[37] Theoretically it is thus possible that the second volume did originate in Worms, that it did not then require any marginal notes to adapt it to the Worms rite, and that it was joined together with the first, Würzburg, volume at some later stage. This is, of course, speculation, which has to be confirmed by a detailed examination of the text. Some typical features of the Rosh Hashanah and Yom Kippur rite of Worms can indeed be observed, but not all of them. All I can say at

this point is that we cannot exclude the possibility that the second volume of the Worms Mahzor was indeed written and used in that city.[38]

Drawing conclusions from these different sources from the Middle Ages and the early modern period, Goldschmidt and Jonah Fraenkel published the Ashkenazi mahzor, which reflects the various regional rites.[39] Additional research on the Worms rite was published in Fleischer's contribution to the commentary volume for the facsimile edition of the first volume of the Worms Mahzor, which confirmed that it is unlikely that the first volume was produced in Worms.[40] There are some indications that Goldschmidt tended to count the Leipzig Mahzor with the medieval sources of the Worms rite.[41] However, the text was never fully examined, and Goldschmidt's suggestions did not enter the scholarly discourse about the Mahzor's attribution.

The Leipzig Mahzor has marginal notes that were attached to its text at later stages in its history. Dozens of such glosses, which mark divergences from the Polish rite, were added at some point after the early seventeenth century, when the Mahzor was taken to Poland to serve a community that prayed according to the Eastern rite. An earlier inscription tells us that in 1553 one David bar Samuel Dekingen purchased the Mahzor in Worms.[42] Most important, however, for our attempts to come to terms with the attribution of the Leipzig Mahzor are four yet-earlier marginal references that refer explicitly to the rite of Worms (noting the "holy community of Worms"). Glosses of this kind constitute an important methodological tool, as they often indicate where the main text diverges from the actual rite common at the time or in the place where the gloss was added. In the case of the Worms Mahzor, where we have seen that numerous such marginal notes can also be found, especially in the first volume, these glosses proved to be important indications that the book was not originally written for the community of Worms. At that time an analogous conclusion was reached regarding the Leipzig Mahzor. The four marginal notes mentioned above marking divergences from the rite of Worms were interpreted as evidence that the Leipzig Mahzor could have been produced anywhere *but* Worms. From Dekingen's inscription, scholars concluded that the Leipzig Mahzor was used in Worms only during the second half of the sixteenth century.[43]

It is striking, however, that in a two-volume mahzor in use in Worms around 1555, only *four* such glosses would refer to divergences from the Worms rite. That rite contains many more distinctive features, and one would expect many more such glosses, as is indeed the case for both the Worms Mahzor and the Leipzig Mahzor. The former received glosses referring to the rite of Worms when it served that community, and numerous such glosses were added to the latter during the Polish chapter in its history.

The four notes in question in the Leipzig Mahzor referring to the Worms rite appear in the second volume, and they all refer to the service of penitential prayers—*selihot*—for Yom Kippur.[44] The first gloss is near the evening service for the eve of Yom Kippur and reads: "In the holy community of Worms the order of *selihot* is written down one by one." The second gloss is more explicit and lists the titles of the *selihot* to be read during the morning service of Yom Kippur according to the arrangement customary in Worms (table 3). This list corresponds in almost every detail to the original arrangement as featured in the main text on the same page, but with the addition of a few more *selihot*. Like the former gloss, this one also refers explicitly to the "holy community of Worms" and, at its end, to the "order of *selihot* written down one by one." This does not mean that we have here an entirely different rite; rather it indicates that by the sixteenth century additional *selihot* had been added to the rite. The same is true of the other two glosses, which do not mark divergences from the order of *selihot* but simply note additional prayers that were added to the rite after the early fourteenth century. Given that more than 200 years elapsed between the production of the Leipzig Mahzor and the addition of these early modern amendments, they cannot serve as evidence that the Leipzig text diverges materially from the medieval Worms rite. In fact, instead of telling us anything specific about that medieval rite, they tell us about early modern additions to it.

Table 3 lists the features in which the Worms rite diverges from the general Western Ashkenazi rite, and lists their appearances in the different editions published in Worms until the early seventeenth century. It is clear from the table that the Leipzig Mahzor includes all of them. They can be divided into two groups: (1) clearly distinguishable and outstanding characteristics of the Worms rite traceable only in Worms and appearing in both the early modern sources and the medieval manuscript sources; (2) features that apparently crystallized only in the early modern period and that, because they do not appear in the Leipzig Mahzor, cannot be indicative of provenance. The Leipzig Mahzor also embraces a few elements that, although typical for Worms, may have spread elsewhere during the Middle Ages, beyond the cultural borders of that community.

It was thus not David bar Samuel Dekingen's purchase of the Leipzig Mahzor in 1553 that brought the manuscript to Worms. The book not only emerges as an early witness to the medieval prayer rite of Worms, but can also provide valuable data concerning its relatively unknown medieval development. What is relevant to the contextualization of its decoration program is the fact that the community of Worms and its scholars were behind the concept, the content, and the messages of its imagery.

Table 3 *Piyyutim* of the Rite of Worms (Leipzig, Universitätsbibliothek, MS Voller 1102/I–II)

Piyyutim typical for the rite of Worms	Davidson	Goldschmidt Fraenkel	Worms, vol. 2 (fall only)	Mich. 436	Mich. 434–435	glosses in Oxford Maharil	Kirchheim	Shammash	Loans
(1) Medieval and early modern rite of Worms (included in the Leipzig Mahzor)									
Pesah		*Pesah*							
adonai melekh (God is king) followed by *uvechen lekha ta'ale qedushah* (Holiness will ascend towards you)				∅			∅	∅	
vayosha or Israel (The light of Israel will save it—*yotser*)	239			∅		∅	∅	∅	∅
Shavuot		*Shavuot*							
adir vena'eh (Great and beautiful—*yotser*)	1092			∅	∅	∅	∅	∅	∅
kevodo ot beribo'ot (His glory is very great—*ofan*)				∅	∅	∅	∅	∅	∅
Rosh Hashanah		*Hayamim-Hanoraim* vol. 1							

(continued)

Table 3 (continued)

Piyyutim typical for the rite of Worms	Davidson	Goldschmidt Fraenkel	Worms, vol. 2 (fall only)	Mich. 436	Mich. 434–435	glosses in Oxford Maharil	Kirchheim	Shammash	Loans
ashre ha'am yod'e teru'ah (Happy the people who have learned to acclaim you—ma'ariv)	8396			∅	∅	∅	∅	∅	∅
kesse uri (Time of light—ma'ariv)	492	18–20		∅	∅	∅	∅	∅	∅
Yom Kippur (selihot)		Hayamim Hanoraim vol. 2							
ana bo'el (It may please you to forgive)	6277	207	∅	∅	∅	∅	∅	∅	∅
ta'aleh tefilatenu (Our prayer may ascend)	429	213	∅	∅	∅	∅	∅	∅	∅
akh bemetah din (Unrelenting judgment)	3221	219	∅	∅	∅	∅	∅	∅	∅
enosh rimah (Man worthless as a maggot)	498	212	∅	∅		∅	∅	∅	∅
al be'apkha (Not in anger)	3487	232	∅	∅	∅	∅	∅	∅	∅
akh bekha ledal ma'oz (A refuge for the poor)	3218	231	∅	∅	∅	∅	∅	∅	∅

shofet kol ha'arets (Judge of the whole world)	712	272	⊘	⊘	⊘	⊘	⊘	⊘	⊘
adonai adonai el rahum (God, merciful God)	2275	663	⊘	⊘	⊘	⊘	⊘	⊘	⊘
elohim al dami ledami (O God, keep not your silence over my blood)	4626	538	⊘	⊘	⊘	⊘	⊘	⊘	⊘
emunat omen etsot (True faith)	5638	661	⊘	⊘	⊘	⊘	⊘	⊘	⊘
adaberah tahnunim (I shall entreat for mercy): eve of Yom Kippur	473	277	⊘	⊘	⊘	⊘	⊘	⊘	⊘
otkha edrosh (I shall seek you): morning	2082	38	⊘	⊘	⊘	⊘	⊘	⊘	⊘
ele ezkerah (I shall recall)	4273	568	⊘	⊘	⊘	⊘	⊘	⊘	⊘
az kashti webaravi (My bow and my sword)	2173	701	⊘	⊘	⊘	⊘	⊘	⊘	⊘
Sukkot		*Sukkot*							
ata levadkha atita or (You are wrapped in a robe of light—*ma'ariv*)	8818	27	⊘	⊘	⊘	⊘	⊘	⊘	⊘
Shmini Atseret									

(continued)

Table 3 (continued)

Piyyutim typical for the rite of Worms	Davidson	Goldschmidt Fraenkel	Worms, vol. 2 (fall only)	Mich. 436	Mich. 434–435	glosses in Oxford Maharil	Kirchheim	Shammash	Loans
erehamkha (I shall adore you—ma'ariv)	7575	305		Ø	Ø	Ø	Ø	Ø	Ø
ahot asher lekha kasafta (A sister you have chosen)	2446	376–379	Ø	Ø	Ø	Ø	Ø	Ø	Ø
(2) Early modern additions (typical for the later Worms rite, but not included in the Leipzig Mahzor)									
Great Shabbath									
iti melevanon kallah (Come with me from Lebanon, my bride)—only if wedding takes place	8891			—		—	Ø	Ø	Ø
Yom Kippur (selihot)									
adonai elohe rabat tseraruni—Often have I been attacked	717	225	Ø	—		Ø	Ø	Ø	

There is, finally, evidence that the Leipzig Mahzor was still in Worms in 1604. In that year another mahzor, now in Oxford (Bodleian Library, MS Michael 434–435), was copied.[45] In comparison to its medieval forerunners, this manuscript is rather crudely written in a poor script and lacks the careful layout typical of the medieval mahzorim. The manuscript also includes some crude decorations, mostly of an ornamental nature. At the beginning, however, for the services of the special Sabbaths before Pesah, we find three illustrations that are faithful, even though amateurish, *replicae* of their parallels in the Leipzig Mahzor. The illustration for the first of the special Sabbaths has an initial panel with scales flanked by medallions with the four living creatures described in the book of Ezekiel (figs. 5 and 16). The initial for the next Sabbath shows a somewhat enigmatic iconography of four male heads in profile wearing funnel hats, typical for Central European Jewish costume after this type of headgear had been enforced upon the Jews in the thirteenth century in some areas.[46] The third illustration adorns the opening of the *yotser* for the last of the special Sabbaths and shows the figure of a man pointing to the moon.[47] All three images are marked by their unique iconography, which is unlike that in other medieval mahzorim. In the second volume we find three more such cases. The decoration of the *qerovah–etan hikir* (The steadfast believer) is a simple architectural frame reminiscent of its more lavish counterpart in the Leipzig Mahzor (fig. 18).[48] It is striking to observe that the Leipzig Mahzor is the only medieval mahzor in which this particular *piyyut* has any embellishment at all, as it is normally not included in any of the medieval decoration programs. The same is true for the design of an initial panel decorating a *piyyut* for the Sukkot service.[49] Another initial decoration for a *piyyut* for *Simhat Torah* (Rejoicing of the Torah) is embellished with two coiled serpents, again clearly reminiscent a similar illustration in the Leipzig Mahzor.[50]

It is apparent that the scribe of MS Michael 434–435 also used the Leipzig Mahzor as a text model, even though it was adapted to the seventeenth-century version of the Worms rite and we can observe some very specific similarities. For example, like the Leipzig Mahzor, MS Michael 434–435 begins with *shokhen ad merom* (He who dwells on high), a statutory prayer recited before the *yotser* complex. This is the only statutory prayer included in the medieval mahzorim, and the Leipzig Mahzor is the only one that has it at the beginning of the book. In both manuscripts *shokhen ad marom* is followed by the service for the Sabbath during the week of Hanukah, also a feature not seen in other mahzorim, which often begin with the services for the special Sabbaths.

These observations suggest that at the time the MS Michael 434–435 was produced in 1604, the Leipzig Mahzor was still in Worms and was

used as a model; it was sent to Poland only at a later stage. We can, perhaps, speculate that it may have been moved to the East as a consequence of a violent persecution that took place in Worms in April 1615. The Jews were readmitted to the city in 1616, but not much is known about those Jews that did not return to Worms, who perhaps made their way to the East. The synagogue was severely damaged during the pogrom, and it is likely that the Mahzor was removed at that time. However, as nothing is known about that period in the history of the Leipzig Mahzor and it cannot be traced in any source material, this has to remain a speculation.[51] These observations not only indicate that the Leipzig Mahzor was in Worms in the early years of the seventeenth century, but also offer further support that it was, indeed, an outstanding representative of the Worms rite. If this were not the case, it would not have been chosen as a model for a declared "mahzor for the entire year according to the rite of Worms," as is noted in the title of MS Michael 434–435.[52]

LET ME conclude this general description of the Leipzig Mahzor with some basic observations about its illustration program.[53] At first sight, the program seems to be inconsistent in its overall approach to the layout of the decorated pages. There are several types of adornments: initial panels, some very elaborate with figural motifs (fig. 7) and others merely decorative and modest; frames with architectural motifs creating decorative arches that circumscribe the text page (fig. 18); and unframed marginal scenes with figural settings describing historical narratives, customs, and other kinds of allusions to the text (figs. 8 and 9).

The opening *piyyutim* for almost all the holiday services are embellished in one of these ways. Only the openings for the last day of Pesah and the second day of Shavuot remain undecorated. The opening words of some of the biblical books and a few of the other types of poems are also adorned with modest initial panels. Elaborate initials with significant iconographic messages are reserved almost exclusively for the opening poems. The visual language of these initial panels is symbolic rather than narrative. Moreover, it often communicates individual motifs arranged in juxtapositions that relate, not necessarily to individual textual expressions in the poems, but rather to the general theme of the specific holidays in more general terms (fig. 3). The second volume includes several frames that form gates or other architectural motifs (fig. 18). These are reserved for the "Days of Awe," a period of penance between Rosh Hashanah and Yom Kippur, and were created as allusions to the frequently used textual expression "Gates of Mercy" in the context of these holidays.

The marginal compositions are of two different types. Several of them accompany initial panels for some of the opening poems. This is the case

for two of the special Sabbaths before Pesah, *shabbat parah* and *shabbat hahodesh;* the first day of Pesah; the first day of Shavuot (fig. 15); the first day of Rosh Hashanah (fig. 3); and the first day of Sukkot.[54] The *musaf* for the second day of Rosh Hashanah is also adorned with a marginal scene (fig. 4). What is unusual is not only that a *piyyut* from the *musaf* prayer service has such an embellishment, but also that part of it appears in the inner margin. Codicological and stylistic evidence indicates that this scene— showing the Binding of Isaac—and two others were added somewhat later, which accounts for this departure. Another unusual case is the *minhah* prayer service for Yom Kippur, which is decorated with an elaborate architectural frame, the upper part of which also functions as an initial panel, and a marginal narrative of Abraham in Nimrod's furnace on the bottom of the page (fig. 18). This scene is discussed in detail in Chapter 5, where this idiosyncrasy is addressed. Other marginal compositions do not appear at the openings of poems, but are found next to the text wherever they seem relevant (fig. 8). As is common in other Ashkenazi mahzorim, Eleazar Qallir's prayer for dew recited on Pesah is accompanied by a series of marginal medallions showing the signs of the zodiac.[55]

The marginal motifs are either narrative and allude to biblical scenes and their exegetical background—often in terms of rabbinic exegesis—or depict religious customs well known and familiar to those who used and viewed the Mahzor. The scene of Abraham in Nimrod's furnace (fig. 18), the Purim story with its lively figural depiction of scenes from the book of Esther, the transmission of the law on Mount Sinai (fig. 15), and the Crossing of the Red Sea are examples of the former group, whereas the cleaning of the dishes before Pesah (fig. 8), the preparation of unleavened bread (fig. 9), and the initiation ritual of young boys on their first day of school (fig. 15) are illustrations of the latter.[56] These images, which are easily understood, function as visual glosses and comments on the text, serving as pictorial counterparts to the somewhat complex wording of the adjacent texts.

There are only a few exceptions that do not fit into either of the genres described above. The first image in the book, a relatively large panel showing Samson rending the lion, which accompanies the Bible readings, stands out stylistically and apparently belongs to the later additions I mentioned earlier.[57] The first image to illustrate the liturgical section shows the prayer-leader in a small, framed panel (fig. 10). It does not relate to any particular text, but represents prayer as such and, in particular, the custom of reciting liturgical poetry, and it may originally have been intended as the first image in the entire manuscript. The third exception is an ornamental panel in the prayer *alenu leshabeah* (It is upon us to praise), which decorates the word *hu* (he) for God.[58]

Several decorated mahzorim were produced in the German lands before the Leipzig Mahzor was written. Although many of them contain mostly ornamental decoration, others have more complex figural illumination programs. They all served the same purpose: communal synagogue services during holidays. As such they contain basically the same text, even though, as we have seen, slight variations can be observed according to local custom.

Perhaps the first of these early Ashkenazi mahzorim is the Amsterdam Mahzor, which was produced before 1250 in Cologne.[59] Numerous pages of this book are embellished with simple pen-drawn initial panels, and only few of them carry an iconographic message. The illuminated Michael Mahzor now in Oxford is dated by its colophon to the year 1258 and may have been produced in Franconia.[60] It too contains many decorated initial panels, most including various animals, both realistic and grotesque, some of which can be associated with the contents of the adjacent *piyyutim*. Many of the initial panels contain battle scenes. The Laud Mahzor, perhaps from the same region and made around the same time as the Michael Mahzor, is more richly decorated. Architectural motifs frame much of the text and numerous initial panels, often with adjacent marginal illustrations that relate to the contents of the *piyyutim*.[61] The first volume of the Worms Mahzor was produced in Würzburg in 1272. Like the designers of the earlier Laud Mahzor and those of the Leipzig Mahzor, the makers of the Worms Mahzor had a preference for unframed images, some of which were cropped during subsequent rebindings. Most of these images appear adjacent to enlarged initial words, which are themselves undecorated and unframed. The so-called Double Mahzor, now split between Dresden and Wroclav, was produced before 1293.[62] In the Tripartite Mahzor, which was made in Constance around 1322, all the illustrations were done as initial panels and there are no marginal decorations or scenes.[63] Most strikingly, the Tripartite Mahzor also lacks the arch-shaped architectural motifs so common in other mahzorim.

These mahzorim are surprisingly diverse in their decoration techniques, layout styles, and imagery, and a relatively few themes developed into iconographic conventions.[64] Architectural designs, for example, were quite popular in illuminated mahzorim, especially arches decorating references to the "Gates of Mercy" in the liturgy of the Days of Awe. The decorations for the special Sabbaths preceding Pesah include depictions of the Red Heifer for *shabbat parah* and the Luminaries for *shabbat hahodesh*.[65] On the former Sabbath, the text about the Heifer (Nm 19:1–22) is added to the regular service, and on the latter the text about the regulations with regard to the month ("*hodesh*") of Nissan, as the first month of the biblical calendar year (Ex 12:1–20), is recited. For the Purim service we usually

find Haman and his sons hanging from a tree.[66] The signs of the zodiac, occasionally accompanied by the labors of the months, illustrate Eleazar Qallir's prayers for dew and rain recited during Pesah and Sukkot. These have a long-standing tradition in German book illumination and appear frequently in Thuringian, Saxonian, and Franconian illuminated psalters. For Shavuot the Transmission of the Law on Mount Sinai, commemorated on that holiday, was usually chosen as the accompanying imagery. Among these conventions we also find the decoration of the *piyyut, shoshan emek* (The lily of the valley) read during the Yom Kippur *musaf* prayer service. In a very literal text–image relationship, this adornment displays several flowers arranged within an arch-shaped framework. The holiday of Sukkot is embellished by the figure of a man holding the four species.

The image of a couple refers in several of the mahzorim to the *yotser* for the Great Sabbath, *iti melevanon kallah* (Come with me from Lebanon, my bride), based on the Song of Songs and its interpretation. Even though the basic theme of the couple motif, interpreted in the Jewish tradition as an allegory of God's love for his people, recurs in several books, the particulars of each rendering are quite different. The same is true of an image of the Binding of Isaac that often adorns the liturgy for the second day of Rosh Hashanah. The fact that this iconography alludes to the biblical readings had turned it into a convention for the Rosh Hashanah service and also led to the addition of the marginal scene in the Leipzig Mahzor at some later stage (figs. 3 and 4).

Although I refer to these themes and motifs in terms of "conventions," it should be noted that in most cases it is only the subject matter as such that has become a convention, whereas the particular imagery is highly variable. It is very rare to find a close iconographic relationship among the different renderings of the various conventions. Rather, the conventionality expresses itself in the fact that the visual reference is to the same subject. Apart from this basic pool of conventions, the decoration programs of the Ashkenazi mahzorim differ largely one from another. The richest decoration program among the thirteenth-century mahzorim can be found in the Laud Mahzor, which—beyond the conventions—includes a wide spectrum of unparalleled subject matter.

The Leipzig Mahzor includes several of these commonalities, but adds numerous innovations in terms of both the iconography and the layout. It uses the Red Heifer, the zodiac signs, the Lily of the Valley, and a variety of architectural frames for which we have found numerous parallels. It also depicts the Hanging of Haman, but enriches the iconography with an elaborate narrative of the Esther story in the lower margins, including exegetical elements.[67] Similarly, the Luminaries for *shabbat hahodesh* are

enriched by two marginal figures pointing to them; the Transmission of the Law is not included in the design of the initial panel, as is found in other mahzorim, but is one of the frequent marginal narratives (fig. 15), with a reference on the opposite page to a contemporaneous custom common in medieval Ashkenaz. The Binding of Isaac, often shown in other prayer books, seems to have been but an afterthought (figs. 3 and 4). The iconography of the couple from the Song of Songs is highly original and differs widely in its details from such depictions elsewhere (fig. 7). The illustrations of customs, such as the cleansing of the dishes before Pesah, are not generally found in other mahzorim (figs. 8 and 9). Most striking in the Leipzig Mahzor is the frequent use of unframed marginal images. In the Laud and Worms mahzorim these unframed images usually appear in conjunction with decorative initial words, whereas the Leipzig Mahzor shows several narratives independent of the initial panels on the bottom of some of the pages (figs. 8 and 9), where they occupy the entire width of the lower margin. The method of unframed marginal narratives is occasionally also found in Christian manuscripts, but rarely from before the fifteenth century. For the most part they appear in secular art or as illustrations in vernacular texts.

During the early decades of the fourteenth century, manuscript illumination flourished in different areas, spreading from Strasbourg and Karlsruhe along both sides of the Rhine River southward via Alsace in the west, Breisgau in the east, and to Lake Constance and beyond into modern Switzerland. The most celebrated illuminated books were produced in this area, especially near Lake Constance. A whole group of lavishly decorated Hebrew manuscripts can also be attributed to this artistic tradition.[68] Other thriving schools were active in the early fourteenth century in Bavaria, especially in Regensburg and adjacent regions. A third stylistically clearly defined school developed in Cologne.

Although the style of the Leipzig Mahzor does echo the norms of the Upper Rhenish schools to some extent, the fact that it clearly follows the rite of Worms contravenes earlier stylistic analyses of its decoration program that attributed it to the Upper Rhine. Moreover, the trademark of the Upper Rhenish style is a delicate treatment of faces, which is not found in the Leipzig Mahzor, as its human heads have a somewhat birdlike appearance.[69] The figure style and the spatial perception of the images in its drapery largely conform to the Upper Rhenish norms, but that is of little account as it is possible that the painters were trained in that tradition.

At the time the Leipzig Mahzor was produced, several areas in Germany could look back at a long-standing tradition of manuscript painting. This tradition began to wane during the later Middle Ages. The core region of the Ottonians and the Staufer, for example, the Middle Rhine, produced

numerous illuminated manuscripts during the tenth and eleventh centuries. Speyer was in all likelihood a major center. Similarly, Lower Saxony and Thuringia had flourishing Romanesque schools that drew much scholarly attention. In Franconia, Würzburg in particular, manuscript illumination thrived around the middle of the thirteenth century. However, around 1300 all these schools were no longer active. Evidence is particularly sparse for the Middle Rhine, as the major collections of manuscripts from this region were lost to fire.[70]

THAT THE LEIPZIG MAHZOR was produced at the initiative of the community of Worms and written there is beyond doubt. That its style does not fully correspond to the known norms from that area may have to do with the fact that not enough of early fourteenth-century Christian art from the Middle Rhine region has survived to enable us to make any significant comparison. The Leipzig Mahzor is neither an outstanding nor a particularly typical representative of Upper Rhenish style, but an influence from that school is certainly observable.

The observation that two different hands can be discerned in the decoration of the Leipzig Mahzor is also somewhat puzzling. The two clearly represent two different artists, but they could certainly be described as belonging to a single workshop style. The images that I believe were added as an afterthought are the ones that are the most lavish. We can speculate that all the images were produced in the same workshop and that most of the program would have been executed by a Jewish member of that workshop. The additions both marked by distinct Christian iconography may have been made by another, Christian, artist from the same workshop. The text of the Leipzig Mahzor speaks for itself. Our book is a product of the Worms liturgical tradition. Where the artists were trained, and whether they migrated from another area, we may never know. What concerns us here more than the stylistic home of its artists is the fact that the Leipzig Mahzor served as a communal ritual object, as well as a reflection of the social and cultural ambience of Jewish life in Worms, the particular community this book served for 300 years.

Worms:
Community, Society,
and Scholarship

Borrowing from ludwig wittgenstein's notion of family resemblance, Ronald L. Grimes delineates rituals by a set of qualities that he refers to as "family characteristics." Among other features, rituals are, for example, repetitive; they lack spontaneity; they are characterized by stylized forms and particular gestures; they are collective, performative, and consensual; they are grounded in tradition; and they have meaning. An action can be referred to as a ritual when these qualities are in evidence, at least in part.[1] More concisely, a ritual can be defined as a "rule-governed activity of a symbolic character which draws the attention of its participants to objects of thought and feeling which they hold to be of special significance."[2]

Prayer as such, which is often private and spontaneous, is thus not necessarily a ritual, but most forms of prayer do follow strict rules and fixed orders to an extent that they become ritualized.[3] This was certainly true of the approach of medieval Ashkenazi Jews to prayer, with its tendency toward fixity and formalization. This is also implied, and particularly so, in connection with the recitation of *piyyutim*. Some theorists of ritual and liturgy underscore the performative aspects of the words uttered during liturgical acts.[4] Indeed, synagogue services are conducted in an archaic language different from the vernacular idiom; both prayers and *piyyutim* are performed publicly by the prayer-leader. The Leipzig Mahzor is thus a ritual object, an object that helps a congregation perform a public ritual. It is

this aspect of the manuscript that, to some extent, will guide me through the discussion of its illustrations, which can serve to elicit the meanings of the rituals performed within the medieval synagogue of Worms.

On every holiday between c. 1310 and c. 1615 a servant would have carried the Leipzig Mahzor into the Worms synagogue (fig. 2) and laid it on a lectern near the Torah shrine. The medieval synagogue was understood to be a "minor Temple," a sacred space. There the Mahzor was to serve the prayer-leader, whose function was understood to be that of a representative of the community before God (fig. 10). Even though the medieval Ashkenazi mahzorim may have been commissioned and owned by private patrons, kept in their own homes, and taken to the synagogue only for the holidays, these books were nonetheless primarily objects of public character. The fifteenth-century scholar Jacob Moelin (*Maharil,* d. 1427) referred to the holiday prayer book as a public mahzor, and did not permit the use of a volume that was not explicitly intended for communal prayer. He went even further, and harshly criticized anyone who introduced changes or corrections in those "mahzorim of the public." Relying on the authority of Eleazar ben Judah of Worms, he explained that these public prayer books were written for the sake of a *mitsvah,* a divine command, and that the scribe's approach to producing such a book is expected to be different from the way he would relate to just any prayer book. The community's reverence for its prayer book, continued Moelin, guarantees the acceptance of its prayers in the divine spheres.[5]

What is clear from these observations is the obvious communal nature of the mahzor. Ritual is defined not only by its formal characteristics, but also "in terms of the purposes it serves in human life," in the life of a particular community.[6] Yet a third approach defines rituals in terms of their meanings: rituals are rooted in myths or theological concepts, and they communicate meaning for which the imagery can be a key.[7] These meanings, as far as they shine through the images of the Leipzig Mahzor, are approached through a set of associations experienced by fourteenth-century viewers of the illustration program. As Mark Searle put it, "a liturgical rite may explicitly mediate contact with the Divine while simultaneously rehearsing the participants in the community's value system, covering over potential sources of conflict in the community, and consolidating the power structure operative in the community by associating it with the sacred and thus with the unquestionable."[8] The Leipzig Mahzor includes the texts of these liturgical rites.[9] Compendia of the ritual law and collections of religious customs provide sources concerning the way scholars orchestrated these rites and customs, how they were supposed to be carried out, and what their symbolic meaning might have been. The illustration program is a key to

understanding how these rites and customs were integratively embedded in the community—in its collective memory and in its identity.

When scholars looked at the medieval Jewish community of Worms in the nineteenth century, the legacy of the public rite and the wealth of medieval manuscripts were still playing a major role in the communal consciousness. In a small booklet about that community published by Samson Rothschild in 1901, there is a photograph showing the seventeenth-century room adjacent to the synagogue, traditionally known as "the school of Rashi," with several illuminated prayer books on the central table.[10]

By mere coincidence the synagogue in which the Leipzig Mahzor would have been read on the holidays is still in existence (fig. 6). The first synagogue in Worms was built in 1034, but was damaged during the Crusader massacres of 1096. It is not clear whether it was restored or not, but it is hard to believe that the community went without a synagogue for the next eighty years. We do know that a new building was erected in 1175. It is likely that the earlier synagogue was restored after 1096, but eventually proved to be too small to provide for the needs of the flourishing, ever-growing community. The new building, even though damaged in later persecutions—in 1348 and 1615—remained in existence until November 9, 1938, when it was completely destroyed during the Nazi riots that took place that night. It was reconstructed by the German authorities in 1961 and is now administered by the nearby Jewish community of Mainz.[11] It is here, in the men's hall of the Worms synagogue near the shrine, that the Leipzig Mahzor would have lain open on a lectern during holiday services for more than 300 years.

I suggest that the imagery in the Leipzig Mahzor was not designed by some patron as a message addressed to the community (as was often the case for the patronage of, say, the architectural sculpture of medieval cathedrals), but that it was meant instead as a sort of communal self-portrait. One's first impression, leafing through the book and attempting to apprehend the decoration program, is that it lacks consistency. A closer look, however, reveals that the program's diversity in both subject matter and the use of various visual idioms is not a symptom of a lack of focus, but rather that the program seems to reflect the multilayered concerns of the community and the worldview of its members. This study is an attempt to sketch the mentality that shines through this faceted "communal portrait." However, before I can go any further, we have to take a closer look at what is known about the medieval Jewish community of Worms.

A (medieval) Jewish community can be looked at from several perspectives. It can first be defined by the presence of a group of Jews in a particular place and the key events that occurred there and shaped the collective

historical memory of that group.[12] These events can be reconstructed through both Jewish and Christian historical documentation. Observations made through the study of this documentation can be set within the context of the political history of the town and its governing authorities, so that the community can be more broadly defined in terms of its legal and political history. A community can also be marked by its demography, its social structures, its organizational systems, and its institutions.[13] Approaches focusing on these aspects tend to concentrate on the general picture of the generic Ashkenazi community and do not necessarily try to crystallize specific features of any particular area.[14]

However, members of a particular community are not only delineated by geographic parameters, shared institutions, and the historical events that occurred in a certain place; they also share a further set of elements apart from locale. In simple geographic terms the Jews of Worms shared their identity with the Christians of Worms, using the same spoken language and having a similar way of life, and they were bound to parallel economic and social structures.[15] Of prime importance, however, is the fact that the medieval Jewish community is defined by its religious beliefs, its cultural history, and its scholarly production, characteristics that create social cohesion, a sense of belonging beyond physical presence at any given place and identity.[16] Scholarly tradition often carried ideological implications with differing moral and ethical stances or differing preferences in terms of scholarly method. This double-bound identity—determined by geographical along cultural and cultural-religious parameters—is specific to minority societies.

The culture of a community can also be approached anthropologically with a view toward understanding its function in the lives of its members and the role it must have played in helping them to make sense of the world around them and shaping their social and religious identity. Jeffrey Woolf recently pursued such an approach in relation to Jewish medieval history.[17] In the eyes of Ashkenazi Jews, their community was sacred; hence the concept of "sacred congregation." This notion held true among Jews throughout the Franco-German realm and ran across specific communities with their particular individual self-definition and communal identity.[18] Beyond being a body for self-government, every community saw itself as an ideal assemblage abiding by the moral requirements implied by the overriding concept of the sacred congregation. Communal autonomy that went hand in hand with the laws of self-government "provided the Jews with the possibility to carve out psychological and sacred space," granting a "defensive buffer . . . [and] refuge in the face of legal deterioration," and enabled them to attenuate the threat of apostasy.[19]

On the other hand, any given community within the Ashkenazi realm also defined itself as a separate entity and by its specificity in relation to other Jewish communities. Apart from distinguishing itself geographically as a physical region, where one's ancestors had lived, a medieval Jewish community also defined itself by its collective history, implying its specific legal position, its political situation, and its relation to the Christian environment. When these relationships deteriorated to the point that there was violence, communal identity was shaped by the memory of its victims.

The distinctive medieval prayer rites were instrumental in molding the individual identities of the medieval Ashkenazi communities, each as a separate sacred congregation. The particular religious customs followed in Worms, the particular prayer rite used there, and the meanings underlying the prayers and rituals, played a major role in the self-definition of this particular community, and all of these aspects have echoes in the Leipzig imagery.[20] The notion of the ideal sacred community that governed the lives of Ashkenazi Jews and the individual history of each community were key elements in the shaping of its specific identity and defining the role that the community played in the lives of its members. The Leipzig Mahzor—textual witness of the rite of Worms together with a well-defined and clearly articulated imagery—can thus serve as a tool for reconstructing the cultural identity of the Jewish community of Worms at the time of its production.

JEWISH WORMS, like Mainz and Speyer, was one of the most celebrated communities of medieval Ashkenaz.[21] In the early Middle Ages these towns were part of the Duchy of Franconia, an area where the Salian and Staufen dynasties would later concentrate their territorial power. The inhabitants of this area, the Jews included, were thus closely linked to royal authority, a fact that would have a determining effect on the latter's political situation throughout the Middle Ages. Both Worms and Speyer were bishoprics, and their dioceses were part of the archbishopric of Mainz. During the eleventh and twelfth centuries, cathedrals were built in all three towns. However, owing to the proximity of monarchial power and the expansion of royal territories, the bishops of Worms, Speyer, and Mainz were limited in their ability to increase their territories and thus their political dominance. This situation remained basically the same even when power would later shift from royal authority to the local counts. From the point of view of inner-ecclesiastical power, Mainz in particular, and the other two bishoprics as well, stood out from the early Middle Ages on. All of these factors encouraged the urban development of the three towns and ultimately resulted in a relatively high degree of independence. They also

had a determining influence on the history of the Jews in the area and the ways their protection—the *Judenschutz*—could or could not be guaranteed.

The three towns are located in the Middle Rhine region and developed along one of the principal trade routes, which followed the river. Jews emigrating from France and Tuscany settled in the Rhineland as merchants, perhaps as early as the ninth or the beginning of the tenth century.[22] The earliest dated, documented evidence of Jews in Worms goes back to 1012, but Jewish texts specifically mention the arrival of Asher Halevi, a scholar from Vitry, which must have been sometime during the second half of the tenth century. Asher's grandson Isaac Halevi (d. c. 1075–1080) was to become one of Worms's most illustrious scholars.

During the eleventh century the community flourished in every respect— economically, socially, and culturally. The town's first synagogue was dedicated in 1034. The Jews integrated into the economic life of the town and joined the citizens of Worms when the latter supported Emperor Henry IV in his struggle against Pope Gregory VII. In exchange, in 1074, Henry granted the town, the Jews explicitly included, certain toll exemptions. In a further *privilegium* in 1090 he accorded the Jews legal autonomy and free movement for the sake of commercial activity. Both charters regulated issues of settlement as well as of tolls and taxes. The Jews were not allowed to own Christian slaves, but could employ free Christians in their businesses and households. They could own houses and land. Henry's *privilegium* also explicitly forbade forced baptism. The upper class of the Worms Jewish community engaged in trade and played a significant role in the economy of the Empire. Apart from these merchants, we find a relatively large social stratum of bankers and moneylenders, doctors and apothecaries, as well as scholars, some of whom were merchants as well.

The Jews of the Rhineland had no formal central organization that compared to that of the rabbinic leadership in the Islamic countries. Occasionally they would appeal to the Eastern authorities about matters concerning religious life or internal Jewish organization, but primarily they demonstrated a great deal of independence and local authorities were empowered to make crucial legal decisions. Despite later developments toward regional organization, the relatively high degree of independence that all of the Rhenish communities enjoyed at this early stage would eventually influence the way they crystallized their communal identity. By the late eleventh century the internal organization of the local communities had a clear structure, which reflected the regulations that had been promulgated several decades earlier. Inner-communal legal decisions were made collectively by a council of rabbinic judges together with the head of the community. A group of Worms "community leaders" is mentioned, for

example, in the chronicles that commemorate the Jewish victims of the Crusader riots in 1096.[23] The jurisdiction of this elite was grounded in their standing as biblical scholars, family prestige, and wealth.[24] With few exceptions, most scholarly authorities in the Rhineland belonged to a few established families, who not only served in spiritual capacities, but also wielded political and economic power. It was also understood that this elite was backed by the Christian authorities. Vis-à-vis the latter, the Jews were represented by the so-called *archesynagogus* or *episcopus judaeorum,* as he is referred to, for example, in the charter of 1090.

From their early beginnings these communities turned into centers of rabbinic scholarship. Deeply rooted in the Palestinian tradition and cherishing a wealth of customs that had been orally transmitted from generation to generation, early medieval Ashkenazi and French Jewry underwent a complex process of reception of the Babylonian talmudic law. Before the Babylonian Talmud became widely circulated and fully obligatory in the Jewish communities of Europe, the ritual law was an oral tradition, which implied the whole range of special dynamics typical of an oral culture. In the Ashkenazi communities this oral tradition was rooted in the practice of Palestinian Jewry. The resulting tension between the Palestinian oral tradition and the Babylonian written law became one of the salient characteristics of medieval Ashkenazi scholarship, which cannot, by any means, be defined as homogeneous. In the post-talmudic period, approximately after the sixth century, the Babylonian law gradually began to overshadow the Palestinian tradition, and Babylonian halakhah (ritual law) became dominant everywhere in the Jewish world.

The Ashkenazi reception of the Babylonian Talmud began in the late tenth century in the rabbinic school of Mainz, where it was occasionally used to guide its halakhic decisions, but most of its rulings were still based on the Bible, the Mishnah (the oral law put into writing in c. 200 C.E.), and the Palestinian tradition. The rabbis of Mainz studied the Babylonian Talmud and produced brief commentaries on various sections, but their attitude toward it remained somewhat ambivalent. Moreover, their approach to the Babylonian tradition vis-à-vis the Palestinian one was all but homogeneous, and, unlike their Sephardi colleagues, the Mainz scholars did not consider the Babylonian tradition, or those who represented it, the ultimate authorities in halakhic matters. They continued to demonstrate a great deal of independence in their own decisions, and the Palestinian tradition certainly had a dominant influence on their scholarship.[25] Gradually the Babylonian Talmud gained more and more authority in academic discussions of halakhic matters, but it took few more generations for it to supersede Palestinian custom for governing daily life.

In the course of accepting the Babylonian Talmud, efforts had to be made to create congruence between the talmudic halakhah and various components of the oral tradition. In a process that was described in detail by Israel Ta-Shma, elements that either were not covered by the Babylonian Talmud or diverged from it crystallized into what would become known as the "custom" *(minhag).*[26] The *minhag* was particularly revered among the Jews of the German lands and—until the twelfth century—in northern France, whereas elsewhere in the Jewish world it never enjoyed any special status. As Ta-Shma pointed out, this reverence for the *minhag* in the German regions may have had its roots in the fact that the two Talmuds reflected different attitudes toward the *minhag.* Whereas the Babylonian Talmud puts the *minhag* at the bottom of its value system, in the Palestinian tradition it had acquired a determining status: the Palestinian Talmud declares on several occasions that "a custom repeals the halakhah."[27] In point of fact, the *minhag* had a major influence on the later culture of Jewish Worms, and we shall see that the imagery of the Leipzig Mahzor refers to it time and again.

During the eleventh century, Worms began to develop as a new center of Rhenish scholarship. This was also a period of economic prosperity for the Jewish community and the entire town. Isaac bar Eleazar Halevi, one of Worms's principal scholars, had studied in Mainz. Nevertheless, his approach to halakhic decisions is marked by two significant differences in relation to the Mainz school: he demonstrated a clear preference for the Babylonian Talmud, and he modified several of the Palestinian customs to make them conform to the Babylonian Talmud.

Among wide circles of Central European Jewry, knowledge and acceptance of the Babylonian Talmud is associated primarily with the scholarship of Solomon ben Isaac (Rashi, d. 1105). Born in 1040 in Troyes, in France, he set out around 1060 to study in the school of Mainz, but four years later moved to Worms, where he became a disciple of Isaac Halevi. He left the Rhineland around 1070 to return to Troyes in order to establish a rabbinic school there. Building on the fruits of Isaac Halevi's revolutionary scholarship, Rashi further developed his teacher's approach into an entirely new chapter in talmudic exegesis.

The Mainz school at that time was apparently pervaded by an atmosphere of crisis and uncertainty. A new generation of rabbis sensed that the customs of their forebears were endangered, and they were preoccupied with efforts to preserve them. This not only tended to block their creativity in developing new scholarly methods, but it also created a certain degree of scholarly tension. Conservative scholars seem to have remained faithful to the somewhat ambivalent attitude to the Babylonian Talmud, anxious

to preserve the *minhag* and to elevate it to a yet more revered status. The effort to preserve the *minhag* is marked by the work of three brothers, usually referred to as the Sons of Makhir *(bene makhir)*, who collected various customs from the three Rhenish communities and undertook the first attempt to put the *minhag* into writing.[28] Their work is particularly significant because of the tension it engendered among of the Jews of the Rhineland over the anxiety that study of the laws in the Babylonian Talmud might endanger the old customs. Other rabbis followed Isaac Halevi's approach or, rather, looked westward toward France, where Rashi's influence was leading to new developments. At this point the Worms school was ready to give up certain customs, but the Mainz scholars, some of whom had moved to Speyer in and after 1084, were deeply concerned with preserving the *minhag,* a reverence that would hold sway in Worms only about 130 years later.

The twelfth century brought about far-reaching political, social, and cultural changes in the lives of Europeans in general and inhabitants of the German lands in particular. For the Jews this period began in 1096 with a series of severe persecutions that destroyed the Rhineland communities and for a time disrupted scholarly life and the social structures that had been built there.[29] Only six years after Henry IV's charter had been issued, the ideological foundations of the First Crusade led to massacres along the Crusaders' route. Henry, himself not involved in the Crusade, was unable to enforce the *Judenschutz* under his authority. Politically isolated after his conflict with the pope and in retreat in a castle near Verona, he dispatched several letters attempting to protect his Jewish subjects, but these had almost no effect, except in Speyer, where the *Judenschutz* proved more effective than elsewhere. Whereas the Jewish victims in Worms and Mainz numbered in the hundreds, eleven were killed in Speyer. After the massacres, Henry, who had returned from Verona, allowed those Jews who had been forced to submit to baptism to return to Judaism and to rebuild the communities that had been destroyed. Documentary evidence for the newly established community of Worms dates back to 1112. Realizing that the old system of *Judenschutz* could no longer ensure the security of the Jewish population, Henry attempted to include the Jews in the *Landfrieden* in 1103, an edict designed to secure the peace of defenseless Christians. Unfortunately, this safeguard never really materialized for the Jews and the *Landfrieden* marked the beginning of their decline to *servi camerae,* serfs of the royal chamber, in the thirteenth century and eventually pushed them to the margins of society.[30]

The Crusades of the twelfth century caused anxiety among the Jews, especially in Worms, but there were no major persecutions. Even in the

wake of the monk Radulf's vitriolic anti-Jewish preaching in the area in 1146, the Jews were able to flee to castles in the environs, where they were protected. In 1157 Frederick I Barbarossa reaffirmed Henry's charter, and during the Third Crusade (1184) the *Judenschutz* proved far more effective in protecting the Jews of Worms. Nevertheless, in 1196 the family of Eleazar ben Judah was attacked and his wife and two daughters were killed. I shall come back to Eleazar's elegies about these losses in more detail in Chapter 5. This apparently was, however, an isolated incident and not a general persecution of the community as a whole.

Despite the losses caused by the Crusader massacres, the community of Worms flourished economically throughout the twelfth century and beyond, a relative affluence that was linked to the economic prosperity of the town as a whole. The Jewish community grew considerably, apparently owing to immigration from other areas where life was more precarious for the Jews than in Worms. A new synagogue was built at the same time as the Worms cathedral by the members of the cathedral masons' guild and was dedicated in 1175. The community also built a *miqveh* in 1185, added a women's section to the synagogue in 1212, and enlarged the cemetery around the middle of the thirteenth century. Most Jews lived not far from the cathedral (map facing page 1) in an area that is still marked as *"Judengasse,"* even though the law did not limit them to any particular area. The earliest evidence of a specific Jewish neighborhood appears in 1080 in a document that mentions a *porta Iudeorum.*[31] Until 1348 Jews were allowed to own houses. They were integrated into the general community, although they did not have the political rights accruing to citizenship. In 1201, when Worms was besieged by the forces of Otto IV during the succession controversy after the death of Henry VI, the Jews participated in the defense of the town.

This period also saw significant changes in the communal organization of the Jewish population. As early as in the eleventh century, attempts had been made to create an organizational network of communities. It is from this time that we first hear of councils of community leaders and the gradual development of a *va'ad,* a loose council made up of rabbinic scholars from the three communities. Its members being tied by family connections, but estranged because of their scholarly approaches, this council was nevertheless considered an authoritative representative of Ashkenazi Jewry in general. Around 1200 this *va'ad* grew into a federation embracing the three communities.[32] From that point on, rabbinic assemblies were held from time to time and representatives from communities all over the Rhineland and beyond convened.[33]

The twelfth century was a period of changing economies and growing populations. It was also a period of ecclesiastical reform, in which the

mendicant orders were established, and far-reaching changes in intellectual life, as newly established universities replaced the older tradition of the seven arts, developed academic scholarship, revolutionized architecture, and introduced science and technology. In terms of Jewish scholarship, the trends that crystallized in the eleventh century continued after the restoration of the Rhineland communities in the early twelfth. The cultural developments in the Christian environments, which historians commonly designate as the "Renaissance of the twelfth century," would also leave their imprint on Jewish culture.[34] Rashi's approach was further developed under his sons-in-law, his grandsons, and later followers of his method, commonly known as the school of "Tosafists" (from the word *tosafot*—"additions"), which soon dominated Jewish scholarship in France and in wide circles in the German lands. Prior to the 1096 massacres, several French students, apart from Rashi, had come to study in Worms. In the following generations the direction of intellectual discourse changed and the Rhenish students traveled to northern France to study the Tosafist approach, which gradually spread across the Rhine and added yet more question marks regarding the Ashkenazi *minhag*.[35] Among the major figures who were concerned with the Ashkenazi tradition and its *minhag* was Eliezer ben Nathan of Mainz (Raban, c. 1090–1170). Although he too had adopted certain important aspects of the Tosafist method, much of his scholarship reflected a deep concern with questions revolving around the *minhag*.

Since the twelfth century, Jewish scholarship was no longer concentrated exclusively in the three Rhenish communities. Eliezer ben Joel Halevi (Ravia, c. 1140–1220), Eliezer ben Nathan's grandson and one of the dominant figures of his generation, was born in Mainz. He studied in France with Eliezer ben Samuel of Metz, and he can later be traced in Cologne, Speyer, Bingen, Bonn, Frankfurt, Worms, and Würzburg.[36] In the thirteenth century, Barukh ben Samuel moved from Mainz to Bamberg, and Meir ben Barukh (Maharam, d. 1293), who had been born in Worms, established his rabbinic school in Rothenburg ob der Tauber, where he occasionally challenged the hegemonic authority of the rabbinic leaders of the Rhenish communities in halakhic and other matters.[37] In short, during the period of the High Middle Ages, Jewish scholarship spread far beyond the Rhineland.

During this period the first of the Ashkenazi Pietists in Speyer, Samuel ben Qalonymos the Pious (born c. 1115), the father of Judah the Pious (d. 1217) with whom Pietism would later primarily be associated, first became active. Because the imagery of the Leipzig Mahzor can be associated time and again with the worldview of the Pietists, describing their scholar-

ship here in somewhat more detail is worthwhile. Samuel was a member of the Qalonymide family, a clan that for decades was associated with conservative attitudes. They claimed to be the descendants of the fathers of Ashkenazi Jewry in Mainz and were stalwarts regarding traditional views and efforts to preserve the customs. The work of Samuel the Pious, having grown out of this tradition, gave it new impetus and direction at a time when it had begun to falter and eventually led to specific ethical stances, asceticism, and a great interest in mysticism. The ethical legacy of the Qalonymide Pietists has come down to us in the Pietists' most prominent text, the *Sefer Hasidim* (Book of the Pious), a large collection of ethical sayings and exempla guiding the reader toward ascetic, moral, and pious conduct.[38]

The Qalonymide Pietists associated many of their values and teachings with older traditions that, by way of their southern Italian roots, could be traced back to Palestine. Their earlier history being somewhat obscured in shadow, they made these links to older strata of their tradition a central issue.[39] The question of what lies at the basis of Ashkenazi Pietism at a particular moment in medieval Jewish history is subject to much debate in modern scholarship. Some historians argue that the fate of the Jewish victims in 1096 had a major impact;[40] others underscore the possibility of an influence of Christian monasticism and penitential movements;[41] and still others view the development of Ashkenazi Pietism as a response to Tosafism.[42]

Samuel the Pious lived in Speyer, but toward the end of the twelfth century his son Judah the Pious moved to Regensburg. Eleazar ben Judah of Worms, a contemporary of Eliezer ben Joel, was the last of the Qalonymide Pietists, and we know from his halakhic work, *Sefer Haroqeach,* that he was well versed in the Tosafist method, having studied in France with Eliezer of Metz. However, he relied on it only rarely, tending more toward the ethical and esoteric teachings of Judah the Pious, who was another of his mentors. In some sense Eleazar reconciled the Pietist approach with academic halakhah. It is significant for this approach that he maintained a lifelong connection with Eliezer ben Joel, also a student of Eliezer of Metz, who played a key role in the adoption of Tosafism in Ashkenaz. The two scholars exchanged queries and responsa, but often they clearly disagreed. Eleazar was a staunch representative of the Ashkenazi tradition and Pietism, with an intense interest in the *minhag,* whereas Eliezer preferred the academic approach of the Tosafists.[43] On the other hand, Eliezer was open to certain aspects of Pietist teaching, but esoteric teachings were never a major area of interest for him.[44] Ivan G. Marcus argues that it was Eleazar who adapted the somewhat eccentric stances and values of his teacher to accommodate larger circles of Ashkenazi Jewry. Whereas Judah the Pious tended to introduce innovations that were not widely accepted, Eleazar's

modifications moved them back to a more traditional path. Cautious toward such innovations, especially when they concerned ritual, he rather tended to maintain earlier traditions and customs.[45]

No scholar of particular fame had been active in Worms since the massacres of 1096. Isaac Halevi's descendants had continued his Tosafist school into the early twelfth century, but not much is known about them. Eleazar's move to Worms toward the end of the twelfth century, bringing the worldview of the Qalonymide Pietists with him, must have marked a significant break with the earlier Tosafist tradition of that community. The fact that his signature appears on decisions made on behalf of the three Rhenish communities indicates that he was not necessarily a secluded eccentric, but must have been very much involved in communal matters.[46]

It is not at all clear to what extent it is possible to define Pietism as a religious "movement," or perhaps rather as a small circle of nonconforming scholars, several circles with different backgrounds, or even just individual charismatic figures. Modern scholars struggle with this and other questions about the historicity of the image of Ashkenazi Pietism as it emerges from the sources and about the extent of Pietist influence on Ashkenazi culture, and here is certainly not the place to answer them.[47] We have seen that Marcus described Qalonymide Pietism as a phenomenon that started within a group of sectarian scholars, which during their last generation was made more accessible to wider circles of the Jewish population.

Eleazar had no sons or other relatives as students (which is perhaps the reason he determined to put his mystical teachings into writing), but scholars have identified some thirteenth-century authors who did not belong to the Qalonymide clan but wrote of Eleazar as their teacher. Among them was the anonymous author of the *Sefer Ha'asufot,* a collection of laws and customs, who extensively quoted his "teacher Eleazar," whom scholars identify as Eleazar of Worms.[48] It is, again, significant for the post-Pietist atmosphere that this same author also relied time and again on the teachings of Eliezer ben Joel, thus putting his two teachers' different stances and views into one context.[49] Another of Eleazar's noted students was Abraham ben Azriel, the author of the *piyyut* commentary *Arugat Habosem.*[50] On the premise that Pietist teachings had a far-reaching influence on later Ashkenazi Jewry, later thirteenth-century scholars, in particular Isaac of Vienna and Meir of Rothenburg, were often credited with being instrumental in diffusing Pietist values, customs, and views into general Ashkenazi culture.[51] Much of this influence, whether widespread or limited, is believed to have concerned the ethical teachings of the Pietists. Their mystical views, on the other hand, were observed to have taken a different direction and were for the most part received by later mystics—Kabbalists—among

them Moses ben Eleazar the Preacher, the great grandson of Judah the Pious, who brought Sephardi Kabbalah to Central Europe. However, Ephraim Kanarfogel demonstrates that Pietist mystical teachings and magical practices did indeed have a great deal of influence on some of the Tosafist authorities, mostly in the German lands but to some extent in France as well. At the same time, Kanarfogel also reassesses the question of Pietist influence on Isaac of Vienna and Meir of Rothenburg and their role in a possible broader reception of Pietism.[52]

Some modern scholars contend that the Pietist impact on Ashkenazi society was more limited.[53] Haym Soloveitchik offers a radically narrowed definition of Ashkenazi Pietism. Filtering out the elements that he considers specific to Ashkenazi Pietism, he argues that these features had no influence whatsoever on any Jewish society anywhere, and that the radical stances of the Pietists went unmarked. Based on a careful analysis of the different parts of what is traditionally transmitted as *Sefer Hasidim,* Soloveitchik excludes crucial segments of the ethical stances traditionally associated with the Ashkenazi Pietism from the Pietist worldview. He also excludes their esoteric teachings, arguing that they are not specific to the Ashkenazi Pietists, but rather reflect their older Qalonymide tradition. Similarly he excludes numerology—an exegetical method widely but not exclusively used by the Pietists—from his definition.[54]

I have chosen to follow the conventional, broader definition of Ashkenazi Pietism, not because I disagree with Soloveitchik, but because I am not interested here in the specificity of some of the more radical Pietist thoughts and ideals. I am instead concerned with a wider range of cultural phenomena that shaped the world of the Qalonymide Pietists, Eleazar of Worms in particular, and the community that was apparently quite deeply attached to his tradition even several decades after his death. The imagery of the Leipzig Mahzor has not much to do with the radical agendas that Soloveitchik attributes solely to the Ashkenazi Pietists. It does, however, have to do with a more broadly defined cultural phenomenon that comprised Pietist ideals and norms and the Qalonymide tradition. Even though they were perhaps not specific to the Pietists in Soloveitchik's strict sense, they nonetheless played a central role in shaping the Pietists' world. Soloveitchik's definition aims at singling out the specific elements of the Ashkenazi Pietists' ideology. The definition I relate to here follows not from a focus on ideology, but rather from an interest in the background and mentality of Qalonymide Pietist culture.

Pietism, or perhaps what should be more accurately defined as a Qalonymide Pietist tradition, was a cultural phenomenon that left certain imprints on Ashkenazi Jewry that cannot be overlooked. To what extent

these imprints shaped Ashkenazi Jewry as a whole is not clear. The observation that the Leipzig Mahzor documents a Qalonymide Pietist legacy that was still alive in the early fourteenth century has some potential for shedding light on this issue. Pietistic stances, especially those associated with Eleazar of Worms, shine repeatedly through the imagery of the Leipzig Mahzor. I do not argue here that the Pietist legacy diffused into wide circles of Ashkenazi culture or that the imagery of the Leipzig Mahzor was instrumental in such a process. However, my discussions do show that among the members of the community of Worms, this legacy, whether considered "Pietist" in the narrow sense or "Qalonymide" in the broader, did play a central role in defining their communal identity. Whatever the degree of Pietist and Qalonymide influence on Ashkenazi Jewry may have been, it is quite clear that the figure of Eleazar of Worms was central to its impact. Considering the fact that the Leipzig Mahzor reflects Pietist and Qalonymide teachings, in particular those of Eleazar, I suggest that it not be approached as a "proof" that Pietist teachings diffused widely into Ashkenazi society, but rather that it be considered as one of the avenues by which we can attempt to find an answer to this question. Many years later, in the early seventeenth century, Yuspa Shammash, the author of one of the handbooks on the rite of Worms and of the *Sefer Ma'asse Nisim,* a collection of miracle stories associated with the community of Worms, stylized both Judah the Pious and Eleazar of Worms as two major legendary figures of that community. Thus it seems that up to the early modern period these two scholars— even though Judah the Pious was historically never associated with Worms— were dominant figures in shaping that community's identity.

The question of the diffusion of Pietist teachings into broader circles of Ashkenazi Jewry can to some extent be tackled while observing how these teachings were adopted and adapted by outstanding thirteenth-century rabbinic authorities, especially Isaac of Vienna and Meir of Rothenburg. This, of course, takes us back to the question of how narrowly or broadly Pietism should be defined. Isaac of Vienna and Meir of Rothenburg were first of all Ashkenazi Tosafists. They combined Tosafist teachings with the Qalonymide legacy and gave full legitimization to the *minhag.* How much of this can be accurately delineated as "Pietist" is an open question, and not for me to decide. Many of the Ashkenazi customs that were observed as well as discussed by the Pietists and made it into the modern period were given form and meaning in the writings of Meir of Rothenburg, in his decisions and responsa, and most of all in a small book entitled *Sefer Tashbets,* written by one of his students. These texts open a window onto the religious lives and the ritual practice of Ashkenazi Jewry of the late thirteenth and early fourteenth centuries.

The political and social landscape of the German lands and its Jewish population changed significantly toward the end of the Middle Ages. The territorial and the political dominance of the local counts in the Rhenish Palatinate had begun to strengthen late in the twelfth century, a tendency that was reinforced after the Staufen dynasty came to an end in 1254. The premature death of Henry VI in 1197 and the following conflict over succession led to an increase in the power of rulers of the territorial states, when the Palatine, and with it the towns of Speyer, Worms, and Mainz, became part of the Wittelsbach State of Bavaria.

For most of the thirteenth century, although the Jews of Worms still flourished economically, this was generally a period in which the political situation of the Jews of Ashkenaz worsened. In 1238 Frederick II declared the Jews as *servi camerae,* and they began to suffer increasingly from deteriorating economic conditions, heavy taxation, and a precarious security situation. As serfs of the royal chamber, the Jews were taxed according to the chamber's needs and they were now depending on royal protection more than ever. For a while Jewish life in the three Rhenish communities continued uninterrupted. The Rhenish Jews were spared the Rintfleisch massacres of 1298, which destroyed the Jewish communities of Franconia and Thuringia, and many in Bavaria. In Worms, Christian and Jewish interests and businesses were still relatively tightly interwoven. A document from c. 1300 describes the legal status of the citizens of Worms, suggesting that by now Jewish and Christian citizens shared similar duties and rights. In 1312 we hear for the first time of a fully organized council of twelve men, one of whom was appointed by the bishop *episcopus judaeorum.* The council decided if a particular Jew could be accepted as a citizen, after he had proven suitable as a member of the community. In 1315 the royal authorities reaffirmed the privilege of Worms and Speyer to grant citizenship to the Jews via this process.[55] In 1336 the Jews of Worms were, again, spared from a wave of persecutions—associated with the leader of some of the rioting gangs and thus often referred to as the "Armleder" persecutions—that took place in other areas in southern Germany.

Even though the Rhenish communities were not directly affected by the attacks in 1298 and 1336, their inhabitants undoubtedly were aware that they had no protection and that their general situation was one of insecurity. The end of the Staufen dynasty and the increasing power of the local counts and the town authorities, together with ecclesiastical pressure and the mendicants' anti-Jewish activity, had an immediate effect on matters of the *Judenschutz.*[56] Money lending had become the primary source of income for wealthy Jews, and the exploitation of Jewish financial power was a determining factor in the ways royal and local authorities built political

power and dealt with political relationships. Royal privileges that allowed local rulers to permit Jews to settle in their areas, and the related taxation policy, played an important part in these power struggles. However, the protection of the Jews was also linked to these privileges, which could be pledged by the king to local rulers and bishops, who, in turn, could pass them on to members of the lower nobility.[57] The specific example of Worms is an eloquent demonstration of this situation. In 1313 the Count of Veldenz was charged by Henry VII with the protection of the Jews of Worms; in 1315 the town acquired the right to take Jewish taxes; in 1335 Louis IV pledged these taxes to Rupert, Count of the Palatinate; in 1338 Louis kept the taxes for himself to finance a march to France; in 1346 Louis again pledged the jurisdiction of the Jews to Rupert; but in 1348 Charles IV passed it to the town. As the privilege of keeping their taxes was linked to the obligation to protect them, this development seriously compromised the Jews' security.

The later medieval period also saw significant changes in the social structure of the Jewish population. Whereas in the early Middle Ages Jewish settlement was concentrated in major urban centers, in the twelfth century its dynamics began to change in a way that had a major effect on the regional organization of the Jewish population. In the area between Cologne and Mainz, as well as along the Main River eastward reaching Würzburg and Bamberg and further to the southeast toward Nuremberg and Rothenburg, Jewish settlement began to expand into smaller towns and villages. Once denser nets of Jewish communities began to appear, they were largely organized into Jewish districts, often congruent with the Christian dioceses. In the area south of Mainz this happened only somewhat later, in the early fourteenth century. Shortly after 1300 the district of Worms embraced some eighteen communities, most of them located within the diocese of Worms.[58]

We can grasp the nature of this district from documentary evidence beginning in 1307. All of these smaller communities were linked with Worms in various ways. They used certain community institutions located there, such as the cemetery, the synagogue, and the ritual bath.[59] In only one of the district communities—in Weinheim—is there evidence of a medieval synagogue.[60] The community councils of Worms and Speyer, respectively, had juridical authority over their district communities, and the distribution of taxes was organized along district lines. Jewish settlement in the dioceses of Worms and Speyer began to spread relatively late in comparison to other areas, where the regional organization played a greater role. Perhaps owing to this delay, these urban communities had a closer-knit cultural and social identity and functioned as more coherent, self-contained

entities. On the other hand, the process of spreading communities could have had a more troubling effect there than elsewhere, leading to concerns regarding communal coherence. Whether this had any impact on, for example, the crystallization of the Worms prayer rite as so obviously distinguishable is a question that goes beyond this study. Expansion of Jewish settlement beyond Worms began at the time when the Leipzig Mahzor was produced. It is possible, then, that the Worms community still saw itself to some extent as a closely knit urban entity, subject to all the psychological and social impacts that might have resulted from communities' being spread out in broader districts and the resulting disintegration of the core community.

AROUND 1310, when the Leipzig Mahzor was produced to serve the prayer-leaders of Worms, the members of that community lived in an ambience of increasing insecurity and deteriorating *Judenschutz*. They had witnessed the Rintfleisch massacres in nearby areas, but certain aspects of their legal status was still similar to that of the Christian citizens, and the town authorities were involved in determining the intra-communal structures. However, in this general atmosphere of deterioration, they could look back at a centuries-long tradition of rabbinic activity, at the fame of early talmudic scholarship in the eleventh century, and at Eleazar ben Judah's Pietism and the Qalonymide tradition. Meir of Rothenburg had been born and educated in Worms. In 1307, fourteen years after his death in the castle of Ensisheim, his body was ransomed by Alexander Susskind, a member of the community, and laid to rest in the Worms cemetery. By that time the center of Jewish intellectual life had shifted to other places— Rothenburg, Würzburg, and Regensburg—and not much is known about rabbinic activity in Worms around the time the Leipzig Mahzor was made. However, there can be no doubt that the cultural and intellectual tradition of earlier centuries played a crucial role in the ways the community defined itself at the time the Mahzor was written.

Communal identity in Worms did not always follow a straight path. In terms of its geographical setting, it was well defined even though the development of the district of Worms may have had a certain influence on the self-definition of the core community. Still, living in Worms or being a descendant of Jews who had lived there in earlier times apparently had a certain meaning. The history these Jews shared, and in particular the memory of the events of 1096, must have been an even stronger factor. Its scholarly tradition, on the other hand, had its vicissitudes not only in terms of the authority and the fame the scholars in that community enjoyed, but also in terms of their ideological stances. In the eleventh century,

Worms was the Ashkenazi bulwark of Tosafist scholarship. In point of fact it was the cradle of the Tosafist approach, having housed the school from which Rashi eventually took home the tools to develop his own influential scholarship.[61] Having lost its position as the scholarly center during the twelfth century, in the thirteenth, Worms again gained prominence as the home of Eleazar ben Judah, an authority from a rather different—Pietist—background.

Another central aspect of the communal identity of the Jews of Worms was their distinct prayer rite, to which the Leipzig Mahzor is such a lavish witness. The particular rite of Worms grew out of the custom of reciting *piyyutim,* which harks back to the Palestinian tradition that the Ashkenazi Jews took particular pride in preserving. In theories of ritual, the role of what anthropologists term "ritual experts" or "ritual specialists" and their definition in terms of social hierarchies drew some attention.[62] Apart from every generation's prayer-leaders, who capably recited the rite, the particulars of the rite of Worms are associated with two outstanding ritual experts: Meir ben Isaac, in the eleventh century, and Eleazar ben Judah, the scholar who brought Qalonymide Pietism to Worms. Together they are the pillars on which the specific form of the Worms rite was built. When this rite crystallized into its distinct form in the late thirteenth and the early fourteenth centuries, the form in which it was transmitted into the early modern period, it most likely played a central role in providing cohesion for a community that faced a certain degree of threat to its identity. Scholarly fame having gone, security ever decreasing, its economic situation deteriorating, organizational structures changing, and the development of the district perhaps affecting its definition, the community of Worms fell back on its rite in order to sustain the safeguard that the notion of the "sacred community" had provided. Judging from the richness of the literature that preserved the Worms rite during the seventeenth and eighteenth centuries, it appears that the rite itself helped bring the communal identity of the Jews of Worms safely into the early modern period.[63]

Anthony Cohen suggests that rituals can play a significant role where the stability of a community is threatened and its traditional boundaries are blurred, which might well have been the situation of any Ashkenazi community.[64] It is thus worth giving some thought to the role rituals may have played in helping the members of the community of Worms cope with their particular reality.[65] Theories about the role of rituals in processes of socialization go back to Émile Durkheim and his thesis of solidarity. Durkheim believed that rituals are dramatized collective representations that encourage value consensus among the members of the collective group.[66] This view later opened the way to discussions about the role of ritual in

social life and in controlling social tensions with a focus on modern industrialized societies.[67] Later scholars discussed whether rituals can help a society delineate its own social norms and values, and the role of those individuals who prescribe the performance of rituals, the specific rules that govern them, and those who imbue the rituals with their meaning.[68] In the case of the Ashkenazi rituals, these people were the spiritual leaders of the communities and those who administered Jewish law.[69] As numerous written records indicate, they were, indeed, overly concerned and preoccupied with performative issues of rituals and accuracy, sensing, as it seems, that this would safeguard the community's identity.

Clearly, Jewish Worms was not a modern industrialized society, but a small medieval minority community, and under the circumstances in which they lived, the need for cohesion was especially great. In the medieval Ashkenazi reality, rituals may also have compensated for the Jews' lack of political authority as a minority society and their consequent concern with issues of identity and communal cohesion.[70] Rituals might also have helped the members of the community deal with increasing levels of anxiety. In some approaches, rituals are referred to as "cathartic performances," as responses to situations of anxiety and fear.[71] Even though this particular notion has been criticized as dichotomizing and setting rituals too sharply apart from other forms of human activity,[72] in the specific situation of the Jewish communities in Ashkenaz this may have been the case. Several *piyyutim* were composed in memory of victims of persecutions; they must have played a significant role in this respect.

Other approaches discuss rituals in their relationship to tradition and custom, the former being addressed as a static aspect of culture and the latter as the more dynamic and flexible one. A ritual or a ritualized act can, from these points of view, be understood as a reenactment of elements from the historical past. This observation, too, seems to be applicable to the situation of Ashkenazi Jews. On the other hand, there is a tendency on the part of communities, or any group performing certain rituals, to constantly reinterpret these elements.[73]

There is no way that the imagery in the Leipzig Mahzor can offer answers to all the questions about the role that community played in the lives of the Jews of Worms. However, as it is one of very few Hebrew illuminated manuscripts that can with a high degree of certainty be attributed to a particular town, and its Jewish population easily singled out by its distinct rite and set of customs, it does offer a rare opportunity to approach the visual arts from this perspective.

The Leipzig Mahzor is among the earliest exemplars of the Worms prayer rite, which began to crystallize in the eleventh century with Meir

ben Isaac. At that time, the *minhag* was still not seriously challenged and the composition of *piyyutim* and their recitation was a natural component of religious life. But Meir was not the sole author of this rite; it was given its final touch by Eleazar ben Judah, when the *minhag,* including the custom of reciting *piyyutim,* could look back at a stormy history. Text and image in the Leipzig Mahzor thus represent a particular phase in this community's history, and both are closely tied to Eleazar as a prime mover in their development. If the decoration program of the Leipzig Mahzor is some sort of communal self-portrait, it appears that Eleazar must have played a central role in how this community defined its identity even decades after his death. I have already described the part he played in the formation of the rite of Worms, and the chapters that follow shed light on the role of his legacy in the design of the imagery of the Mahzor several decades after his death. Beyond what textual background can offer us, this imagery provides a key to the heritage of one the most illustrious communities of medieval Ashkenaz.

A Pesah Sermon by
Eleazar ben Judah of Worms

B EFORE WE MOVE on to consider several specific illustrations in the Leipzig Mahzor in detail, a brief look at a Pesah sermon authored by Eleazar of Worms can demonstrate that his approach can provide some sort of general framework beyond his scholarship's impact on specific images and particular details. The liturgy of the Great Sabbath, the Saturday before Pesah, begins on fol. 64v. After Hanukah, Purim, and the first three special Sabbaths, the Great Sabbath leads into the first major holiday of the spring season. The service begins with the *yotser iti melevanon kallah* (Come with me from Lebanon, my bride), a liturgical poem that is based largely on the biblical Song of Songs. The opening word *iti* (with me) is set in a large initial panel framed by elaborate architectural motifs under a large gothic arch. A couple is seated on a throne (fig. 7). To the right a rather simply dressed young man, identified as a Jew by his funnel-shaped hat, addresses a woman of significantly higher rank. Three lilies are growing between the two, which at first sight seems to be a simple background motif, as they also appear in the lower part of the initial panel. Leafing through the rest of the book, however, we realize that although the technique in which the lilies are executed—white pen decoration on a blue ground—is indeed typical for background patterns of initial panels (see, e.g., figs. 3 and 16), the lily motif is not found anywhere else.

Further on in the first volume we find the next illustration only few pages later, adjacent to the poem *adir dar metuhim* (The Invincible dwelling on

high).[1] This poem, recited during the *musaf* prayer on the Great Sabbath, includes guidelines for preparing for the upcoming Pesah holiday, especially for cleaning the house. A small marginal illustration (fig. 8) at the bottom of the page shows two women standing beside an enormous cauldron, holding dishes to be scalded in boiling water. The liturgy of the Great Sabbath ends on fol. 70v and is followed immediately by the *ma'ariv* of the first night of Pesah, where another aspect of the preparation for the holiday, the baking of *matsot* is depicted (fig. 9).

At first sight the three images do not seem to be at all interrelated thematically. The couple from the Song of Songs, an elaborately designed allegory of the love of God for His people, is utterly different in character from the small genre scenes on the other two pages, both taken from daily life during the Pesah season. However, when viewed against the background of Eleazar of Worms's sermon for the Great Sabbath, the three images combine to form a coherent series.

Eleazar, who was known as an eloquent preacher, generally spoke in the synagogue on every Sabbath. Although the custom of preaching on the Great Sabbath was common in the Ashkenazi communities and is mentioned in the *Sefer Pardes*, as Simha Emanuel indicates in his introduction to the modern edition of Eleazar's text, no other written versions of sermons have come down to us.[2] This makes Eleazar's Pesah sermon a *unicum*. More important than the immediate circumstances that led to the survival of this text is the fact that the sermon was the subject of scholarly interest even many years after his death. Portions of it were quoted in several later texts, including *Amarkol, Minhagim Debe Maharam*, a collection of customs associated with Meir of Rothenburg (d. 1293), and in the fifteenth-century *Sefer Maharil*, the collection of customs compiled by one of Jacob Moelin's students.[3] In his opening sentence Eleazar notes that he received the contents of the sermon from his two teachers, Judah the Pious and Judah ben Qalonymos. This indicates that we are dealing with a formulaic sermonic text not necessarily delivered orally and spontaneously, but carefully composed and meant to be passed on from generation to generation as a reference in halakhic matters.[4]

The sermon opens with a long paragraph about the love of the Holy one blessed be he for his companion, commonly understood in the Jewish tradition to be the community of Israel. The opening of the liturgical section for the Great Sabbath, "Come with me from Lebanon, my bride," thus corresponds with the opening of the sermon. The opening paragraph of the sermon reads as follows: "'My beloved is mine and I am his, the one who feeds among the lilies (Song of Songs 2:16)'—praised be the name of the king of all kings, the Holy one, blessed be he, for his desire in Israel, his people. Out of the love burning in his heart he called them 'my compan-

ion'; as it is written 'For my brethren's and my companion's sakes, I will say (Ps 122:8)' and he called them 'my wife'. . . . Out of desire he called them lily, 'as a lily among the thorns (Song of Songs 2:2)'. . . . 'The one who feeds among the lilies'—do not read 'among the lilies' *(shoshanim)*, read 'in the joys *(sassonim)*. . . . And large is the house that [you and] I build.' . . ."[5] The "one who feeds among the lilies" is a dominantly recurring motif in Eleazar's wording, and we have seen that the lily is also part of the decoration of the initial panel. The large house, finally, leads us to the architectural frame with its two churchlike towers and the ashlar wall in the background, which can be interpreted as the Temple, God's house.

After this opening celebrating God's love for Israel, with some hints as to the mystical interests of the sermon's author, the rest of the text is devoted to halakhic issues: the ritual cleansing of dishes;[6] the removal of leaven;[7] the preparation of the *matsot*;[8] and various acts and observances for the eve of Pesah and during the *seder*, the ritual meal at the eve of the holiday.[9] In the closing section of this paragraph Eleazar takes us back to the lilies, this time with a projection to the Messianic Era: "All the plagues that happened in Egypt, will in the future be sent by God to Edom.[10] . . . And in the days of the Messiah he will give us wine to drink, made of grapes, and he will lead us into his garden which is surrounded by eight-hundred thousand roses and lilies, as Solomon said through the Holy Ghost: 'My beloved is mine and I am his, the one who feeds among the lilies (Song of Songs 2:16)' [this appears in the Midrash] *Avkir*."[11]

Three of the sermon's foci—the couple of the Song of Songs, the instructions for cleansing the dishes, and the preparation of *matsot*—are evoked in these illustrations, suggesting that these images form some sort of coherent program designed with the contents of the sermon in mind. Given the fact that there is good reason to assume that the sermon was known in Worms around 1310 and may still have been read publicly at that time, we can plausibly conclude that its contents were meant to be handed down to the generations to follow. The triplet of illustrations may thus in all likelihood have been designed as a series of visual anchors meant to recall the major foci of Eleazar's sermon. The rest of the sermon's contents address issues of the household during Pesah, of the *seder*, and of food not to be eaten during the holiday, issues that are of no particular concern within the communal or liturgical framework of the Mahzor.

We can delineate many more links between the imagery in the Leipzig Mahzor and the scholarship of Eleazar of Worms. These associations, which concern all three major aspects of Eleazar's work—law and custom, ethics, and mystical thought—are dealt with in the chapters that follow, where the three images related to the sermon, among others, will be discussed in detail.

Halakhah and *Minhag:*
Religious Law and Custom

THE LEIPZIG MAHZOR has been carried from its patron's home to the synagogue, the congregation is assembled in the sacred space of the "minor Temple," and it is now time for the prayer-leader to approach the shrine, wrap himself in a *talit,* a large, rectangular garment, and begin to recite. The illustration at the beginning of the liturgical section shows this exact moment (fig. 10). This depiction and several other images in the Leipzig Mahzor address issues of the religious law, the performance of rituals, and the observance of the *minhag.* The texts for the Great Sabbath address, among other things, preparations for Pesah. Although these preparations were family-based and in principle centered on the home, in medieval Ashkenaz they were not performed privately but carried out within a community framework (figs. 8 and 9). The opening for the beginning of the Shavuot service depicts an initiation ritual for schoolboys, which was common in some of the Ashkenazi communities (fig. 15). As these customs and rituals are religious actions of a public nature, such images underscore the communal character of the Mahzor.

All these rituals and acts are not based solely on the halakhah, but are instead grounded primarily on the *minhag.* The following sections attempt to reconstruct the specifics of their performance, their meaning, and their development—the processes of ritualization—with the help of a wide range of sources. Halakhic codices and collections of *minhagim* guide us in studying the aspect of performance. Both types of sources are very much

concerned with definitive instructions as to *how* to perform certain acts. They reflect the end of ritualization processes, or certain of their steps, and the question is not only what is being performed and why, but how a certain act turned into a ritual.[1]

The latter—the history of the depicted rituals—is given a great deal of attention here, especially in the first part of this chapter, for which the sources provide copious information. My goal is not merely to come to terms with a particular ritual act; rather, tracing them leads me to the roots of Ashkenazi custom and the role that custom played in Pietist scholarship, on the one hand, and in the community of Worms, on the other.

Ritualized acts develop because such acts are imbued with some meaning. Whereas the ritual law informs us about the performative aspects of these acts, other sources, such as exegetical traditions (midrashim), commentaries, and ethical texts, help us understand their meanings. Rituals are part of the system of symbols by which people make sense of the world, and religious myths and narratives offer a window on the more symbolic layers of the meaning attached to them.[2] Occasionally later believers lose the sense of the original meaning of a ritual or imbue it with different significance.[3] Moreover, often meaning as held by ritual experts changes for the community of believers. Clifford Geertz noted that there are, in fact, two different meanings: one is that for the believer, and one is that for the observer, who grasps the meaning differently; that is, the observer understands it as a cultural phenomenon.[4] An understanding on the part of the historian (Geertz's observer) of the meaning behind a ritual act beyond the mere performative aspect is thus essential in any attempt to define the ritual's cultural context or, in our case of the Leipzig Mahzor as a whole, as a ritual object whose decoration also happen to depict rituals.

The following sections are, in part, attempts to describe such processes. Reviewing the rituals and embedding them in the discourse of ritual theory, however, are not the only purposes of this chapter. By tracking these processes and tracing them back to the roots of certain customs as a methodological step, we can arrive at a fuller picture of the cultural background that defines the Leipzig Mahzor and the community that used it. What we find depicted in the Leipzig Mahzor falls into the category of religious ritual, which is different in nature and meaning from political rituals. However, because a religious ritual in the Middle Ages has certain characteristics, functions, or meanings that are similar to those of political rituals in modern societies, I concur with the attempts to define rituals broadly. I tackle the performative aspect despite the distance in time, but expend even more effort on the meaning, not merely the meaning of the particular actions, but of the overall significance of the rituals within the cultural

context of Ashkenaz. This involves not only the particular depicted rituals, but also the Leipzig Mahzor as a whole being approached as a ritual object. The awareness of the role that these rituals—both the depicted acts and prayers, including the recitation of *piyyutim*—play in the communal life of those who performed them influences the discussion here time and time again.

Prayer and *Piyyut*

The Holy one blessed be he wrapped himself in a fringed *talit* and put up Moses on one side, and Aaron on the other (Eleazar of Worms).

To a fourteenth-century viewer the image of the prayer-leader wrapped in a large *talit* (fig. 10) would very probably have brought these words by Eleazar of Worms to mind.[5] The picture shows a man performing the ritual of wrapping himself in a large *talit,* which covers his head, with two of the fringed corners prominently displayed. He seems to be actually in the act of wrapping, his right hand arranging the *talit* around his head. One of the corners is lying on his back, apparently having been thrown over his shoulder. He and the two men accompanying him appear within a somewhat oddly shaped zigzag frame, creating some sort of space—more a symbolic space than a realistically perceived one.

The picture raises several questions about the act of wrapping in a *talit* as a ritual performed before the beginning of prayer and about the *talit* as ritual attire. The *talit* here is worn by the prayer-leader, what anthropologists would call a ritual expert, and one wonders about the latter's status within the community. But it is not only the act of wrapping that is addressed here. The image functions as a kind of visual introduction to the ritual of praying and reciting *piyyutim,* relating not only to the particular prayer it accompanies, but standing for prayer as such and, by extension, for the Mahzor as a whole. The illustration was placed at the beginning of the liturgical section, after the short *shokhen ad merom* (He who dwells on high). It is followed by the reader's *qaddish* and *barkhu* (Bless the Lord). These texts form part of the daily statutory liturgy, and in the Leipzig Mahzor they immediately follow the twenty-five folios of biblical readings for the various holidays. This is the only part of the statutory prayer that was occasionally included in the Ashkenazi mahzorim.[6] The reader's *qaddish* and *barkhu* mark the part of the prayer service for which the presence of at least ten men is required. It precedes the reading of the *shma,* the blessings of which are the framework for the *yotser.* In the Leipzig Mahzor, *barkhu* is followed immediately by the *yotser* recited on the Sabbath dur-

ing the week of Hanukah, whereas the text of the *shma* itself, being part of the statutory prayer, is omitted. *Shokhen ad merom* and *barkhu* thus mark the beginning of the congregational service and open the liturgical section of the Mahzor.

In a commentary on the religious law by one of the most prominent Rhenish scholars, Eliezer ben Nathan of Mainz (Raban, c. 1090–1170), we read: "The prayer-leader *(sheliah tsibur)* goes down to the shrine only if there are at least ten [men assembled]."[7] Our image thus figures the exact moment that the prayer-leader begins his part. More importantly, beyond being a halakhic requirement, the presence of ten men also underscores the public character of the prayer as a communal ritual.

In comparison with the illustration methods apparent elsewhere in the Leipzig Mahzor, the designs used in the creation of this image stand out. The picture is a framed panel on the lower half of the page, at the end of the prayer. It is neither an initial panel at the opening of a particular liturgical section nor one of the many unframed marginal illustrations, two formats typical of the Leipzig Mahzor's decoration program. Still more remarkable is the fact that the panel is inserted at the end of the prayer instead of at the beginning, indicating that it is not necessarily to be associated exclusively with that particular text. If it had appeared on the following page, it would have been visually associated with and understood to refer to the opening of the liturgy for the Sabbath during the week of Hanukah. Clearly it was not intended to be linked specifically either to *shokhen ad merom* or to the following *yotser*. Instead, the image marks the beginning of the congregational part of any of the holiday services, on the one hand, and of the section of *piyyutim*, the *raison d'être* for the Mahzor, on the other. As such it is a visual representative of liturgy, of liturgical poetry, and of its congregational nature.

The structure of an Ashkenazi mahzor, containing only the *piyyutim* and not the statutory liturgy, is particularly relevant to the imagery of this panel. As we have seen, the *piyyutim* and the custom of reciting them are typical of the Jewish communities in the German lands. The image of the prayer-leader at this particular place near the first congregational prayer not only marks the transition to the section of liturgical poetry, the main part of the mahzor, but also indicates how and by whom the book was used and, even more importantly, highlights the custom of reciting *piyyutim*. A typical feature of the Rhenish and other Ashkenazi communities, the custom of reciting and composing liturgical poetry met with criticism in other parts of the Jewish world. All this adds a great deal of significance to an image that otherwise might seem to be simply a somewhat naive genre scene of a medieval Jewish prayer-leader going about his pious duties.

The prayer-leader dominates the image. To the modern viewer, a Jew wrapped in a *talit* prominently displaying two of the prescribed four ritual fringes is not necessarily an eye-catching image; in fact, it seems quite familiar. The modern association with this portrayal is that of an almost trivial quotidian religious ritual performed automatically upon entering the synagogue (or before the morning prayer at home). What may strike one, in view of modern practice, is that his two companions are not wearing *talitot*. The image raises several questions about thirteenth- and fourteenth-century prayer practices and the status of prayer in medieval Ashkenazi society. Moreover, as a reflection of several well-defined aspects of Ashkenazi custom, it plays a crucial role in elucidating the cultural ambience of the Leipzig Mahzor. Some of these issues appear to have reached a turning point in their history around the time the imagery of the Leipzig Mahzor took shape. These observations, which are discussed here in quite some detail, indicate that associations that the medieval Jewish viewer must have had were clearly quite different from those perceived by the modern observer. The cultural ambience of this imagery emerges as a vital force in the development of this ritual of wrapping, which is relevant to the status of the prayer-leader as well as to his attire. These two aspects are the focus of the first part of this section. Whereas the prayer-leader has been studied, the history of the *talit* has yet to be written, so a brief outline of this history follows.[8] The importance of the prayer-leader as a figure of a certain status and that of the *talit* as ritual attire, both strongly linked to a particularly Ashkenazi notion of prayer, are then contextualized, relying on the broadest possible range of sources.

LATE ANTIQUE Jewish synagogal service was marked by two distinct functions, that of the prayer-leader *(sheliah tsibur)* and that of the *hazan*.[9] In the modern context the latter is usually understood as cantor. The *sheliah tsibur* emerges in tannaitic sources (before the third century) and the Babylonian Talmud (before the sixth century) as the medium, so to speak, through which the community can observe the obligation of prayer. His function is to "go down before the Torah shrine and to fulfill the obligation of many."[10] No sacramental aura is attached to the *sheliah tsibur;* he does not have to be either of priestly descent or an ordained religious functionary; he acts as the representative of the congregation, expected to be able to recite the prayers.[11] He has to be in command of his senses, to be adult, and to have an exact knowledge of the prayers, as errors should be avoided when reciting prayer. He should not be guilty of sin or transgression and should have a good reputation since his youth. The term *sheliah tsibur,* literally the "messenger of the public," indicates that he is chosen by

the community.[12] In contrast, the *hazan,* literally an "overseer," appears as a simple functionary: as a teacher of children, keeper of the *lulav,* the person who raises the Torah scroll, and more.[13] In the late antique period he is hardly ever associated with the liturgy.

Babylonian, Sephardi, and Tosafist authorities of the Middle Ages follow the talmudic tradition closely in defining these two functions.[14] In Middle Eastern communities the *hazan* could be made responsible for the *psuqe de zimra,* the collection of biblical verses recited at the beginning of the morning service, the evening prayer, and the liturgy accompanying the Torah reading on Monday and Thursday, but the core parts of the liturgy were recited by the *sheliah tsibur.*[15] In a discussion of the suitable minimum age of the *sheliah tsibur,* the Catalan scholar Nahmanides (Nahman ben Moses, Ramban, d. 1270) explains: "The *sheliah tsibur* takes care of all their needs, he blows the *shofar,* appoints the chair of the community. . . . The person who is entrusted with the needs of the public, such as the one who is referred to in the Talmud as *hazan* of the community, and it is not right to call him *sheliah tsibur;* rather, the two are different; the *sheliah tsibur* is worthy to go forth towards the Torah shrine."[16]

In eleventh-century France this had also been the position of Rashi (d. 1105): "*Hazan:* he is the functionary *(shammash)* of the community and I never heard that he has any significance."[17] Rashi thus associates the *hazan*'s functions with those of a synagogue attendant. Elsewhere, however, Rashi occasionally links traditional functions of the *sheliah tsibur* with the *hazan.*[18] Menahem Ben-Sasson suggests that during the period of the "conquest" of the Babylonian rite in the Mediterranean region, as a by-product of turning this rite into a more and more rigid version of statutory prayer, the status of the *sheliah tsibur* became stronger. At the same time the status of the *hazan,* who over time became increasingly associated with the composition of *piyyutim* and their recitation, also went through some changes.[19]

Rashi's insistence on the status of the *hazan* seems to imply that he was witnessing a change of which he apparently did not approve. Actually such a tendency is observable in the Rhineland, and it was in this realm that the *sheliah tsibur* and the *hazan* ultimately became one and the same. Moreover, it was here that the *sheliah tsibur* acquired the special status that is reflected in our image. In the writings of Eliezer ben Nathan of Mainz, for example, the concepts of the *sheliah tsibur* and the *hazan* are interchangeable.[20] Eliezer, we should keep in mind, was a dominant figure in his time, a typical representative of Rhenish Tosafism, on the one hand, but, on the other, a staunch defender of the Ashkenazi scholarly tradition in some conservative opposition to the increasing influence of the French

school. From this period on, the attitude of Ashkenazi scholars to the *hazan* can be clearly distinguished from those of their Sephardi and French colleagues. Increasingly we hear of scholars referred to as rabbis on certain occasions and as *hazanim* on others.

In Rhenish Jewish culture the prayer-leader, whether referred to as *sheliah tsibur* or as *hazan,* acquired thus a central status, and the function was associated with certain families of particularly high rank. Not only was he a "mediator," who facilitated the participation of the members of the community in prayer, but he also had a significant influence on the development of liturgical rites.[21] The term *hazan* no longer referred to the function of an attendant, but instead indicated a certain degree of expertise in matters of text and the language of prayer and *piyyut.*[22] The most outstanding figure in this connection was Meir ben Isaac of Worms (d. c. 1095), who composed some fifty liturgical poems. A contemporary of Rashi's teacher, Isaac Halevi, one of the most outstanding rabbinic authorities of Worms, Meir probably died shortly before the persecutions of 1096. Esteemed and appreciated by many, Meir was the principal proponent behind the emergence of the special rite of Worms. His title in written records is Rabbi, but he is also referred to as *sheliah tsibur, payyat* (composer of *piyyutim*), and *hazan.* In subsequent generations some even believed that he possessed miraculous powers.[23] Isaac Halevi's son Asher was another skilled poet about whom we have, however, much less information.[24]

This development of the *sheliah tsibur* into an individual of special status within the community can in all likelihood be linked to Pietist attitudes toward prayer that emerged around the same time. Certain specific rules regarding the *sheliah tsibur,* such as the mandate that the entire congregation agree on him, first appear in the writings of Judah the Pious.[25] This may also have to do with the growing tendency in medieval culture, both Christian and Jewish, to textualize oral tradition, particularly prayer.[26] Apparently in reaction to the increasing proclivity to write down the prayers, the *Sefer Hasidim* expresses concerns about the possibility that an unworthy *sheliah tsibur* could recite them without understanding their meaning. Even more serious, the authors of the *Sefer Hasidim* claimed at another occasion that some *shelihe tsibur* were corrupt and morally unfit.[27] Around 1250 Isaac ben Moses of Vienna was still concerned about these matters, which accounts for the rule that the *sheliah tsibur* had to be chosen by general consent. Isaac dedicates an entire section of his *Or Zarua* to the position, the status, and the mandated qualities of the *sheliah tsibur.*[28] Similarly, and around the same time, the anonymous author of the *Sefer Ha'asufot* elaborated on these issues, especially on the requirements regarding the

prayer-leader, to whom he refers as a *hazan,* whereas in other sources the term *sheliah tsibur* is more common.[29]

From both these texts it is evident that by then the *sheliah tsibur* and the *hazan* had become one and the same, but also that in comparison with the Babylonian tradition and those who fully depended on it, the Ashkenazi *sheliah tsibur* had acquired a special status. Even though in times of emergency one can call on a young, inexperienced *sheliah tsibur,* says Isaac of Vienna, the norm should be that he is an "outstanding person." The author of the *Sefer Ha'asufot* made it clear that, although, according to the basic talmudic law, any decent man with a basic knowledge of the prayers can "fulfill the obligation of many," the ideal is that a scholar should be chosen.[30] At some point, both the author of the *Sefer Ha'asufot* and Isaac of Vienna studied with Pietists; the former apparently was a student of Eleazar of Worms and the latter of both Eleazar and Judah the Pious. References to scholars acting as *sheliah tsibur* certainly correspond well with what we know about Asher Halevi and Meir ben Isaac.[31]

The roots of this particular Ashkenazi attitude to the prayer-leader can be traced in late antique Palestinian legends *(aggadah),* in the Palestinian liturgical tradition, and in early medieval midrashim. These three strings lead, as several scholars have maintained, to the specific characteristics of Ashkenazi traditions, rituals, rites, and customs.[32] It is against this Palestinian background of the Ashkenazi tradition that, on the one hand, we observe particular definitions of the *sheliah tsibur* and, on the other, note certain changes in the function and the status of the *hazan.* For example, as early as in the Palestinian Talmud, Rabbi Zinon is identified as a *hazan.*[33] The Palestinian version of *Masekhet Sofrim,* one of the so-called "minor tractates," occasionally associates the *hazan* with the liturgy.[34] The fact that a *hazan* was referred to by the title of Rabbi indicates a status beyond that of a synagogue functionary and blurs the otherwise clear-cut definitions of *sheliah tsibur* versus *hazan,* still common in late antiquity.

Toward the end of the late antique period the *hazan* took on an additional important function: he composed *piyyutim,* a typical Palestinian feature intended to embellish the basic statutory prayer.[35] At the same time the obligatory prayer remained in the domain of the *sheliah tsibur.* From then on, the *hazan* was identified with the tradition of composing and reciting *piyyutim,* a crucial factor in the evolution of the special status he eventually attained in Ashkenazi society, where the *piyyut* became a major feature of the synagogue service. It was at that point that the *hazan* was ultimately granted the same status as the *sheliah tsibur.*

Some traits of the *sheliah tsibur* belong to the realm of legendary tradition. In certain legendary contexts, for example, he occasionally may

possess the ability to overcome satanic powers.[36] Such traditions led to a perception of the *sheliah tsibur* unknown in Babylonian culture. In these contexts the terms *sheliah tsibur* and *hazan* can be interchanged. The *Midrash Tehillim*, for example, offers the following image: "On the first day of the Festival [of Sukkot], all the Jews—young and old—raise their *lulavim* in their right and their *etrogim* in their left hand, . . . and on the day of *hoshana rabba*, they raise willow branches and perform seven rounds, and the *hazan* of the congregation stands there like an angel of God and the Book of Torah in his arms, and the congregation encircle him as if he were an altar."[37]

The image of the *hazan* who appears like an angel of God returns later in almost identical wording—but referring to the *hazan* as *sheliah tsibur*— in several sources from the Rhineland. We find it first in Eliezer ben Joel's (Ra'aviah, c. 1140–c. 1220) *Sefer Ra'aviah*, which refers explicitly to the *Midrash Tehillim*; around the same time it also appears in Eleazar ben Judah's *Sefer Haroqeah* and in a collection of customs from the Rhenish communities that emphasizes those of Mainz and Worms, especially singling out traditions associated with Eleazar.[38] I come back to this aspect of the *sheliah tsibur* and related traditions later on. Not only does the status of this *hazan* seem to be similar to that of the *sheliah tsibur,* but, more important, he had turned into a figure of mystical dimensions and could be associated with heavenly beings. This goes hand in hand with the belief that a *sheliah tsibur* of the status of Meir of Worms had miraculous powers. Israel Ta-Shma has pointed out that, perhaps under Christian influence, the *sheliah tsibur* was perceived of as a person capable of fighting the evil powers.[39]

The *sheliah tsibur* in late medieval Ashkenaz who approached the shrine during holiday services was thus a ritual expert of a particular kind. Not simply any man from the congregation with a pleasant voice and basic knowledge of the prayers, he was a man of scholarly caliber with a well-defined place in the centuries-long tradition of medieval Ashkenazi scholarship, a poet as well as a man who was believed to have miraculous powers. The prayer-leader, as he is shown in our image, communicates a great deal of solemnity, dignity, authority, and scholarship. Moreover, the man shown here may very well also have been envisioned as a Pietist mystic. Eleazar ben Judah himself would have appeared in this function time and again throughout the years he spent in Worms—a halakhic authority, a Pietist mystic, and a poet who gave the final touches to the prayer rite of Worms.

THE SPECIAL STATUS of the *sheliah tsibur* is emphasized in the image by his large and striking *talit*. This attire went through crucial evolutions

within the context of the Ashkenazi tradition, where the act of wrapping would eventually be fully ritualized. In fact, this image in the Leipzig Mahzor happens to evidence the completion of this process. It appears that the early fourteenth-century Ashkenazi viewer would have associated the *talit* with certain meanings, traditions, and customs to which a Sephardi or French coreligionist, whose religious behavior relied almost exclusively on the Babylonian tradition, would not have been receptive. In fact, Jews from Iberia and France would have seen a very different kind of object. Neither does our modern view of the *talit* and the role it plays in religious life permit us to come to grips with the nuances of meaning associated with this object in Worms around 1310. A late antique Jew, finally, would have made sense of our image in yet a different manner. Let us, therefore, take a short look at what can be understood from textual references about the different meanings medieval Jews from different cultural realms attached to this object, before we focus on what the community of Worms would most likely have made of this portrayal of a *sheliah tsibur* wrapped in a *talit*.

Late antique sources frequently refer to the *talit* as part of a man's everyday costume. From these references it appears that the *talit* was a toga-like mantle, a rectangular piece of cloth, worn as an upper garment fit for various mundane purposes.[40] It seems that it could have been of considerable value, was used primarily by the upper classes, could be considered part of an inheritance, and could serve as a token for the redemption of a firstborn.[41]

The late antique *talit*, as a rectangular garment with four corners, had to have the halakhic fringes *(tsitsit)* attached to it as a constant reminder of the full array of the 613 divine precepts.[42] Tannaitic sources indicate that donning a cloth with fringes required a benediction; that women are exempted from the precept of fringes, whereas young boys should observe the precept as soon as they can wrap themselves in a cloth; and that leaving one's house on a Sabbath wearing a *talit* without ritual fringes was considered a transgression.[43] Some of the rabbinical sayings from the tannaitic and talmudic periods draw an analogy between the fringes and the *mezuzah,* a piece of parchment with the text of the *shma Yisrael* placed in a small housing attached to the doorpost. Just as the entrance to one's home should be marked by the *mezuzah,* one's *talit* should be marked by the fringes. From this the basically mundane character and function of the late antique *talit* becomes clear. As a commonplace object of use, it was analogous to a house: it is supposed to be marked by the ritual fringes as the entrance to one's home is marked by a *mezuzah.*[44]

The *talit* had still another purpose, which later linked it more closely to prayer and teaching. Both these activities require that one's body be

appropriately covered. Whereas for recitation of the *shma* an improvised covering of the lower body up to the hips was sufficient, recitation of the *amidah* required full covering of the entire body.[45] During the talmudic period the custom developed in both Babylonia and the Land of Israel of fully wrapping oneself in a garment during prayer. Most narratives that speak of leaders wrapped and standing in prayer do not explicitly mention a *talit,* but it is easy to imagine that the *talit* would have been the most suitable piece of apparel for that purpose. Uri Ehrlich argues that the act of mantling for prayer should be considered within the context of other activities that require mantling, such as an appearance in court.[46] It is significant, however, that the Babylonian Talmud, in advising the worshipper as to what to do when he has the urge to spit during prayer, directs one to use the *talit* to dispose of one's saliva.[47] This instruction clearly emphasizes the mundane nature of the *talit,* even when it was used for wrapping oneself during prayer.

Clearly, then, in the Babylonian tradition the *talit* had primarily a social but no ritual significance; it was an expensive garment and a status symbol, but was, nonetheless, linked with halakhah. First, it was required to have fringes; second, in this form it functioned as a constant reminder of the divine law in general; third, it was used to fulfill the halakhic requirement of wrapping oneself during prayer and study. In these functions the *talit* also figures in the Babylonian tradition and in Sephardi and North African scholarship.[48]

At some point during the Middle Ages—in the twelfth century at the latest—the rectangular toga-like mantle went out of fashion. Once this change in style became apparent, the various Jewish cultural spheres reacted in different ways. From a commonplace item of apparel whose use required some actions of religious significance—as did many other objects in Jewish life—the *talit* developed into a different kind of object, one reserved exclusively for the realm of religious practice. However, it took on different roles in different Jewish communities. Rabbinic authorities were confronted with the question of whether the fact that the *talit* had gone out of general use could and would mandate elimination of the ritual fringes. If no rectangular mantle is worn, the fringes are theoretically no longer necessary. On the other hand, the precept of fringes is a biblical one: the fringes are meant as daily reminders of the 613 precepts and are therefore of central significance. In short, the obsolescence of the *talit* did not and could not contravene the precept of fringes or push it into oblivion. In some specific contexts, however, the disappearance of the *talit* from the everyday wardrobe not only caused some concern from the point of view of the halakhic consequences, but also opened the way to the evolution of

the *talit* as a ritual object as it appears in the Leipzig illustration. Both earlier associations of the *talit* with prayer and study and the Palestinian aggadic tradition contributed to this development.[49]

The French Tosafists were aware that, theoretically, if the *talit* was not necessarily part of one's everyday wardrobe, the precept of fringes would no longer be obligatory. Some implied that keeping a *talit* was not required by the law, but most of the Tosafists strongly recommended buying one.[50] Across the Rhine we find a similar attitude among scholars representing the German school of Tosafists. Here it was Eliezer ben Nathan who noted that no longer does everybody naturally own a *talit:* "if you have a cloth with four corners, you should attach fringes to it; if you do not own a *talit* you are not required to do so."[51] He continues the discussion by referring to the traditional analogy between *tsitsit* and *mezuzah* and *talit* and house.

The reaction of the Ashkenazi Pietists to this development was different. Ivan Marcus demonstrates in detail the Pietist tendency to eccentric behavior.[52] Although by the twelfth century the four-cornered garment was apparently no longer a common item of apparel, Samson ben Abraham of Sens, a Tosafist contemporary of the Pietists, informs us that "the *talitot* made like c[h]aperons are like the *talitot* of the Pietists in Ashkenaz. It [the *talit*] has four corners and when it is removed, one folds it and then wraps oneself in it. There are those who say, however, that a garment is not a (proper) *talit* unless it is like ours that is made to be wrapped in and covered with it, as it is written: your mantling garment; [on this *talit*] one says the blessing. I refrain from wearing those . . . but the *cotte* that has sleeves has nothing to do with it."[53] This description, cited in a responsum by Meir of Rothenburg, indicates that the Pietists continued to use a fringed four-cornered garment as a mantle and that both Samson of Sens and Meir of Rothenburg were reluctant to accept the practice of wearing a *talit* as a common everyday garment. Between the lines we read that for them the *talit* was reserved for the purpose of prayer. From the *Sefer Hasidim* we likewise learn that the Pietists wore a *talit* all day long, apparently of the kind referred to by Samson of Sens. During prayer they would fold it and wrap themselves, or, as indicated elsewhere in the *Sefer Hasidim,* they put on an additional *talit,* especially intended for prayer.[54] This practice, however, is not mentioned in the extant writings of Eleazar of Worms and may have been given up by the time he came onto the scene.

All these concerns associated with the *talit* are halakhic in kind. At the same time, however, we find references of another sort. A closer look at these enables us to understand the meaning of the *talit* in our image in more depth. Some post-talmudic sources bring the *talit* into the sphere of

ritual and prayer and mark a shift of status from a mere reminder of the precepts to a garment carrying ritual significance and occasionally even an aura of sanctity. This development was not necessarily a by-product of the *talit*'s going out of mundane fashion, but was rather reinforced by it. The basis for the eventual emergence of the *talit* as an item of ritual attire was first of all in the blessing required upon donning a fringed garment.[55] Moreover, we have seen that talmudic sources mention the requirement of being wrapped during prayer, the *talit* being the most suitable piece of cloth for this purpose. Several post-talmudic and early medieval references, in both Palestinian midrashim and Babylonian early medieval scholarship, focus on this function of the *talit*. Whereas texts from the latter context can usually be localized and dated, pinpointing clearly defined developments in the Palestinian tradition is decidedly more difficult.

It is in this early medieval context that the *talit* is increasingly mentioned in close association with the phylacteries, so that it acquires something of the ritual significance of the latter. The phylacteries *(tefilin)* are worn during the morning prayer in fulfillment of Exodus 13:9: "And it shall be for a sign upon your hand, and for a memorial between your eyes, that the law of the Lord may be in your mouth; for with a strong hand has the Lord brought you out of Egypt." This and other related verses are written on parchment and put into small leather containers to be tied to one's left arm and forehead. The tractate *Berakhot* in the Babylonian Talmud prescribes the benediction to be said when putting on a cloth with ritual fringes, together with several other typical early morning routines, including getting up, getting dressed, putting on a girdle, and washing one's face and hands.[56] Although the morning prayer is not included in this list, at some point the benediction for putting on phylacteries was inserted here, apparently in analogy to the blessing over the four-cornered garment, but originally the act of wrapping was associated with mundane procedures of morning hygiene and dressing.[57] The tendency to associate the act of wrapping in a fringed cloth with phylacteries became more widespread in the later Middle Ages, and we are aware of it in Rashi's circle. Both the *Mahzor Vitry* and the *Siddur of Rashi,* liturgically oriented compilations from the school of Rashi, repeatedly mention the *talit* in association with phylacteries.[58]

It thus appears that once Jewish scholars had observed that the *talit* was no longer a common item of attire and redefined its function as a reminder of halakhah, they became aware that an entirely new question was involved: what would actually be a suitable situation in which to wear a *talit?* Not everybody was prepared to wear one at a time when the *talit* was perceived as a strange looking, eccentric costume. The Ashkenazi Pietists

were not overly concerned with eccentric appearance and continued to wear four-cornered garments all day long. In other circles, however, the *talit* began to turn into an item of attire worn exclusively for prayer. The Tosafists wore *talitot* only for prayer, but from their discussions it is by no means clear that they approached the *talit* as a ritual object. In the context of twelfth-century costumes, prayer was simply the most suitable occasion on which to abide by the halakhic requirement to wear a fringed cloth.

At this stage, there was evidently a great deal of uncertainty and uneasiness regarding the role of the *talit*. Even though the *Mahzor Vitry* puts the *talit* and phylacteries into one context, implying a certain degree of ritualization of the former, we also still find a reference to the talmudic recommendation to use the *talit* as a device for spitting there.⁵⁹ It was not entirely clear when a *talit* should be worn and when not. Moreover, there were thoughts about the exact role it should play in prayer. The *Ma'asse Hage'onim,* for example, the first collection of Rhenish customs from the early twelfth century that transmitted the traditions collected by the *bene makhir,* bears witness to such considerations: "On the night of Yom Kippur our great teacher Rabbi Isaac ben Judah (d. c. 1090) did not wrap himself upon entering the synagogue; neither did he wrap himself during the entire night. But in the early morning for the morning prayer he wrapped himself and remained that way during the entire day and for the evening prayer until the end of Yom Kippur when he left the synagogue."⁶⁰ This text not only contains some reflections on when it is appropriate to wrap oneself (for example, only during the daytime), but more importantly, it communicates something of the solemnity of the scholar wrapping himself in preparation for a certain moment of the service. The act of wrapping was about to emerge as an actual ritual, and something of the scholar's solemn attitude and of the ritual character of the act he performs is reflected in our image.

Moses ben Maimon, better known as Maimonides (Rambam, d. 1204), approached the *talit* in an attitude similar to that of the talmudic rabbis. His response to a query, however, shows that the role of the *talit* had changed in his time and place as well, and that there was at that point a great deal of confusion about it. The inquirer asked Maimonides's advice regarding a person who owned a *talit* and "added beautifully crafted silk embroidery on its edges in order to embellish the *talit* with precepts. He also embroidered a verse from the pericope *vayomer* and added [a reference] to the name of God using the letter *yod* three times."⁶¹ Maimonides's answer is clear-cut: Wearing a *talit* with verses from the Torah and a reference to the name of God embroidered on it is absolutely prohibited. Applying biblical verses to a commonplace object such as a *talit* is a profanation

of the Torah. To emphasize the point, Maimonides observed that people may happen to enter a bathroom—undoubtedly the most profane action of all—wearing a *talit*.[62] His response leaves no doubt as to his opinion that the *talit* is not a ritual object that bears an aura of sanctity. It is worth noting in this context that the *Sefer Hasidim,* unlike Maimonides, explicitly forbade entering the bathroom with a *talit*.[63] The man who committed the embellishing "sin," on the other hand, certainly considered the *talit* an object deserving adornment with Torah verses. We have no information about the social or cultural context of this transgressor and whether he saw in his *talit* a reminder of the precepts thus worthy of embellishment or whether it was the *talit*'s role in prayer that made it so special for him. All we know is that his notion of the *talit* was very different from that of the Babylonian Talmud and echoed by Maimonides.

However, there is more to this story. Beyond the association of the *talit* with prayer and the synagogue service, an additional feature can be discerned, a feature that leads into the world of the Pietists and their Qalonymide tradition. Moreover, we can observe a reception of Palestinian aggadic motifs, which eventually added a special twist to the Pietist attitude toward the *talit*. We have seen that a paragraph in the *Midrash Tehillim* describes "the *hazan* of the congregation" as "an angel of God and the Book of Torah in his arms."[64] We can trace several similar traditions in the same context of late antique, Palestinian, and early medieval aggadah, a corpus that had a particularly strong impact on the Pietists. This applies in particular to a group of midrashim recently discussed by Amos Geula and attributed to early medieval southern Italy, which includes the *Midrash Tehillim* and the *Pesiqta Rabbati*.[65]

Against the background of the late antique custom of wrapping oneself during prayer and study, the Babylonian Talmud reports a commentary by Rabbi Yohanan on Exodus 34:6: "'And the Lord passed by before him [on Mount Sinai] and proclaimed.' Rabbi Yohanan said: Were it not written in the text, it would be impossible for us to say such a thing; this verse teaches us that the Holy one blessed be he, wrapped himself like a *sheliah tsibur* and showed Moses the order of prayer."[66] Whereas Babylonian and Sephardi texts hardly concern themselves with this motif, which attaches a great deal of sanctity to the notions of both the *sheliah tsibur* and the act of wrapping, later midrashim repeat Rabbi Yohanan's dictum, often associating it explicitly with a *talit*.[67]

One example is the Palestinian midrash *Pesiqta de Rav Kahana,* tentatively dated to the fifth century: "Rabbi Hiyya in the name of Rabbi Yohanan: the Holy one blessed be he wrapped himself in a fringed *talit* and placed Moses here, and Aaron there, and called upon Michael and Ga-

briel, and made them [Moses and Aaron] emissaries for the [beginning] of the month [to communicate calendrical issues to remote communities]. He spoke to them: on which side did you see the moon? Before the sun? Behind the sun? In the north or in the south? How high is it, and whereto is it tending. . . . He said to them: in this order that I show to you now, my sons shall arrange the year—with an elder, with witnesses, and with a fringed *talit*."[68] The image of the *sheliah tsibur* wrapped in a *talit,* together with the distinct ritual significance he enjoys in texts such as this one, creates a notion of the *talit* that differs widely from that of the late antique mundane piece of cloth as a mere reminder of halakhic precepts. In its association with God and in the meaning it attaches to the *talit,* this notion goes far beyond the link observed in halakhic sources regarding *talit* and prayer. There can be no doubt that such an image also implies a particular status for the *sheliah tsibur.*

Indeed, the motif of God wrapped in a *talit* is found also in various later Ashkenazi sources, many of which can be associated with a Pietist background, and variants of this tradition can be found in several places and in different wordings in Eleazar of Worms's writings. One instance in his *Commentary to the Siddur* reads: "What did he reveal to him? Rabbi Yohanan said: 'And God passed by before him and called upon him (Ex 34:6)'; this teaches us that God came down from the fog wrapped in a *talit* like a *sheliah tsibur* who goes down to the shrine and revealed to him the order of penitential prayers."[69] The *Sefer Haroqeah* remains close to the text in the *Pesiqta Rabbati:* "'This month will be [the first among all other months]' up to 'until they did not depart from Egypt,'—the Holy one blessed be he sits and calculates [the calendar], determines leap-years, sanctifies the years and determines the months. Because Israel departed from Egypt, he told them 'this month . . .'; Rabbi Berekhiah in the name of Rabbi Yohanan said: 'the Holy one blessed be he wrapped himself in a fringed *talit* and put Moses on one side and Aaron on the other; he called upon Michael and Gabriel and made them emissaries for the [beginning] of the month.' "[70] The motif of God being wrapped in a robe of light, finally, is the subject of a short *piyyut* by Eleazar, which is included in the Sukkot service of the Worms prayer rite and the Leipzig Mahzor, *ata levadkha atita or* (You alone are covered with a robe of light, vol. 2, fol. 179r).

The motif of God being wrapped in a *talit* appears again in another Pietist text, the *Sefer Shaqud,* an esoteric treatise authored perhaps a generation after the main circle of Pietists by an anonymous scholar who did not move within the Qalonymides' orbit.[71] A remark made by Isaac ben Moses in another context is similarly revealing about the nature of the *talit* in post-Pietist Ashkenazi culture. In a paragraph dealing with synagogues as

places of learning and prayer he observed: "Everyone is obliged to take part in the efforts to build the school and the synagogue, so that in the future he will be wrapped in a *talit* and go and be seated in the synagogue amongst the righteous."[72]

The associations among the Ashkenazi Pietists and others—such as Isaac of Vienna, who had studied with the Pietists—with the *sheliah tsibur* being wrapped in a *talit* thus go much beyond the recommendations of the Tosafists and Sephardim to purchase a fringed garment and use it during prayer. In the Pietist mind the act of wrapping was associated with God visualized as a *sheliah tsibur* adorned with a *talit*. We have seen that the prayer *shokhen ad merom*, adjacent to our image, is not a *piyyut*, but is rather part of the statutory holiday and Sabbath liturgy and is concluded by the recitation of the reader's *qaddish* ending with *barkhu*. These words, which in the Leipzig Mahzor appear immediately above the image, are dwelt on in Eleazar of Worms's *Commentary of the Siddur;* his thoughts add a further—angelic—dimension to the Pietist notion of the *sheliah tsibur* being wrapped in a *talit*: "Bless the Name of God (*barkhu et adonai*): one angel stands in the center of the firmament and his name is Israel and he says bless, as our *hazan*, and when he says the Name [of God] he elongates the word name so much that meanwhile the angels prepare themselves and they immerse 365 times; then they immerse seven times in fire; these immersions are like the wrapping in a garment of fire; the voice of Israel, the angel, is being heard in all the seven firmaments, and the angels reply: blessed be the Lord."[73]

Some of the midrashic traditions about God wrapping himself like a *sheliah tsibur* include an additional feature that deserves attention. In the Leipzig image the *sheliah tsibur* is accompanied by two men. We have seen that in the version in *Pesiqta de Rav Kahana,* the Holy one blessed be he is accompanied by Moses and Aaron.[74] The custom of two men flanking the *sheliah tsibur* is mentioned (based on an earlier version in the *Mekhilta*) elsewhere in the same midrash and linked to Moses, Aaron, and Hur, who went up the hill during the battle against the Amalekites.[75] In the Middle Ages this notion was first considered by Eleazar of Worms and then must have led to common practice in his community. Eleazar's *Sefer Haroqeah* cites both midrashim as told in the *Pesiqta de Rav Kahana* and explains: "About the men who stand next to the *hazan*—according to the *Mekhilta*, Aaron and Hur support [Moses] from either side. Therefore the Sages say that no fewer than three men should go forth to the shrine during the public fast."[76] Later we also find a mention of the custom in the *Hagahot Maimuniot,* which suggests that this may have been a common practice among Ashkenazi Jews during the late thirteenth century.

The *Hagahot Maimuniot* were compiled by Meir Hakohen of Rothen-
burg, a contemporary of Meir ben Barukh. After noting the full reference,
he declares: "This is our custom for Rosh Hashanah and Yom Kippur."[77]
In the *Sefer Maharil* we finally read: "Maharil Segal would normally ap-
pear as the first *sheliah tsibur* on Rosh Hashanah and on Yom Kippur for
the whole day; and he would put up distinguished [members of the com-
munity] one to his right and one to his left.'"[78] In Yuspa Shammash's de-
scription of the rites and customs typical for Worms we read in the context
of the morning prayer for Rosh Hashanah: "Two honest men (literally
owners of houses, meaning wealthy members of the congregation) are to
be flanking the *hazan* on his right and his left."[79] Other sources for the rite
of Worms inform us that the custom of having two honorable members of
the community accompany the *sheliah tsibur* was practiced in Worms dur-
ing New Year and Yom Kippur every year until 1615. In April 1616 the
Jews of Worms were attacked and violently expelled and the custom fell
by the wayside, not to be renewed even after Jews were readmitted to
Worms.[80]

Finally, the *sheliah tsibur* is not portrayed simply in our image, but was
clearly purposefully drawn in the actual act of wrapping himself. As the
talit had grown into an item of ritual attire, the act of wrapping oneself in
it had developed into a ritual in its own right. Geula recently analyzed
textual evidence of three lost midrashim that he attributes to southern It-
aly. He offers convincing arguments that these texts survived only in Ash-
kenazi Pietist scholarship from the twelfth and thirteenth centuries and in
the *Yalqut Shimoni.* From this he concludes that they were not necessarily
part of the Qalonymide tradition, which had traveled to the Rhineland in
the ninth and tenth centuries, later to become part of the Pietist heritage.
Rather, he argues, their reception began only in the twelfth century, Elea-
zar of Worms playing a major role in this process. The traditions included
in these texts then occupied a significant place in the teachings of the Ash-
kenazi Pietists, but were unknown in other circles and were lost once the
Pietists were no longer on the scene.[81]

One of the motifs Geula discusses in his effort of textual reconstruction
is the custom described in one of these texts, the *Midrash Avkir,* of throw-
ing two of the four fringes of the *talit* over one's back during wrapping.
The *Midrash Avkir* mentions this practice three times, and its wording
seems to imply that all the fringes were supposed to lie on one's back; later
versions, however, are clearer in indicating that two fringes were to be
thrown over one's shoulders. The author of the *Midrash Avkir* links this
practice to the Crossing of the Red Sea, maintaining that four symbolic
signs of the precepts protected the Israelites on their way through the

waters: the phylacteries on the head, the phylacteries on the arm, the circumcision, and the fringes.[82] In the *Sefer Haroqeah,* Eleazar of Worms explicitly refers to the *Midrash Avkir* by noting: "Wrapping oneself one throws the corners to the back, as it is written in the *Midrash Avkir.*"[83]

A fuller and different description of this practice is found in *Midrash Tehillim,* where it is also explicitly linked to prayer: "I put phylacteries upon my head, on my neck I fulfill the commandment of fringes . . . on my chest, near the heart I put the fringes during the entire recitation of the *shma,* as it is written (Dt 6:6): 'these words that I command you [on this day], should be on your heart'; I throw the corners of my *talit* to my back and to my front, two corners to the back, two corners to the front. With my right hand I write and with it I show the accents of the Torah; with my left hand I attach the phylacteries to my hand, and in the same hand I hold the fringes during the recitation of the *shma.*"[84] Not only the custom of throwing two corners of the *talit* to the back is mentioned here, but more explicitly, two corners are put over the shoulders and two remain in front of the body.[85] The fringes of one corner are held by the left hand near the heart. Finally, an anonymous responsum mentions that the *talit* should be laid on the head.[86]

Several Ashkenazi sources document a reception of these acts in circles beyond that of the Pietists. The author of the *Sefer Ha'asufot* noted that one should hold the fringes in one's left hand and look at them while reading. He relates to another section in *Midrash Tehillim* about the glory of the *shekhinah* dwelling upon the Israelites when they wrap themselves and look at their fringes.[87] A very similar version is cited in the *Hagahot Maimuniot.*[88] The customs are also described by Eliezer ben Joel, Isaac of Vienna, and in the *Sefer Mordekhai,* a commentary to the Babylonian Talmud.[89] In the words of Isaac of Vienna: "As soon as a young boy is able to wrap himself, he is obliged to [fulfill the precept] of fringes. But it is not enough to simply wrap oneself; rather one has to throw two corners to the back and two to the front of the body, and one holds the fringes in one's hand during the recitation of the *shma.*"[90]

The prayer-leader in the Leipzig illustration follows all these rules. He is shown in the very act of wrapping, his head being covered by the *talit.* Two of the four fringes are visibly indicated; one appears to be thrown over the shoulder. The man's left hand forms a fist, it is covered by the *talit* and kept near the heart. The medieval *talit* thus had two roles. It was a constant reminder of the 613 divine precepts, and was understood as such by Sephardi and Tosafist scholars. Owing to the fact that in late antiquity the *talit* was used to wrap oneself during prayer, it became increasingly associated with liturgical practice. Palestinian mythical traditions about God

being wrapped were adopted by the Ashkenazi Pietists and added an aura of sanctity to the *talit*. Certain special customs were developed that underscored the ritual character of the act of wrapping oneself before prayer, and it is this role of the *talit* as a liturgical object and an item of ritual attire used for prayer that shaped the iconography of the image in the Leipzig Mahzor, where all the elements are shown.

The process of turning the *talit* into ritual attire thus took place in the German lands, most likely under the influence of the Qalonymide Pietists. In the same Ashkenazi realm, finally, we observe the last stage of this development. In view of the double role of the *talit* as ritual attire and as a reminder of the precepts, a new practice emerged, wherein it became common to wear a small four-cornered garment underneath the ordinary costume. As early as the twelfth century Eliezer ben Joel mentions such a practice for bridegrooms.[91] A southern French source comments on it with a critical undertone: "those who wear a *talit* underneath their tailored mantle, and they do not fulfill the precept of fringes."[92] Isaac ben Moses of Vienna offers more detail: "In the days of the Sages when everybody owned a *talit* with four corners [those who transgressed the precept of fringes] were punished. . . . But now, when it is strange to wear a *talit* with four corners, one does not punish [those who transgress the precept]; this is the reason that [one wears it] in the synagogue; and in everyday life one wears it underneath the upper garment *(sarbal)* so that it will not look strange."[93]

The generation after Isaac ben Moses made a still clearer distinction between the *talit qatan,* the "small *talit*" (literally "the *talit* of a small person"), as this means of fulfilling the daily obligation of the precept of fringes came to be known, and the *talit gaddol,* the "large *talit*" (literally "the *talit* of a grown person"), which developed into distinct ritual attire, worn for the morning prayer both at home and in the synagogue.[94] According to Ashkenazi sources from the thirteenth and early fourteenth century, the custom of wearing a *talit qatan* under one's upper garment on a daily basis was introduced and popularized by Meir of Rothenburg. It is also significant that, whereas earlier halakhic collections only contained chapters entitled "Laws of Fringes" *(hilkhot tsitsit),* the *Sefer Tashbets Qatan,* a collection of Meir's decisions and customs composed by one of his students, included a section entitled "Laws of *Talit*" *(dine talit),* which lists the rules referring to the *talit* and also mentions the *talit qatan.*[95] Moses Parnas of Rothenburg, the early fourteenth-century author of the *Sefer Haparnas,* explicitly notes that the custom of wearing a *talit qatan* beneath one's clothes was introduced by Meir: "According to the custom of Meir of Rothenburg, one should wear a *talit qatan* under one's clothes

every day, because one is obliged to observe all the precepts that are written in the Torah."[96]

The ritual of wrapping oneself in a *talit,* from the ancient practice of putting on proper clothing for prayer up to the ritualized act shown in our image, has thus had a complex evolution. These processes of ritualization over centuries are often marked by a high degree of dynamic and change. Some theorists focus on these dynamic developments and open up a discourse on ritual from the rather limited focus on formal (static) worship within the frameworks of organized religious institutions to differentiate specific features of individual rituals and the processes by which they developed. The medieval *talit* lost the practical features of its ancient forerunner, which functioned as a mundane status symbol. Over the centuries the act of wrapping in the once-mundane garment had become formalized and implied fixed gestures.[97] The process of ritualization creates a demarcation between the mundane and the meaningful and—focusing on religious rituals—demarcation between the profane and the sacred imbues the ritualized acts with symbolic meaning. Associating the *talit* with the Holy one blessed be he and the fringes with the Crossing of the Red Sea endows the act of wrapping with the mythical dimension needed for a successful ritual.

A look at some representations of worshippers in illuminated manuscripts demonstrates the specificity of the different elements of the Ashkenazi ritual of wrapping in a *talit.* Several images of men, mostly *shelihe tsibur,* covered or wrapped in *talitot* can be found in French, German, Italian, and Sephardi manuscripts. In all these realms worshippers commonly covered their bodies, including their heads, with a *talit.*[98] In Italy (fig. 11), France, and Spain (fig. 12), the *talit* simply drapes from the head, with its four corners touching the shoulders, and covers the upper body. Occasionally, when the worshipper is shown holding a Torah scroll, the *talit* covers his hands (fig. 12). In images from the German lands, however, men with *talitot* are almost always shown with the end of the *talit* "thrown" over the shoulder, and the fringes are clearly visible on their backs. This is seen very clearly in the Amsterdam Mahzor from Cologne, where, unlike in the other examples, the *sheliah tsibur*'s head is not wrapped but is covered by a Jewish hat.[99] The Bird's Head Haggadah pictures four *shelihe tsibur,* three of them wearing the *talit* in the same fashion as in the Leipzig image; only the fourth apparently did not perform the wrapping as indicated in our sources.[100]

An early fourteenth-century fragment of an Ashkenazi mahzor now in Milan shows a man tightly wrapped, using a lectern near the shrine; the image accompanies the *kol nidre* prayer at the beginning of the Yom Kippur

liturgy.[101] The De Castro Pentateuch from 1340 in the Israel Museum shows a similar imagery.[102] A figure with one end of his *talit* over his shoulder is portrayed in another Ashkenazi manuscript from the first half of the fifteenth century. He is holding an infant during circumcision.[103] In the Hamburg Miscellany, which was produced around the same time, an unfinished sketch shows a *sheliah tsibur* and a congregation all wrapped in the Ashkenazi way, the ends of their *talitot* "thrown" over their shoulders (fig. 13). Similarly, the male members of an Ashkenazi congregation are shown in a siddur now in Oxford.[104] The same arrangement appears in the Ashkenazi Sassoon (Floersheim) Haggadah from 1502 showing a *sheliah tsibur* reciting the *shma* on the Shabbat during the Pesah holiday.[105] The Rothschild Mahzor, produced in 1490 in Florence, is the only Italian manuscript that contains representations of worshippers with one end of the *talit* "thrown" over the shoulder. However, some illustrations in this manuscript can perhaps be associated with Joel ben Simeon, a scribe from the Rhineland who traveled back and forth between southern Germany and northern Italy several times, and the illustration in question belongs to that group.[106] In none of the other Italian examples do we find evidence of this posture, which by that time had turned into a typical Ashkenazi mode. It is in itself significant for the history of the *talit* that the great majority of medieval visual renderings of *talitot* come from the German lands.

The image of the *sheliah tsibur* is an eloquent illustration of the process of ritualization of the act of wrapping oneself for prayer. It demonstrates how the *talit* turned into an item of ritual attire used here as an iconographic device to highlight the *sheliah tsibur* and his status as a ritual expert and underscores the communal aspect of the mahzor as a public ritual object. The mahzor from which the *sheliah tsibur* is reading is prominently displayed on the large lectern. Another book is held open by the second companion, the one to the right. Mahzorim usually come in two volumes. It is unlikely that each man would have had his own mahzor; the detail refers rather literally to the physical appearance of the mahzor as a large book in two volumes, emphasizing its communal function.[107] We have seen that Jacob Moelin differentiates between public mahzorim and private ones (for instance, for one's own personal use), and forbids making any changes and corrections in the former. Let us now have a closer look at his statement:

> Maharil Segal said that at one time they would honor him and bring lavish mahzorim to pray from them. He wanted to pray in public only from mahzorim and siddurim that were intended for the public, even if they were old and black and had errors in them. He referred to the *Haroqeah* (Eleazar of Worms), who had said that one should pray only from public prayer books, because they were written for the sake of [fulfilling] the precepts. As to other

prayer books the copyist did not intend to produce them for the sake of [fulfilling the] precepts, but rather to be praised. It is possible that the prayers read from these will not be received. And Maharil Segal said that it is false to make corrections to public prayer books, because the editor has a deeper understanding than the corrector [lit. is greater than the corrector].[108]

This emphasis on publicly used texts can only be understood in the century-long transition of Jewish culture from orality to textuality. Talya Fishman shows that the Ashkenazi Pietists had an ambivalent attitude toward the tendency to textualize the Jewish tradition, a trend that had been gaining strength since the twelfth century. Even though the Pietists appreciated that the prayer book enables one to utter the prayers accurately, they had a clear preference for reciting prayer correctly from memory.[109] They observed very specific rules as to where their gaze should be directed and when their eyes should be closed, but these gestures do not imply that the worshipper actually *read* the prayers.[110] In Eliezar ben Nathan's time, prayers being recited by heart was still the norm.[111] Ta-Shma argued that when Ashkenazi Jews began to write down the prayers, the only copy available in any given congregation would have been entrusted to a *sheliah tsibur,* to make certain that only he recited the *piyyutim.*[112] The image in the Leipzig Mahzor reflects a specific stage in this process of textualization.

ILLUSTRATING A PROCESS OF RITUALIZATION and documenting the textualization of medieval liturgical poetry would not have been the only goals that the designer(s) of the Leipzig image had in mind. There is good reason to assume that there were further layers of meaning that a fourteenth-century viewer would associate with the solemn portrayal of the *sheliah tsibur.* We have seen that the "sacred communities" in the Ashkenazi realm had a range of parameters by which they defined themselves culturally, socially, and spiritually. Their particular attitude toward prayer, liturgical poetry, and the related rituals that had developed over the centuries was one of them. Every community held its own unique custom and rite to be sacred and created some sort of spiritual shield to withstand apostasy and to define its own identity. The custom of reciting liturgical poetry has to be approached from this point of view. As early as in the Palestinian tradition and in later Ashkenazi culture, the composition and recitation of liturgical poetry were closely associated with the *hazan;* and it was in this function that the *hazan* would later gain his special status and that conceptually the *sheliah tsibur* and the *hazan* would become one and the same. It was in those communities that cherished the *piyyut* of the Palestinian tradition that this development could take place. Hence, the *hazan* in our image

represents the whole of the phenomenon of liturgical poetry with all the meanings attached to it in Ashkenazi culture, particularly in Pietism.

I noted earlier that our image is singled out by its location and unusual layout on the page and the fact that it is the first liturgical illustration in the decoration program. It accompanies a section from the statutory prayer *shokhen ad merom,* followed by the reader's *qaddish* and *barkhu,* and thus marks the beginning of the communal prayers. The reader's *qaddish* then marks the transition from the statutory prayer to the *yotser,* the first liturgical poem to follow. At the very end of the *barkhu* formula, *or olam* (Light of the world) is added immediately above the image of the *sheliah tsibur.* This text is not part of the regular statutory prayer, but a remnant of a late antique *yotser* by Yossi ben Yossi, which was used in the Middle Ages as an embellishment of *barkhu* before one began the *yotser,* that is, the first nonstatutory *piyyut* addition. The *Seder of Troyes,* a thirteenth-century collection of prayer customs from the community of Troyes, recommends adding *or olam* before every recitation of a *yotser.*[113] Eleazar of Worms noted this and explained that the *yotser* should have a proper opening. He associated it with Psalm 119:130: "The opening of your words gives light; it gives understanding to the simple," a sentence that is a reference to the light of the divine Glory, which enables the worshipper to understand the words.[114] In the Leipzig Mahzor the text of *or olam* is placed immediately above the image, as if the latter is intended to further emphasize the transition from regular and statutory prayer to liturgical poetry.

Looked at from this point of view, our image becomes one grand celebration of *piyyut* as a cultural phenomenon in which Rhineland Jews took particular pride. In this cultural realm, with its Qalonymide-Pietist heritage, the *sheliah tsibur* was not only a worthy representative of the community in matters of prayer, but more than anything else was associated with liturgical poetry, the very *raison d'être* of the mahzor. Liturgical poetry and the custom of reciting *piyyutim* were truly part of this culture. Several issues appear to have been involved in the practice of liturgical poetry with its roots in the Palestinian tradition, and its development as a cultural phenomenon of Rhenish Jewry did not pass without criticism.

Whereas in early Palestinian prayer the poetic versions could at some point replace the statutory prayer, in Babylonia the prayers were obligatory. In fact, Babylonian scholars accepted poetic embellishments of the statutory prayer only reluctantly, if at all. Even as early as in the Mishnah, the issue of poetic embellishments occasionally appears to be controversial owing to a mishnaic prohibition against adding anything to a benediction. The established exact wording of the blessings was not subject to change.[115]

Moreover, some criticized the *piyyutim* as a burdensome and lengthy distraction, a position that was adopted primarily in Babylonian scholarship.[116] During the early medieval period, tension increased as critique against *piyyutim* became an issue in the context of Babylonian attempts to attain hegemony over Palestinian scholarship. Criticism, with the ninth-century scholar Pirqoi ben Baboi as the dominant figure, focused on the halakhic restrictions regarding the alteration of fixed formulae of blessings and their order, and on the fear that *piyyutim* might express inappropriate content, such as personal petitions or mystical teachings.[117] Babylonian claims of hegemony over other communities and attempts to enforce Babylonian halakhah met with the Palestinian reaction that "custom annuls halakhah," a standpoint of some relevance with regard to later Ashkenazi dealings with custom.[118]

After the "classical" period of liturgical poetry in the sixth century, the situation changed. Some measure of liturgical poetry began to be acceptable in Babylonia; it never replaced the statutory prayers, but always remained a mere embellishment. What remained a definitive rule was the prohibition against tampering with fixed talmudic formulae, and this was adopted as the norm in all other Jewish realms. Palestinian Jewry also renounced most of the poetic prayer versions and began to combine liturgical poetry with the statutory prayer. Later Babylonian positions became a bit more lenient. As Ruth Langer argues in her exhaustive study on the role of *piyyut* in the different Jewish societies, later Middle Eastern authorities were less concerned with Babylonian hegemony and began to soften their attitude toward *piyyutim,* even making certain efforts to reconcile them with the halakhic point of view. Saadia Gaon, Amram Gaon, and Sherira Gaon—"Gaon" being the commonly employed title for early medieval Babylonian authorities—found various solutions. Saadia is known to have composed *piyyutim* himself, but would not allow those by other authors. Amram accepted *piyyutim* for the Yom Kippur service as part of the liturgy, and Sherira permitted sages to pray with the community, even though the prolonged performances of *piyyutim* take up precious time that might otherwise be used for studying.[119]

Similar positions can be observed later in Iberia, where *piyyut* was practiced but never with the same degree of enthusiasm as in Ashkenaz. Sephardi Jews preferred contemporary *piyyutim* to the classic Palestinian compositions, but Sephardi scholars were cautious, critical, and worried about potentially improper forms and content. Both Judah ben Solomon Al-Harizi (1165–1225) and Maimonides lamented the fact that *piyyutim* can become tiresome and interfere with the pious intentions of the worshippers, an issue that also caused Ashkenazi scholars much concern, even

though their point of view and the solutions they offered were different, as we shall see below. Finally, Abraham ibn Ezra (1089–c. 1164) complained that understanding the often complex wording of *piyyutim* was frequently beyond the capacity of the common members of the community. Likewise, he was concerned with the halakhic question of embellishing fixed formulations of prayers and prohibited the addition of liturgical poems to the statutory prayer. A statement by Nahmanides seems to imply that he was well aware of the status of the Ashkenazi *hazan* as an interpreter of *piyyutim* and was himself a *paytan,* but he apparently had been influenced by Ibn Ezra's earlier criticism of *piyyutim:* "According to our ways we learned that those who add *piyyutim* and songs are not acting properly; also I found in the midrash on *Qohelet* that it is better to hear the rebuke of the wise, these are the preachers, than to hear the song of the fools, these are the *hazanim,* who add to the basic prayer. This is a simple issue. . . . who shortens where he is told to lengthen and who lengthens where he is told to shorten (*Mishnah Berakhot* 1:4) . . . and I already saw in the works of the late Rabbi Abraham ibn Daud that this is not to be encouraged."[120]

Ashkenazi liturgical practice is more deeply rooted in the early "classical" Palestinian tradition than is any other Jewish rite. In Ta-Shma's words: "Ashkenazi liturgy was basically Babylonian in both text version and general structure; however, there is no doubt that it deliberately preserved elements that are specific and typical of Palestinian prayer."[121] More than anywhere else the scholars of Ashkenaz were much more concerned with issues of liturgy; more Central European liturgical manuscripts have survived than Iberian, and the Ashkenazi mahzor is longer and more complex in structure.[122] Not only was the tradition of *piyyut* less dominant in other realms of Jewish culture, but it also frequently met with actual criticism. In the Middle Ages the critical voices no longer challenged the Palestinian tradition, but rather dealt more specifically with the Ashkenazi practice. The earliest Ashkenazi counter-critic was Gershom Me'or Hagolah (c. 960–c. 1028) in Mainz, who received an inquiry from an Ashkenazi community that had been instructed by an anonymous rabbinic authority not to recite *piyyutim* along with the statutory prayers. Nothing is known about the community or about the rabbi who gave the instruction; all we know is that Gershom supported the recitation of *piyyut* wholeheartedly.[123] On another occasion Gershom was pushed into a more defensive position. This can be gleaned from a later reference to a responsum quoted by the thirteenth-century Italian scholar Zidkiyahu ben Abraham in another apology for liturgical poetry, whereas Gershom's original responsum is no longer extant. Zidkiyahu lists a group of late antique poets who should be revered and adds later names from the time of Gershom, namely Qalonymos

and Meshullam, explicitly mentioning some of their works. He concludes: "One should learn from them and one should not cancel any *qrovot* that are intended to praise the Lord, the Holy one blessed be he. . . . this is the *responsum* by the late Rabbi Gershom Me'or Hagolah. Also my brother Rabbi Benjamin wrote that we should not cancel any *qrovot* and *piyyutim* that were written with the intention to praise the Lord." [124]

During Gershom's time the Rhenish communities already had a well-established and flourishing tradition of custom in general and *piyyut* in particular. The originally Palestinian custom of reciting *piyyutim* had reached the Rhineland via its earlier Italian cultural origins. Thus it was around then that Rhenish Jews had to deal with the tension caused by the increasing domination of Babylonian halakhah vis-à-vis that Palestinian tradition, and much of the subsequent rabbinic activity in the Rhineland was directed toward reconciling these tensions. As severe as such disagreements could become, there is, in Langer's words, "no evidence of an Ashkenazi rabbi during the period of the Rishonim [earliest generation of scholars] ruling that all *piyyut* should be excluded from the statutory prayer." [125]

Among northern French rabbis, *piyyut* was generally held in high esteem, even though there is evidence of certain signs of ambivalence. As Grossman points out, the greater the dominance of the Babylonian tradition in France, the stronger became the opposition to the custom of reciting *piyyutim*. [126] In the responsa collection *Sefer Hapardes* compiled by one of Rashi's students, we find a defense of the *piyyut* in the name of Isaac Halevi of Worms. [127] Rabbenu Tam, Rashi's grandson, made a clear distinction between *piyyutim* of the ancient tradition and those he regarded as unnecessary innovations. [128]

Thus, although the custom of reciting *piyyut* was an issue in twelfth-century France, it was unchallenged in the German lands, and it was there that the tradition truly flourished. Ashkenazi Jews not only preserved a large corpus of "classical" Palestinian *piyyutim*, but they also developed a rich liturgical poetry of their own. The language of liturgical poetry is complex and difficult, and from the eleventh century on, scholars in the Rhenish communities wrote numerous commentaries on *piyyutim*. In fact, liturgical poetry and the interpretation of *piyyutim* made up part of the curriculum in the Rhenish *yeshivot*. [129] Some of the most outstanding liturgical poets lived in Worms, including Meir ben Isaac, who worked there in the eleventh century, and Eleazar ben Judah, who composed poetry among his other activities, both of whom had a determining influence on the emergence of the rite of Worms.

The Qalonymide Pietists played a special role within this general framework of Ashkenazi attitudes toward prayer and *piyyut,* and Grossman

even argues that it was this aspect of their teachings that had the greatest impact on the culture of Ashkenaz for generations to come.[130] The Qalonymides were very much concerned with matters of prayer, their precise wording, and the rules for their proper recitation, and above all with issues of intention *(kavanah)*. Prayer occupied a central place in any Pietist's religious life and was a crucial aspect of their mystic experience. It is in this realm that the *sheliah tsibur* would receive a mystic dimension and be associated with God. The Pietists were concerned not only with the precise wording of the prayers, but also and primarily with the numbers of their words and their numerical value.[131] Ta-Shma argued that this method of exegesis caused a great deal of disagreement and that it was the resulting conflict that eventually caused the German and French prayer rites to drift apart.[132] There is also evidence of a fierce polemic against communities in France and England, which, in the Pietist's judgment, were lax in matters of prayer.[133] The *Sefer Hasidim* also objects to *piyyutim* that start with a mention of the divine name, insisting that referring to the titles of such *piyyutim* outside the synagogal context would mean profaning the Name of God. Indeed, *piyyutim* that begin with a reference to the divine name are extremely rare in Ashkenazi rites.[134]

The Pietists favored the recitation of *piyyutim* as part of Ashkenazi custom, even though they say surprisingly little about it. For the sake of piety and precision, they called for a particularly careful attitude toward *piyyutim*. At times they concentrated on particular issues of exact wording—not only for the statutory prayer, but also for the *piyyutim*—or the precise placement of a *piyyut* within the scheme of the statutory prayer.[135] For example, both Judah the Pious in the *Sefer Hasidim* and Eleazar of Worms in the *Sefer Haroqeah* emphasize that no *zulatot* are to be said during the Rosh Hashanah and Yom Kippur morning services, as they interfere with the precise rules for reciting *emet veyatsiv*.[136] Indeed, no *zulatot* are included for the High Holidays in Ashkenazi mahzorim, including, of course, the Leipzig Mahzor.[137] However, the clearest evidence of the role *piyyut* played in the world of the Qalonymide Pietists is found in connection with Eleazar of Worms himself, as many of his *piyyutim* have survived as part of the rite of Worms and are included in the Leipzig Mahzor. We can say, then, that this aspect of Eleazar's creative work makes up, so to speak, for the limited number of references to liturgical poetry in Pietist writings.

Langer argues that in Ashkenazi culture *piyyut* had a status akin to that of prayer.[138] This contention finds support from the colophon in the Worms Mahzor, in which the scribe, Simha ben Judah, explains that he wrote the book for his uncle Rabbi Barukh ben Isaac and that he "arranged . . . the *prayers* to be recited by the *hazan* [my emphasis]"[139] Like every other

Ashkenazi mahzor, however, the Worms Mahzor contains only *piyyutim* and no statutory prayers. This means that for Simha the Scribe the contents of the mahzor were considered prayers.

Ashkenazi prayer had thus grown into a particular cultural phenomenon, and liturgical poetry had become a seminal element of Ashkenazi culture. The high esteem the *piyyut* enjoyed in that culture in general and in Pietist circles in particular somewhat blurs the sharp distinction between prayer and *piyyut* that was characteristic of attitudes to liturgical poetry in other realms. In the context of critique against liturgical poetry elsewhere in the Jewish world, the recitation of *piyyutim* had become a cultural value, part of a worldview according to which the *minhag* was a core issue. Our image depicts the ritual of *piyyut* recitation, equates it to the ritual of prayer, and underscores both by focusing on the *sheliah tsibur* shown in the performative act of wrapping himself in a *talit*. Merging the meanings of all these aspects against the background of the Ashkenazi attitude regarding *piyyut* recitation reaffirms thus some of the Ashkenazi cultural values.[140]

From all of the above we can appreciate the degree to which the act of reciting *piyyutim* in medieval Worms and other Ashkenazi communities had become ritualized. The ritual began with the act of bringing the book into the sacred realm of the synagogue and putting it on the lectern. The placement of the mahzor in the sacred space is also addressed in the image by means of the shape of its frame. It is, in fact, the only framed picture in the book that is not an initial. Most of the other images that depict customs and rituals appear as unframed marginal pictorials (figs. 8, 9, and 15). In these images the lack of frames seems to draw viewers into the realm of the image and invites them to participate. In this respect the image of the *sheliah tsibur* stands out. The frame with its somewhat unusual shape and the deep-blue background create the ritual space in which the *piyyut* recitation is taking place. It seems that the illuminator declaredly intended to demarcate this space as different from the amorphic backgrounds of the marginal images. From the time when they began to take an interest in rituals, anthropologists have emphasized the importance of the physical space in which rituals are performed and with the transitions into such spaces. The notion of transition or "passage" into a ritual space (or into a new phase of life), associated primarily with the scholarship of Arnold van Gennep and later of Victor Turner, can help us understand the somewhat unusual composition of the frame as a liminal area marking a demarcation between the profane world and the sacred space.[141]

Somewhat abstractly—the Leipzig illustrators never dealt with realistic settings—this demarcation is created by the frame. A frame is usually understood as a divide between the picture space and the viewer's space.

The unusual design of the frame on this page goes beyond the simple defi-
nition of images normally employed in illustrated manuscripts by straight
frames and engages our eye in a special way. It is painted in a peculiar zig-
zag pattern in which each angle is met by a matching angle on the opposite
frame pointing in the same direction, similar to pieces of a jigsaw puzzle.
Moreover, each corner element is echoed diagonally by a counterpart in
the opposite direction, resulting in a sort of chiastic design. The zigzag pat-
tern links the sacred space of the synagogue interior with the space outside
the frame; it also creates a sense of movement but at the same time delin-
eates a defined space. All three men seem to be walking on the bottom edge
of the frame, as their feet actually touch it, and thus are in the liminal area
at the threshold of the sacred space. The frame also draws the viewer con-
ceptually into the space of the protagonists.

Not at odds with the unrealistic approach of the Leipzig imagery, the
frame nonetheless creates the necessary setting for the ritual space and
thus adds a crucial aspect to the essence of the depicted ritual. Had the im-
age been encompassed by a conventional frame, this would not have been
so easily felt. Likewise, constructing the frame in terms of clearly defined
architectural forms—for example, one typical for a gothic sacred building—
would have put limits on the degree of liminality of the transition from
the profane to the sacred. Had it been the intention of the designer(s) of
the image to refer specifically to the synagogue or the "minor Temple," he
would have had a rich symbolic language at his disposal to express such a
notion. In the illustration for the Great Sabbath (fig. 7), for example, set in
an elaborate tympanum, which refers explicitly to the symbol of the Tem-
ple, the intention to designate a sacred space is made very clear. The image
of the *sheliah tsibur,* on the other hand, visually expresses not only the
transition from the profane to the sacred, but also movement into a sphere
where the community is dominant, thus a transition from the private to
the communal. Finally, the physical attachment of the lectern to the frame
makes it clear that the protagonists are within the physical space of the
synagogue.[142] When the Leipzig Mahzor lay open to that page on the lec-
tern near the shrine or perhaps the *bimah,* the congregation assembled for
prayer would be in this very phase of transition from the profane to the
sacred and from the private to the communal. The bearer who brought the
book into the synagogue performed such a transition. The *sheliah tsibur's*
ritual act of wrapping himself in a *talit,* no longer simply a halakhic re-
quirement but an act associated with the mythical dimension of the Holy
one blessed be he wrapped in a *talit,* also marks that transition.

The Leipzig image of the *sheliah tsibur* thus documents two processes of
ritualization: the ritualization of prayer and the process of transforming

the halakhic requirement of covering oneself properly into the ritual of wrapping oneself in a *talit*. What is significant in Ashkenazi culture, how-ever, is the ritual dimension of the recitation of *piyyutim* beyond that of prayer. On the one hand, rituals tend to be static and fixed; they are a sta-bilizing factor, one that provides continuity of a tradition. The fixity of rituals tends to furnish a social group with a secure fence that maintains its existence.[143] On the other hand, the pluralism of rabbinic scholars with regard to the particulars of the medieval prayer rites is quite remarkable. What was important was the actual act of reciting the *piyyutim*. But every community was free, so to speak, to develop its own variation, and that turned the rite into a powerful force toward communal identity. The rite of any particular town was not just a random order of liturgical hymns, but was rather a structure that the members of any given community could approach as belonging to their particular communal entity. It was a by-product of the special attitude of Ashkenazi Jews toward their *minhag*, a way to preserve the specific values and norms of any given community. *Minhagim* are not universal, and it is the preservation of the particular variations of the *minhagim* that turns the *minhag* into a cultural value.

Catherine Bell argued that liturgical renewal can occur either in parallel with or in reaction to social and cultural change and can be a powerful tool with which to come to grips with the latter.[144] The precise steps in the emergence of the liturgical rite of Worms are still obscure, but the rite's development is certainly marked by a great deal of ongoing renewal and change. The first significant phase occurred in the latter part of the elev-enth century, when the study of the Babylonian Talmud flourished in Worms and laid the groundwork for what would later become Tosafist scholarship. At the same time the Mainz scholars were deeply involved in efforts to preserve the *minhag*. As I noted earlier, Meir ben Isaac, the poet who composed many of the early poems that would become specific for the Worms rite and was in effect primarily responsible for the beginning of that rite, was active during these decades. In a period when Ashkenazi Jewry was pulled in different scholarly directions between the *minhag* and Tosafism, Meir was celebrated as both a ritual expert safeguarding the tradition and an innovative poet. He was a mystic who was credited with possessing miraculous powers, but was not a figure in mainstream talmu-dic scholarship. Although he died several years before the Crusader perse-cution of 1096, the inclusion of his poems into what would become the rite of Worms seems to have taken place, at least in part, during the years of crisis at the end of the eleventh century and during the early twelfth.

As noted, the second figure who was instrumental in the development of the rite of Worms was Eleazar ben Judah, and he also lived during a time

of great change. His scholarship, which represented the worldview of the Pietists, was quite radically different from that of the twelfth-century rabbis. The ritual changes he inspired, which were introduced in the years between his death and the production of the Leipzig Mahzor, seem to reflect significant changes in the communal structures and the living conditions of the Jewish community of Worms. Thus the two cardinal figures in the early development of the liturgical rite of Worms lived shortly before or during turbulent times. Moreover, it appears that the reception of their liturgical work goes hand in hand with other dynamics of the period, which had an impact on those who consolidated the rite in the form that we see in the Leipzig Mahzor. The earlier phase in the rite's development was a reaction to the tension between the *minhag* and Tosafism, and the later phase was one aspect of the community's coping with the Pietist legacy.

It was during this period by and large—between the lifetimes of Meir and Eleazar—that the status of the *sheliah tsibur* changed from that of a simple representative of the community into a scholar, a rabbi having some of the qualities of an ordained ritual expert. When post-70 Jewish liturgy began to emerge, neither the *sheliah tsibur* nor the *hazan* had such a status. The rituals were created by scholars and performed by *shelihe tsibur*. At some point the *hazanim* began to produce liturgical poetry to embellish the statutory prayer, which had been designed by authoritative scholars, thus bringing about a ritual change that would play a pathbreaking role in future developments. In the time when Meir ben Isaac was on the scene, the functions of the *sheliah tsibur* and the poet-*hazan* had merged into one, and that individual's status had grown into that of a ritual expert. Both Meir and Eleazar ben Judah played that role. They were not only capable performers of prescribed rituals, but they were themselves the creators who prescribed them.

The emergence of the specific rite of Worms was thus an ongoing process and coincided with these developments. Even though the early steps of its evolution into a specific rite go back to Meir's poetry, manuscript evidence regarding surviving copies of the Worms rite point to the possibility that its final consolidation into a specific rite occurred only after Eleazar's time. As already noted, the Leipzig Mahzor seems to be one of the earliest, if not *the* earliest, surviving copy of the rite. Together with the visual portrait communicated in its painted panels and marginal scenes, it appears that this book with its specific rite marks a turning point in the community's attempts to come to terms with tradition and change and to define its own identity.

We are thus able to understand fairly well what acts were performed in the sacred community of Worms within the sacred space of its synagogue,

when the *sheliah tsibur* got ready to perform his duty. We also have a basic notion of the meaning of the rituals, perhaps more than about the performative aspects of the acts involved. The above analyses enable us to apprehend the associations the designer(s) of the image and a medieval viewer looking at it would have had. The image of the *sheliah tsibur* appears as a concise sketch of an entire concept, encompassing the meaning of prayer, the meaning of *piyyut* recitation, and the social and religious implications attendant on the *sheliah tsibur*. But whose concept was it? Was the entire community of Worms indebted to this idea of prayer and *piyyut*? Most likely it was to some extent. But, as Robert Scribner noted, "Rituals are [not] always understood by their audience in the way intended by those who stage them."[145] The image was certainly conceived by those who "staged" the ritual of *piyyut* recitation, and it stresses the symbolic meaning of the *sheliah tsibur* and the acts he performed. Or as Bell put it, cohesion and solidarity depend on the actual existence of the symbols involved in performing a ritual, not on the consensual interpretation of these symbols.[146] Scholars and prayer-leaders—the ritual experts— would understand the theological implications of the act of wrapping oneself in a *talit* differently from the less educated but pious adherent. As Philipp Converse emphasized, the less educated "still have a fairly accurate knowledge of concrete matters of ritual and mundane taboos"; for them their particular religion is a collection of meaningful practices, and the theology behind them is of less concern.[147]

Getting Ready for Pesah

We have seen that every year on the Sabbath before Pesah, the Great Sabbath, Eleazar ben Judah delivered his famous Pesah sermon, which he said he had received from his teacher. As previously noted, this sermon was apparently intended to turn into some sort of tradition and to be "recited" by later authorities, so it was accorded a kind of liturgical status. Apart from offering a basic interpretation of the Song of Songs, to be read during the holiday, it communicates the regulations that guarantee a kosher Pesah week, and the Great Sabbath is the time to recall those stipulations.

The *piyyut adir dar metuhim* (The Mighty One dwells on high) is recited during the *musaf* service.[148] The poem opens with a general thought about God giving the law to Israel and the poet or the *sheliah tsibur* reminding the congregation to observe these particular laws during the upcoming week. It then goes into great detail about the particulars of the Pesah-related regulations. Authored perhaps in early medieval Babylonia,

the poem was accorded a great deal of authority, and in the Middle Ages was discussed and its contents incorporated into the corpus of *Tosafot*.[149] The central issues referred to in the *piyyut* and in Eleazar's sermon—the ritual cleansing and scalding of vessels and the baking of *matsot*—are both depicted in the Mahzor's margins accompanying the liturgy of the Great Sabbath (figs. 8 and 9). During the days before the holiday the house is cleaned from leftovers of leaven. Vessels that had been in touch throughout the year with leaven need to be cleaned, and in certain cases scalded, in order to become fit for use during the week of Pesah. Even though the tasks of scalding the dishes and baking unleavened bread can be performed within one's own house, it appears that in some communities of medieval Ashkenaz, Worms among them, they were carried out in the communal arena.

The marginal image accompanying the first page of the *piyyut* shows two women standing beside an enormous cauldron over a fire (fig. 8). Various metal dishes are pictured on the cauldron to indicate its contents. The women have other items in their hands: a bucket, not to be scalded, but to add water; a metal platter; and a large knife with a wooden handle. All the metal parts of the dishes within the cauldron and in the hands of the women are carefully marked in gold.

The *piyyut* gives precise instructions about what kinds of dishes and implements have to be burned or scalded in order to become ritually clean for Pesah: knives and the like have to be cleaned carefully and then scalded. In principle, iron utensils are supposed to be burned, but ladles, spits, and gridirons can be scalded. Other items, such as earthenware, cannot be made kosher at all. Rendering dishes kosher for Pesah by heating them in a fire or scalding them in boiling water was (and is) a procedure of major importance before the holiday. The *piyyut* concisely summarizes more-complex halakhic issues that concern primarily the types of materials that can be made kosher. Whereas modern practice implies that wood, for example, cannot be made ritually clean by scalding, this apparently was not the case in the Middle Ages.[150] Apart from the material, the specific ways a dish is used also determines if and how it can be made kosher for Pesah. Dishes are used for boiling, cooking, grilling, or just for serving, functions that imply different kinds of contact between the food and the material, and it is the function that determines how a dish can be made fit for Pesah. Special regulations apply to dishes owned by Gentiles.

There were various developments regarding these matters over the centuries. The Mishnah refers to these procedures only in the context of dishes bought from Gentiles and the Temple vessels.[151] The Babylonian Talmud extends these concerns to the requirements for Pesah, explaining the procedures for knives and emphasizing that there is no way that earthenware can be

made fit for Pesah.[152] The late antique references also mention that the particular procedure depends on the way a utensil is used.[153]

Since the early medieval period scholars have considered whether scalding for certain vessels instead of burning would be sufficient. According to most sources, metal objects that are used to grill food over fire—spits and gridirons—should be burned, whereas knives and cooking pots can be treated with boiling water.[154] In the responsa of the Gaon Natronai (c. 855) precise instructions are given: the dishes have to be carefully washed, then scalded in boiling water and rinsed in cool water. This procedure applies to "small pots, knives and wooden cooking ladles." It is emphasized that the water must continue to boil. The rim of the cauldron should be covered with mortar and the cauldron should be filled up to the point that the boiling water spills out.[155]

Early Sephardi halakhists and the French Tosafists follow these guidelines and distinguish between metal utensils whose use implies contact with fire (spits and gridirons) and those that are used only for cooking (pots).[156] Some later sources, however, suggest that spits and gridirons can also be scalded.[157] Eleazar of Worms insisted on the distinction between utensils used in fire and those used for cooking.[158] Surprisingly enough, however, in his Pesah sermon he explicates only matters of scalding in great detail, whereas the rules for burning are kept very short. He opens the discussion by saying "every vessel that came in contact with leaven by heating has to be scalded. This includes cauldrons used for cooking and boiling vessels . . . our wooden bowls are to be scalded . . . an iron pan will be scalded in the cauldron. . . . Likewise an iron used for cutting meat, if it came in contact with leaven, it has to be scalded . . . a knife needs to be scalded."[159]

The image in the Leipzig Mahzor, which likewise focuses on the scalding procedures, is somewhat ambiguous in specifying the precise nature of the different dishes. But the variety of utensils, some of them clearly made of metal, indicates that it is meant as a reference to these discussions.[160] That the designer(s) of this image were fully aware of the halakhic issues involved becomes clear when we look closely at the cauldron's rim. It is light brown in color, suggesting the instruction that the rim should be covered with mortar, as prescribed in early medieval Babylonian sources.

Apart from discussing the halakhic issue, Eleazar mentions in both his *Ma'asseh Haroqeah* and the sermon that in the community of his uncle Abraham ben Samuel—apparently in Speyer—the scalding was undertaken publicly for the entire community in a large cauldron, rather than privately in one's own home.[161] In later sources the communal scalding was explicitly referred to as a custom, a *minhag*. The transition from the private into the communal sphere is remarkable here. The dishes are used

within the framework of a private household, but the process of making them kosher is performed within the communal arena. Shortly before 1650, during the last phase of the Thirty Years' War (1618–1648), Yuspa Shammash seems to have been well aware of the significance of communal scalding, lamenting that in times of war people commonly scald their dishes at home:

> The custom of scalding: even though now during the war every individual scalds the dishes by himself and not at the customary location, I do not refrain from putting the custom into writing. It is a good custom, and God may bring back peace upon us soon, so we can return to our customs, and one will be able again to see this custom performed here. It is done as follows: one day before the baking of the *matsot* one scalds [the dishes]. On this very day the *shammash* announces during the morning prayer: bring your dishes to be scalded at this or that hour. And this is the custom: one brings a large cauldron that belongs to the community—it is called *kessel*—and it is ready for this purpose year after year. A big fire is lit right before the entrance into the ritual bath of the women behind the synagogue (map 1). First the cauldron itself is scalded, and then the dishes of the entire community are scalded. And nearby the rabbi, the juridical authority, is seated to supervise the scalding and he alerts the people that the water should be boiling well. On the same occasion everybody shows him the dishes to be scalded and he determines if the dish is suitable for scalding.[162]

In Yuspa Shammash's time, rabbinic supervision seems to have been an important factor in the preference for communal scalding, but the initial lines of this quotation show quite well that this was not solely an issue of rabbinic authority, but still one of reverence toward communal customs. This was certainly so in the early fourteenth century.

Thus there is evidence indicating that this practice was first introduced by a member of the Qalonymide family and became common under the influence of Eleazar. However, there is perhaps an additional layer of meaning to this custom and our image. In his discussion of Jewish-Christian relations in the Middle Ages, Israel Yuval draws our attention to an anti-Jewish libel that began to spread after the First Crusade. Christian reports of libel stories occasionally included an element of scalding, either of the victim when still alive or the corpse. An account of the Crusader massacres notes that in Worms the attacks began with an accusation that the Jews had scalded a Christian near the Pesah holiday with the intention to poison the wells. Likewise, the story about William of Norwich includes the scalding motif. As the story has it, a Christian servant peeking through a hole in the door claimed to have seen Jews pouring hot water on William before he would have been killed. The boy's murder was believed to have taken place just before Pesah, and the hot water may have been intended

for scalding the dishes. Thus, it seems that the custom of scalding dishes before Pesah led to the libel of Jews scalding Christian victims, which was spread to demonize the Jews for subverting the baptism. From the late thirteenth century on, various host-desecration libels also mention the scalding of the host.[163]

It is thus possible that turning the custom of scalding dishes before Pesah into a communal activity was to some extent motivated and came about in reaction to such libels. The libels implied that the scalding of Christian victims and the host took place behind the closed doors of the Jewish home, so taking the custom into the streets was perhaps intended as a countermeasure. At the same time, it might also have been done to provide an "answer" on a more theological level. In both religions the immersion in water is heavily loaded with symbolic meaning as an act of purification. Ritual immersion and baptism are symbolic acts of purification, and the scalding of dishes can be understood in this context as well.

The enormous size of the cauldron depicted in the marginal image clearly suggests that it refers to the practice of communal scalding. In contrast, the parallel scene in the Darmstadt Mahzor seems to take place in an interior and shows a single man seated on a chair scalding a pitcher in a significantly smaller cauldron.[164] This representation apparently refers to a private rather than a communal setting. What began as a practice in twelfth-century Speyer and Worms in the vicinity of the Qalonymides can still be seen today in Orthodox neighborhoods in Jerusalem (fig. 14).

The second act of preparation for Pesah depicted in the Leipzig Mahzor is the baking of *matsot* (fig. 9). This scene appears a few pages after the scalding scene in the margins of a text that forms the ending of the *piyyut* for the Great Sabbath and the beginning of the Pesah eve service. The image shows a woman kneading dough in an enormous vessel to the right. Another woman is carrying a platter with three round *matsot,* while to the left a man is putting a *matsah* into a large oven. Instructions for the process of baking the *matsot* are extremely detailed in medieval halakhic sources. The meticulous observation of these instructions guaranteed that contact between flour and water was minimal and leavening avoided. Only eighteen minutes may pass from the moment the flour comes into contact with water, a period of time that can be extended by constant kneading.[165]

The *matsot* were baked in a communal bakery, and the large stove seems to be indicative of that custom. Jewish bakeries were also among the several community institutions mentioned in medieval sources.[166] A document from 1354 mentions that the Jewish bakery *(bachus)* of Worms was sold by the town council to a burgher after Jewish property had been confiscated. The reason given was that the bakery was located within the parish of

St. Martin, an area in which attempts had been made for some time to limit Jewish ownership of property—"ein bachus gelgen hinder sante Martin gelgen by sante Martins porthen." The St. Martin's gate was near the *Judengasse,* but the bakery was within the area of the parish (map 1).[167] After 1354, special arrangements had to be made with the Christian authorities to guarantee the use of the stove for baking the *matsot* before Pesah.[168]

In Yuspa Shammash's records of 1648 the custom of communal baking seems, again, to be primarily a matter of rabbinic supervision. He refers to the entire section as "The Custom of Baking *Matsot,*" by which he does not mean the halakhic prescriptions, but the actual custom of baking the unleavened bread in a communal stove under the aegis of the community *shammash.* Yuspa first notes that the *shammash*'s salary does not include the job of baking but that he has to be paid for every single *matsah.* First the community and synagogue functionaries are provided with *matsot;* after they received their share, the members of the community make use of the communal facilities on a first-come-first-served basis. A rabbi supervises the process and among other concerns makes certain that the portions of dough are not too big and that the dough is kneaded constantly so that it will not rise.[169]

Like the scalding of the dishes, the baking of unleavened bread was loaded with both theological and polemical meaning. Yuval discusses the polemical dialogue between the religious concepts of host and *matsah* in great detail.[170] Since the 1290 host-desecration libel in Paris, and even more so since the 1298 riots in Franconia and in Bavaria, which had started with a host-desecration libel in Röttingen, these notions had taken an ever more menacing turn.[171] The baking of *matsot* was related to this polemical discourse around the host. More threatening, however, was the fact that the *matsah* was also associated with the blood libels, owing to the belief that the blood of Christian victims was used for the dough of the unleavened bread.[172] The insistence on preparing the *matsot* in the communal arena may have partly had to do with countering these accusations.

It is not necessarily the precise halakhic instructions that should be of interest here, if we want to understand the more general cultural issues involved in the imagery of the Leipzig Mahzor. First of all, both the scalding and the baking are central concerns in Eleazar's sermon. Second, both images emphasize communal aspects of the activities that mark the days before the holiday. Getting ready for Pesah involves many acts, most of them performed within the private sphere of one's own home, which has to be cleaned and searched for leftovers of leaven. These are not reflected in any of the Leipzig images that relate to Pesah. Rather, the small marginal pictures refer explicitly to those aspects that were the responsibility of the

community and its authorities—a further element that shows the communal character of the Mahzor as a whole.

Shavuot

Similar to other major holidays, the *yotser* for the first day of Shavuot is decorated by both an initial panel and a double-page series of marginal illustrations running across the pages below the text (fig. 15). On the right-hand page Moses is standing on Mount Sinai presenting a golden codex to four representatives of the Children of Israel. On the left-hand page we see an initiation ritual of young schoolboys that was customary in several Ashkenazi communities during the late Middle Ages. A teacher is seated to the left with a young boy on his lap, and two other children are approaching him. A man carries a fourth child wrapped in his father's mantle. To the far right another man accompanies two more youngsters nearing a river. All the children hold cakes and eggs in their hands.

This ritual was studied in depth by Marcus several years ago from an historical-anthropological point of view, considering, on the one hand, issues of acculturation of Ashkenazi Jews to Christian society and, on the other, anthropological concepts about rituals of passage.[173] I describe it here only in very general terms, summarizing Marcus's observations, and then address specific questions about the role Worms, Eleazar, and the Ashkenazi Pietists may have played in the history of that ritual.

Studying the background of the "coming of age" ritual first of all poses questions about the education of young male children in the Jewish communities of Ashkenaz. Whereas Moritz Güdemann argued in the 1880s that the medieval communities maintained a fully organized system of early education, Ephraim Kanarfogel showed more recently that elementary education in Ashkenaz seems to have been rather a matter of private initiatives. Early education, he argues, focused on Bible study and was put into the hands of *melamdim,* tutors for elementary education. Kanarfogel notes that there is surprisingly little discussion of issues concerning early education in medieval rabbinic sources. Some Tosafists gave the matter some thought and discussed the skills required of the *melamed,* but it received somewhat more attention in the *Sefer Hasidim.*[174] According to the latter, biblical education for young children provides the foundation for ethical conduct in later life. Therefore, the teacher has to be sincere, honest, and learned and should devote his full time to the education of the boys.[175]

During the later Middle Ages it seems that teachers of young children were typically in dire economic straits, and several sources describe many

wandering teachers desperately seeking income. Nevertheless, the *Sefer Hasidim* required high standards and often referred to these teachers not by the term *melamed* but by *rav* (rabbi). Some of the sources describing the initiation ritual depicted here also refer to the teacher as *rav,* a fact that sheds some further light on these issues. This also corresponds to the visual language in the Leipzig image, where the teacher on the left is an elderly man with gray hair and a beard, mirroring the appearance of Moses on Mount Sinai to the right. In contrast, the father who is carrying one of the boys is shown as a young beardless man with blond hair.

Another question with regard to early education is that of concern for biblical versus talmudic study. Tosafists of the twelfth and thirteenth centuries gave considerable weight to the latter, and we read about Judah ben Asher (d. 1349) complaining that, in his opinion, his education as a youth in the German lands did not provide him with sufficient biblical knowledge.[176] In contrast, the depicted initiation ritual indicates a clear focus on Torah study among young children, and Marcus shows that this focus can be reconstructed from six different written records, as well as from this image in the Leipzig Mahzor. All the sources link the study of Torah with the Mount Sinai scene. According to some, the ritual was performed during the Shavuot holiday, whereas others seem to imply that it was done individually as any young boy arrived at a suitable age. As the sources differ from one another, it is quite possible that there were local variants to the ritual. What they do have in common, though, is the particular stress on Bible study.

What seems to be the earliest record concerning the initiation ritual is found in the work of Eleazar of Worms, and it is excerpted here from Marcus's translation of the full text:

> It is the custom of our ancestors to sit the children down to study [the Torah for the first time] on Shavuot because that is when the Torah was given. . . . the boy should be covered so that he will not see a Gentile or a dog on the day he is instructed in the holy letters . . . he is covered with a cloak on the way from [his] house to the synagogue or the teacher's house. . . . The child is placed on the lap/bosom of the teacher who sits them down to study. . . . They bring over the tablet on which is written [the alphabet forward, beginning] *alef, bet, gimel, dalet;* [and the alphabet written backward, beginning] *tav, shin, resh, qof.* . . . The teacher recites aloud each letter of the *alef bet* [forward], and the child [recites] them after him; [then the teacher recites] each word of *tav, shin, resh, qof* and the child does so too. . . . And [the teacher] puts a little honey on the tablet, and with his tongue, the child licks the honey, which is on the letters. After this, they bring over the cake kneaded with honey on which is written, "The Lord God gave me a skilled tongue, to know how to speak timely words to the weary. Morning by morning, he

rouses, he rouses by ear to give heed like disciples. The Lord God opened my ears, and I did not disobey, I did not run away" (Is 50:4–5). The teacher recites aloud each word of these verses, and the boy [does so] after him. After this, they bring over a cooked egg that has been peeled and on which is written, "as he said to me, 'Mortal, feed your stomach and fill your belly with this scroll that I give you.' I ate it, and it tasted as sweet as honey to me" (Ez. 3:3). The teacher recites aloud each word and the boy [does so] after him. They feed the boy the cake and the egg because it is good for the opening of the heart."[177]

Several specific elements of this text are depicted in our image. The boy is covered on the way to the teacher; after he arrives at his teacher's home, his face is revealed, but his body is still wrapped in his father's mantle. To the left, the teacher is seated on a bench, and on the opposite page on the far right we see Moses on the mountain.[178] This rendering of the teacher in parallel to Moses and the teacher's bench in parallel to the mountain echoes Eleazar's statement about the teacher's home representing Mount Sinai. The teacher holds a child on his lap, again explicitly mentioned in Eleazar's text. He shows him a golden tablet with text, echoing the book in the hands of Moses on the opposite page, a visual reference to the tablet mentioned in Eleazar's description. The teacher's tablet had the letters of the alphabet inscribed, and it was coated with honey and licked by the boy. The child holds a boiled egg and a cake. According to the text, both bore inscriptions symbolizing the child being fed with spiritual food. Thus, according to Marcus, the custom ritualizes Ezekiel's metaphoric vision of eating God's sweet words of Torah.[179]

How important issues of language and gaining knowledge through language were in the eyes of the Pietists is clear from another reference in the work of Eleazar ben Judah. He believed that it was man's possession of language that lies at the root of his being created in the image of God. By means of the Hebrew language man is able to study the Torah, which, in Eleazar's eyes, was a mystical event. When a man utters words of Torah, he wrote, firelike words descend from heaven and cast light on the words coming out of his mouth. The transmission of the law on Mount Sinai, commemorated on the holiday of Shavuot, is prototypical of this process.[180]

Eleazar's student, the anonymous author of the *Sefer Ha'asufot,* offers a variant mentioning all the basic elements as Eleazar does: the boy is carried to the teacher while covered by his father's cloak; he is put on the teacher's lap; after the recitation of letters and verses, he licks the honey. The *Sefer Ha'asufot* also mentions an incantation against Potah, the prince of forgetfulness, a detail that has no echo in our image. It continues by describing how the children are taken to the riverbank, as is shown in the

picture on the far right: "After the study session, the boy is brought to the riverside, according to the Torah's being compared to water and [the verse] 'Your springs will gush forth [in streams in the public squares (Pv 5:16)],' so that the boy should have an expanded heart."[181] The third text, a *piyyut* commentary from 1318 that survives only in a manuscript now in Hamburg, may be associated with Abraham ben Barukh, the brother of Meir of Rothenburg, whose father had been a scholar in Worms. Some 80 to 100 years more recent than Eleazar's reference, it suggests that within that period of time some elements of the ritual had changed. Instead of in a mantle, the child is supposed to be wrapped in a *talit*. He is brought to the synagogue, the option of the teacher's house not being mentioned. The description of the ritual is incorporated in the commentary to the *ma'ariv* for the first day of Shavuot, owing perhaps to the fact that the text mentions several times that the cakes and the tablet with the letters have to be ready on the eve of the holiday. The entire description of the ritual is replete with references to the transmission of the law on Mount Sinai.[182]

The Ashkenazi evidence for this custom thus points to the Rhineland; it may have been introduced by Eleazar, but was mentioned again later by a scholar who listed Eleazar among his teachers and in a text that can be associated with the son of Barukh of Worms. The various texts do not fully correspond, each has specific elements, and the image in the Leipzig Mahzor reflects Eleazar's own rendering and that of the *Sefer Ha'asufot*, which adds the walk to the river.

It is difficult to reconstruct the earlier history of the initiation ritual. Eleazar's attempt to present it as an ancient one ("it is a custom of our ancestors") fails to provide a specific reference. It cannot be traced in its full form in any earlier record. Likewise, the evidence for areas outside the Rhineland is not clear. The ritual is mentioned in the *Mahzor Vitry,* but, as Marcus argues, belongs to a later stratum of the text and should not be attributed to Simha of Vitry. This is a shorter variant of the Rhenish reference, offering fewer details and sketching only the basic lines of the ritual. However, a late thirteenth-century copy of the *Mahzor Vitry* adds an entire section about the meaning of the different acts, which is discussed in detail in Marcus's book.[183]

In the early fourteenth century, Aaron Hakohen of Lunel refers to the custom. Believed to be the author of two very closely related collections of law and custom, *Sefer Orhot Hayyim* and *Sefer Kol Bo,* Hakohen used Ashkenazi material on various occasions and was also familiar with the work of Meir of Rothenburg. He used, among others references, a book entitled *Haye Olam,* attributed to an otherwise unknown scholar, Isaac the Pious. Judging from the contents of the book, Judah Galinsky links

this author to the teachings of the Qalonymide Pietists.[184] As we shall see later in the discussion of penitence, Hakohen was also familiar with Eleazar's work. His account, which is short and concise, starts with Eleazar's remark about the ritual being an old custom, but is otherwise closer to the version in the *Mahzor Vitry.* Toward the end of the section he presents the initiation ritual as a sort of curiosity, based, he claims again, on an ancient custom, and "still done in some places."[185] This wording indicates that it was apparently not particularly common beyond the Rhineland and certainly does not suggest that it was performed in southern France.

All this evidence taken together suggests that the initiation ritual apparently only developed in the late twelfth century and only in the Rhineland. Marcus's study goes into great depth discussing the different cultural phenomena that can be associated in one way or the another with this development: late antique and early medieval Palestinian traditions about eating cakes as a symbolic act of learning and intake of spiritual nourishment; Christian traditions of the *sedes sapientia,* Mary nourishing the child, and the consumption of the Eucharistic host; and polemical aspects vis-à-vis Christianity. Some degree of familiarity with Christian visual culture is also clearly apparent in the adoption of pictorial motifs of the Jesus child seated on Mary's lap or the standing Madonna being caressed by the child.[186] All these, Marcus argues, had an impact on the development of the Jewish initiation ritual.[187]

The texts that describe the ritual present it as a custom, as part of the cultural network of the *minhag* that shaped the mentality of wide circles of Ashkenazi Jewry. Even though they fail to reconstruct the ancient history of this particular custom, they present it in the context of the *minhag* and do not seem overly concerned with the fact that this is a "new" custom. Eleazar concluded his description of the ritual with the following words: "Let no one deviate from [following] this custom, as we say in [tractate] *Pesahim,* in [the] ch[apter beginning] *Maqom shenahagu* ["Where they were accustomed"]; and [we read] in Midrash *Bereshit Rabbah,* section *Va-year elav* ["And he appeared to him," Gn 18:1]: 'when you come to a [new] place, follow its custom'; and [we read] in the Palestinian Talmud . . . and in *Aggadat Shir Hashirim:* Custom is valid."[188] Marcus addresses the question of the sudden appearance of a schooling ritual and sees it within the context of the "cultural shock" caused by the Tosafists promoting new types of learning that emphasized the study of Talmud and higher education. The development of the initiation ritual, Marcus argues in great detail, can be understood as a response of conservative circles to this trend and as part of the defense of the Ashkenazi *minhag.*[189] Eleazar's conclusion makes that point clearly.[190]

It would be wrong, however, to define this response as typical of the Ashkenazi Pietists. Judah the Pious, for example, opposed any religious activity that implied eating food with biblical verses inscribed and digesting it.[191] Eleazar, on the other hand, not only describes the ritual but also promotes it. Finally, the author of *Sefer Ha'asufot* was well aware of Judah the Pious's objection and made a note of it in the introduction to his description.

It is very likely, then, that the ritual was performed primarily in Worms and perhaps in Mainz and Speyer as well. Texts originating from outside the Rhenish realm, such as *Sefer Kolbo*, refer to it as a curiosity carried out elsewhere. The original version in the *Mahzor Vitry* is not at all concerned with the performative aspects of the ritual, and the later one with the insertion focuses on the meaning of the different symbols and acts, rather than on the actual form of the ritual itself. The image in the Leipzig Mahzor, on the other hand, being grounded in Rhenish Jewish culture, does not depict it as a foreign curiosity or as a rare custom observed in "some places." Instead it appears as a local ritual performed on a regular basis and in full correspondence with the cultural norms and values of the particular community that perhaps had developed it in the first place. Marcus's observation that it may have come into being in response to the challenges that Tosafist scholarship represented in the eyes of conservative Rhenish Jews makes a lot of sense in the context of the cultural mentality that shines through all the imagery of the Leipzig Mahzor.

Marcus's research and the texts that he referenced teach us the formal and functionalist aspects of the described ritual. We know in quite some detail how it was performed, what its stages were, and who the participants were. Unlike the case of liturgical rituals for which liturgical texts function as the primary source for research, the texts consulted in the study of the initiation ritual are descriptive of its performance. From these texts we learn that it must have been approached with a great deal of flexibility and that variants may have existed at different times and in different places. Its social function as a ritual of passage is apparent, and Marcus relates in detail how the different acts correspond to the typical stages of rituals of passage. The male child leaves the realm where his mother is dominant and is accepted into the community of adult male learned individuals.[192]

Again we are reminded of Turner's definition of the community in the context of rituals of passage.[193] Such acts are ritualized transitions through the social order that help the child cope with the social change he is about to experience. The image conveys the aspect of transition, of movement from one stage to another, in a beautiful fashion. It uses the narrative approach, which is normal for the visual narration of biblical stories, and

presents the stages of the ritual in three phases. The stage when the father carries the child to the teacher's home or the synagogue is particularly important and implies a great deal of movement. An entire section of this tripartite composition addresses only this one stage. Looking at the image, we seem to learn more about its cultural, communal (social) function than about accurate details regarding its performance. The users of the Leipzig Mahzor were familiar with these details, as they commonly engaged in the ritual. The image comments on the ritual and seems to go beyond the symbolic meaning that religious imagery commonly conveys and that is usually the subject of art historical inquiry: the figure of the teacher, the cakes, the eggs, the meaning of the water source, and more. Instead it devotes a great deal of effort in visually commenting on the function of the ritual from the communal and social point of view. It draws the viewer into the actual performance of the ritual. Following Marcus's analysis we also know a great deal about the cultural-historical context of the initiation ritual, from the focus on Bible study to the development of the ritual as a counter to Tosafist educational values. The image in the Leipzig Mahzor appears to be indebted to the particular version described by Eleazar of Worms and as such also conveys the cultural and scholarly background against which it stands.

However, our image also addresses a third stratum, that of the symbolic meaning of the ritual. "It is the custom of our ancestors to sit the children down to study [the Torah for the first time] on Shavuot because that is when the Torah was given," said Eleazar, thus providing us with the main symbol of the Jewish ritual of passage, the transmission of the law on Mount Sinai. Marcus has already pointed out the parallel features of the two adjacent compositions, such as the figure of the teacher vis-à-vis the figure of Moses, the male children of the community vis-à-vis the Children of Israel, and the golden tablets on both pages. The Sinai scene, however, lacks the narrative aspect and the emphasis on movement and transition. It is a static, monumental scene, a moment frozen in time. It does not narrate a story, but functions instead as its symbolic representation. On the one hand, it serves as an illustration for the *piyyut* about the law, and on the other, it provides a key to the symbolic meaning of the initiation ritual. This symbolic meaning, finally, goes much beyond the educational value of Bible study, touching on the basic foundations of Jewish society, the observation of its law, the essence of Jewish identity by which the Jews define themselves in relation to the Gentile environment.

THE IMAGES DISCUSSED IN THIS CHAPTER offer a visual dimension for an understanding of several customs and rituals beyond what the copious

written records from the period can provide. But they also point out the status of each of these acts and the central role they must have played in the communal life of the Jews of Worms. The Leipzig Mahzor is a huge book, and most of its pages are undecorated. The ritual acts and customs that were chosen for representation must have been of central significance, and it seems that it was not necessarily religious or theological considerations that led to the choices. The scalding of dishes, the baking of *matsot,* and the ritual performed on the first day of a young boy's schooling are not necessarily the most meaningful acts in terms of theological, rabbinic knowledge. But they were acts that the Jews of Worms saw as essential in their religious and communal lives, and in that capacity their representation is able to sketch an image of this community that takes us beyond the written records.

The decision on the part of the designer(s) of the Leipzig Mahzor to exhibit some of the rituals commonly performed in their community adds further emphasis to several observations made by anthropologists about the nature of rituals. We cannot approach these images in the way an anthropologist would approach a modern video recording of a particular ritual. They are not realistic enough to provide us with a comparable amount of information. But with all the distortion in relation to realia that an image from the early fourteenth century implies, they still offer, even though to a limited degree, that visual dimension that enables us to see beyond the culture of written records. The choices made in selecting the specific rituals and customs shown, and the focus on specific details and elements, enable us to discern the community's attitudes and values, the symbolic meanings that lie behind them, and their function in daily life. The medieval approach to the visual, even though it does not offer an accurate reference to the acts and gestures performed, does, however, provide a great deal of information on the meaning of the depicted actions and the mentality of those who prescribed the rituals and those who performed them—perhaps to a greater extent than any fully realistic image.

These illustrations are an homage to the Ashkenazi *minhag* in the midst of the tension between the observance of the Babylonian Talmud and the reverence for the Palestinian oral tradition with its customs that had been observed over the generations and others that had been freshly introduced. It was due to Eleazar ben Judah that it was Worms that turned into a center of *minhag* reverence in the thirteenth century. Owing to the fact that his influence reached far beyond Worms to affect the lives of Ashkenazi Jews everywhere between the Rhine and the Elbe, the *minhag* enjoyed a revival in the German lands during the fourteenth and the fifteenth centuries. At that point it was no longer an issue of particular controversy. From

the time of the generations of Isaac of Vienna and Meir of Rothenburg, scholars imbibed both traditions and reconciled them; they held to both the Tosafist approaches and the Pietist tradition without the fierce controversies that had mattered so much back in the twelfth century. Still, as we can see in the Leipzig Mahzor, there were certain tendencies and preferences, and the imagery of our codex clearly reflects the preferences of the community of Worms.

In this chapter I discussed issues of religious practice as they are expressed visually in these images from the point of view of both the written halakhic law and custom. Scholars such as Eleazar ben Judah did not challenge the halakhah, but they revered the *minhag* to a degree that elsewhere was true only of the law. Their work was aimed at settling discrepancies between law and custom, not at challenging the law. Eleazar ben Judah's *Sefer Haroqeah*, for example, is an essential source in matters of both halakhah and the *minhag*. What mattered in the first place was observance as such: a "sacred community" was supposed to observe both halakhah and the *minhag* to the same degree. That volume delineates the ideal standards of conduct for any Franco-German community and reflects the norms set by those who expected the performance of the *minhag* and the observance of the ritual law. Both the Jewish tradition and earlier academic scholarship approached Ashkenazi Jewry as some sort of pure society with the highest possible standards of halakhic observance. Both Pietism and the approach of Tosafists to the law contributed to this ideal picture. This image was challenged recently by David Malkiel, who sheds some light on issues of obedience and deviance, but whatever the degree of disobedience and whatever the reasons for it, the way the community of Worms represented itself in the imagery of the Leipzig Mahzor is consonant with the ideals of a pure "sacred community."[194]

As much as the formality and the fixity of Ashkenazi prayer and *piyyut* recitation turned them into a ritual, paradoxically each community developed a slightly different rite that turned out to be instrumental in shaping its identity as different from that of the others. This raises the question of the relationship between rituals or ritualized acts and tradition or custom. The local prayer rites of Ashkenaz play a central role in defining the boundaries between the different communities within the larger context of Ashkenazi Jewry with its more broadly understood cultural identity. Whereas the veneration of the *minhag* as such is a matter of differing religious and cultural values—as opposed, for example, to the values of Tosafist scholarship—and can get quite close to matters of doctrinal difference, the various prayer rites have nothing to do with theological stances. Their distinctiveness within Ashkenazi culture has no connection to values or

doctrine. On the contrary, the legitimization of each community's distinct rite is a declared value within the framework of the veneration of the *minhag*. These rites then function as extensions of the essence of the *minhag* and its legitimate particularism. Moreover, they also provide a crucial means for delineating the different community boundaries, which were defined not doctrinally or linguistically but solely geopolitically.

The development of the medieval Ashkenazi rites involved yet another paradox. One of the motives for adhering to the *minhag* was the belief that it harked back to earlier generations, and this aspect of the custom of reciting *piyyutim* provided its legitimization. On the other hand, the different medieval Ashkenazi prayer rites were not shaped as outcomes of early roots in a remote tradition; their distinctive features developed at much later stages and were a by-product of a great degree of flexibility. What distinguishes the rite of Worms from other rites is not some ancient feature but rather the addition of *piyyutim* by medieval poets, especially Meir ben Isaac and Eleazar of Worms. It is *their* contribution to the rite, these later additions, not the ancient elements, that distinguish the Worms rite from others. Somewhat paradoxically this is in direct contrast with the process of ritualization of Ashkenazi prayer as it moved toward formality and fixity.

Theorists of ritual have given a great deal of thought to paradoxes of this sort. Whereas some define tradition as the one aspect of any given society that does not change, others focus on the tension between the unchanged, atemporal, structure of tradition and temporal changes.[195] Similarly, anthropological scholarship has addressed the relationship between tradition, often understood as the more static and fixed aspect of a society's culture, and custom as something more dynamic. Rituals can play a crucial role in both; they can be understood as expressions of fixed traditions, but can also be associated with more flexible customs.[196] The other way around, ritualized acts can construct both traditions and customs. These observations, it seems, shed extra light on the role these rituals play in the creation of communal cohesion, beyond geographic or political boundaries, and the shared history and scholarly tradition of any given community.

Ritual is the active aspect of religion. Anthropologists have struggled for a long time to define rituals as actions in relation to thought and myth and their role in religion.[197] Questions as to whether action and thought, ritual and myth, should be looked at separately or in an integrative fashion divided the older anthropological schools. Early scholarship tended to distinguish sharply between these two basic aspects of religion and to refer to them hierarchically, whereas later approaches sought to (re)integrate them. Among those who went beyond the functionalist approach was Geertz,

who described religious ritual as the meeting point of conceptual and dispositional aspects of religious symbols and as a means of acting out thought. He distinguished between the believer and the observing anthropologist, and it is with the former that the integration between action and thought takes place.[198] To some extent this idea can apply to the study of the Leipzig Mahzor, which is itself a ritual object. It is its imagery that integrates ritual practice and its meaning, reflecting both the performative aspects of the rituals and the theological concepts behind them.

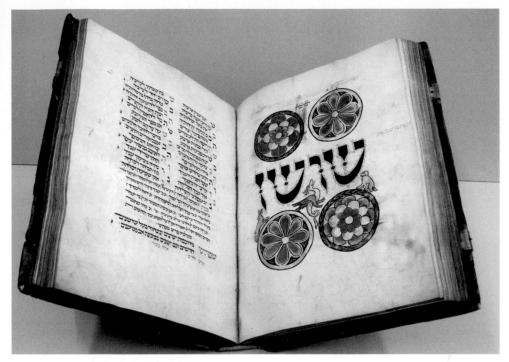

Figure 1. Leipzig, Universitätsbibliothek, MS Voller 1102/II, Mahzor, Worms c. 1310, opening of fols. 129v–130r, with permission of the Universitätsbibliothek Leipzig

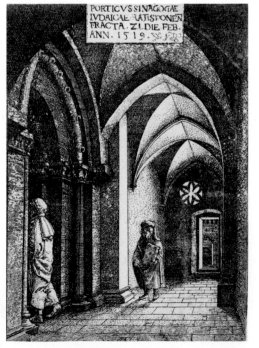

Figure 2. Berlin, Staatliche Museen, Preussischer Kulturbesitz, Kupferstich-kabinett, Albrecht Altdorfer, Entrance to the Synagogue of Regensburg, Regensburg 1519, etching, with permission of the Bildagentur für Kunst, Kultur und Geschichte, Berlin/Kupferstichkabinett/Jörg P. Anders

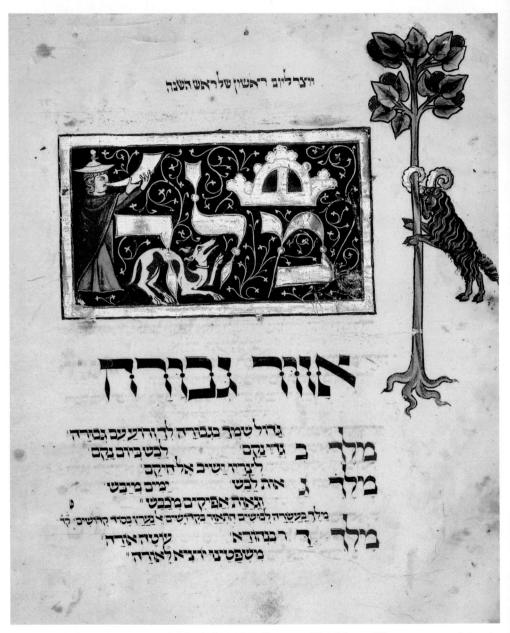

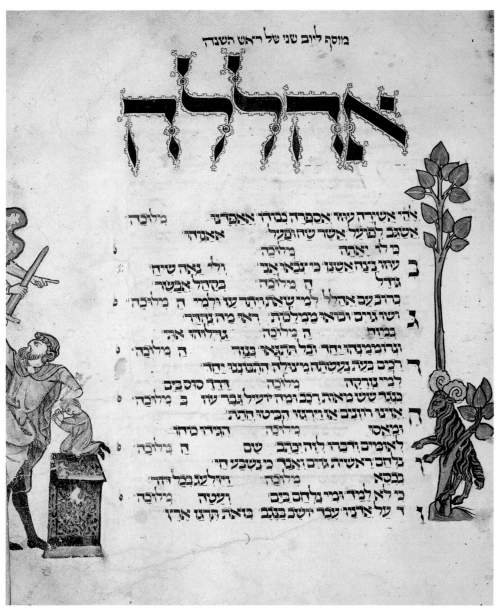

Figure 4. Leipzig, Universitätsbibliothek, MS Voller 1102/II, Mahzor, Worms c. 1310, fol. 66r, Rosh Hashanah, with permission of the Universitätsbibliothek Leipzig

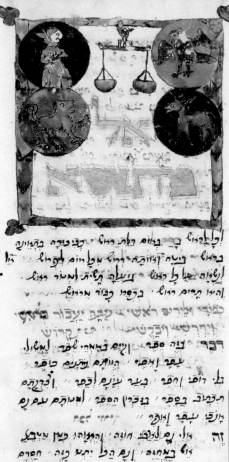

Figure 5. Oxford, Bodleian Library, MS Michael 434–35, Mahzor, Worms 1604, vol. 1, fol. 12v, *Sheqalim* pericope, with permission of the Bodleian Libraries, University of Oxford

Figure 6. Synagogue of Worms, built in 1175, interior of the men's section, with permission of the Bildarchiv Foto Marburg

קרוא בגרון בני אהרשישך אשי תנונים אשר על גבי חרש
ר אותם מה תורש מצורשינשיר הדשיוהגא מידרשים
תרונה שפהרי בשירי ארבעה הרשים
ארבעה הדשים כבמיחזה כיארתהזה מזה להזה
כאשי שמענו בן עיר נחזה ברכנו כשליב בהודש הוה
בר אתה המנברך את עמו בשליב

מילכנון כלה מדיאש אמנה השירי בטוהר עריי
לובש התבהני והתפאירי בושב ריקוח הבשמי מור
ולבונה התקטרי בי בא עה ויהגיע שעה אשר למולך
תשורי בין שדי ילין אשכל הכיפך מינפצעפת
ונדאמה כלה באימרי שפר בני מטון וטוֹלֹו רוחשים

Figure 7. Leipzig, Universitätsbibliothek, MS Voller 1102/I, Mahzor, Worms
c. 1310, fol. 64v, the Great Sabbath, with permission of the Universitätsbibliothek
Leipzig

ובבא ולך העלה קדושה כי אתה קדוש ישר ומושיע

ובבם

בי אין לפניך לילה הכל לפניך יום
יום ליום יביע אומר ולילה ללילה
דעת יודיע וחושך לא יחשיך ממך

וגנהורא שרי עמיך בקרים גירי חסריך ולילות ישני אה
אמינתך ושחר ובשה ונגה ובקר וצהרים וערבים ולילה
וכל עה ועירך וזמן ורגע זכברה נסי פלאותיך אותת ומרה
ומיפהים נפלאתיך המיחדש ישועה ומפליא פל
פלאות ומיחליה נראה הסספר ימיב ומונה עתים ויומך
אלה שנב ושנותיך לא יתמו כי הבל בלה ואתה לא מלך
ובאשר אתה חי מן פשרתיך חיים טהור והם ט
טהורים קדוש והם קדושים וקדושה לקרוש משלשיב

כמה ויקרא זה אל זה ואמ

כד כד כד

אדיר

דר מתווחים בחסר כל מילהיב איזן אקת אנוחים והדין
והוציאם מבני הזוחים או כרוב המילתי דר ממיעז י
דירתד ופרה מפתרד אוומיתו וכינב חבל נחלתך
בט בשבעים עמיים וגמיעאן לפני עמויים יהגריל צ
כמילאבי מדהרים וגפל חבלי בנעירמים בשורו גזר ובריקם
שמיחו בעם לו השוקיקים כוזם נטיית הזק ואריקים תת למו

Figure 8. Leipzig, Universitätsbibliothek, MS Voller 1102/I, Mahzor, Worms c. 1310, fol. 68v, the Great Sabbath, with permission of the Universitätsbibliothek Leipzig

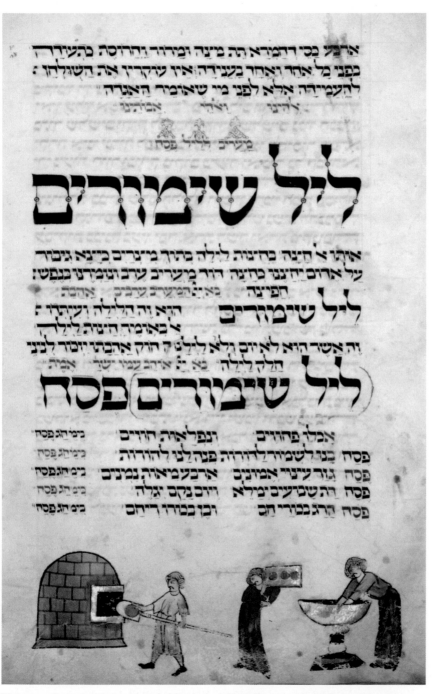

אירבל כי דהמרא תה מיצה ומידור והרוסת בעירה
בפני כל אחד ואחד בעגידה אין עיכרין את השלחן
להעמידה אלא לפני מי שאומר האגדה
לדינו יצלהי אמרינו

מירב ליל פסח
לֵיל שׁיָמוּרֵים

אתו צ חזנה נחזות לילה מדוך מיצרים כיצא גיבור
על ארום יחזנו כחוצה דור מעריב ערב ותמדתנ בנפשי
חפינה רא:: המצרים עלב אהה
לֵיל שׁיָמוּרֵים היא זה הלילה ועינדי
ל באומר הינות לילה
זה אשר היא לא זם לא לש ל חוק אהבתי יזכר לנני
תלה לילה בא ל אהב עמו שי אמה
לֵיל שׁיָמוּרֵים פסח

אכלו פהודים ונפלאות חודים בימי הג פסח
פסח בנו לשמיר לדורה פה לנו להורות בימי הג פסח
פסח גוד עצי אמינו ארבע מאה נמינם בימי הג פסח
פסח הת שנעים ימלא ויוב נקב יצלה בימ הג פסח
פסח הרג בנורי חק ובן בבדה ריחם בימ הג פסח

Figure 9. Leipzig, Universitätsbibliothek, MS Voller 1102/I, Mahzor, Worms
c. 1310, fol. 70v, the Great Sabbath, with permission of the Universitätsbibliothek
Leipzig

דְּקוּדְשָׁא בְּרִיךְ הוּא לְעֵילָא מִכָּל בִּרְכָתָא וְשִׁירָתָא תֻּשְׁבְּ
תֻּשְׁבְּחָתָא וְנֶחָמָתָא דַּאֲמִירָן בְּעָלְמָא וְאִמְרוּ
אָמֵן

בָּרְכוּ אֶת יְיָ הַמְבוֹרָךְ

בָּרוּךְ יְיָ הַמְבוֹרָךְ לְעוֹלָם וָעֶד

בָּרוּךְ אַתָּה יְיָ אֱלֹהֵינוּ מֶלֶךְ

הָעוֹלָם יוֹצֵר אוֹר וּבוֹרֵא חֹשֶׁךְ עֹשֶׂה
שָׁלוֹם וּבוֹרֵא אֶת הַכֹּל אוֹר עוֹלָם בְּאוֹצַר
חַיִּים אוֹרוֹת מֵאֹפֶל אָמַר וַיֶּהִי

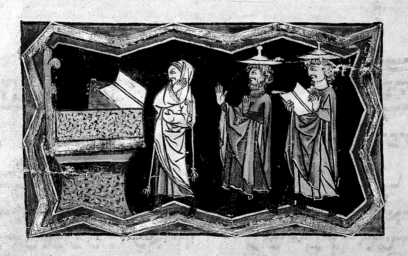

Figure 10. Leipzig, Universitätsbibliothek, MS Voller 1102/I, Mahzor, Worms c. 1310, fol.
27r, Beginning of the Liturgy, with permission of the Universitätsbibliothek Leipzig

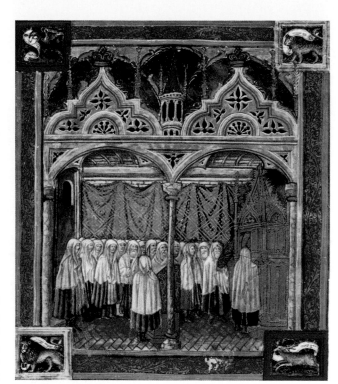

Figure 11. Vatican, Biblioteca apostolica, cod. Ross. 555, Jacob ben Asher, *Arba'a Turim*, Mantua 1435, fol. 12v, Synagogue Service, Biblioteca Apostoloca Vatican © 2011

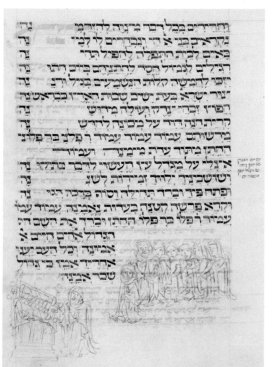

Figure 12. London, British Library, MS Add. 14671, Passover Haggadah, fol. 66v, Recitation of *Hallel* in the Synagogue, © The British Library Board, London, All Rights Reserved 03/11/2011

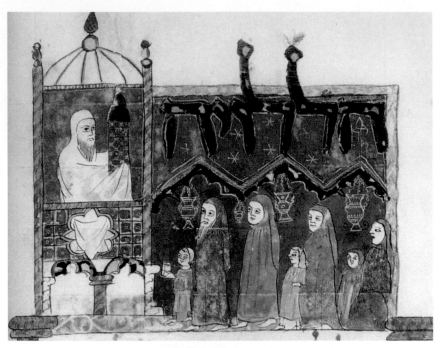

Figure 13. Hamburg, Staats- und Universitätsbibliothek, cod. Heb. 37, Miscellany, Mainz (?) c. 1425, fol. 114r, Synagogue Service, with permission of the Staats- und Universitätsbibliothek Hamburg

Figure 14. Scalding of Dishes before Passover in Jerusalem, Mea Shearim ultra-orthodox neighbor- hood, photo by the author

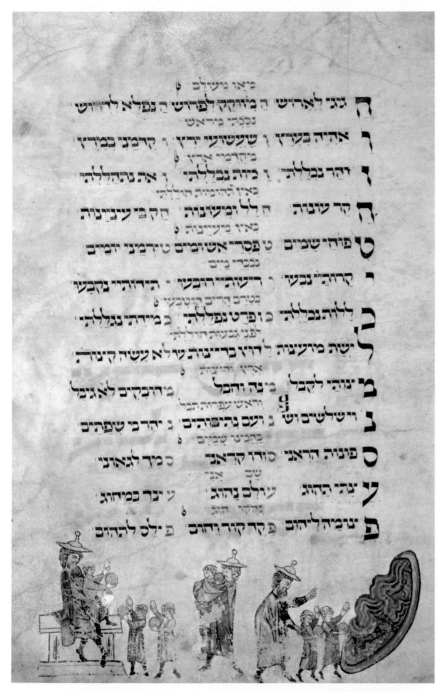

Figure 15. Leipzig, Universitätsbibliothek, MS Voller 1102/I, Mahzor, Worms c. 1310, fols. 130v–131r, Shavuot, with permission of the Universitätsbibliothek Leipzig

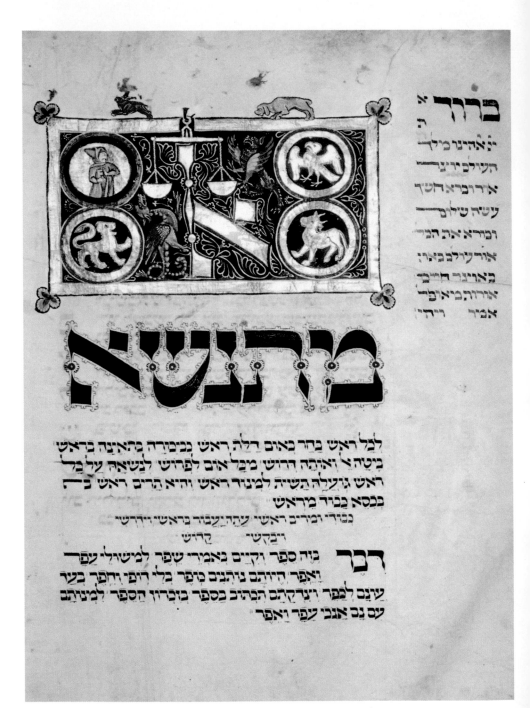

Figure 16. Leipzig, Universitätsbibliothek, MS Voller 1102/I, Mahzor, Worms c. 1310, fol. 31v, *Sheqalim* pericope, with permission of the Universitätsbibliothek Leipzig

Ezechiel

wa==d ob der vestenkut die da was
vff dem haubte sy stunde vnd
vnder liessen dee vettich Vnd ob
der vestenkut die da was angehe=
ngt die houbt als die gestalt des
staines des saphires Sie glaichsam
vnns des trons vnd ob der glaichsa
vnns des trons im glaichsam wo die
als die angesicht aines menschen Vnd
ich sach als ain bild des glutstaine

als die angesicht des fures hure
dis von sine lancken vnd daruber
vnd von sine lancke vntz vnze als
anbild des staunende fures In der
vmbhalbung als ain angesicht des
boge so er reret In de wolcken an de
tage des regens Dis was die ange
sicht des staines durch all Vie eze
kiel der gyphet vier tier sach ge
lich air menscke vnd ain ochse
vnd air lewe vnd ay adler mit
vettike vnd mit hende vnd husse

Dis ist die gestalt der glich=
saumig der minneclich gots
Vnd ich sach sy vnd viel nyder

vff myn antlitz vnd ich hort ay
stym des redenden Vnd er sprach zu
mir Nun des menscke stee vff dm

Figure 17. Heidelberg, Universitätsbibliothek, cpg. 18, Bibel, Germany, 15th century, fol. 256r,
Vision of Ezekiel, with permission of the Universitätsbibliothek Heidelberg

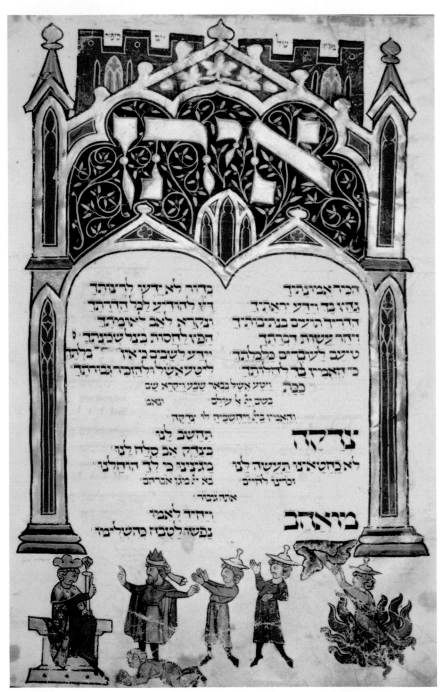

Figure 18. Leipzig, Universitätsbibliothek, MS Voller 1102/II, Mahzor, Worms c. 1310, fol. 164v, Yom Kippur, with permission of the Universitätsbibliothek Leipzig

Figure 19. Röttingen, formerly in the Parish church (removed after 1985), Anonymous, 14th–15th century, host-desecration libel, photo by Dr. Joachim Hahn (with permission)

Figure 20. Senlis Cathedral, west façade, tympanum, c. 1170, Christ and Mary in Heaven, with permission of Bildarchiv Foto Marburg

Figure 21. Berlin, Staatliche Museen, Preussischer Kulturbesitz, Kupferstichkabinett (Schreiber 1837a), Christus und die minnende Seele, with permission of the Bildagentur für Kunst, Kultur und Geshichte, Berlin/Kupferstichkabinett/Jörg P. Anders

Musar:
Pietist Ethics

ONE FEATURE WAS PARAMOUNT in distinguishing the Ashkenazi Pi-etists from other groups: their attitude toward issues of ethics and mor-als *(musar)*. Two images in the Leipzig Mahzor address the Pietists' ethical stances, which were central to their worldview. The *Sefer Hasidim*, the one work that more than any other text is associated with the Pietists, is for the most part a book of ethics. Its two initial sections about the fear of God and penitence are believed to have been written by Samuel the Pious and offer what is essentially an outline of Pietist ethics.[1] Similarly, the in-troductory chapters of *Sefer Haroqeah* are also primarily concerned with pious conduct and penitence.[2] The core of the Pietist ethical concept is not only observation of the religious law per se, but the effort that it takes, which becomes in effect an individual measurement of piety. The law should not be observed for fear of divine punishment, but for the sake of a pious life. The love of God is another central issue, up to the point that the pious individual is expected to be willing to die for it, an idea that lies at the base of Qalonymide attitudes toward martyrdom. Martyrdom was not only a Pietist ideal but widely embraced by Ashkenazi Jewry. The love of God, finally, is a central theme in Eleazar of Worms's teachings, where it is set against a mystical background. Ethical conduct and the fulfillment of the religious law are, naturally, the precondition for any mystical experience. The Pietist ethical concept does not revolve simply around the fulfillment of the law, but elaborates on issues of overcoming the weaknesses of

human nature, the danger of transgressing the law, and the temptations to do so.

Penitence

Typical for its genre, the *yotser* for the first special Sabbath *el mitnasse* (God, the mighty one) refers repeatedly to the Pentateuch portion (*parashat sheqalim:* Ex 30:11–16) that is read in addition to the regular Sabbath pericope during the morning service.[3] The *sheqalim* reading describes the Israelites giving half a *sheqel* each for the Tabernacle, every man paying a ransom "to avert plague breaking out among them," and promises expiation and atonement. The liturgical poem suggests a close connection between the ransom and atonement for sins. Its first part, however, ends with an allusion to the divine Throne of Glory as it is described in the first chapter of the book of Ezekiel (Ez 1:26–28).

In the Leipzig Mahzor the opening word *el*—"God"—is decorated with a large panel containing the four living creatures, each in a medallion (Ez 1:4–25): a man, a bull, a lion, and an eagle; there is a balance scale in the center of the composition, flanked asymmetrically by two dragons (fig. 16). In the upper margin we can discern a small hunting motif—a hare and a dog. The imagery of this initial panel, which has no close parallel and does not follow any established iconographical tradition, addresses the central aspects alluded to in both the pericope and the *piyyut*. On a literal level the balance refers to the *sheqel* contributions of the Israelites, and although any interpretation of this biblical event would assume that the money collected for the Tabernacle was weighed, scales are also a common symbol for the atonement of sin. The scales, which are balanced and level, are attached to the upper frame by a hook, and the vertical pole lies along the *lamed* of the *alef-lamed* ligature standing for *el,* so that in some sense it is God who holds the balance.[4] Research has paid scant attention to this image and the peculiar arrangement of its pictorial elements, which, at first sight, seem to be entirely indebted to Christian art.[5] The four living creatures and the scales all play an important role in Christian eschatological iconography (fig. 17), so the Leipzig image has been understood as a weighing of souls, modeled after Christian representations of the Last Judgment.[6]

There can be no doubt that some degree of awareness of Christian pictorial renderings of the end of time lies behind the initial decoration of *el mitnasse.* However, our image departs from most Christian versions in quite significant details. In Christian art the two motifs usually represent

two different thematic settings, but here they are combined in one image. In architectural sculpture of the Romanesque and Gothic periods, the four creatures are associated with the final arrival of Christ at the end of time, whereas the scales dominate the imagery of the Last Judgment. In the Christian context the scales are never evenly balanced, but tend markedly to the side of the blessed. Unlike the creatures in the Leipzig Mahzor, the animals in the Christian renderings are winged and the man appears as an angel. A similar composition of the four creatures of the Ezekiel vision is found in a later German Bible from 1477, showing the prophet prostrating himself before the Throne, shown as four medallions with God—rendered anthropomorphically—in the center (fig. 17). In the Leipzig panel, which might have been modeled from such a Christian rendering from an earlier date, the anthropomorphic figure of God is replaced by the golden initial holding the scales.

If the Leipzig panel was indeed fashioned after Christian models, it merged two well-known aspects of the messianic scenario: the coming of the Messiah, marked by the four creatures, as described in John, and the Last Judgment, represented by the scales. Nevertheless, the iconographic peculiarities of the Leipzig panel demonstrate that although the designer(s) of this iconography certainly knew how Christian art dealt with the Messianic Era, he produced his own version, to be understood against the background of Ashkenazi culture, particularly the Pietist penitential concept. The image represents the messianic equilibrium of sin and virtue.

Let us begin with the small hunting motif over the upper frame: a reddish hare is running from right to left, and to its right a heavy, tired-looking hound is standing, rather than running, sniffing desperately at the ground as if he had lost the scent. This is a variation of the traditional hunting motif used as an allegory of anti-Jewish persecution: a doe, based on the interpretation of a phrase from Song of Songs (2:7), stands for Israel; she is pursued by a Gentile hunter and his dogs, who represent the non-Jewish persecutor.[7] In some examples it is a hare that is attempting to escape.[8] This was a particularly widespread allegory, often referring topically to specific current situations. In a Catalan example from c. 1330, the black and white dogs allude to the Dominicans, who saw themselves as *domini canes,* the "dogs of God," hunting the heretics and the Jews.[9] Another Catalan haggadah shows an inversion of the traditional hunting scene, an image of what will occur in the Messianic Era: an enthroned hare is being served by a dog, the latter representing Christianity and the former the people of Israel.[10]

In the Leipzig Mahzor we are still not there. But the situation has changed: the hare is free; the hunting hound has lost his good nose and he

is exhausted, but he is not yet in the servile position that was to mark the final stage of the messianic scenario. This variation of the hunting motif thus shows an earlier stage, a stage in which the preconditions for the arrival of the Messiah are about to be fulfilled. Messianic expectations had become particularly acute around the year 1240, the turn of the sixth millennium by the Jewish calendar. The year 5000 was expected by some to open the last phase before the Messianic Period. Detailed descriptions of the Messianic Era, the arrival of the Messiah, and the preconditions necessary for his coming increased significantly around that time.[11] The first precondition was the restoration of Jewish political power in the Land of Israel, and the second was a massive campaign for repentance. The following discussion demonstrates that the Leipzig image is meant to depict the divine power measuring sin against virtue and receiving the repentant.

A particularly complex system of penance had been developed during the late twelfth century by the Ashkenazi Pietists, principally by Judah the Pious.[12] This system was not necessarily understood as a way of bringing closer the day of the Messiah's coming, but rather centered on an individual goal of balance between sins and virtues. During the early thirteenth century, Judah's views, which were distinguished by a decidedly sectarian attitude, were somewhat modified by Eleazar of Worms, who made the concept more acceptable to broader circles.[13] Judah adopted the late antique notion of four types of penance: (1) penance for a sin that the sinner commits involuntarily; (2) penance by means of avoiding the object of sin; (3) penance by means of suffering that equals the sin; and (4) penance by means of the punishment mentioned in the Bible for a particular sin.[14] The concept as such was thus not new in the twelfth century, but Judah elaborated on it and explained that the aim of this penitential system was a balance of the divine scales of reward and punishment for acts of virtue and for the commission of sins. It is the idea of eschatological balance and the manner in which virtues can balance sins that marks the specific Pietist contribution to the original talmudic concept.

Judah the Pious's attitude tending to be sectarian, some of his ideas were not relevant for wider segments of the medieval Jewish population: for example, the idea of a ritual of confession to a Sage was never institutionalized. A generation later Eleazar of Worms reinterpreted the system, renouncing the idea of confession. It was this and other modifications that made the Pietist penitential system applicable to broader circles. Diverging from Judah's system, in which the Sage played a central role, Eleazar developed what Ivan G. Marcus calls a private penitential system, one that functioned between the sinner and God.[15] Although the penitential acts described by Eleazar were more severe in terms of physical or mental

effort than those suggested by Judah, Eleazar's approach enjoyed a much longer period of acceptance and had an enormous impact on future rabbinic literature.[16] Reflections of his ideas are apparent in the writings of Isaac of Vienna, Meir of Rothenburg, Jacob Weil, Israel Bruna, and others, even beyond Ashkenaz.[17]

Eleazar wrote at length about penance. The first eighteen paragraphs of his *Sefer Haroqeah* are dedicated to the subject, the entire section being titled "Laws of Penance." He opens this first part of his book with a general statement about penance having preceded the world and explains that penance was among the seven things that were created before the world. In the paragraphs that follow he expands on the particulars of the Pietist penitential system, explains the four types of penitence one by one, and describes in great detail specific sins and transgressions and the acts of penance they require. Continuing his discussion on the importance of penance, he describes it as an act that not only is performed on earth by means of the various prescribed penitential actions but leads to the final atonement. This latter aspect of penance is performed before the Throne of Glory and brings mankind closer to salvation.[18]

The point is further elaborated in Eleazar's *Commentary to the Siddur:* "We seek our paths, we investigate our deeds, and we search the paths that we walked; we search them and we shall return to You, we shall repent, so that we shall not sin again; forgive us our sins. Your right hand is stretched out to receive the penitent: 'and the hands of a man were underneath their wings (Ez 1:8);'—'the hands': this is the hand of the Holy one blessed be he stretched out to receive the repentant." Alluding to his discussion in the *Sefer Haroqeah,* Eleazar repeats "and penance preceded everything."[19] Late antique interpretations of the Ezekiel vision (Ez 1:8) comment on the verse "the hand of a man underneath their wings . . ." as the hand of God, who received the repenting in other contexts.[20] It was Eleazar who combined this interpretation with the Pietist concept of penance. This association is the key to the particular iconographic arrangement in the initial panel of the *piyyut:* the balance is held by God, who is represented by the two letters *el.* The four living creatures indicate that this all takes place at the Throne of Glory.

Two of Eleazar's students discuss issues of penance at great length and in much detail. The anonymous author of the *Sefer Ha'asufot* addresses the practical aspects, whereas Abraham ben Azriel focuses on the heavenly judgment. The former opens his section on penance with the same remark about penance being in existence prior to the creation of the world, a motif that also served Eleazar as an opening for his own discussion. The author of the *Sefer Ha'asufot* continues and sketches in general terms the

types of sins and the kind of action required for atonement. He then mentions that a special prayer related to penance is included in the daily morning and evening service: *wehu rahum* (He is merciful). The rest of the text offers a full and detailed explanation of the four types of penance followed by a detailed list of sins and the appropriate penitential acts required for atonement.[21]

Abraham ben Azriel, on the other hand, adopted the motif of God's hand receiving the repentant. Several of his commentaries in *Sefer Arugat Habosem* refer to it time and again. Commenting on one of the verses in the *piyyut–esh'har el* (I shall follow God), he mentions the penance that reaches the Throne of Glory.[22] His commentary to the poem *kevodo ot beribo'ot* (His glory is very great), an *ofan* for the second day of Shavuot according to the Worms rite and included in the Leipzig Mahzor, relies on Eleazar's statement cited above: "When people repent, the *shekhinah* is in a curtain near them. According to the poet the creatures are also there, as it is said in the tractate *Pesahim,* 'and the hands of a man were underneath their wings (Ez 1:8)'; this means that the hand of the Holy one blessed be he appears under the creatures' wings to receive the repentant."[23] Elsewhere, in a commentary on the poem *elohim lo eda zulatkha* (I shall know no God beside you), he elaborates on the balance between sins and virtues and how the two will be counted: "When the sins of a person will be weighed against his virtues, the first and the second sin will not be considered, but only the third sin and beyond will be counted," followed by further particulars.[24]

This understanding became more widespread later on. The early fourteenth-century collection *Sefer Kol Bo,* compiled by Aaron Hakohen of Lunel, combines the two motifs even more prominently. It has been noted that Aaron Hakohen made extensive use of Ashkenazi material.[25] In matters of penance he relies largely on Eleazar and, in fact, reflects some aspects of the development from the strict sectarian trend of Judah to the more generally applicable concepts of Eleazar. *Sefer Kol Bo* describes the penitential process as follows: "Rabbi Simon, the son of Lakish said on behalf of Rabbi Simon, the son of Rabbi Yosse and the Rabbanan: it is written (Ez 1:8) 'and hands of a man were underneath their wings'; the interpretation is: underneath the wings of the four animals, in order to receive those who repent according to the law. His right hand is stretched out to receive those who repent and to prevent them from touching the Throne of Glory, as it is written (Hos 14:2): 'return Israel to God, your Lord.' Those who repent reach a place where the ministering angels are not allowed to come."[26]

A few lines further on, the text focuses on God's call for repentance: "Return Israel to God: . . . I gave you my law to fulfill the precepts and to

adhere to it all your days in order to remember all the good I have done to you; I warned you not to sin before me and not to follow a foreign god in your uncircumcised, unclean heart. . . . Return to me . . . because I created penance for you . . . because I loved you, son, return to the Lord with all your heart . . . and this is what 'his hand is stretched out to receive those who repent,' means, because the Holy one blessed be he embraces all those who repent and receives them as it is written (Song of Songs 2:6), 'his right arm embraces me.' "[27] After this the four types of penance are described in detail, followed by a lengthy list of different kinds of sins and, finally, a long list of virtues or, rather, qualities that lead to virtue. Whereas the other parts of this text rely on Eleazar's writings, this section concludes with a detailed description of the penitential process based on the prescriptions in the *Sefer Hasidim*.[28]

The Leipzig panel thus shows God on the Throne of Glory. God, who is invisible and shown only in the shape of the *alef-lamed* ligature *el*, will, when the time comes, measure the weight of the sins and the virtues and accept the repentant. The scales as a symbol of justice and judgment were borrowed from Christian art; however, here they refer not to judgment in the Christian sense, but rather to the Jewish view that penitence will bring about a balance between sins and virtues. The appearance of the scales was thus modified to deliver the Jewish message: they are held up by an abstract reference to God, and the image reflects the balance between sin and virtue as a precondition for the Messianic Age addressed in Ashkenazi scholarship.

What at first sight appears to be a mere reproduction and juxtaposition of common Christian messianic motifs emerges as a rather sophisticated image of the penitential system that had been developed earlier by the Ashkenazi Pietists. God receives the repentant at the Throne of Glory, whose design is indebted to various relevant Pietist traditions that I discuss later on. The Pietist campaign of penance addresses each individual worshipper and prepares the world for one of the preconditions for the arrival of the Messiah: a balance between sin and virtue. This balance, measured by God seated on the Throne of Glory, is reached in the image, and at the same time the hound, the non-Jewish persecutor, has lost his power and capacities. Israel is free of him and able to establish its own power, another precondition for the coming of the Messiah.

Martyrdom

Leafing through the second volume of the Leipzig Mahzor, the reader encounters an elaborate decoration for a *qerovah* recited during the evening

prayer on Yom Kippur. This type of poem is not illustrated anywhere else in the entire book. The poem *etan hikir emunatkha* (The steadfast believer discerned Your truth) opens with a particularly lavish initial *"etan"*— "steadfast."[29] The panel is elaborated to form an arch that circumscribes the entire page (fig. 18). The bottom margin has a narrative scene: Nimrod, king of Chaldea, receives Terah, an elderly man, a devout, pious, and obedient Chaldean citizen and a maker of idols, who is about to hand over his son Abraham to the authorities on a charge of blasphemy. Abraham, who destroyed the idols in Terah's shop after he discovered monotheism, is condemned to death by fire and about to be burned to the far right of the image, but is saved by the hand of God.

The story of Abraham and Nimrod, of which there is no hint anywhere in the book of Genesis, is among the most widespread extrabiblical accounts in midrashic literature.[30] Moreover, it is probably referred to as early as in Isaiah 29:22: "Therefore these are the words of the Lord, the deliverer of Abraham, about the house of Jacob." The story as such, as well as related pictorial renderings, was also found in the Islamic and Christian traditions, although it was rare in both, neither very well known nor frequently depicted.[31] The Leipzig rendering of the Abraham-Nimrod narrative is most likely the earliest extant depiction of the story in Jewish art, but different pictorials of the legend appear somewhat later in several of the Sephardi haggadot.[32] The subject recurs several times in fifteenth-century Ashkenazi manuscripts and is found in two sixteenth-century Byzantine haggadot.[33] Unlike most of the other images in the Leipzig Mahzor, this scene is often represented in Jewish manuscript painting and seems to be part of a well-established pictorial tradition, but the fact that the Leipzig version may be the earliest one should not be overlooked.

Moreover, a closer look reveals that the Leipzig depiction features several peculiarities in appearance, imagery, and page layout, which turn it into much more than yet another midrashic tale visualized. In the reading that follows, I approach this small depiction of the Abraham story as a powerful message of steadfast faith and martyrdom at a time when these issues had been meeting difficult challenges for more than 200 years. During a period in which martyrdom was among the very serious concerns in a society that faced severe religious persecution, the image and its exegetical background would have been looked at with these issues in mind. Facing forced baptism and execution upon refusal to accept the Christian faith, Ashkenazi society made Abraham its primary model for steadfast faith.

Let me first point out, however, the specific features of the Leipzig version of the Abraham story in relation to the adjacent text and the midrashic

background. I have already noted that, according to the program usually employed in the decoration of mahzorim, the *qerovah* of the Yom Kippur evening service was not supposed to be adorned at all. We have observed that initial panels, are, with few exceptions, reserved for the *yotsrot*. Although the designer(s) of the Leipzig Mahzor did not adhere rigorously to the norms and added numerous marginal decorations in unusual places, they did normally follow the tradition of decorating initial words only for the *yotsrot*. From this perspective, the composition for "The steadfast believer" is an outstanding exception.

Yet more striking is another observation. Whereas in almost all the other illustrations in the Leipzig Mahzor a particularly strong relationship between text and image can be discerned at first sight, the Abraham-Nimrod pictorial does not elicit an obvious thematic link to the adjacent text. The *piyyut* was composed by Elia ben Mordechai, an Italian poet from the eleventh or twelfth century. The first section of the poem describes a righteous person, firm and steadfast in faith, who fears the Lord. It begins with the word *etan* (steadfast). But *etan* is also a name: Ethan the Ezrahite is a poet mentioned briefly in Psalm 89, whom the Babylonian Talmud associates with Abraham: "Rav said: Ethan the Ezrahite—this is Abraham, as it is written (Is 41:2): 'who has raised up from the East, etc.' "[34] The second line of the *piyyut* mentions "the generation that did not know how to please you," alluding somewhat vaguely to Abraham as the discoverer of monotheism and the idolatrous culture he grew up in. The sixth line of the poem offers an explicit biblical reference with a quotation from Genesis about Abraham planting the tamarisk in Beer Sheva (Gn 21:33). This quotation is followed by a verse from Psalms (86:5) about divine forgiveness and another reference to Abraham's faith taken from the story about God's covenant with the Patriarch (Gn 15:6). There can thus be no doubt that the poet followed the talmudic tradition and associated *etan*, the firm believer, with the figure of Abraham.

In its second section the *piyyut* shifts to Isaac and refers at length to the binding on Mount Moriah (Gn 22), focusing on the aspect of salvation: "Beloved and only [son] to his mother he agreed to be slaughtered; *seraphim* called from above; they call to the merciful Lord: spare him; he redeems him and saves him in his mercy and ordains that a sheep (be slaughtered) instead; he attended (the call): do not shed his blood; with mercy he took to the heavens; he saved his name, he improved his appearance as the splendor of his day; he will be seen on that day as a burnt offering in its chamber, remember his binding and give mercy to his people." As is common for the particular genre to which this *piyyut* belongs, the first six lines of each section are followed by biblical verses. This particular section

quotes a selection of verses that all deal with divine mercy and the hope for salvation, and alludes not only to the Binding of Isaac, but to a midrashic tradition about Abraham actually harming Isaac, who ascended to Paradise, was saved, and returned.[35] We shall return to this tradition later on.

The *piyyut* lists several religious virtues that all relate in one way or another to Abraham and the strength of his faith. In terms of supporting narratives, it refers to the planting of the tamarisk and God's covenant with Abraham and relates more explicitly and in great detail to the Binding of Isaac, the most extreme demonstration of steadfast faith and obedience. It does not allude to the story of the fiery furnace, but that narrative is treated in another *piyyut,* which is also included in the Leipzig Mahzor and is part of the general Western Ashkenazi rite: *asher mi ya'asseh kema'asekha* (Who is able to accomplish deeds as Your deeds) composed by the early eleventh-century poet Simon ben Isaac of Mainz.[36] This latter *piyyut,* part of the *qerovah* for the second day of Rosh Hashanah, praises God and the covenant with his people. The covenant, the poem stresses after several verses of praise, goes back to the first Patriarch, who was tested ten times. This is a famous midrash about Abraham, first rendered in *Pirqe de Rabbi Eliezer,* listing ten trials Abraham underwent throughout his life, the first being the test in Chaldea.[37] In terms of a plain, literal relationship between text and image, this poem would thus have been a more suitable place (on fol. 64r) to add a marginal image of the midrash, but the *qerovah,* which in the Leipzig Mahzor begins on fol. 56r, remains undecorated throughout.

The *piyyut* about the steadfast believer is also referred to visually in two other illuminated mahzorim. The illustration in the mid-thirteenth-century Laud Mahzor in Oxford focuses on the tamarisk and shows a group of four men seated beneath a large tree—the tamarisk—eating.[38] The Michael Mahzor displays an initial panel that alludes to the Binding of Isaac by means of a ram as a symbolic reference to the second section of the poem.[39] In both cases the decoration works in a way similar to that of the text, functioning by means of allusion rather than as a full narrative. The method of illustrating the Yom Kippur poem on steadfast faith in the Leipzig Mahzor is thus different from that in the Laud and Michael mahzorim, which both display illustrative echoes to the allusions in the text. The Leipzig image ignores the tamarisk and the Binding of Isaac stories altogether and, using a different method of illustration, offers a different line of thought. The inclusion of a different pictorial narrative shifts the understanding of the reader-viewer from the somewhat evasive allusions in an overall complex text to something much more substantial: to a well-known story, to a role model, to a myth that relates to the notion of steadfast faith in a specific way.

The story of Abraham in Nimrod's furnace is one of the most frequently noted narratives in medieval Hebrew literature. It appears in numerous late antique midrashim, in versions of the "rewritten Bible," a genre that developed in the early Middle Ages, and in later medieval biblical exegesis. Originally the story developed as an interpretation of Genesis 15:7: "I am the Lord who led you out of *Ur* of the Chaldeans, to give this land to you to inherit it." *Ur*, understood in Aramaic as "fire," was interpreted in late antique midrashim as "a furnace." Instead of God leading Abraham from the town of Ur, the verse was thus understood as God saving him from the fire.[40] This interpretation was merged with that of Genesis 11:27, noting that Abraham's brother Haran died in Ur in Chaldea while his father, Terah, was still alive. The legend as told in *Bereshit (Genesis) Rabbah,* for example, elaborates on this information and explains that Terah was a maker of idols and put Abraham in charge of his shop during his absence. After having reached the understanding that the idols are powerless, Abraham smashed them with a stick. Upon his return Terah handed Abraham over to Nimrod, who, after a short religious discussion, decided to sentence the young man to death in the furnace. Haran, watching these events, was uncertain if he should follow Abraham or Nimrod and decided that if Abraham would be saved, he would declare his faith in God. When he finally followed Abraham, he was punished for his doubts and killed by the fire.[41] Later versions elaborate on various aspects of the story, such as the circumstances in which Abraham discovered monotheism, or the dispute with Nimrod.

The Abraham midrash remained well known and widespread throughout the Middle Ages. It is included in medieval collections, Bible commentaries, and the late medieval anthologies, including the *Yalqut Shimoni* and the *Sefer Zikhronot,* both of which were compiled in Ashkenaz in the early fourteenth century.[42] It appears, however, that the image in the Leipzig Mahzor is in no apparent way specifically linked to any of these versions but instead is linked to a variant that emerged at an unknown date, perhaps in Persia, and most probably under Islamic influence.[43] Three related versions of this narrative have come down to us: *Midrash Avraham Avinu* (Midrash of our father Abraham), *Ma'ase Avraham* (The story of Abraham), and *Ma'ase Avraham Avinu* (The story of our father Abraham).[44]

The three share several motifs, but each of the versions also differs significantly from the other two. The Leipzig image appears to be indebted to at least two of them. *Ma'ase Avraham Avinu* opens with a remark that Nimrod subjects considered him a god and prostrated themselves before him. After Abraham's birth and his discovery of the one and only God are

reported, Terah is mentioned as approaching the king, bowing to him, and reporting his son's birth. A few lines later we read that Satan has prostrated himself before Nimrod. The text explicitly describes the king as seated on a throne when Terah approaches him again, alerting him to his son's apostasy. After his idols were demolished, Nimrod imprisoned the young man and commanded that he be starved to death, but Abraham, miraculously nourished by an angel, survived. The jailer went to the king, prostrating himself, to tell him about Abraham's miraculous salvation, at which point Nimrod sentenced Abraham to death by fire. The influence of the *Ma'ase Avraham Avinu* version is apparent in the stress on the Chaldeans worshipping Nimrod and prostrating themselves before him, as the prostrate figure in the Leipzig Mahzor image clearly reflects this motif. Nimrod is described as particularly cruel, and when his advisors saw in the stars that a boy would be born who would stand up against him, he went so far as to kill 70,000 male infants.

Although the depiction of Nimrod and the prostrate figure seems to be indebted to the *Ma'ase Avraham Avinu,* in the particulars of the description of the furnace and the way Abraham was catapulted into the flames, our image diverges from the text.[45] According to the *Midrash Avraham Avinu* and as depicted in the Leipzig image, the attempt to burn Abraham takes place at a stake. As is elaborated below, the fact that a stake is pictured rather than a furnace is very significant for coming to terms with the full context of the story and its depiction. Finally, it is this version that refers to Haran, who appears in the imagery as well.

Whatever the precise relationship among these texts, it appears, finally, that the version of *Midrash Avraham Avinu* was known to Judah the Pious, who worked it into the *Sefer Gematriot* in the early thirteenth century.[46] Judah's text quotes the midrash literally, indicating that at least this particular stratum of the tradition goes back to the high Middle Ages. The image in the Leipzig Mahzor was, as we have seen, fostered from both the *Midrash Avraham Avinu* and the *Ma'ase Avraham Avinu,* which indicates that its designer(s) had knowledge of the text preserved in Judah's book, as well as of another variant found in the *Ma'ase.*

Let us recapitulate these oddities before we take a closer look at the historical circumstances: following the usual decoration method of the Leipzig Mahzor, this particular poem, a *qerovah,* was not supposed to be decorated at all. The image not only departs from a basic principle of the decoration program, namely that of creating a close linkage to the text, but also ignores the biblical allusions found in the *piyyut.* Instead of choosing a biblical myth as a paradigm for steadfast faith, it uses a midrashic motif. All of these features indicate that the designer(s) of the im-

agery took issue with the subject matter of the *piyyut*, and that theirs was a particular message associated with it.

Being steadfast in faith had become an issue of particular significance among Jews in the German lands from the time that the wave of persecutions hit the communities of the Rhineland during the First Crusade in the early summer of 1096.[47] Three Hebrew Chronicles describe in great detail what had happen in that year in the flourishing communities of Speyer, Worms, and Mainz, as well as elsewhere.[48] At least two of them, however, were written more than a generation after the actual events. Among the most difficult episodes reported in these texts are the accounts of Jews who chose to kill themselves and to slaughter their wives, children, and other relatives before the arrival of the enemy, when presumably they would have had the choice between conversion and execution. In some cases the suicides were perceived as acts of penance after forced conversion. David Malkiel suggests that often there might have been no real option of baptism; rather he believes that the Crusaders simply intended to kill the Jews. His reexamination of the Chronicles suggests that baptism was often "offered" only to a few survivors after most of the Jews had already been murdered.[49] Further light was shed on this question by Shmuel Shepkaru, who agrees that the Jews were not always offered the choice of conversion, especially during later persecutions. Moreover, he also shows that the Jewish authorities did not necessarily look at forced conversion as "a dead end," but discussed various ways to deal with it later on and return to Judaism.[50]

Scholars are divided as to what extent these texts should be treated as accurate accounts of historical facts or as literary renderings representing a state of mind several decades later regarding a phenomenon that undoubtedly evoked a whole range of emotional reactions.[51] In any event, these texts not only describe the deeds of active martyrdom, but also played a crucial role in turning them into a religious, ideological, and educational ideal during the first half of the twelfth century.[52] The suicides and killings were also commemorated in a prayer composed toward the late twelfth century in the Rhineland and in numerous liturgical poems read during synagogue services by succeeding generations.[53] The victims of both active and passive martyrdom were listed in memorial books known as the *Memorbücher*. For more than 400 years these (self-)killings were occasionally emulated, but, more importantly, they were regarded as a religious ideal, even if not practiced widely, and left a decisive imprint on the religious feelings of Ashkenazi Jews.

Judaism had developed a tradition of martyrdom in late antiquity, as can be demonstrated by the story of the three youths who willingly went

into the furnace in Babylon for refusing to worship Nebuchadnezar's idol (Dn 3).[54] Before the Bar Kokhba revolt against the Romans (132–135), however, there was a clear tendency *not* to risk one's life for the sake of religious observance. A pious Jew was expected to avoid confrontation with Gentile authorities. It was only after the Bar Kokhba revolt and the famous martyrdom of Rabbi Akiva, who was sentenced to death for transgressing the Roman prohibition against teaching Torah, that dying for the sanctification of the name of God *(qiddush hashem)* became a religious ideal.[55] Akiva's contemporary Rabbi Hanina ben Teradyon, who was burned by the Romans for the same reason, was even criticized by another authority for risking his life by teaching the Torah publicly when doing so was forbidden by the Romans.[56] Simha Goldin argues that during the second century Rabbi Akiva and Rabbi Hanina were viewed as individual cases reflecting personal relationships with God. It was only in the post-talmudic period that they became role models in a more general Jewish context. Goldin argues that this occurred in reaction to Christian martyrdom and owing to a tendency to demonstrate yet stronger faith than the Christian martyrs.[57] In this spirit, Abraham in the furnace turned into yet another role model for martyrdom during the talmudic period. The version of the story in *Bereshit Rabbah,* a late antique commentary to the book of Genesis, notes explicitly, "Abraham sanctified the name of the Holy one blessed be he in the fiery furnace."[58]

Until 1096 the "sanctification of the name of God" was normally understood as passive martyrdom expressed in the willingness to be killed for the Jewish faith. Apart from a few cases reported in earlier sources, active martyrdom as practiced in the Rhineland communities in 1096 was a new phenomenon. Avraham Grossman and more recently Shepkaru discuss earlier incidents, and Grossman even goes as far as to claim that there was an earlier tradition of active martyrdom that began in the Land of Israel and reached southern Italy, which, in turn, would have influenced early Ashkenazi Jews.[59] Shepkaru, on the other hand, also introduces earlier French cases of active martyrdom into the discussion, which he believes were adopted as models. In any event, he convincingly points out that it is not the occurrence of self-killings that was new in Ashkenaz, but instead it was the process of ritualizing these killings that should be considered an Ashkenazi phenomenon. It was the three Hebrew Chronicles that stylized the self-killings and slaughter of others as a particularly heroic and particularly Ashkenazi phenomenon. As Jeremy Cohen puts it, the Hebrew Chronicles aim at communicating a notion of "collective piety of Ashkenazi Jewry."[60]

To be sure, many medieval Jews in their references to the phenomenon do not make that much of a distinction between passive and active martyrdom.

Whether they fell by the hands of the persecutors, killed themselves, or were killed by fellow Jews, the victims were considered martyrs who sanctified the name of God. Neither do all modern scholars make such a distinction, and some of them refer to the phenomenon of martyrdom as such, be it passive or active, as if to foster the notion that for the medieval Jews who were confronted with martyrdom there was no such distinction. Modern scholarship also tends to approach martyrdom as a general Ashkenazi phenomenon without distinguishing among different religious mentalities, scholarly circles, or specific communities.[61]

Many scholars, especially during the last fifteen years, have proffered attempts to understand the circumstances that led entire groups of Jews to active martyrdom and to turn these acts into a social and religious ideal. Some see among the causes the overall religious atmosphere in 1096 and shortly before, in a period of particular disgust with Christianity and the resulting aversion to conversion.[62] On the other hand, one cannot exclude the possibility that, apart from anti-Christian feelings, it was also the atmosphere of Christian religious zeal during the Crusader period and the Crusaders' willingness to die for the sake of faith that had an impact on Jewish martyrdom, both passive and active.[63] Others show how the Hebrew Chronicles legitimized the 1096 events, stylizing them into myth and a religious ideal, according to which generations were educated from childhood, guided, and prepared for when their time would come to face forced baptism.[64]

Marcus approaches the phenomenon from an anthropological point of view and writes of the Ashkenazi tendency to ritualize metaphors, this tendency reflecting "the influence of the surrounding medieval Christian culture, which was saturated with symbols and rites derived from sacred texts." Active martyrdom would thus appear as an act of ritually reenacting the metaphor of Abraham's sacrifice, turning it into sacrificial martyrdom. Marcus believes that active martyrdom emerged in resistance to the Christian root metaphor of the sacrificed Jesus: "The ritualization of the specific metaphor that a Jewish community is collectively a sacrificed Isaac takes on special significance as an acted-out polemical riposte to Christian claims that Jesus' death was an atoning sacrifice."[65]

The ideal of active martyrdom was, indeed, linked to two paradigm motifs from the Bible. As Marcus demonstrates, both can be interpreted as metaphors to be ritualized and acted out as active martyrdom. One of these was the description of Temple offerings; the act of sacrificing oneself, of suicide, or slaughtering, was perceived as a burnt offering. In Marcus's view it emerged as a polemical assertion that Jesus represents and supersedes the Temple.[66] The other paradigm was the Binding of Isaac, the story

about a father who was prepared to sacrifice his own son.[67] All of the three Hebrew Chronicles describe the acts of active martyrdom in Mainz by means of "binding"; time and again they use this term in references to the self-slaughter, comparing it explicitly "to the Binding of Isaac by Abraham" on "Mount Moriah."[68] Midrashic elaborations of the biblical story in Genesis 22 added a significant motif, which became particularly important in this context: Abraham did harm Isaac, who actually died and visited Paradise to return only when Rebecca arrived with Eliezer.[69] This midrash is, as we have seen, also alluded to in the *piyyut*. The story of the Binding of Isaac represented both types of martyrs—those who were able to slaughter their children (and themselves) would identify with Abraham, whereas the passive victims would have looked toward Isaac. Whoever promoted active martyrdom tended to focus on Abraham's role in the story.

Shepkaru demonstrates that these paradigms had begun to take shape even before 1096. Both the Temple sacrifices and the Binding of Isaac appear time and again in poems by Gershom Meor Hagolah and Simon ben Isaac as early as the first years of the eleventh century.[70] More prominently, the Binding of Isaac was the subject of several liturgical poems by Meir ben Isaac, the slightly later famous prayer-leader of Worms. These poems about Isaac—defined as *aqedah* (Bindings), a subgenre of *selihot*— would become a leitmotiv somewhat later when the survivors of the Crusader riots attempted to come to terms with the deaths of the victims, especially those who had died by acts of active martyrdom.[71] Among these *aqedot* we find *el har hamor* (To Mount Moriah), not included in the Worms rite, and *az behar hamor* (On Mount Moriah).[72] The tradition of composing *aqedot*, which began with Meir ben Isaac, was later continued by several other Ashkenazi poets.[73] Ephraim ben Jacob of Bonn, who made a contribution to this genre in the second half of the twelfth century, incorporates into his poem *et avotai ani mazkir* (Let me recall my fathers) a reference to the midrash about Isaac actually having been killed on the altar, making him a sacrifice for the sanctification of God in the fullest sense.[74]

Against this background, the choice of the designer(s) of our image not to depict the Binding of Isaac raises several questions. Does the image allude to martyrdom as such, or to a particular form of it? Before we return to the content of the image and its full significance, however, we should take a brief look at the halakhic positions in order to come to terms with the different rabbinic stances concerning the different forms of martyrdom. According to the halakhic law, only three situations allow one to risk one's life. Every precept may be transgressed when life is endangered, except three: illicit sexual acts, murder, and idolatry.[75] This does not imply

suicide or active killing. Rather, even though the halakhah seems clear regarding these prohibitions being enforced even in cases of serious risk, Rabbi Ishmael in the Mishnah and later Rabba in the Babylonian Talmud claimed that if one is forced to perform idolatry, but can avoid doing so in public (that is, in the presence of ten men), one is advised not to put one's life in danger.[76]

Late antique authorities were extremely careful in these matters, and their decisions were guided by the tendency to preserve life by all possible means. Moreover, the halakhah does not call for punishment of people who converted when forced.[77] It is rather non-halakhic sources that refer to those who give in to forced conversion in extremely negative terms. Hence, it was often by means of the aggadic tradition that some rabbinic authorities of the twelfth century were able to support the phenomenon of active martyrdom. The deeds of 1096 were, as a matter of fact, approved only after the killings had occurred and legitimized ex post facto by halakhic authorities.[78] Even though the suicides and slaughters contradicted the talmudic law, because they were done for the "sanctification of the name of God" they could not be objected to officially.[79]

There are, in fact, surprisingly few halakhic statements on active martyrdom, and most of them are quite ambiguous. An exception is the very clear position apparently taken by one of the most prominent French Tosafists, Jacob of Ramerupt (*Rabbenu Tam,* d. 1171), who states that when faced with forced conversion it is a precept to harm oneself.[80] The attribution of this statement to Rabbenu Tam is not certain, however, and Haym Soloveitchik suggests that it might be a later addition to the text in which it appears.[81] Whether it was Rabbenu Tam's personal position or that of a later Tosafist, it shows how these scholars perceived of the threat of conversion.[82] As noted, halakhists often grounded their argumentation in talmudic tales rather than in firm legal statements anchored in biblical or talmudic law. In this context there was usually a discussion of an account of 400 youths who drowned themselves in the sea for the fear of being sexually abused by the Romans.[83] In other cases the stories of Rabbis Akiva and Hanina were discussed.[84] Suicide was easier to legitimize, whereas the slaughter of others was much more difficult to anchor in tradition.[85]

Legitimization of active martyrdom normally either grew out of the fear of incapability to withstand torture or was rooted in the dread that children might fall into the hands of the persecutors and grow up as Christians.[86] Against the background of reservations of talmudic law against putting one's life at risk, the religious leadership of the twelfth and the thirteenth centuries also turned to sources other than halakhah to make their case in favor of martyrdom, both passive and active. They tended to

express their opinion in diverse literary genres, especially in liturgical poems, rather than in well-grounded halakhic precepts.[87]

The question, however, is not simply how this was legitimized in halakhic terms. It is important to identify and understand the main forces that drove this aspect of religious zeal and allowed it to turn into a religious ideal *beyond* the halakhic issue. As we have seen, it was particularly the texts of the three Hebrew Chronicles that were instrumental in creating the Ashkenazi ideal of self-afflicting actions of martyrdom, turning them into rituals of a sacrificial character. Of the three authors of the Chronicles, only one, Eliezer ben Nathan of Mainz (Raban, 1090–1170), is known from other contexts. We have no further knowledge about the other chroniclers; one is anonymous; the other was Solomon ben Samson, an otherwise unknown writer. In their positions about martyrdom, however, the three Chronicles are quite similar and the two unknown authors reflect an attitude similar to that of Eliezer of Mainz.

Eliezer, who was born in 1090 in Mainz, only six years before the riots, was one of Ashkenaz's most outstanding spiritual leaders and an important figure in the transmission of Tosafist teachings to the Rhenish rabbinic schools.[88] Apart from authoring one of the Chronicles praising the acts of active martyrdom ("there [in Speyer] there was a pious woman who killed herself for the sanctification of the name,"[89] and so on), he also composed several *piyyutim* referring to the deaths as acts of *qiddush hashem,* linking them to the Binding of Isaac and commemorating the victims.[90] Scholars have been concerned primarily with the anti-Christian sentiments in these *piyyutim* and the strong polemical tone rather than with the role their author must have played in shaping the Ashkenazi ideal of active martyrdom. Putting all this evidence together indicates that Eliezar ben Nathan must have been instrumental in promoting the notion of active martyrdom several decades after it first occurred.

Eliezer's son-in-law, Joel Halevi, was the teacher of Ephraim ben Jacob of Bonn, who as noted above was the author of one of the *aqedot* that promoted active martyrdom. Ephraim also composed the *Sefer Zekhirah,* an account of the persecutions during the Second Crusade (1146),[91] written in much the same fashion and with similar intentions and aims as the Chronicles concerned with the events of 1096. His contemporary, Ephraim ben Isaac of Regensburg (1110–1175), similarly associated with Ashkenazi Tosafism, also wrote a series of liturgical poems that highlight active martyrdom.[92]

Eliezer ben Nathan's grandson, Eliezer ben Joel Halevi (Ra'avia, c. 1140–c. 1220), who was also an outstanding Ashkenazi Tosafist, was among those who attempted to legitimize active martyrdom, in particular the killing of

fellow Jews, through the halakhah. We have observed that most authorities based their discussions of this issue on the aggadah, which was problematic vis-à-vis halakhic decision making. Eliezer called the martyrs holy and legitimized their suicides if it would not be certain that they were able to withstand torture.[93] It is possible that he followed the path taken by Rabbenu Tam or a later anonymous French Tosafist, who, as we have seen, similarly tried to legitimize active martyrdom and recommended that one "harm oneself" in case unbearable torture might lead to baptism. Eliezer ben Joel is also the author of an *aqedah* celebrating Abraham and Isaac's joy as they faced the sacrifice.[94]

If the poem "The steadfast believer" had been accompanied by an image of the Binding of Isaac, the message would have been quite clear: Abraham as a role model willing to slaughter his son for the sake of faith and obedience. An image of the Binding of Isaac could have functioned as a means of encouragement, of guidance toward an act of active martyrdom, of suicide or child slaughter. Such an image would have corresponded well with the ideal of active martyrdom as it was stylized in the Chronicles. Moreover, as I have argued above, it would also have been an appropriate illustration of the poem, which alludes to this particular aspect of the Abraham story. The Binding of Isaac is a biblical story that underscores the depth of Abraham's faith, which went so far as to have him take a hand to his own son. But this is *not* the story depicted on our page. Rather, an extrabiblical story not referred to explicitly in the poem was chosen to serve as pictorial commentary. Does our image, then, conform at all to the mainstream attitudes toward active martyrdom, which was apparently promoted so stridently among Ashkenazi Jews?

Against this background, our image, in fact, appears to be the bearer of an ambivalent message regarding the Tosafist ideal of self-sacrifice. Turning away from the unambiguous imagery of the Binding of Isaac, heavily burdened with the sacrificial theology of active martyrdom, the author(s) of this imagery seem to have had some reservations regarding the emotionally difficult practice of active martyrdom. Thus they chose to comment pictorially on the *piyyut* using an image that reflects passive martyrdom, rather than infanticide and/or suicide. Abraham in Chaldea was willing to accept death for the sake of his faith. He faced Nimrod's decrees with steadfast faith, and as a firm believer he went into the furnace, but he did not lay a hand on himself.

Passive martyrdom also had its paradigm myths.[95] Among them we find the story of Daniel's three friends sentenced to the furnace by Nebuchadnezar, a narrative that, as a biblical motif, was more authoritative than the Abraham-Nimrod story, because unlike the latter it has a biblical motif.[96]

There were, however, also post-biblical, historical role models, such as the Maccabeans and Rabbis Akiva and Hanina. A list of ten rabbinic martyrs is read during the Yom Kippur liturgy. These were the most prominent figures, as they actually met their deaths, whereas Daniel's friends, although willing to die, were saved, and so could not be considered martyrs in the full sense. The same criterion applies to the story of Abraham in the furnace.

In the talmudic period, thus, these two motifs were considered prototypes, not necessarily of martyrdom, but rather of salvation and trust in God.[97] What is more important in these early traditions than the mere demonstration of steadfast faith is Abraham's trust in God and his belief that salvation is certain. Surviving the furnace served as proof of God's existence, and the aspect of martyrdom here is only a by-product of the overall concept of salvation. On the other hand, we have seen that as early as the late third or early fourth century, Abraham was considered to have "sanctified the name of the Holy one blessed be he in the fiery furnace."[98] This aspect became more dominant in the medieval understanding of these narratives, where Daniel's friends and Abraham in Chaldea began to serve as role models for passive martyrdom. In many sources that present Abraham as a hero of the sanctification of the name of God—even though not in all of them—there is emphasis on the fact that he was thrown into the fire, that is, that he did not go into the furnace on his own.[99]

A paragraph in *Midrash Tanhuma* discusses a whole group of different paradigms for passive martyrdom and puts them into one context with the Abraham story:

Rabbi Berekhiah began: "We have a little sister and she has no breasts (Song of Songs 8:8)." What does the scripture refer to? To Abraham whom Nimrod had cast into the furnace. "Little"—the Holy one blessed be he had not yet performed any miracles for him. . . . "and she has no breasts" refers to the fact that he had no sons yet. "What shall we do for our sister on the day when she shall be spoken for? (ibid.)." On the day when Nimrod spoke [and commanded] that Abraham be cast into the fiery furnace; "if she is a wall, we will build upon her a turret of silver (ibid. 8:9)"—if he will offer his life like this wall that withstands many wars, when he will offer himself for the sanctification of the name; "we will build upon her a turret of silver"—these are [the people] of Israel who are called "the wings of the dove that are covered with silver (Ps 68:14)." . . . Abraham said: "I am a wall (Song of Songs 8:10)" and I offer my life for the sanctification of his name—and not only me, but "my breasts are like towers (ibid.):"—these are the sons of his descendants Hananiah, Mishael, and Azariah and the generation of Rabbi Hananiah ben Teradyon and his companions, who offered their lives for the sanctification of the name; "then was I in his eyes as one that found peace (ibid.)"—there was peace coming out of the furnace.[100]

A similar point is made in *Midrash Tehillim* when it discusses the story from the book of Daniel, defining the act of the young companions in the furnace unambiguously as an act of sanctification of the name of God. The interpretation focuses on the willingness of the youths to go down into the furnace and offer their lives for the sake of that sanctification.[101] These texts read like programmatic statements listing the role models and paradigm narratives for matters of steadfast faith and martyrdom, and the Binding of Isaac is not among them.

The question is thus whether in post-1096 Ashkenaz there were voices to be heard that promoted passive martyrdom rather than active self-sacrifice. It seems that one would not expect to find such positions among the authors of the Hebrew Chronicles and other Tosafist scholars who followed their lead. But what role did martyrdom play in Qalonymide scholarship and among the Ashkenazi Pietists? The Pietist point of view and its effects on later mentalities influenced by the Pietist legacy are by no means clear. Many scholars have argued that Pietists considered martyrdom to be an ultimate ideal. According to Joseph Dan, their pious, even ascetic, way of life would have been nothing but a preparatory stage toward the moment that a Pietist would have been put into a position to sanctify the name of God.[102] Scholars also assume that the cases of martyrdom experienced during and since the First Crusade were crucial in shaping the Pietist worldview several decades later.[103] Elliot Wolfson discusses the role martyrdom played in Pietist views on the mystical (erotic) union with God.[104] Robert Chazan suggests that active martyrdom "represents an expansion of the normal directives of halakhah in a manner parallel to the later *Hasidut Ashkenaz.*"[105] Others, however, observed that the Qalonymide Pietists, in fact, said very little about martyrdom and persecution, especially in regard to the events of 1096, and that it is thus hard to imagine that they were in any serious way instrumental in shaping those ideas. Moreover, some also find it hard to explain that the profound thrust of spirituality that characterizes the Pietists should have grown out of not much more than coming to terms with a catastrophe.[106]

There have been attempts to define the attitudes of members of the Qalonymide circle to martyrdom as far as they can be discerned from the reports in the Chronicles. Several of them, we are told, stood out in their tendency to do everything in their power to save their own lives and the lives of others.[107] The story of Qalonymos ben Meshullam, the *parnas* of Mainz, is told in great detail, even though his fate is not entirely clear. Qalonymos, indeed, tried everything to save the community, but when his attempts failed, he slaughtered his son, Joseph. Solomon ben Samson, who related the story of Qalonymos, had access to three different versions

of the latter's death: one of them implies that he killed himself, but according to other two he was killed by the Crusaders.[108] Whatever the case, it becomes quite clear from the report that Qalonymos had his doubts and that his first reaction was to preserve the lives of the members of his community.[109]

The most outstanding Pietists, Samuel ben Qalonymos and Judah the Pious, were descendants of a survivor of the riots of 1096. This is explained by Eleazar of Worms, who, listing the genealogical lineage of his family in order to show the transmission of secret teachings, mentions the fate of his ancestors in that year: "There [in Mainz] they [the Qalonymides] were fertile and prolific and multiplied very greatly, until God's wrath struck these sacred communities during the year 5856 [1096]. There we were cut down and wiped out; we were all wiped out, except for a small number that remained of the family of our relative [R. Qalonymos] the Elder."[110] After 1096 Samuel ben Qalonymos left for Speyer, where he died in 1126; his son, Samuel the Pious, was still a youth when his father died.[111]

The tendency to do whatever was in one's power to save endangered lives is clearly apparent through subsequent works of the Ashkenazi Pietists. Their determination to sanctify life went hand in hand with the awe and admiration they had for the martyrs and the fact that martyrdom was central to their worldview. If nothing could be done to prevent conversion, martyrdom was certainly expected. Whether this implied self-termination, however, is another story. Recent scholars who revisited the *Sefer Hasidim* for references to martyrdom observe that the book advances numerous suggestions for protecting oneself in a precarious situation: disguising as Christians, and even as nuns and priests, for example, and more of the kind.[112]

Issues of apostasy and stories about converts returning to Judaism run throughout the *Sefer Hasidim,* and its authors look favorably upon those who wished to repent.[113] Shepkaru discusses one of the relevant stories in *Sefer Hasidim* relating to a persecution in Mainz initiated by the bishop of the city. The Jews, having been warned, threw their possessions into the streets in the hope that the persecutors (referred to in the text as Crusaders) would busy themselves with the goods rather with the conversion of their victims. "While the Crusaders were occupied with plundering, many of the Jews fled through the courtyards to the homes of the burghers and were saved."[114] This tale suggests that the Jews did everything in their power to save their lives. The same motif of throwing their goods into the streets in order to gain time also appears in the Chronicles, but there the time gained was used for active martyrdom before the persecutors could invade their homes.[115] This, Shepkaru observes, clearly reflects a significant difference from the approach in the *Sefer Hasidim.*[116]

Another story in the *Sefer Hasidim* discusses two men hiding from the persecutors. One of them, driven by the need to empty his bowels, was about to leave the hideout and was stopped by the other, who warned him of the danger: "His companion said: you might get killed; the other one answered: it would be for the sanctification of the name. The first replied: it would be a sin to cause your own death or to risk the lives of your descendants or of the people in your town, as it is written (Lev 22:32)—'I will be hallowed among the children of Israel'—this means when the gentiles afflict him by saying: if you do not this or that we shall kill you; and it is written (Ps 44:23)—'for your sake we are killed all day.' But if he causes death to himself, it is written (Gn 9:5)—'I will require your blood of your lives,' and it is also written (Dt 4:9)—'keep your soul diligently.' "[117]

Eleazar of Worms refers frequently to martyrdom and describes several such instances, among them incidents in Speyer from 1187 to 1188, and those in 1196, when his own wife and two daughters were killed. Eleazar reports the details, all of which refer exclusively to passive martyrdom. He describes many attempts to escape, is acutely aware of man's desire to save his life, and praises those who saved those Jews who were not killed. He also wrote a *piyyut* to lament and commemorate the Jews of Erfurt, who were attacked in 1221.[118] The poem was recited according to the rite of Worms on the Sabbath of the week of the 25th of Sivan.[119] Many Jews were killed, and according to other sources several laid hands on themselves.[120] Eleazar bemoans their deaths, but, as Shepkaru notes, nowhere in his poem does he praise, or even mention, the suicides, and makes significant and prominent use of the passive voice: he refers to "those who were hanged," "those who were burnt," and "those who were killed."[121]

To this we can add some observations from a *Commentary to the Pentateuch*, traditionally attributed to Eleazar of Worms, whose authorship is, however, in doubt. The text refers to the Binding of Isaac at some length, but nothing in the commentary alludes to the interpretation of the scene as a paradigm for active martyrdom. In reference to Genesis 22:2: "Offer him there as a burnt offering," the commentary explains: "Offer him: God did not mean that he should slaughter him, but to offer him, and told him in order to try him." A few verses later (Gn 22:12) "Lay not your hand upon the lad, neither do you anything unto him" is explained: "Lay not your hand—to slaughter him; nothing—to burn him." The section ends with a reference to Abraham's plan to build an altar on the site so that Isaac and his descendants could commemorate the act of their father's obedience. This in turn was the reason that Solomon chose that site as the place on which to build his Temple.[122]

A similar stance can be observed in *Sefer Arugat Habosem*. Among the poems Abraham ben Azriel discusses is one by the Iberian scholar Solomon ben Judah ibn Gabirol, entitled *az behar hamor* (On the Temple Mount), which refers to the Binding of Isaac. Abraham ben Azriel focuses on the figure of Isaac as the passive protagonist of the story. In the opening verse, Isaac, led by his father to the place of sacrifice, is described as facing his fate with joy. The verses that follow elaborate on Abraham's readiness to fulfill the will of God and to perform a pure sacrifice. Still, when they arrive at Mount Moriah, Isaac wonders what animal will be offered. Abraham replies that he is hopeful that God will hear Isaac's prayer and that he will be saved. Once Isaac understands that he is to be bound, he tells Abraham to make sure nothing will prevent the perfect fulfillment of the sacrifice, as it is God's wish. Meanwhile the angels in heaven are determined to prevent the act and pray. They succeed, Isaac remains unharmed, and a ram is offered in his place.

Abraham ben Azriel's emphasizing that Abraham did not touch Isaac, did not spill his blood, and did not in any way harm him reflects a very different approach from those voices of the twelfth century that added to the tale of the Binding the motif that Isaac's throat was cut, that he actually died and miraculously returned to life. The commentary ends with a clear statement that Isaac is considered a saint, even though he was not actually sacrificed. There follow a few words that underscore Isaac's redemption and note that "he proffered his throat," using the same wording that often appears in the Chronicles in connection with those who awaited the Crusaders who killed them. It seems that in Abraham ben Azriel's view, however, the Binding of Isaac had shifted from being a paradigm of self-affliction to being one of passive martyrdom. Finally, it is quite telling that Abraham ben Azriel also incorporated into his commentary the talmudic allusion of *etan* to Abraham: the verse "taking him [Isaac], he was steadfast" is commented on by: "steadfast *(etan)*—Abraham."[123]

Likewise, when he refers specifically to the persecutions, Abraham ben Azriel, like Eleazar of Worms, refers to the victims in the passive voice. This can be observed in the commentary to another *selihah*–*brit krutah* (A covenant), where he writes about the conduct of certain scholars during the persecutions, referring to those scholars who were slaughtered and should be viewed as role models.[124] This apparent emphasis on passive martyrdom does not contradict his manifest awe for the martyrs as such. On the contrary, in another commentary to a *selihah* entitled *elohim el dami ledami* (O God, keep not your silence over my blood), he writes at length about God avenging his people at the end of time. This *selihah* forms part of the Worms morning service for Yom Kippur and is included in the

Leipzig Mahzor.[125] He first explains that it was written in reaction to the persecutions. The victims to whom he refers, again only in the passive voice, are compared to the pure offerings in the Temple. Although active martyrdom is in no way highlighted, martyrdom as such is certainly described as an ultimate ideal and the only means of dealing with the Christian pressure to "prostrate before the hanged one, that is, Jesus the *notsri*."[126]

These examples certainly show that martyrdom did indeed shape the Qalonymides' worldview and post-Pietist mentality. However, whether this means that they also promoted active martyrdom is by no means certain. The many suggestions about ways of saving one's life and Eleazar's and Abraham ben Azriel's emphases on victims who passively found their deaths seem to indicate that they had no particular appreciation for those who harmed themselves. They certainly did not highlight their deeds in the way that the Chronicles did with their recurring references to "slaughtering," presenting these acts as rituals. An exception to this is a lament by Judah the Pious's brother that perhaps commemorates the victims of the persecutions of Blois, which had taken place in 1175. One of the verses in this lament praises the women who "went down into the fire." It is not clear, however, if he uses an expression that is often found in the context of being killed by fire or that he meant to imply that those women performed active martyrdom. Whatever the case, this stands out among the noted citations from the Qalonymide circle.[127]

The early fourteenth-century designer(s) of the Leipzig Mahzor thus chose a paradigm of passive martyrdom as the pictorial commentary to the *piyyut* about steadfast faith. In this they may have been faithful to the path taken earlier by the Qalonymide Pietists, but it is also possible that their intention went even beyond those Pietist positions. It appears that, as much as active martyrdom had become an ideal, there may also have been some ambivalence toward this aspect of religious zeal. However, as it had become such an ultimate ideal, reservations regarding it were extremely subtle, hidden, rare, and hardly ever explicit. Scholars are divided as to the extent to which such reservations existed. Goldin describes active martyrdom as a dominant normative ideal characteristic of Ashkenazi society in its entirety and argues that reservations were rare exceptions.[128] Soloveitchik maintains that objection to active martyrdom was expressed only by unrenowned, unknown, unimportant rabbis.[129]

However, some scholars have recently discerned a certain degree of ambivalence toward active martyrdom, even in regard to some of the protagonists described in the Hebrew Chronicles, despite the apparent purpose of the Chronicles to promote active martyrdom. Even though the Chronicles certainly highlight active martyrdom, several of the cases they

report are about Jews who awaited their fate at the hand of the enemy but did not do anything to harm themselves. An example is the group of Jews from Mainz who gathered in the bishop's courtyard, where they were eventually killed by the Crusaders.[130] Malkiel suggests that in certain cases suicide may have been an act of desperation instead of martyrdom.[131] A later source tells of an anonymous scholar who went so far as to refer to a rabbi who had slaughtered "many infants" for the sanctification of the name of God as "a murderer."[132] There can be no doubt that this particular individual had a negative opinion about the killings, and his attitude may have been shared by the author of the text, one Maharash ben Abraham, known as Uchmann.

Scholars are divided as to whether Maharash ben Abraham was an exceptional outsider or representative of a more widespread opposition that was perhaps shut down by mainstream rabbinic leadership and therefore difficult to access in modern scholarship.[133] The thirteenth-century French scholar Hisqia ben Manoah may also have hinted at a critical attitude toward active martyrdom, avoiding any details and finishing the passage with the well-known formula "the one who knows, understands," often used by rabbis when they were reluctant to express certain issues explicitly in written form.[134] A similarly reserved statement is known from Rashi's grandson Samuel ben Meir (Rashbam; c. 1080–c. 1160), which argues that the transgression of minor precepts should not cause one to consider risking one's life.[135]

Objections and reservations were subtle; they were not necessarily argued in terms of the religious law, but were often rooted in emotional considerations.[136] Finally, clear objection is found in the position of the sixteenth-century Polish scholar Solomon Luria (Maharashal), who leaves no doubt that harming oneself is against the law under any circumstances. Referring to several earlier French and Ashkenazi authorities of Tosafist background, he states unambiguously that it is forbidden to kill oneself, but stresses repeatedly that one may accept death passively without harming oneself. Similarly, he declares that it is forbidden to kill children even when facing baptism. The only action that may be taken is to burn one's house and remain in it to await death. In the same context, he also discusses forced baptism and the option of returning to Judaism.[137]

The observation that some Ashkenazi Jews held ambivalent views about active martyrdom sheds light on the choices made by the authors of our image and offers some tools toward understanding what the notion of martyrdom may have meant to those who used and viewed the Leipzig Mahzor around 1310. Although it had been stylized by the Hebrew Chronicles into a general Ashkenazi ideal, a behavioral pattern claimed to

be a typical Ashkenazi phenomenon, active martyrdom was approached somewhat differently by the Qalonymides. Martyrdom as such was a central ideal in their worldview, but they apparently did not promote self-termination as the Chronicles did. Whether the choice of a paradigm of passive martyrdom as a pictorial commentary of "The steadfast believer" implies some of the reservations occasionally voiced in Ashkenazi Judaism is hard to say. The striking preference of the midrashic motif of the furnace over the biblical story of the Binding of Isaac enhances the plausibility of such a conclusion. Moreover, against the background of the different traditions involved in the issue of martyrdom, the authors of our picture certainly emerge as holders of an ambivalent position. In this context it is notable that contemporary *piyyut* commentaries discussing *etan hikir emunatkha* tend not to highlight the Binding of Isaac, even though the *piyyut* itself certainly lends itself to doing so. They tend, rather, to underscore Isaac's passive position and to focus, for example, on the Seraphim complaining about the cruel death awaiting Isaac.[138]

By the early years of the fourteenth century, which was when the iconographic program of the Leipzig Mahzor was laid out, martyrdom had again become a particularly relevant issue. We have no clear notion as to what extent active martyrdom—even though a theoretical ideal in the eyes of many—was de facto practiced after 1096. We have seen that persecuted Jews perhaps did not always have the choice of baptism at all. Even though accounts of such later events were often modeled after the 1096 Chronicles, Jewish victims of persecution were, strictly speaking, not martyrs, but they were considered saints, adherents of the ideal established after 1096.[139] This attitude can be observed well into the thirteenth and fourteenth centuries, especially in the Jewish martyrology, the *Memorbücher,* where the ideal of the Chronicles was further stylized. A case in point is Eleazar of Worms's poem commemorating the events in Erfurt in 1221 in comparison to the analogous references in the *Memorbuch.* Eleazar describes a series of passive killings; the *Memorbuch,* on the other hand, includes several acts of self-termination.[140]

A responsum by Meir of Rothenburg concerning a man who had killed his wife and children during the persecution of 1265 in Coblenz is quite informative regarding attempts to come to terms with attitudes toward martyrdom during the thirteenth century. Having subsequently escaped the killings and forced conversion, this man turned to Meir asking if he should repent by killing himself. Meir gave a lengthy reply that reflects a great deal of doubt and uncertainty. He argued on the grounds of the suicides and killings of 1096, his official position apparently in line with that of the Tosafists. The fact that Meir had to go back to the events of 1096

indicates, as Yuval observes, that active martyrdom and infanticide did not often occur after the First Crusade. Although active martyrdom had remained an ideal and there were still occasional instances, it does not seem to have turned into a regularly practiced norm.[141] In 1265 Jews still related to this ideal in various ways, and, as Shepkaru emphasizes, the query and Meir's response show that many Jews must have struggled with the concept.[142] In particular the killing of others raised many questions, even for a rabbinic authority of the caliber of Meir of Rothenburg.

In 1298 a new wave of persecutions, often referred to as "Rintfleisch massacres" after the initiator and leader of some of the raiding gangs, more severe than any of the earlier ones, swept through southern Germany. Several features in our image suggest that it may well refer specifically to the victims of these massacres, even though the community of Worms was not directly affected. The sources indicate that the persecutions began in April with a host-desecration libel in Röttingen, a small town near Rothenburg within the realm of the Count of Hohenlohe, and continued after a two-month break, sweeping through Franconia and adjacent regions in southern Thuringia, northern Swabia, and parts of northern Bavaria. Some 140 Jewish communities were attacked: small villages and towns during the earlier phases of the massacres, and larger towns, including Rothenburg, Bamberg, and Nuremberg, during a later stage, as by the end of July the gangs had become larger and stronger.[143]

The host-desecration libel in Röttingen was later, perhaps in the fifteenth century, documented in a painting that until recent years could be seen in the local parish church.[144] One of the roundels (fig. 19) shows the burning of two men: a Christian who was believed to have stolen the host and sold it to a Jew, and the Jew who was falsely accused of buying and abusing it. According to a written account, however, it was a whole group of Jews who were sentenced to death, while at the same time the peasants in the nearby villages burned their Jewish neighbors.[145] Shortly after the Röttingen massacre another burning seems to have taken place in Weikersheim, initiated by the local ruler, Kraft von Hohenlohe-Weikersheim, which was most likely directed not only against the Jews of Weikersheim— perhaps only one couple—but also Jews from neighboring areas.[146]

Other burnings occurred later during the summer in Upper Franconia, in Lichtenfels, Niesten, and Bamberg, where one man and five women were murdered; in Lower Franconia in Gamburg, where 130 Jews from Tauberbischofsheim died; and in Stufenberg, where the Jews of Baunach lost their lives at the stake.[147] Most burnings, however, took place in Middle Franconia, in Eichstätt, Hersbruck, Neustadt/Aisch, and Bad Windsheim.[148] In Nuremberg, 728 Jews were burned around August 1.

When the Rintfleisch gangs approached, the Jews escaped into the Castle of Nuremberg, where some of the subsequent deaths may actually have been the result of active martyrdom. Among the victims were prominent scholars: Yehiel ben Menahem Hakohen, Mordechai ben Hillel, and a well-known composer of liturgical poetry, Abraham ben Joseph.[149] Jews were also burned in Rothenburg, although it seems that Rintfleisch himself was not involved there, and Lotter argues that it was the citizens of Rothenburg who were responsible. Meir of Rothenburg's brother, Abraham ben Barukh, was among those victims.[150] More than 840 Jews were murdered in Würzburg, their bodies were burned, and the Dominican chronicler Rudolph of Schlettstadt (c. 1300) also reported several instances of active martyrdom by fire.[151] Other burnings took place in adjacent regions: in Hürnheim and Nördlingen, both in Swabia; in Bad Salzungen in Thuringia; in Möckmühl, which in the thirteenth century was part of the realm of Hohenlohe, but now belongs to Baden-Württemberg.[152]

To what extent active martyrdom occurred during the Rintfleisch massacres is not entirely clear; cases of self-termination and the slaughter of fellow Jews were reported in Christian chronicles for Würzburg and in the Castle of Nuremberg, perhaps in expectation of forced baptism.[153] However, the Jewish martyrologies and several elegies use the motifs and the wording of the 1096 Chronicles in their references to the deaths of some of the victims.[154] All in all, Shepkaru observes, "descriptions of active martyrdom slowly disappeared from thirteenth-century writings, probably because of a lack of will and because of lack of time for negotiations between the would-be martyrs and the eager inquisitors and the mob."[155]

Perhaps what guided Ashkenazi Jews in 1298 was not so much the traditional ideal of active martyrdom, but rather Meir of Rothenburg's advice. In the *Sefer Tashbets,* the collection mentioned earlier of laws and customs associated with Meir and composed by his pupil Samson ben Tsadoq during the time his teacher was imprisoned in Ensisheim, a whole chapter is dedicated to the issue of the sanctification of the name of God; hence its title, "Laws of *qiddush hashem."* Martyrdom is certainly an ideal there, but it discusses passive martyrdom, which, Meir promises, is not painful: "When a man insists on sanctifying the name [of God] and on handing over his soul for the sanctification of the name, all that is done to him: stoning, burning, burial live, hanging, do not pain him ... many hand themselves over to be burnt and killed for the sanctification of the blessed name and they do not scream."[156] Although not mentioned explicitly, Abraham in the furnace could certainly have provided a model for this kind of advice.

The Leipzig Mahzor was produced some ten to fifteen years after the persecutions of 1298. Although the Jews of Worms were not physically affected by the massacres, the Rintfleisch killings did not pass unnoticed in the Rhineland communities, which frequently interacted with their coreligionists in Franconia. One only has to remember that Meir ben Barukh, who ran a rabbinic academy in Rothenburg, was a native of Worms.[157] His murdered brother, Abraham, who lost his life during the riots, had lived for some time in Nuremberg. Worms is only about 35 kilometers from some of the places the gangs had visited. The Jews of Worms were well aware of the massacres, and they mourned the fallen, many of whom were relatives. But most of all they must have been afraid that the violence would spread yet further, eventually reaching their own community, knowing that there was nothing they could do to ensure that they would be spared from similar events in the future. Jewish scholars often related to and wrote about tragic incidents, even when they occurred further away. For example, Rhenish scholars commemorated the victims of the 1171 persecutions in Blois, France, to be discussed below. All the more we can be certain that the Jews of Worms were affected by what happened ten to fifteen years earlier only two- or three-day trips away. During the seventeenth century, the Jews of Worms were still observing special fast days and mourning customs to commemorate the victims of 1096.[158]

Death at the stake had by that time become the frequently employed way of executing Jews. Owing to lists of victims to be memorialized, the *Memorbücher,* we have quite detailed information on numbers and names of the victims and how they were executed during the massacres. There were many more burnings of Jews in southern Germany before 1320 than anywhere else in Europe. Yet before the Rintfleisch massacres, Jews of Franconia and adjacent areas also met their deaths at the stake, as in Erfurt in 1221 and Mellrichstadt in March 1283.[159] After the Rintfleisch wave, further burnings were documented, as in 1302 in Dettingen unter Teck, where the Jews of Kirchheim were burned.[160]

This background accords even further topicality to the Leipzig Abraham image, referring as it does not only to the content of the *piyyut* about steadfast faith and a related midrashic narrative, but to actual burnings of Jews in Franconia and the adjacent regions before, during, and after the Rintfleisch massacres. The depicted scenery, rather than focusing on Abraham being thrown into the fire, emphasizes Terah's and Abraham's appearance before Nimrod. Although he is enthroned and crowned, Nimrod is imaged as a judge.[161] We know of several instances where Jews who were accused of host desecration or refused baptism were handed over to Rintfleisch, whom the mob called "König Rintfleisch." Mock trials were held,

at the end of which Rintfleisch would sentence the Jews to death. The accounts of the burning in Bamberg indicate that in one such trial there, one of the Jews was tortured and then, together with the rest, sentenced to death.[162] Another such case is mentioned as taking place in Würzburg, where the *magistratus* and some of the upper-class citizens had the Jews arrested and handed over to Rintfleisch.[163] Friedrich Lotter indicates that there is a possibility that the motif of the trial is a literary topos fashioned after the account of the 1290 host-desecration incident in Paris, which is how he interprets the Röttingen incident for which Rudolf of Schlettstadt's chronicle also mentions a trial and a judge.[164]

Hence, the depiction of the Abraham-Nimrod narrative takes on the features of a contemporary drama. Nimrod, the king who judged Abraham for abiding by the wrong faith and destroying the idols, stands for "König" Rintfleisch passing judgment on the Jews. Abraham represents the steadfast role model, who courageously faces death by fire. Salvation, of course, would be expected only in the Messianic Era. In the reality of Jews being burned during the Rintfleisch massacres, this shift in the understanding of the Abraham story is significant. Abraham now becomes a figure with whom those facing death by fire could identify.[165] This also explains why the Leipzig imagery shows Abraham at a stake rather than in a furnace. Judah the Pious's version in the *Sefer Gematriot* is the only text version that explicitly deviates from the original story and refers to a stake. Two *piyyut* commentaries emphasize the gleaming coals, also somewhat recalling the realities of victims being burned at a stake.[166] In contrast, the iconographic parallels offer a more literal version of the common narratives and picture the event as taking place in a furnace.

The possibility that Nimrod is identified with Rintfleisch might also explain why the image was modeled, at least in part, after *Ma'ase Avraham Avinu*. This version—as observed above—focuses in particular on the cruelty of Nimrod, whereas other texts tend to characterize him as hunter, a war hero, and a rebel.[167] *Ma'ase Avraham Avinu*, however, opens with the description of Nimrod worshipped as a god and his cruelty when he sensed that his authority and status were in danger. The story not only mentions the slaughter of 70,000 male infants, but the author judges and underscores it several times: "more than seventy thousand male children were killed and when the angels in heaven saw the killing of the children they said to the Holy one blessed be he: did you see what this evil and sinful man Nimrod ben Cana'an did, and how many children he killed?"[168] According to the story, God promises to punish Nimrod for his deeds. With the description of Abraham's mother giving birth in the cave, the killings are mentioned once more, and again later, when she explains to her

son why she left him in the cave: "I gave birth to you at the time when King Nimrod ruled and because of the fear of you he killed 70,000 male children."[169] In short, of all the accounts and references to Nimrod in rabbinic and medieval Hebrew literature, it was the version of *Ma'ase Avraham Avinu* that emphasized Nimrod's cruelty in particular and thus created an image that could later easily be associated with Rintfleisch.

Death at the stake had occurred occasionally in both northern France and in the German lands, but became very common at the time of the Rintfleisch massacres. In what was apparently a desperate effort to come to terms with these killings, Jews in those areas likened the burnings to reenactments of the burnt offering in the Temple. A very well-documented incident occurred in 1171 in Blois, where the Jews were accused of the murder of a Christian child. We know from several contemporary letters and a Christian source that several Jews were arrested and that, after unsuccessful attempts to ransom them, more than thirty victims were burned to death in a wooden building. Several liturgical poems—some composed by the Rhenish Tosafists Ephraim ben Jacob of Bonn, his brother Hillel of Bonn, Barukh of Mainz, and Gershom ben Isaac—lament the fate of these victims. The murderous episode was also chronicled by Ephraim of Bonn around 1190.

Martyrdom is particularly underscored in later sources: the victims facing the option of baptism and refusing to convert; they are compared to Temple offerings; as the animals were chosen as offerings for the burnt sacrifice, so were the victims in Blois chosen.[170] From the Jewish point of view, the act of burning thus had a special significance and theological meaning could be attached to it.[171] We have seen that the biblical description of the burnt offering was one of the two major paradigms of active martyrdom. In 1241 this attitude toward burning and burnt offerings led to another incident of active martyrdom in Frankfurt. While waiting for the Christians to attack, Jews who were being accused of trying to prevent the baptism of a fellow Jew locked themselves in their houses and burned themselves there.[172] We have seen that Solomon Luria's view of the sanctification of the name of God in the sixteenth century implies that killing oneself by burning one's own house is the only form of active martyrdom of which he approved.[173] Not only was the association with burnt offerings significant, but, as Yuval shows, the understanding of fire as light was also important, as it characterizes the Abraham Midrash, where the town Ur is understood as the light/fire of the Chaldeans.[174]

If the depiction of the Abraham story in the Leipzig Mahzor can be contextualized within Pietist attitudes toward martyrdom, in expressions of ambivalence about active martyrdom, and in a sacrificial theology associ-

ated with the killing of Jews at the stake, what should we, finally, make of the two images of the Binding of Isaac that illustrate the poems for Rosh Hashanah? The first (fig. 3) appears adjacent to the initial *melekh* for the *yotser–melekh azur gvurah* (A king girded with might) on the outer margin as an unframed image of a ram, his horns entangled in a tree. We are shown neither Isaac and Abraham nor the altar, as if to emphasize the fact that Isaac was not slaughtered. The second image of the Binding of Isaac appears next to the poem *ahallelah* (I shall praise God), and going beyond the allusion to the ram, it displays a full representation of the scene (fig. 4).

Both pictures were painted, as we saw in Chapter 1, by a different hand than most of the miniatures of the Mahzor. As I noted there, in his 1964 analysis of the style of the Leipzig Mahzor, Bezalel Narkiss attributed these two images—together with that of Samson at the beginning of volume one—to the "master artist," a superior craftsman. Although this artist executed only three of the images, Narkiss believed that he gave the codex its tone and determined its basic stylistic standards. However, as I suggested in connection with the codicological examination, it is more likely that these illustrations were added shortly after the Mahzor was completed, perhaps just before it was bound. It is possible that at that stage it was decided that the liturgy for Rosh Hashanah should be accompanied by illustrations of the Binding of Isaac after all.

Abraham appears on the outer (left) margin; his large figure with the elaborate drapery is significantly different from the small, somewhat stiff and isocephalic figures with their simply outlined garments in the rest of the marginal images. Opposite Abraham in the inner margin we find the ram and the tree, similar to what can be seen a few pages earlier. Nowhere else in the entire book are the inner margins used for illustration, and the image here seems to intrude into the layout of the *piyyut,* also a feature clearly avoided on all the other pages of the book. The *piyyut* opens the liturgy for the *musaf,* the additional section for the Sabbath and holiday liturgy, which is not embellished anywhere else in the Mahzor. Perhaps, then, the entire decoration of this page was some sort of afterthought and not part of the original program. This would also be true of the marginal ram on the *yotser* page, painted by the same hand. That image does not match the careful composition of the initial panel, executed, if we agree with Narkiss's stylistic observations, by another hand, the one that was responsible for most of the Mahzor's art.

This suggests that according to the original decoration program the Binding of Isaac with all its topical implications as a paradigm story for active martyrdom was perhaps not supposed to be shown at all. The only allusion to Abraham would then have been the Nimrod story. On the

other hand, the Binding of Isaac is *the* scene with which the liturgy of Rosh Hashanah is associated, as it is the text of Genesis 22, which is read during the holiday service, and it is frequently shown in other mahzorim as an illustration to that liturgy.[175] One possibility is that the original decoration program did not call for a depiction of the Binding of Isaac because it would somehow contradict the message of the marginal scene of Abraham in the furnace, but that in the end the designer(s) of the program may have decided that, given its close association with the Rosh Hashanah liturgy it had to be included. They then commissioned a different artist—Narkiss's "master artist"—to add the marginal paintings, which thus look somewhat out of place. Because the *yotser* had already been illustrated, only the ram was added there, apparently as an allusion to the *shofar*, shown in the initial panel, and the full scene was added to the *musaf*, which is the next section. As nothing in this latter text alludes to the scene, the image indeed seems to be very much out of place.[176]

THE TWO IMAGES discussed here demonstrate certain ethical stances, each emerging from quite clearly defined contexts within the framework of late medieval Ashkenazi society. What at first sight appears to be simply a reproduction and juxtaposition of common Christian messianic motifs emerges as a rather sophisticated image of the penitential system that had been developed earlier by the Ashkenazi Pietists. Understood by the Pietists as a set of religious acts performed individually, in our image the system seems to be perceived perhaps instead as a collective method to achieve a balance of sins and virtues as a precondition toward messianic redemption. The composition of our image does not address a ritual of penance, but rather juxtaposes symbolic representations that communicate the ethics of penitence.

The Abraham narrative works differently. As a marginal composition it emphasizes not only the ethical value of martyrdom, but also its ritual function. The pictorial narrative operates on several levels. It highlights Abraham as a role model for martyrdom; it expresses ambivalence toward the practice of active martyrdom; and it relates specifically to the circumstances of persecution. Moreover, with its promise of salvation it served as an example of encouragement, hope, and trust in God.

Penitence and martyrdom as religious values were held in particularly high esteem within the cultural ambience of the Leipzig Mahzor. Qalonymide stances in regard to both phenomena dominate the imagery. Both played a crucial role in Ashkenazi life, and both were frequently addressed by the Qalonymides, who stressed their particular ideas in regard to these matters. Neither issue disappeared with the death of the last Pietist, and

Ashkenazi authorities were concerned with both in the decades that followed. The penitential system was the one issue associated with the Pietists that would be widespread and well known even beyond the borders of Ashkenazi culture. Further, the ever-increasing threat of persecution finally turned martyrdom into a value of increasing topicality as the fourteenth century progressed toward the waves that would accompany the Black Death in 1348–1349. The images thus appear as ethical guidelines for a community coping with persecution and hoping for redemption.

Sod:
Mystical Dimensions

W E HAVE SEEN that the Qalonymides had a highly developed ethical system and that their penitential system was both prominent and widespread. They also embraced a rich repertoire of customs and rituals. That the Leipzig Mahzor is part of their legacy is abundantly clear from the initial panels and marginal illustrations of this lavish book. Let us now turn to the third aspect of Pietist scholarship and see if the Leipzig imagery has mystical dimensions as well.

In the Pietist worldview a fulfilled life was governed by the observance of the religious law for the sake of the love of God. This love for the Divine could be approached mystically and often was described in sexual terms. The Pietist mystical teachings, like those of other scholarly circles, are concerned with issues of divine revelation, first of all those described in Scripture. Coming to terms with descriptions of divine revelation meant following particular hermeneutic rules, many of which involved the numeric values of textual expressions. On another level, esoteric issues concerning knowledge of the upper world are subject to mystic speculation. Mystical teachings, especially those of an esoteric nature, were supposed to be transmitted orally from teachers to trusted students, and not be put into writing. One of the enigmas in the research on Pietism is why Eleazar, and others after him, broke with this convention and left copious written material. Some scholars have suggested that Eleazar determined to do so because he was afraid that with the deaths of his own son in 1196 and his

teacher, Judah the Pious, in 1217, their tradition would come to an end, as there was no one close to whom he could pass on his esoteric heritage.[1] Others have noted that he did indeed have students who may have been interested in his esoteric teachings and suggested other possible reasons for that decision.[2] The Qalonymide mystical tradition continued to hold sway into the late thirteenth and early fourteenth centuries, after which it was increasingly challenged by early Sephardi Kabbalah, with which it ultimately merged.

Nevertheless, and unlike the Qalonymide approach to ethics, which is more-or-less clearly defined in the *Sefer Hasidim* and other books, the extent of both their exoteric and their esoteric mystical activity is considerably less clear in terms of texts they left behind. Even though a great deal of material has survived, many of their texts were lost and many of their treatises suffer from uncertain authorship. Texts that were originally attributed with some certainty to figures such as Judah the Pious or Eleazar of Worms have recently been reevaluated, and some are now associated with Pietists from other circles.

This chapter discusses three images in the Leipzig Mahzor in terms of Pietist mystical teachings. The first, which is one of the most lavish illustrations in the entire Mahzor, depicts the couple in the Song of Songs (fig. 7). This image seems to be unconnected with any ritual aspect beyond the recitation of the *piyyut* it illustrates, and will be discussed here against its theological background. The two other images (figs. 10 and 16) address prayer and penitence. These have already been discussed, but as they also reflect aspects of Pietist mystical teachings, they will be revisited here beyond their ritual and ethical dimensions.

The Mystic Couple

Eleazar of Worms's Pesah sermon opens with a lengthy reference to several verses from the Song of Songs. This biblical love poem, commonly understood as an allegory of God's love for his people, is also the core theme of the *yotser* of the Great Sabbath, *iti melevanon kallah* (Come with me from Lebanon, my bride, Song of Songs 4:8).[3] Hence, the poem is accompanied by the image of a couple (fig. 7). The interpretation of the poem as an allegory for divine love has dominated rabbinic exegesis ever since Rabbi Akiva's fervent reference to it in the early second century: "All the books are holy; the Song of Songs is the holiest of holy."[4] God's love for his people does not diminish even when Israel fails and sins, and it endures through exile and persecution.[5] This is also the principal message of the *piyyut,*

which alludes specifically to the covenant with Abraham, the pharaonic bondage, and the liberation from Egypt, the concept also deriving from several commentaries on *piyyutim* that circulated during the thirteenth and early fourteenth centuries.[6]

The addition of an illustration of a couple to this *piyyut* thus seems to be a suitable choice. Similar motifs appear in other mahzorim.[7] Moreover, similar imagery is seen for the illustration of the Song of Songs in Christian art. In one way or another all the Jewish depictions echo the Christian iconography of the mystical union between Christ and Mary (fig. 20), a theme visually linked to the more usual imagery of the Coronation of the Virgin.[8] As common as the couple iconography appears for the *yotser* for the Great Sabbath, however, in its details the Leipzig image differs widely from its counterparts in other mahzorim, and, more than any of the cited parallels, it is particularly close to its Christian iconographic sources.

The man and the woman are seated within an elaborate architectural structure that recalls a tympanum in the façade of a Gothic cathedral, but it is also reminiscent of a symbolic convention, representing the Temple, that was widely used in late antique and medieval Jewish art. More importantly, however, and again in clear contrast to the parallels, which all suggest either a wedding ceremony or another form of an institutionalized or romantic love relationship, in the Leipzig Mahzor there is a clearly marked difference in rank between the female and male figures. Whereas the woman—a matron apparently—is crowned and beautifully dressed, and wears an enormous brooch, the man, clearly marked as a Jew by his funnel hat, is young and very simply clothed in a short tunic. He has no beard and is not wearing a mantle, nor do we see any other detail that would indicate rank in terms of scholarship, authority, or sanctity. The woman is wearing a crown, which Sarit Shalev-Eyni suggests might be a wedding diadem and thus reflect a contemporary wedding custom.[9] However, unlike other examples appearing in marital contexts, the Leipzig crown is rendered as a royal crown, typical for representations of kings and queens throughout Gothic art, rather than as a bridal diadem. It would thus seem that the Leipzig crown alludes explicitly to the notion of kingship, rather than to a real-life wedding ceremony.

The female figure is shown frontally, whereas the man appears in three-quarter profile. Frontal representation is known to have been associated throughout late antiquity and the Middle Ages with hieratic representation, sanctity, or outright holiness. In the Leipzig image the woman does not appear frontally in the same sense as do Christian saints, because her face—like all the faces in the entire illustration program of this manuscript—appears in profile, but her body indeed faces the viewer frontally.

The different ways the artist chose to represent the man and the woman also had an effect on the way he used color. The three-quarter representation of the man requires a different approach to shading than does the frontal image of the woman. Her garment hardly shows any gradation in color or shading, whereas the man's short tunic is rendered in a darker shade on the right, as it is closer to the background, with the left part appearing as if exposed to light. The woman's body, then, is completely in the light, whereas the man's is partly in the shade. In comparison with other images in the Leipzig Mahzor, it appears that here the artist paid particular attention to light and shade. Some other Leipzig figures in three-quarter profile have, for instance, one arm colored darker than the rest of the body (figs. 3 and 8), but the artist often ignored even this minimal feature (fig. 18). In any event, shading does not seem to have any specific iconographic meaning in any of the other images, so the fact that in our image the artist was more precise in his rendering of light and shade should perhaps not go unnoticed.

The many pictorial parallels and most rabbinic interpretations of the Song of Songs suggest that the female figure stands for *kneset Israel*, as a personification of the people of Israel, and that the man represents the divine male partner in this drama of godly love, but these roles do not seem to be the same in the Leipzig Mahzor. The emphasis on the significantly lower rank of the man marked as a Jew by his hat immediately rules out such an understanding.[10] Judging from the visual information in the Leipzig image, it is more likely that the young Jew represents Israel, which would mean that the female matron-queen is the divine partner in the relationship. This divine partner emerges, as we shall see, as a multifaceted hypostasis with several layers of meaning. Before we address her, however, a few remarks on anthropomorphism are in place.

THERE ARE MANY WAYS to interpret the biblical prohibition "You shall not make a graven image (Ex 20:4)": from a broad understanding that no created being should be depicted in any form to the narrower view that the prohibition applies only to three-dimensional figurations. One point, however, is clear beyond question: no matter how broad or narrow the approach to the commandment, God is beyond representation. Once ancient polytheistic idol worship was no longer an issue, the two-dimensional portrayal of plants, animals, and human figures became possible and was widely practiced during the early talmudic period, until c. 550. But with the exception of several images of the hand of God, figural depictions within Jewish culture normally do not contain a full or partial anthropomorphic representation of the Deity.[11]

If the negation of any anthropomorphic representation in visual form ran throughout Jewish culture, how can the male figure be supposed to embody the partner of the female personification of Israel in a visual allegory of divine love? It has been suggested that the fact that the images illustrating the *piyyut* for the Great Sabbath approach the theme of divine love allegorically apparently minimized any anxiety about the anthropomorphic appearance of the male lover, even if he stood for God.[12] The Bible and the rabbinic tradition refer to God repeatedly in anthropomorphic terms. Not only did God create man in his image, according to Genesis 1:26, but the Bible and talmudic literature are replete with details such as the hand of God (for example, Ex 9:3: "The hand of God will be upon your cattle"), or God putting on phylacteries, and so on.[13] In fact, the most usual method of dealing with biblical anthropomorphism was to interpret it as an allegory of theophany rather than as a revelation of an anthropomorphic God.[14] It was then possible to approach a visual allegory as a counterpart to allegorical exegesis of biblical anthropomorphism. The traditional interpretation of the Song of Songs refers to the divine lover in decidedly anthropomorphic terms, an issue that has attracted the attention of a number of scholars.[15] Although this understanding of the couple as a visual allegory might have been current in certain circles of medieval Judaism, others would most likely have taken issue with the figural representation of the male partner.

The traditional opinion consistently held in modern research, as well as in traditional Jewish scholarship, is based on Maimonides's assumption that "our Sages were far from the belief in the corporeality of God."[16] Recent reassessments, however, show that late antique and medieval Jewish approaches to anthropomorphism varied greatly. Not only are the Bible and rabbinic literature full of anthropomorphic references to God, but so is late antique mystical literature, and to a significantly higher degree. Time and time again the *Hekhalot* tradition, a group of late antique mystical texts about the heavenly shrines, refers to God anthropomorphically, and the so-called *Shi'ur Qomah* texts discuss the enormous size of God and his limbs.[17] More recently it has been suggested that some tannaitic scholars, in particular those of the school of Rabbi Akiva, had a clear anthropomorphic view.[18]

It is, indeed, only in the Middle Ages that verbal anthropomorphism became subject to criticism, and Maimonides (d. 1204) went so far as to condemn even an imagined picture of God. Anthropomorphism, he argued, sets the imagination working, and an imagined picture of God turns every prayer into an act of idolatry.[19] Maimonides was not the first to express anxiety regarding descriptions of the Divine in anthropomorphic

terms. As early as the ninth century Saadia Gaon tended toward an abstract apprehension of God, but he did not dismiss biblical or talmudic anthropomorphism as mere folklore, as Maimonides did later.[20] In particular, he was concerned with divine revelation to the Prophets, which is approached anthropomorphically throughout biblical scripture.[21]

The difficulties medieval philosophers had with the essence of God and the resulting question of how to refer to prophetic revelation led to a variety of approaches. Maimonides's position can be defined as radically anti-anthropomorphic. God is abstract and cannot be approached in terms of human features, and divine revelation was the result of the Prophets' imagination. If we follow medieval references to the Maimonidean controversy of the 1230s, we get an impression of radical opposition to Maimonides's anti-anthropomorphism among the Tosafists of northern France. Several Sephardi thinkers—both rationalist and anti-rationalist—propounded the notion that the "scholars of France" were radical anthropomorphists.[22] It appears, however, that we know very little about this "radical Tosafist anthropomorphism" and that Ashkenazi scholars held rather diverse opinions with respect to descriptions of the Divine. Anthropomorphism, whether radical or not, may thus have been more of a popular religious belief than a scholarly position.[23]

However, both anthropomorphism and radical opposition to it suggest a specifically strict approach to the matter of a visual representation of the Divine in the form of a human figure. The notion of an anthropomorphic God does not necessarily imply the creation of an anthropomorphic image as a physical object. On the contrary, the fear that anthropomorphic description might encourage visual representation and lead to the transgression of idolatry meant that the prohibition of visual representation of the Divine has to be taken very seriously.[24] Allegorical interpretation of biblical anthropomorphism grew out of an anti-anthropomorphic view and an abstract perception of God. It was, in fact, one way to confront biblical anthropomorphic descriptions within the scope of anti-anthropomorphism. In such a case we reach a point where allegorical exegesis and visual allegory can no longer be considered analogous to one another. A visual allegory involving a painted image of a figure that allegorically would represent God cannot coexist with anti-anthropomorphism. Let us not forget that for the most radical of anti-anthropomorphists, Maimonides, even an imagined image of God meant a transgression of the prohibition of idolatry. In short, from both points of view an anthropomorphic rendering of a figure that is part of an allegory of divine love is not particularly suitable. Hence, the assumption that a visual allegory would be suitable as an illustration of "Come with me from Lebanon, my bride" can apply only to image-makers

not overly concerned with issues of the perception of the Divine, who approached this allegorical image naively, without giving much thought to anthropomorphism.

However, for those who did concern themselves with these matters, an allegorical depiction alluding to the Divine might very well have been extremely problematic, and the Ashkenazi Pietists were certainly among those so concerned. Issues related to anthropomorphism and, even more, to divine revelation, mattered a great deal to them. Many treatises composed by Pietists targeted these issues, but the picture we get from these writings is not entirely clear. In fact, Pietist negation of anthropomorphism, on the one hand, and Pietists' knowledge of and reliance on late antique anthropomorphic views, on the other, appear somewhat contradictory.[25] Pietist thought implies that God, the Creator, is hidden from any experience of the senses. This Godhead has never been revealed in any form; God has no material form or physical presence; he is purely abstract and cannot be approached through anthropomorphic imaginings.

A central question for anyone dealing with these issues concerns the form of divine revelations to the biblical Prophets. The Pietists developed a comprehensive scholarly tradition, most of it esoteric, aimed at resolving the apparent contradiction between the hidden Godhead and divine revelation. Rabbinic sources of late antiquity occasionally refer to biblical anthropomorphisms as *kavod* (literally Glory). In Saadia Gaon's "Beliefs and Opinions," a Hebrew paraphrase of which was known among the Qalonymides, divine revelation is described as an angel named *kavod*.[26] The talmudic Sages called it *shekhinah,* a name for the divine Presence on earth (literally God's in-dwelling).[27] Whereas according to Saadia, the *kavod* was a created being, which was also the notion of later medieval philosophers, for Judah the Pious the *kavod* is related to God by emanation. Being identical with God, the *kavod* emanates from the Creator; further emanations form a chain, and it was the lowest linked member of that chain that was revealed to the Prophets.[28] The Pietists occasionally distinguished between the upper and the revealed *kavod*.

An entire corpus of Pietist literature, the so-called Literature of Unity *(sifrut hayihud),* deals with matters of divine revelation. A prayer entitled *shir hayihud* (Song of unity), which may have been written by Samuel the Pious, is part of the core of this literary activity. A praise of God and his Creation, it is based largely on Saadia's approach and is clearly anti-anthropomorphic. At some point during the late Middle Ages (the exact date is unknown) it was integrated into the regular Ashkenazi liturgy to be recited at the end of the Sabbath and holiday morning services. It is, in fact, included in the Leipzig Mahzor, where it was added on the pages in-

serted during the changes that were made in connection with the biblical texts at the beginning of each volume.

Unlike the abstract Godhead, the revealed *kavod* (Glory) is approached, imagined, and visualized in anthropomorphic terms. Often late antique anthropomorphic motifs from the *Hekhalot* literature or the *Shi'ur Qomah* tradition are related to the revealed *kavod.* According to Eleazar of Worms's *Commentary to the Siddur,* the appearance of the *kavod* with human features refers to the *shekhinah:* "Blessed be the *kavod* of the great Name that enlightens the beasts in his holiness from the place of his Throne. . . . This means blessed be the *kavod* of the Lord, who comes from the great Throne high up, and the *shekhinah* of his great *kavod* is in the place that is high up before the Throne; [it has] the appearance of a man."[29] By this he presumably did not mean an ontological being, but rather that God is revealed as a reflection of the upper *kavod,* as a visual equivalent without any physical quality. It is to this reflection that man turns in prayer, addressing his prayers to the upper *kavod.* On the other hand, it is concentration in prayer (and specifically concentration while uttering the letters of the tetragrammaton), together with proper intention and the resulting contemplation, that leads to the visualization of an anthropomorphic image of the *shekhinah.* The human imagination where the image is formed is compared to a mirror, in which the *shekhinah* appears as a reflection of the abstract Godhead. In the absence of the Temple, this visualization can take place only within the sacred space of the synagogue.[30]

This approach can be seen as a compromise between the two more radical attitudes—that of Maimonides and the assumed anthropomorphic position of the Tosafists. On the other hand, it appears that much of this controversy arose out of a clearly articulated opposition to anthropomorphism. One of Eleazar of Worms's treatises about the "Secret of Unity and Faith," was apparently composed in order to offer a clear answer to anthropomorphism.[31] The Qalonymides—like the Sephardi thinkers—were convinced that radical anthropomorphism existed and that there was an urgent need to counter it. To them it implied the tendency to refer to the Creator (and not only to the revealed Glory) in anthropomorphic terms. Even if we do not have a full understanding of those who held anthropomorphic views and their opponents, the Pietists certainly thought they did and were much agitated over these issues.

To those who were familiar with Pietist teachings and held a worldview influenced by the Pietist legacy, the visual allegory of a couple, with the bridegroom representing the male partner of divine love as found

in other mahzorim, would thus have been disturbing. Even if the image of the bridegroom was meant as an equivalent to the revealed Glory rather than the Creator, the mere possibility that it could be misunderstood would have been enough reason for them to recoil from such a depiction.[32] Even if it had been understood as an allegorical reference to the revealed Glory, the male figure would not have been sufficiently distinct from the notion of the male Godhead-Creator.

How, then, could the designer(s) of the Leipzig Mahzor ensure that an anthropomorphic figure, representing a visualization of the Song of Songs allegory, referred to the revealed *kavod* and not to the hidden Godhead? My reading of the Leipzig image of the couple suggests that the shift in gender roles grew out of concerns regarding anthropomorphism and the nature of divine revelation. A solution to this problem came from the circles that were so deeply troubled by anthropomorphism. The concept of a feminine divine principle emerged among both Ashkenazi Pietists and early Kabbalists in Spain and southern France in the twelfth century. Like the Pietists, early Kabbalists also grappled with questions of the hidden Godhead and the divine powers that could be revealed. There are two realms within God: a hidden and transcendent realm beyond human comprehension and the divine powers of God as he was revealed to the Prophets. These divine powers possess ten potencies—the *sefirot*. One of them, the tenth and lowest, is the *shekhinah*, also referred to as *malkhut* (kingship). In rabbinic Judaism the *shekhinah* was the presence of God in the world.[33] During the twelfth century a feminine principle was introduced and associated with the lowest of the potencies. The feminine *shekhinah* was studied in great depth in the twentieth century, first by Gershom Scholem and later by Peter Schäfer and Arthur Green.[34] More recently Dalia-Ruth Halperin and Irmi Dubrau suggested associating it with the bride in the Jewish wedding scenes.[35] Although this notion may not necessarily apply to all the parallels, in the framework of the Leipzig Mahzor and its connection with the Pietist legacy this suggestion deserves a further look.

Modern scholarship has given much thought to the precise emergence of the feminine principle and to its sources. As far as we know, the female features of the *shekhinah* appeared fully articulated for the first time in the *Sefer Habahir*, an early Kabbalist text written in the second half of the twelfth century in southern France. Most kabbalistic schools of the thirteenth century developed the concept further and focused on the (sexual) union between a masculine and a feminine divine potency, the goal of religious ritual being to induce this union.[36] A few decades after the development of the bahiric notion of a feminine divine potency, similar ideas also found their way into Pietist contexts. Around 1250 early Sephardi Kab-

balah began to be known in the German lands, especially among scholars who tended toward esoteric teachings, where it would ultimately be merged with Pietist mysticism. Our image will be approached here as a visualization of the feminine divine principle as it may have evolved in the mind and the imagination of the early fourteenth-century Ashkenazi designers of the Leipzig Mahzor. This concept was then conjoined with the content of the *piyyut* and the Song of Songs and, using a common Christian model, was merged into the elaborate composition that adorns the liturgy for the Great Sabbath.

Two notions encountered in rabbinic scholarship are expressed in the feminine grammatical form: the *shekhinah*, the divine Presence on earth, and *kneset Israel*, the community of Israel. The use of the feminine form does not necessarily imply that both these concepts were perceived as feminine beings. Despite the feminine gender of the word, talmudic thought associated the *shekhinah* unambiguously with the male Godhead,[37] and in the minds of Jewish philosophers the *shekhinah* was genderless.[38] Not only was the notion of the *shekhinah* as a female being alien to rabbinic thought and Jewish philosophy, but the *shekhinah* was in fact not perceived at all as a separate being, an independent hypostasis. It was only in the early Middle Ages that the *shekhinah* became a distinct *persona*. A text in *Midrash Mishle* describes the *shekhinah* standing before God and speaking to him.[39] Traditions such as these could then have led to the perception of the *shekhinah* as a distinct hypostasis, either created or emanating. Similarly, the definition of *kneset Israel* is a complex matter. *Kneset Israel* can be understood as a term defining the people of Israel.[40] It can also be thought of as a personification of the people or as an allegory, an understanding that governed the traditional allegorical interpretation of the Song of Songs in rabbinic literature. Kabbalists, on the other hand, understood *kneset Israel* as a separate hypostasis belonging to the divine realm, often identified with the *shekhinah*.[41]

The Kabbalah adopted the system of ten divine potencies developed in the late antique mystical treatise *Sefer Yetsirah* (Book of Creation) and employs it to deal with the question of divine revelation. As I noted above, according to the *Sefer Habahir* the lowest of these potencies is the *shekhinah*, which is at the borderline between the heavenly and the earthly realms and is sent down to earth as God's emissary.[42] More importantly, the *shekhinah* is understood as a female potency. The following parable demonstrates these two latter points.

Through the *shekhinah* man can access the oral Torah by means of the thirty-two paths of wisdom, a motif first developed in the *Sefer Yetsirah*: "What are [these] thirty-two? He said: these are the thirty-two paths. This

is like a king who was in the innermost chamber, and the number of rooms was thirty-two, and there was a path to every chamber. Did it suit the king to allow everyone to enter his chamber by these paths? No. But did it suit him not to display openly his pearls and hidden treasures, jeweled settings and beautiful things at all? No. What did he do? He took [his] daughter and concentrated all paths in her and in her garments, and whoever wishes to enter the interior must look this way [at her]. . . . At times, in his great love for her, he calls her 'my sister,' for they come from the same place; sometimes he calls her 'my daughter,' for she is his daughter; and sometimes he calls her 'my mother.' "[43]

This section alludes to the *Midrash Shir Hashirim Rabbah,* where it is the bride, Israel, that is described in these terms. The point of departure is Song of Songs 3:11: "Daughters of Zion, go forth and gaze upon King Solomon, upon the crown wherewith his mother has crowned him on his wedding day: This is compared to a king who had an only daughter, whom he loved very greatly and would call her 'my daughter.' Not satisfied with that he called her 'my sister.' And still not satisfied with that he called her 'my mother.' Thus the Holy one blessed be he, loved Israel above all else and called them 'my daughter.'"[44] The version in the *Sefer Habahir* thus adjusts the identity of the protagonists of the Song to correspond to the original midrashic version, and Israel becomes the *shekhinah.* A similar adjustment, I suggest, was made in the pictorial version of the Leipzig Mahzor, endowing the female figure, understood in the pictorial parallels as Israel, with the identity of the *shekhinah.*

Once the *shekhinah* had become a *persona* and been endowed with feminine features, her relationship to the Godhead and to Israel took on new dimensions. The bond between God (or the *shekhinah*) and Israel was a central issue in early Jewish mysticism, and the preoccupation with it probably counted as one of the factors in the process of canonization of the Song of Songs around the second century. It also had a determining influence on subsequent interpretations of this book, both exoteric and esoteric, redefining God's bond to Israel in terms of sentimental/erotic love and other forms of relationship common between human beings.[45] In earlier Jewish thought the male Godhead was not seen as seeking a heavenly partner; instead the object of his love, the female allegory of Israel, was in the human realm. Medieval mysticism added another type of relationship, the bond between the male Godhead and the female *shekhinah,* apparently one of the radical features of the *Sefer Habahir.*[46] Eventually, especially in later Kabbalah, this bond would be described in terms of erotic love and sexual symbolism.[47] The masculine principle dwells in the seventh or eighth potency and is paired with the feminine principle in the

tenth.[48] This pairing is also a dominant motif in early kabbalistic exegesis to the Song of Songs.[49]

Given our designer(s)' apparent concern with anthropomorphism, the pairing of the Godhead and the female *shekhinah* is unlikely to be implied in the image. Moreover, the way the male figure is represented and the notable difference in rank between the two partners decidedly preclude such an understanding. This leads us back to the notion of a relationship between the Divine (the female *shekhinah*) and Israel. According to the *Sefer Habahir*, the bond between the male Godhead and the female *shekhinah* engenders descendants, the people of Israel. This implies a range of further types of relationships: parental love and anger when Israel sins, and the mother, the *shekhinah*, is expected to assume responsibility for its behavior.[50] Elsewhere, finally, the *Sefer Habahir* also describes the bond between the Godhead and the *shekhinah* as a father–daughter relationship. The *shekhinah* appears as the daughter of a king being married off to a prince, perhaps understood to be Solomon.[51] The description of the *shekhinah* as a princess-bride in the *Sefer Habahir* certainly recalls the figure in the Leipzig Mahzor: "This is comparable to a king who had a daughter who was good and comely, graceful and perfect. And he married her to a prince and gave her garments, and a crown, and jewelry and he gave her to him with a great fortune."[52]

The quest of the object of divine love, as implied in the Song of Songs, is yet more complex. Another aspect of divine love was introduced in Sephardi religious poetry, where, for the first time, divine love not only referred to God's love for his entire people personified but could also mean divine love for an individual believer. The idea of a bond between God and an individual believer is also found in Sephardi philosophy, and we see it in the thought of Maimonides, Moses ibn Tibbon (early thirteenth century), Levi ben Gershom (1288–1244), and Joseph ibn Kaspi (1279–1340). Bearing in mind that the love described in the Song of Songs could refer not only collectively to the community of Israel but also, or rather, to the Jewish individual, the male reader of the Song of Songs could not easily identify with the female image of the bride. This reader is married to a human woman and prays daily, "Blessed are you Lord who did not make me a woman." In this constellation, the notion of the feminine *shekhinah* took on a new dimension and was put into a relationship with the individual male worshipper.[53]

Although the pairing of the Godhead and the *shekhinah* is undoubtedly the dominant motif in Kabbalah, under the influence of poetry and philosophy it can also be the Kabbalist himself who unites with the *shekhinah*. This idea first appeared in the *Sefer Habahir* in the parable about the

tripartite relationship among the *shekhinah,* the Godhead, and the prince to whom she is given in marriage.[54] In the writings of Joseph Gikatilla (d. c. 1305), a later Sephardi Kabbalist, or in the *Book of Zohar,* for example, the female divine potency could become the partner of the individual Kabbalist, who in penetrating her ascends into the upper realm.[55] As the pairing of the Godhead and the *shekhinah,* the definition of the relationship between the *shekhinah* and the Kabbalist can involve sexual symbolism. Abrams describes this as a revolutionary approach that dramatically changes the address of the individual Jew in prayer.[56] The male Jew no longer addresses a male God, the King of Kings, but rather the *shekhinah,* the feminine partner of the male God. The *shekhinah,* the Godhead's female lover, in her function as mediator, guides the individual believer through prayer and assists him in his efforts to imitate her in her attitude toward the Holy one blessed be he.[57] The *shekhinah* helps Israel to gain access to God and to the oral Torah.[58]

The feminine *shekhinah* as she emerges in the *Sefer Habahir* shares many features with the woman in the Leipzig Mahzor image. Dressed in beautiful garments, wearing a crown and a brooch, she seems to be listening to the young man who addresses her. The interaction between the figures underscores her function as a mediator who receives the worshipper's prayer and transmits it to the Godhead, whereas her matron-like appearance alludes to the motherly aspects of the bahiric *shekhinah.*

There are, however, yet further layers to the understanding of the female potency. In some contexts of the medieval mystical tradition, perhaps as early as in the *Sefer Habahir,* the *shekhinah* was associated with *kneset Israel,* a notion that had already occasionally been hypostasized in rabbinic thought.[59] Scholars have interpreted the bahiric divine mother, who is punished together with her children for their sinful conduct, either as the *shekhinah* or as *kneset Israel.*[60] Perhaps the identification of one feminine principle with the other accounts for this ambiguity. In the thirteenth century the association of the *shekhinah* with *kneset Israel* was clearly articulated in the *Zohar,* where, for example, the motif of the mother and her sinful children is now unambiguously identified as *kneset Israel.*[61] It was also well known to David ben Judah the Pious around 1300, an Iberian Kabbalist, who translated large portions of the *Zohar* from the original Aramaic into Hebrew and integrated them into his work. In his discussion in the context of *kneset Israel* as the lowest potency, the individual "can ascend and probe the existence of the intellect, which is the highest crown."[62] In her role as *kneset Israel* the *shekhinah* pleads for Israel before God. The feminine *shekhinah* thus emerges as a more complex figure: she is associated with the divine Presence below and represents the people of Israel above.[63]

There was yet another feminine notion, that of the personified female Torah, which became associated with the feminine *shekhinah* and would have particular influence on Ashkenazi mysticism. The idea of a female personification of the Torah somewhat echoes antique wisdom traditions. Wisdom *(hokhmah)* is a feminine notion identified with the Torah who served as God's tool for Creation. However, wisdom/Torah is understood as a book, not a hypostasis.[64] Still, the Torah is often personified in rabbinic literature and can be described as a daughter, a bride, or a mother. As a bride she can be betrothed to Israel, to God, or to Moses. Numerous sources refer to the Torah as the bride and the people of Israel as the bridegroom; the wedding is to take place on Mount Sinai, when the father gives the daughter away to the bridegroom. In one of these sources, the Torah "comes from the bridal chambers, adorned in all kinds of jewels and in all kinds of royal ornaments."[65] In Kabbalist and Pietist thought, the Torah was accorded features of a female *persona* and is occasionally identified with the *shekhinah*. This understanding is rooted in another rabbinic motif, namely the strong link many talmudic sources envision between the study of the Torah and the visible appearance of the *shekhinah*.[66]

The *Sefer Habahir* not only describes the Torah as God's bride, but also adumbrates the notion that the *shekhinah* is identified with the Torah.[67] The written Torah is placed in the third potency—*binah* (reason), from which all the (seven) lower potencies emanate, which also suggests the *shekhinah*'s central role as a mediator between God and man. In this capacity, she makes the Torah comprehensible to man. The divine manifestation of the Glory is associated with the written Torah, whereas the *shekhinah* in her earthly manifestation represents the oral Torah, which is considered more accessible to human beings. As Schäfer puts it, "the oral Torah . . . is not just a 'book,' but God himself who enters the world in the form of his daughter."[68] Equating the female Torah with the feminine *shekhinah* can be traced back as early as in the works of Judah ben Barzillai of Barcelona (early twelfth century), who may have influenced Pietist circles.[69] It was further developed by other Sephardi thinkers, particularly Nahmanides (d. 1270), and in the *Zohar*.[70]

If the crowned woman in the Leipzig image represents the female divine potency understood as the *shekhinah, kneset Israel,* or the Torah, the clearly indicated difference in rank is intended to mark the distinction between the couple's divine and the human partners. This brings us back to the treatment of light and shade in our image. As I noted earlier, the right side of the man, shown in three-quarter profile, is painted in darker shades than the left side, which is in the foreground. That the female figure shown frontally is cast totally in light suggests that this is an additional way of

differentiating between the Divine and the human. Light and dark are associated—not only in Judaism—with good and evil. In a reference to the *Sefer Yetsirah,* for example, Eleazar of Worms describes what is termed "good" and "evil" there as light and darkness. Following Dan's analysis of this section, darkness is a sphere that is reached by God, but is not part of God. A more striking reference to light and darkness, with interesting implications for my suggestion that light and shade in our image were employed to differentiate between the Divine and the human, appears in the *Zohar.* The text in question belongs to the stratum of *Tiqqune Hazohar,* composed by an anonymous author in the early fourteenth century. In a section that interprets Genesis 1:26 "Let us make man" we read the following:

> And God said, let us make man. . . . The most reverend elder opened an exposition of this verse by saying "Simon, Simon, who is it that said: 'let us make man?' Who is this *Elohim?* . . ." Rabbi Simon . . . said to his colleagues: "of a surety this is the Holy one blessed be he . . ." He then proceeded: we must picture a king who wanted several buildings to be erected, and who had an architect in his service who did nothing save with his consent. The king is the supernal wisdom above, the central column being the king below; *Elohim* is the architect above being as such the supernal mother, and *Elohim* is also the architect below, being as such the divine presence *(shekhinah)* of the lower world. Now a woman may not do anything without the consent of her husband. . . . When he came to the world of separation, which is the sphere of individual beings, the architect said to the master of the building: "let us make man in our image, after our likeness." Said the master of the building: truly it is well that he should be made, but he will one day sin before Thee, because he is foolish, as it is written (Prv 10:1): "a wise son rejoices his father, and a foolish son is a heaviness to his mother." She replied: since his guilt is referred to the mother and not the father, I desire to create him in my likeness. Hence it is written: "and God *(Elohim)* created man in his image," the father not being willing to share in his creation. Thus in reference to his sin it is written (Is 50:1) "and through your transgression your mother is dismissed." Said the king to the mother, did I not tell you that he was destined to sin. At the same time he drove him out and drove out his mother with him.

As we have seen, the notion of the *shekhinah* being made responsible for the sinful behavior of her children also appears in the *Sefer Habahir.* The text continues:

> The colleagues here interrupted and said, Rabbi, Rabbi, is there such a division between father and mother that from the side of the father man has been formed in the way of emanation, and from the side of the mother in the way of creation? He replied: my friends, it is not so, since the man of emanation was both male and female, from the side of both, father and mother and that is why it says (Gn 1:3): "and God said: let there be light and there was

light"—"let there be light" from the side of the father, and "there was light" from the side of the mother; and this is the man of two faces. This man has no image and likeness. Only the supernal mother had a name combining light and darkness—light, which was the supernal vestment and which God created on the first day and then stored away for the righteous, and darkness, which was created on the first day for the wicked. On account of the darkness, which was destined to sin against the light, the father was not willing to share in man's creation, and therefore the mother said: "let us make man in our image after our likeness." "In our image" corresponds to light, "after our likeness," to darkness, which is a vestment to light in the same way that the body is a vestment to the soul.[71]

Human existence thus knows both light and darkness, good and evil, whereas the Divine is cast in light and there is no darkness in it.

It thus appears that the Leipzig image of the couple owes much to early southern French and Sephardi Kabbalah, and we should look briefly at the channels that existed between the mystic circles of Iberia and those of the German lands. There is good reason to believe that the bahiric feminine *shekhinah* was known to Ashkenazi Jews of the early fourteenth century, especially among circles that were concerned with the Pietist esoteric tradition. Modern scholars long believed that the *Sefer Habahir* was introduced in Ashkenaz around 1270. At that time it was known to Moses ben Eleazar the Preacher, the great-grandson of Judah the Pious, who lived in Erfurt in Thuringia. Apart from his familiarity with the *Sefer Habahir,* we know that Moses was well acquainted with the teachings of the Ashkenazi Pietists and the *Hekhalot* tradition.[72]

Moshe Idel recently studied a group of texts that he attributes to a lesser-known Pietist, Nehemiah ben Solomon the Prophet. In this context he makes several observations that suggest that bahiric material was known in Ashkenaz even earlier than 1270. Nehemiah, who was active in Erfurt perhaps from the 1220s on, was associated not with the Qalonymides but with a less well-known school referred to in modern scholarship as "the circle of the *Sefer Haheshek.*"[73] We find several links between one of these texts and the bahiric concept of potencies and the ideas of the feminine *shekhinah* described as a princess. Earlier research always interpreted links between the *Sefer Habahir* and Pietist scholarship as an obvious sign of an Ashkenazi stratum in the bahiric tradition.[74] Idel, however, proposes that these motifs suggest the possibility that—on the contrary—the circle of Nehemiah the Prophet had some knowledge of early southern French Kabbalah.[75] Another Ashkenazi scholar, Ephraim ben Samson, active around 1240, seems to have been familiar with both the *Sefer Habahir*[76] and teachings now associated with Nehemiah.[77] In any event, by the time the Leipzig

Mahzor was produced, the *Sefer Habahir* had in all likelihood been known in the German lands for several decades.

Less is known about the transmission of other kabbalistic traditions, in particular the zoharic ones, to Ashkenaz.[78] A key figure in the reception of the *Zohar* was David ben Judah the Pious, who, as mentioned earlier, translated portions of the *Zohar* into Hebrew and integrated them into his *Sefer Mar'ot Hatsov'ot*. He is known to have traveled extensively to the German lands, among other places.[79] The making of the Leipzig Mahzor coincided with the period during which he was active, a particularly interesting chapter in the history of Jewish mysticism. Let us look, then, at what can be educed from Pietist writings toward delineating the role played by the feminine *shekhinah* in the German lands beyond and parallel to the kabbalistic influence.

Among the different notions associated with the feminine *shekhinah,* that of the personified Torah is particularly interesting in the Ashkenazi context. The Torah had a great deal of mystical significance in Ashkenazi Pietism, a feature that was studied in depth by Elliot Wolfson. The mystical dimension of the Torah is manifest in three different aspects: the divine names, the tetragrammaton, and the divine Glory. The latter can be found in several of Eleazar of Worms's writings and other Pietist sources.[80] In an anonymous *Commentary on the Seventy Names of God* the Torah is described as the "Glory *(kavod)* of the Holy one blessed be he."[81] Eleazar himself approaches the issue via number symbolism and refers to the thirty-two paths of wisdom, which as I noted earlier was a motif found in the *Sefer Yetsirah.* According to Eleazar, one way to write the name of God is with three *yods,* their numerical value being thirty. To this the letter *bet,* with which the Torah begins, should be added, its numerical value being two, making thirty-two altogether. The numerical value of the word *kavod* (Glory) is likewise thirty-two. Finally, the Torah begins with a *bet* (two) and ends with a *lamed* (thirty). He concludes this explanation by saying: "Thus we have thirty-two, which is the numerical value of *kavod.* There is no *kavod* but the Torah."[82] This recalls the bahiric *shekhinah,* who helps the worshipper access oral Torah via the thirty-two paths of wisdom.

Already in earlier rabbinic references the notion of the Torah personified can be found linked to the synagogue, the Torah shrine, and the Ark of the Covenant. In *Midrash Tanhuma* the Torah is described as the king's daughter, and the king declares: "Whoever enters against my daughter, it is as if he enters against me. The Holy one blessed be he, says: if a man desecrates My daughter, it is as if he desecrates Me; if a person enters the synagogue and desecrates My Torah, it is as if he rose and desecrated My Glory."[83] This text can be linked to late antique mystical traditions and suggests that

the Torah hidden in the synagogue ark is compared to a princess hidden in the seven *hekhalot* (heavenly shrines) and identified with the divine Glory hidden in the Ark of the Covenant.[84] Eleazar of Worms, finally, explains that the saying of the *qaddish* engenders visualization of the *shekhinah* within the Torah shrine: "When he says *yitgaddal* he should cast his eyes to the holy ark, for the *shekhinah* rests in it, as it says, 'I constantly place the Lord before me (Ps 1:8).' "[85]

The architectural structure that houses the crowned matron in our image can readily be associated with this notion. The arch refers to the symbolic form of the Temple, the house to be built by the couple of the Song of Songs and mentioned by Eleazar's sermon.[86] The Temple being destroyed, it is the synagogue that stands in its place. This was not a new idea in the thirteenth century and it was certainly not specific to Ashkenaz, but Jeffrey Woolf has recently shown that it attained new significance in medieval Ashkenaz, to the point that it could have had an effect on the ritual law and the development of new customs.[87] According to the *Zohar*, the Song of Songs, perceived by the Kabbalists as a mystic love poem about the Godhead and the *shekhinah* (the bride), was composed "when the Temple was built."[88]

Some of the Ashkenazi Pietists knew of the connection between the *shekhinah* and *kneset Israel*. A passage in the *Sefer Hahokhmah*, a text long associated with Eleazar of Worms but recently attributed in part to Nehemiah the Prophet, reads: "[The word] *bereshit* (in the beginning) [the first and last] letters [*bet* and *tav*] spell *bat* (daughter), and she is the community of Israel *(kneset Israel)*, who is called daughter [of Jerusalem, Lam 2], and daughter of Judah, as well as *bat qol* (literally daughter of the voice, a heavenly voice) for the voice of the prayer of the daughter if Israel ascends to the head of the Creator and sits next to him like a daughter that is called the *shekhinah*."[89]

Finally, the identification of the *shekhinah* with the Torah leads us back to the young man. We have seen that early Kabbalah speaks about the bond between the *shekhinah* and the individual believer. Idel, who follows Wolfson's interpretation of the Torah as the divine Glory, notes that if the Torah is "tantamount to the face of the *shekhinah*," as can be understood from Pietist writings, the "student of Torah may be conceived of as meeting the light of the face of the Glory or of God."[90] This thought implies a similar bond between the Torah/*shekhinah* and the individual believer rather than the allegorical understanding of *kneset Israel*.[91]

Finally, there was also a notion of prayer imagined as a female personification equated with the *shekhinah*, which could indeed easily be associated with the image of the individual worshipper. Based on an examination of texts associated with Nehemia the Prophet, Dubrau suggests that it

is this notion, equated with the female *shekhinah,* that stands behind the illustrations to "Come with me from Lebanon, my bride" in the Ashkenazi mahzorim. Her conclusion is based on the diadem *(atarah)* as a dominant symbol of prayer and identifies it with the bridal diadems shown in the mahzorim. It should be pointed out, however, that the crowns depicted in the various images of the couple are not all the same. Whereas in most mahzorim the brides indeed seem to be wearing bridal diadems, the woman in the Leipzig Mahzor wears a royal crown design.[92]

How, then, should the woman in the Leipzig illumination for the Great Sabbath be defined? Who is her companion and how does their relationship illustrate the *piyyut?* The poem, as we have seen, functions as a commentary to the Song of Songs and represents the rabbinic reading of the book as an allegory of God's love for his Chosen People. Thus the couple represents, first of all, the bride and bridegroom of the Song of Songs and the relationship between the Divine and the human. The way the two figures are depicted and the obviously higher rank of the woman suggests that the divine partner was endowed by the designer(s) of the decoration program with a new meaning, other than the traditional understanding of the Holy one blessed be he as the bridegroom, and that the gender roles were switched. If the divine partner is to be understood as a representation of the feminine divine principle, how close can we come to grasping what the early fourteenth-century designer of this imagery associated with this female figure and understanding how the image was viewed at the time? Which aspect of this figure can be linked to the Song of Songs and the *piyyut* to provide a satisfactory relation between text and image?

Several lines lead to insight regarding this representation: the bahiric concept of the female *shekhinah;* later kabbalistic sources, namely the *Zohar* and even the *Tiqqune Hazohar;* views that can be associated with the scholarship of Nehemiah the Prophet; and, to a lesser extent, traditions that can be linked with Eleazar of Worms. Whereas Eleazar's scholarship is well able to guide us through a reading of other images, here, as a matter of fact, it leaves us with a great deal of ambiguity. The *Commentary of the Song of Songs* attributed to Eleazar's circle follows the traditional rabbinic reading.[93] His *Hilkhot Kavod,* a short treatise on the divine Glory, deals with Saadia's views and does not reflect any familiarity with the bahiric concept or any other form of awareness of the feminine divine principle.[94] Even though some sources associated with Eleazar's scholarship do suggest this line of thought, albeit to a very limited degree, it seems, rather, that it was Nehemiah the Prophet who had a much clearer notion of the feminine divine principle. Several observations indicate that he was aware

of the bahiric concept, and, moreover, it is in his vicinity that we find various associations with the female *shekhinah*.

However, it was probably not any of these particular lines that led independently to our imagery. By the time the Leipzig Mahzor was produced, Nehemiah the Prophet's material was apparently no longer clearly identified as such, and much of it had already been associated with Eleazar of Worms and Qalonymide Pietism.[95] In modern research it was Idel who took great pains to separate the teachings of Eleazar of Worms and those of Nehemiah the Prophet. His meticulous analyses of Nehemiah's corpus not only enabled him to identify the author, but also to define his scholarly views, which were somewhat different from those of the Qalonymides. Nehemiah depended heavily on *Hekhalot* traditions and early magic literature, as well as on late midrashic traditions with leanings toward magic; he had a particular interest in the Metatron, the angelic Prince of Countenance of the late antique mystical tradition, but unlike the Qalonymides, he did not rely on the *Sefer Yetsirah*.[96] He also seems to have had a well-defined image of the feminine *shekhinah*. In terms of the reception of his writings, however, it appears that as early as the late thirteenth century the distinction between the two lines—the one associated with Nehemiah and the other connected with the Qalonymides—were already unclear and their traditions had mingled.[97]

From the point of view of the patron(s) and designer(s) of the Leipzig Mahzor, then, we should perhaps think of Nehemiah and the Qalonymides together, as these individuals might no longer have been fully able to distinguish between the two different lines of Pietism. As to why Nehemiah the Prophet was forgotten and the Qalonymides became one of the forces of medieval Jewish scholarship, it was perhaps the Qalonymides' tendency to open up to some degree to philosophical terminology that can account for it.[98] It seems to me that the Leipzig Mahzor image, which echoes a whole spectrum of notions associated with the feminine *shekhinah*, reflects something of this openness, rather than Nehemiah's conservatism and isolation. The authors of our image with their leanings toward the Qalonymide heritage may well have been dealing with Nehemiah's thoughts about the feminine divine principle without being aware that they did not fully represent Eleazar's worldview, but instead represented a distinct Pietist circle. Moreover, and more importantly, the author of the image must have been quite familiar with some of the Sephardi traditions, in particular the bahiric material, which, by the way, was also a determining influence for Nehemiah. It is not clear when exactly zoharic material was first known in Ashkenazi circles—as it is not clear when exactly during the early years of the fourteenth century the Leipzig Mahzor was produced—but if we

put all the evidence together, we can perhaps entertain the possibility that the designers of the Leipzig imagery also had some familiarity with zoharic ideas.

Most certainly, the author of the image did not see all the elements as separate scholarly traditions. He very probably had a mental image of the female *shekhinah,* with all her bahiric characteristics, being addressed by the individual worshipper in prayer and in Torah study. She is an imagined visualization, a result of prayer and study within the sacred space of the synagogue, the minor Temple. The image thus not only illustrates the *yotser* for the Great Sabbath, but also addresses the essence of the Leipzig Mahzor in its function as a communal prayer book. In a sense it closes the circle that begins with the representation of the prayer-leader at the beginning of the illustration program.

All that being said, the female figure in our image serves, first and foremost, as an illustration for the Song of Songs and represents the bride of the Song. To what extent did the early fourteenth-century designers of the image associate this feminine divine principle with the bride of the Song of Songs? How would it be employed as an illustration for the *piyyut?* Was the traditional view of the Song of Songs as an allegory of divine love still relevant for those who designed the image and those who viewed it around 1310? In studying the mystical concepts of the feminine divine potency, one cannot help but notice that they have less to do with the Song of Songs than might be expected. Motifs from the Song of Songs and interpretations of the book play only a very minor role in early kabbalistic descriptions of the female *shekhinah* in her relationship to the male Godhead or to the male human mystic.[99] The question is not simply whether the bahiric concept was a fitting way to illustrate a *piyyut* about the Song of Songs, but also and primarily whether this concept might or might not have had any impact on late medieval Ashkenazi thoughts about the Song of Songs. The *Sefer Habahir* and the Ashkenazi texts discussed here hardly ever cite the Song of Songs as direct proof text, but a second look at these texts shows that the Song and its medieval interpretations did inform the concept of the feminine *shekhinah,* though perhaps only indirectly. Scholars who have examined the concept have, indeed, observed various links to the Song of Songs.

We have seen, for example, that the notion of a female *shekhinah* may have been, in part, the result of an exegetical difficulty with regard to the Song after Sephardi poets and philosophers had introduced the idea of divine love for the individual.[100] This idea leads us back to the realm of early Sephardi Kabbalah. At first sight, the *Sefer Habahir* does not offer any specific link to the Song of Songs. Despite its several references to sexual

symbolism and allusions to human-type love relationships, it hardly ever quotes the Song in discussion of the *shekhinah*. We have also seen, however, that one of the parables in the *Sefer Habahir* characterizing the *shekhinah* in all her feminine qualities and containing all the female symbols accumulating in the tenth potency relies on the late antique commentary to the Song, the *Midrash Shir Hashirim Rabbah*.[101] Another section of the *Sefer Habahir* presents the etrog as a symbol of the female divine potency, equating it to the Song of Songs, which Rabbi Akiva had described as the holiest of books.[102]

One or two generations after the *Sefer Habahir* was composed, Kabbalists who wrote commentaries on the Song of Songs posited closer links between the bride and the *shekhinah*. Of these commentaries, those by Ezra ben Solomon of Gerona (d. 1230), Isaac ibn Sahula (d. after 1284), and Joseph ben Abraham Gikatilla (d. c. 1305) have survived.[103] These works, especially the first, which was the earliest, mark a shift from the traditional allegorical interpretation of the Song of Songs to a mystical reading of the book. In his introduction Ezra describes three approaches to the Song: the first, which he rejects, sees the Song of Songs as an earthly poem of "sexual desire, seductive enchantment and falsehood, vanity lacking all value"; the second is the allegorical one telling about the "love of the Creator, the God of the entire world, for the splendor of Israel." The third approach is mystical and belongs to "those who receive *shekhinah*. . . . the true wise men of Israel who have revealed its [the Torah's] secrets and hidden mysteries."[104]

These kabbalistic commentaries refer to Solomon as a priestly mystic composing the Song of Songs as a poem about the Godhead and the (female) *shekhinah*, the latter being, in turn, synonymous with *kneset Israel,* a notion that we have already observed in other kabbalistic contexts.[105] Kabbalistic links to the Song of Songs thus focus on the bond between the Godhead and the feminine *shekhinah* with its sexual symbolism, rather than on the relationship between the latter and the individual worshipper that seems to be reflected in the Leipzig image. From the point of view of the designer of the Leipzig composition, however, there were two good reasons to depart from the dominant kabbalistic motif. If the motivation to represent the feminine *shekhinah* arose out of an effort to preclude any misunderstanding of the bridegroom as an anthropomorphic rendering of the male Godhead, a representation of the love between the different divine potencies in terms of human love would not have made much sense. Furthermore, the representation of the young Jewish worshipper enabled the designer of the composition to make a last move in his iconographic journey and get back to the original understanding of the love between

God and his people, the main theme of the liturgical poem he was illustrating. He did not visualize any of the notions described in the different texts and translate them into a literal pictorial equivalent. Rather, he adopted motifs commonly found in the repertoire of the mystical thought of his environment, used them in combination with a Christian model, and adapted them toward a reinterpretation of the divine love described in the *piyyut.*

It is not the divine wedding, the mystical union between the Godhead and the *shekhinah,* that is shown in our image, which may be the reason its author scrupulously avoided any marriage-related symbols and allusions to romantic and erotic love.[106] Rather, the female *shekhinah* evoking the different meanings she implies, is shown addressing the Jewish man, and it is at this point that the imagery loses its straightforward link to kabbalistic readings of the Song of Songs. The erotic union between the potencies was not something that could be expressed anthropomorphically in a visual rendering. Neither could it be linked to the content of the *piyyut,* which focuses so clearly on the love of the Divine for Israel. Focusing on the *shekhinah* and the individual worshipper thus enabled the author of the image to exploit the bahiric concept of a feminine divine potency and still preserve the original meaning of the Song of Songs allegory and establish a maximum number of text-image relationships.

Moreover, kabbalistic exegesis of the Song of Songs occasionally goes beyond the reference to a mystic union between God and the Glory. In Ezra ben Solomon's commentary, the interpretation of "Let him kiss me. . . . (Song of Songs 1:2)" alludes not only to the union between the potencies, but also to the desire of the soul to unite with God: "These are the Glory's words, full of longing, desiring to make its ascent, to adhere to the light of the supernal luminescence to which nothing else is like. It ascends in thought and idea and thus speaks in third person. The kiss symbolizes the joy attained by the soul in its adhesion to the source of life."[107]

In the *Commentary to the Ten Potencies* attributed to Jacob ben Jacob Hakohen, a thirteenth-century Castilian Kabbalist who may have been acquainted with Ashkenazi material, the various characteristics of the *shekhinah* are joined together, with a clear link to the Song of Songs: "The tenth potency is called *shekhinah.* She is the diadem *(atarah)* and receives from the *yesod,* she is defined by her feminine [form]. She is this world, because the conduct of this world lies in her hand. . . . And she is called angel, and the Angel of God, because she was revealed in the burning bush, and to Hagar, and at many instances; she is called angel, and the *malkhut* emanates from her. . . . She is called the House of God, because it is a house of prayer; and she is the bride of the Song of Songs, the one who

is called daughter and sister; and she is *kneset Israel,* in which all are assembled."[108] It was also around the same time that Nahmanides, in his *Commentary to the Pentateuch,* related to some of the motifs of the *Sefer Habahir* and linked the bahiric divine Presence explicitly with the bride of the Song of Songs, which it identified as the congregation of Israel.[109]

Finally, the *Zohar* is replete with quotations from the Song of Songs, and these have been the subject of a recent study by Shifra Asulin. Naturally, the *Zohar*'s primary concern is with the bond between God and the *shekhinah,* and it lends the imagery of the Song of Songs a whole new dimension.[110] On the other hand, the Godhead also agrees to the *shekhinah*'s relationship with Israel.[111] Occasionally zoharic texts also discuss the notion of the union between God and the human soul that had been touched upon earlier in Sephardi Kabbalah.[112]

It is thus not necessarily the traditional motif of the bridegroom based on the fifth chapter of Song of Songs that lies behind the union that is alluded to in our image. This bridegroom has been the springboard for many mystical views concerning God's anthropomorphic features since late antiquity.[113] Although very common in kabbalistic interpretations of the Song, the motif of the divine bridegroom was not suitable for informing our imagery, which apparently was designed in an effort to eliminate any possibility that God's anthropomorphic features could be misinterpreted as being visualized in a painting. In the realm of visual representation, the alternative bond between the feminine *shekhinah* and the individual worshipper did not pose a problem and thus was preferred. The dominance of the divine bridegroom in mystical interpretations of the Song of Songs is the reason the Leipzig imagery seems to be linked to the Song only to a limited degree, a feature that at first sight makes the relationship between our image and the text appear to be a loose one. Thus it is that the bridegroom seems not to share much with the man in the image. Moreover, this may be the reason for subduing any romantic or erotic hints in the image, as the late medieval Jewish mind acquainted with the main themes of mystical thought would unavoidably have associated such hints with the kabbalistic notion of the erotic union between the female and male principles in the Godhead.

BOTH SCHÄFER AND GREEN argue that the notion of the feminine *shekhinah* owes a significant debt to the ever-growing Marian cult, which was a prominent feature in the Christian environment in which Kabbalah and Pietism developed. However, before we try to come to terms with this issue, it is worth looking at the channels of iconographic transmission between the two cultures. At first sight the image of the couple in the Leipzig

Mahzor reminds us strikingly of the familiar representations of Mary and Christ that began to appear on the tympana of thirteenth-century cathedrals (fig. 20). A by-product of the medieval cult of Mary, many such images were produced all over Europe—in France, England, the German lands, and Italy. They appeared not only on cathedral tympana, but in all the artistic forms of the time from frescoes to mosaics and from panel paintings to small objects, as well as in manuscript illumination. They show Mary, generally on the left of the composition, and Christ to the right, both seated on a broad, benchlike throne. Numerous examples show Christ crowning Mary. In others, angels or the dove of the Holy Spirit come down from above and place a crown on Mary's head. In some images the coronation itself is not shown, but Mary and Christ are engaged in speech or some other form of interaction. They face one another. Christ is normally shown in a gesture of speech, and Mary has her hands folded in prayer; in other examples they both gesticulate. In the majority of the latter type Mary is crowned, wearing the type of crown that in medieval iconography is normally worn by kings and queens.

Although the Leipzig image displays several of these elements, it also takes up a clear distance from others. Notable is the Gothic architectural structure reminiscent not only of the tympana compositions, but also typical of those in other media. The architectural motif plays a major part in the Leipzig image, both as the house to be built by the couple of the Song of Songs and as the proper setting in which the union between the *shekhinah* and the individual worshipper can take place. Similar, too, is the broad throne on which the couple is seated. Finally, as Christ in the Christian examples, the man in the Leipzig representation appears on the right, and the *shekhinah* occupies the left side, reserved in the Christian versions for Mary.

Although the general composition and the arrangement of the figures are thus strikingly similar, there are many differences in the details. These divergences suggest that the Jewish designer(s) of the Leipzig image made several efforts to adapt the imagery to suit the Jewish audience and were perhaps also inspired by more remotely related imageries. First, only the woman is crowned, whereas the man is a simple representative of the human Jewish believer. Moreover, the matron-like mature woman, in contrast to the virgin's veil and simple garment, is striking in her clearly secular costume—a yellow dress and a long red *surcotte*. Her hair is arranged under a net, a mark of a married woman, unlike the brides with uncovered, unbound hair in the other Jewish examples. Although decidedly expressing authority, she is rather passive, her hands resting on her lap (perhaps in an adaptation of Mary's hands folded in prayer), whereas the

young man seems to be doing all the talking. The difference in rank represents the gap between the heavenly and the human, whereas in most Christian images of the same period both figures are crowned and haloed and seem to be of the same rank, indicating that by that time Mary had acquired some degree of divinity.[114]

More interesting than a detail-to-detail comparison is the observation that the two imageries—the Christian and the Jewish—share some common ground in terms of the exegetical contexts that led to their emergence. However, there are also major differences that go hand in hand with the similarities, and, as it happens, these differences had crucial consequences for the Jewish–Christian polemical discourse. In the same way that the image of the couple in the Leipzig Mahzor illustrates the Song of Songs and its exegesis, Christian images of Christ and *Ecclesia*—the Church or the community of Christians—or Christ and Mary reflect Christian readings of the Song.[115] The Christian bride of the Song of Songs was originally understood as *Ecclesia*. In the third century Origen struggled with the question of whether she was to be referred to as the Church or the individual soul. The bridegroom represents the word of God and "indeed, he loves her deeply, whether she is the soul, made in his own image, or the Church."[116] Of these two options, it was the latter that had the most powerful influence on Western readings of the book.

During the twelfth century, when the *Sefer Habahir* was composed, the understanding of the bride as *Ecclesia* shifted to Mary.[117] This was the time when the imagery of the Coronation of the Virgin developed as an iconographic counterpart of this new understanding of the Song of Songs. According to Jacob of Voragine's thirteenth-century account of Mary's death, assumption, and glorification, the celestial meeting between Mary and Christ was accompanied by angels chanting "Come with me from Lebanon, my bride," sung a moment before she was united with her son.[118] Honorius of Autun (d. 1151) and others identified Mary with *Ecclesia* ("the glorious Virgin Mary manifests the type of the Church").[119] The image of Mary as the companion of Christ enthroned thus grew out of representations of *Ecclesia,* and in early renderings of the Coronation of the Virgin it seems that the two are one and the same.[120]

Similar to Jewish interpretations of the Song, the Christian exegesis at some point also underwent a development from allegorical approaches of the kind of Honorius's commentary to a search for an understanding of the literal sense and mystical meaning. From the latter point of view the bride becomes (again) the individual Christian soul seeking union with Christ the bridegroom. An early example of this concept is found in Bernard of Clairvaux's sermons on the Song of Songs, which combine

the allegorical ecclesiological and the mystic experience.[121] In Jeffrey Hamburger's words, "the Song is understood as a drama of amorous experience . . . of the affective, mystical relationship between God and the soul."[122]

German Dominicans were the leading proponents of this exegesis. The union between Christ and the soul takes place in the enclosed garden. This line of exegetical thought is the background to a series of images reproduced several times during the fourteenth and fifteenth centuries, entitled *Christus und die minnende Seele (Christ and the Loving Soul),* of which only fifteenth-century examples are extant. They appear as a woodcut series but hark back to manuscript examples from the early fourteenth century. These series translate the mystical exegesis of the Song of Songs into a rich narrative cycle with a step-by-step visualization of the encounters between Christ and the loving soul. Hamburger demonstrates that the sequence of images referring to the Song of Songs in the Rothschild Canticles, a Rhenish collection of mystical writings from c. 1300, must have been inspired by such a series.[123] Numerous motifs in the Rothschild codex are based on the Song of Songs and its mystical interpretation. Intended for daily use by a nun, this book, according to Hamburger's analysis, was supposed "to reinforce (the female reader's) identity as *sponsa Christi.*"[124] The original series of *Christ and the Loving Soul* was later enriched by a poem with the same title.[125] An example from c. 1470 of the picture series can be found in the Berlin Kupferstichkabinett (fig. 21); the image of Christ and the soul seated on a throne in conversation certainly recalls the Leipzig composition, although in a much more simplistic version.[126]

These observations are intriguing. Representations of the Mary–*Ecclesia* allegory were widespread all over Europe and could be seen in public places, such as the façades of churches, that were also easily accessible to Jews. Images of *Christ and the Loving Soul,* on the other hand, though in existence during the early fourteenth century, were not only relatively rare but, as Hamburger points out, also confined to the enclosed world of the female convent. The motif emerged in an ambience of mystical Pietism (of which the mystical interpretation of the Song of Songs was a by-product), an ambience that shared some features with Ashkenazi Pietism with its mystical tendencies. The Mary–*Ecclesia* imagery would have appeared to be a Christian counterpart to the Jewish reading of the Song of Songs as an allegory of God's love for his people. The motif of the *minnende Seele,* on the other hand, would have been the by-product of a novel interpretation of the Song of Songs in the thirteenth and fourteenth centuries that read the Song as a mystical text. In some sense, despite the fact that images of the loving soul may have been less accessible than cathedral tympana with the *Ecclesia* allegory, the *minnende Seele* seems to be a closer equiva-

lent to the mystical interpretations of the bride as the *shekhinah,* as Torah personified, or as *kneset Israel* accompanied by the individual worshipper or his soul imagined as the bridegroom. In essence, and despite the reversed gender roles, the relationship between the *minnende Seele* and Christ is very similar to that of the individual Jewish worshipper and the *shekhinah.*

Our image is thus part of the history of the interpretation of the Song of Songs. In many respects, Jews and Christians shared similar exegetical approaches to this book, designed to make particular points in the polemical discourse. First the bride was the community of believers. This basic interpretation was not questioned, the crucial matter being whether she was the *kneset Israel* or *Ecclesia.* Later the bride was understood to be Mary or the *shekhinah,* the former being at some point identified with the Church and the latter with *kneset Israel.* The Christian bride can also be seen as representing the Christian soul, and by analogy the Leipzig bridegroom appears to represent the individual Jewish worshipper. Do we necessarily have to assume that the Leipzig artist used a Christian model, adapting it, or should we see the Christian and the Jewish authors of the images as members of a similar visual culture? The designer(s) of the Leipzig image had certainly seen images of the Coronation of Mary, the *Ecclesia* allegory, and the mystical union of Christ and his *sponsa* on church façades in his environment. In one way or another he might also have had a notion of the *minnende Seele.* Thus our image reflects a certain degree of familiarity with Christian ideas and is indicative of shared cultural tendencies.

This all brings us back to the assumption that the bahiric concept of the female *shekhinah* emerged under the influence of the Christian cult of Mary, which developed to a significant degree during the twelfth century and had a strong hold on Western religious life in the thirteenth and fourteenth. Schäfer and Green juxtapose similar notions of the *shekhinah* and the Virgin and consider a direct Christian influence on the bahiric concept.[127] However, they did not take into account questions of adaptation, particulars of the translation from one culture to the other, and the issue of polemical dialogue. Neither did they consider the emergence of the feminine *shekhinah* as a result of parallel cultural traits within an environment of shared mentality.[128]

We can, indeed, discern several links between the notion of the *shekhinah* and the qualities represented by Mary. Similar to the complex bond among the Godhead, the *shekhinah,* and Israel, the relationship among Mary, Christ, and the Christian community has more than one aspect. Mary and Christ represent a mother–son relationship, but they are also the bride and bridegroom of the Song of Songs in the Christian understanding

of this text. In this sense Mary becomes the partner of God/father. The couple relationship between Mary and God implies that she is also the mother of mankind.[129] In the *Sefer Habahir*, as we have seen, the pairing between the Godhead and the feminine *shekhinah* produces the community of Israel. Mary's divine features are shared by the bahiric *shekhinah*, a divine potency. Another of Mary's attributes is her role as mediator between God and the Christian believer. Similarly, the *shekhinah* is an intercessor between God and humanity, receiving the prayers of individual believers and passing them on to the divine realm.[130] There are, however, also notable differences in the two concepts, especially the notion of virginity as a value, which is utterly rejected in Jewish thought in general and in mysticism in particular.[131] The cult of the Virgin also lacks the aspect of sexual union, which is so central to the Kabbalistic concept.[132]

Whether the assumption that the Jewish notion of the female *shekhinah* is solely indebted to the Christian cult of Mary is not for me to decide, but observation of the two imageries certainly adds an interesting dimension to the question. As much as the Leipzig image combines a whole set of different notions into one visual rendering, the emergence of the bahiric *shekhinah* is most likely indebted to a more complex set of circumstances than the cult of Mary alone. What concerns us here is not necessarily the ultimate root of this or that idea, but rather the dynamics of such borrowings—on both the textual and the visual level—in the Ashkenazi context.

Christian models were attractive, but at the same time also highly problematic. The Coronation of the Virgin, "the new theophany of Gothic art," as Philippe Verdier refers to the Christian compositions, was not just a model.[133] Admittedly, it encompassed a range of notions that were shared by Jews and Christians, but at the same time Jews totally rejected crucial central aspects of the Christian versions. Depictions of theophany as such do not exist in Jewish art, but are circumscribed in various ways, and recognizing the parallel features of Mary and the *shekhinah* might, indeed, lead to a suitable formulation of a theophanic composition. As such our illumination goes far beyond the allegorical images of other mahzorim, but adopting a Christian model of theophany posed two problems that had to be solved by the author of the Leipzig picture. First he had to make certain that the man would not be misunderstood as Christ; second, he had to be sure that the figure could not be taken as an anthropomorphic representation of the Creator. The theophanic element thus moved from the man to the woman, indicated in the difference in rank between the two. Now, the author of the image had to make sure that the woman would not be misinterpreted as Mary. He adapted her, made her a married matron, and dressed her in the secular garments of a queen, so that he

could endow the figure with all the features of the bahiric *shekhinah*. The resulting theophanic image was thus acceptable within the framework of Jewish attitudes to the Divine and to divine revelation. The notion of the loving soul may have made that process of adaptation easier, even though we cannot say anything conclusive concerning the role it may have played in the conception of this composition. The male Christ figure would have been transformed into an image of the female *shekhinah,* and the loving soul, a woman in the Christian context, would have turned into the image of the young male worshipper. Whatever the case, the focus on the female *shekhinah* and the change in gender roles in relation to the traditional allegory of divine love provided a proper Jewish response to the Christian reading of the Song.[134]

CAN WE ASSUME then that the designers of the Leipzig Mahzor went so far as to "portray" the divine Presence in an anthropomorphic image of the female *shekhinah?* What exactly would such a "portrayal" mean? In his discussion of the ways that Jewish mystics and in particular of Ashkenazi Pietists created mental images of God, Wolfson points out that although visual representations of the Divine exist in Judaism in various forms, they were not approached iconically, but served only decorative or symbolic functions. Mystic speculations always tend to be highly visual; they grow out of a strong will to visualize the Deity. Jewish culture tends to be aniconic in the sense that it endows visual representation with decorative or symbolic, but not with iconic value. However, "religious experience," as Wolfson puts it, "described in the different currents of Jewish mysticism from late antiquity through the Middle Ages is overwhelmingly visual." This creates a great deal of tension in Jewish mysticism.[135] He notes that "seeing the *shekhinah* is not a purely mental vision, but involves some corporeal shape or tangible form—if only in the imagination— usually described as luminous in nature." Several texts in the rabbinic literature indicate that seeing the divine Presence is possible only after death; others imply that such a vision can be "harmful and dangerous."[136] Wolfson argues that Ashkenazi Pietists connected this notion of visualizing the light of the *kavod* as an anthropomorphic shape with the tradition of late antique Chariot mysticism. In this sphere, too, such speculations produced a great deal of tension between the notion of God's incorporeality informed by the medieval philosophical discourse and midrashic anthropomorphism.

The *Zohar* refers to the *shekhinah* as the "image comprising all images."[137] The Aramaic text uses the word *diokana*. The *Zohar* uses this term hundreds of times, and the English translations are not entirely consistent in this matter, referring to "image," "form," "sign," "paradigm," "likeness."[138]

Whereas Matt's recent translation reads "image" referring to the *shekhinah*, Sperling's and Simon's has "form," an understanding that also underlies Scholem's reading of this section.[139] It is worth noting, however, that David ben Judah's translation into Hebrew of "the *diokana* that comprises all the *diokana'ot*" reads *tmunah*—"image"—the same *tmunah* that is included in the biblical prohibition against making a graven image of God (Ex 20:4).[140]

Wolfson also observes that the idea of worshipping a "mental icon" perceptible in Pietist arguments has a counterpart in John of Damascus's defense of icons, claiming that the icon becomes a mental image. Similarly, the notion of identity between a (mental) icon and its prototype figures in both Pietist thought and Byzantine discussions of icons.[141] Unlike the rabbinic concept that emphasizes that different visualized images of God do not imply separate hypostases, in Pietist thought, Wolfson argues, the different images—God as warrior or as elderly scholar and the *shekhinah* as Torah—are hypostatic entities.

These remarks indicate that the boundary between physical image and mental icon can be blurred. How exactly does a mental image become a two-dimensional small-scale picture in a liturgical manuscript? Could the Pietist notion of a mental image develop into a more "popularized" version of a physical representation? This is a complex question, which also has to do with the problem of whether or not esoteric teachings should be written down. At the beginning of the Pietist movement esoteric teachings were supposed to be kept secret and transmitted orally to a small circle of students and disciples. Scholars are still struggling to discern the motive that led to Eleazar's decision to put his esoteric teaching into writing.[142]

In any case, the appearance of these texts initiated a process of reception that we find difficult to reconstruct. Most extant manuscripts of the esoteric Pietist writings are later than the fourteenth century, but the fact of their existence certainly indicates that there must have been some uninterrupted manuscript tradition, even if not all the books survived. We do not know much about who copied such manuscripts or who commissioned them. This is true, of course, for all Pietist writings and also includes, for example, the texts of Nehemiah the Prophet. Moreover, oral communication must have been involved as well. What did scholars do with knowledge they acquired from esoteric texts? Did they teach it to small exclusive circles or to wider audiences? In Daniel Matt's words, "the notion of a feminine aspect of Divinity. . . . became a keystone of all Kabbalistic thought and had a profound effect on the *masses* of Jews from the 14th century on [my emphasis]."[143] It is here that the patron(s) and designer(s) of the Leipzig Mahzor become relevant. In what way did they represent these "masses"? How did they become familiar with the notions of an

imagined female *shekhinah* personifying the Torah and communicating with the individual worshipper?

Of course, we should not imagine a patron or artist, as the designer(s) of the imagery, seated before a sheet of parchment, planning an image suitable for the *piyyut* of divine love and at the same time consulting some esoteric text that offered all the details and only had to be translated into a visual idiom. This was certainly not the case. Rather, our image is the result of an altogether different kind of mental process, which consisted of several particular ingredients—certain cultural phenomena. The idea of the feminine *shekhinah* lived on in the thought of later mystics, who were nourished from both the Pietist heritage and Sephardi Kabbalah. Echoes of it are found, for example, in a controversy between Judah the Pious's great grandson Moses ben Eliezer and an anonymous mystic about the *shekhinah* interacting with the human soul.[144] Moreover, only the particular combination of these elements could have led to a particular image in a particular place at a particular time.

First, the esoteric texts had been written down and the *Sefer Habahir* had reached the German lands apparently as a physical book, so that these esoteric traditions had clearly lost some of their intended secrecy. Second, there was the wish on the part of the designer(s) of our manuscript to endow the *piyyut* "Come with me from Lebanon, my bride," with a proper meaning; this wish was informed by notions of the female *shekhinah*, known in some way or another to the author(s) of our imagery, who associated them with the bride from the Song of Songs. Third, there was the stress on an imagined vision of the revealed Glory in some of the esoteric traditions, which spoke a highly visual language. Fourth, there was an interest in the tradition of allegorical exegesis of the Song of Songs, which had encouraged representations of the couple in other manuscripts, and the fear that the bridegroom allegory might be misunderstood as an anthropomorphic figure of the invisible male Godhead. Our image is thus evidence of the long way traveled from the secret teachings to an act of visualization in a physical picture and several factors determined the direction this journey would take. It seems to me that this process and the resulting image offer some insights into the reception history of esoteric Pietist and Kabbalist thought.[145]

The Throne of Glory

The image of the couple addresses issues of visualization of the revealed Glory, the feminine *shekhinah*, and her relationship to the Jewish

worshipper. There is, however, yet another image that approaches the notion of the invisible Godhead. The initial panel decorating the *yotser* for *shabbat sheqalim* (fig. 16) functions as a call to repent and can be associated with the penitential system of the Qalonymide Pietists. The act of penance, leading to final atonement and bringing mankind closer to salvation, is performed before the Throne of Glory, where the hand of the Holy one blessed be he is stretched out underneath the wings to receive the repentant. The *piyyut* itself *el mitnasse* (God, the mighty one) deals not only with the People of Israel paying ransom, which promises redemption and atonement, but also refers repeatedly to Ezekiel's vision and the Throne of Glory.[146] In its very first sentence, in fact, the *piyyut* mentions Israel's chosenness and declares that "Israel raises her head at the Throne of Glory."

Visions of the Throne of Glory have been among the central themes of Jewish mysticism since biblical times. Whereas in the biblical and post-biblical tradition the locus of the visualized divine Presence was the Ark in the Holy of Holies and the Throne provided the more abstract notion of the upper realm, in the late antique *Hekhalot* tradition and apocalyptic literature God is visualized in the heavenly realm rather than in the Temple.[147]

The Leipzig depiction of the Throne is confined to the medallions with the four creatures, whose arrangement follows the description in the book of Ezekiel. Their appearance, however, does not correspond to the biblical text. According to Ezekiel, each creature emerged as a figure with four faces: lion, bull, eagle, and man. As most artistic renderings, the Leipzig Mahzor presents them as separate beings; moreover, they do not have the wings that figure so prominently in the Christian renderings. Even though wings figure abundantly in Ezekiel's description, they might have been associated with Christian angelology to a degree that made the Jewish designer(s) of the image uncomfortable. Their appearance as separate beings, on the other hand, does follow the Christian model closely. However, the reason for this divergence from the biblical text probably lies not solely or primarily in adherence to the Christian counterparts, but in a halakhic restriction regarding the visualization of the tetramorph. In his treatise *Orhot Hayyim*, Aaron Hakohen of Lunel quotes a relevant responsum by Solomon ibn Adret of Barcelona (d. c. 1310) on laws concerning idolatry: "It is forbidden to create the form of the four creatures as one figure with four faces, but creating one of them alone is not [forbidden]." After a few words of reservation regarding a figure of the man, he goes on: "and that is why it is allowed to create the form of the lion, the eagle, and the bull—each on its own."[148] As it is remarkable that halakhists treated this subject at all, artistic renderings of the visionary creatures must have been an issue.

Hence, the image with its visual reference to the Throne of Glory, or, more precisely, its lower part, does not function merely as an encouragement to perform acts of penance. Pietists' writings are replete with visions of the Throne and the figure of the human creature is the key to coming to terms with their visualizations. Not only does it lack the wings—as the other creatures do—and thus diverges from its Christian angel-like counterpart, but it was clearly meant to appear yet more distinctly in relation to the other three creatures. The three animals—the lion, the bull, and the eagle—gleam as golden silhouettes against a blue, almost black, background. They are framed in golden medallions alluding to the mention of the wheels in the visionary text in Ezekiel 1:15: "and I saw wheels on the ground, one beside each of the four." The man, on the other hand, is not shown in silhouette, but as a figure painted in color wearing a rather simple hooded garment, perhaps of sackcloth, and holding, almost embracing, a book. His medallion is red and blue rather than gold, whereas its background was meant to be silver, even though it has darkened owing to centuries-long exposure to oxygen. If we assume that the use of precious metals underscores the gloriousness of the beings, the figure of the man is thus no less glorious than that of the animals, but he is clearly meant to be distinguished from them. The realistic rendering of his figure seems to underscore the human aspect of the creature, and a closer look guides us specifically to the Pietist notion of the Throne of Glory.

Visions of the Throne of Glory abound in late antique mystical literature, and the lines that can be drawn from these latter traditions to Pietist thought and early Sephardi Kabbalah have been among the primary interests of scholars of Jewish mysticism in their discussions of the Throne.[149] Not only was mystic envisioning of the Throne of particular interest in Qalonymide scholarship, but it is in this realm that it was often linked specifically to prayer and *piyyut*. In fact, the genre of *ofan*, a type of *piyyut* that belongs to the *yotser* complex, focuses on the heavenly wheels *(ofanim)* and the four living creatures. Whereas early poets were careful not to elaborate on these aspects following the talmudic restrictions regarding speculations about the Throne, later Rhenish scholars were more inclined to incorporate these features into their poetry. The *ofan* genre thus became especially popular in medieval Ashkenazi culture.[150]

Although approaches to the Throne itself and the abstract Godhead are for the most part purely esoteric, discussions of the Throne's base and the four creatures tend to be more descriptive, merging mystical and traditionally exegetical notions. This is also true of the mystical treatises associated with the Ashkenazi Pietists. Their discussions of the tetramorph often cross another tradition—that of the image of Jacob engraved on the

Throne of Glory. The roots of this latter tradition lie in the Aramaic version of the narrative of the dream of Jacob's Ladder, which talks about the angels who climb up the ladder on the night of Jacob's dream to call their fellow angels to look at the figure whose image is engraved on the Throne.[151] This motif later became part of the exegesis of Ezekiel's description of the Throne (Ez 1:26): "Above the vault over their heads there appeared, as it were, a sapphire in the shape of a throne, and exalted on the throne a form in human likeness," and figures prominently in the *Hekhalot* literature.[152]

Several different ideas were associated with this image of Jacob, but most often it was simply implied that a likeness of the Patriarch's face is engraved on the Throne.[153] Another tradition explains that the human form believed to be seated on the Throne (Ez 1:26) is that of Jacob.[154] A third one associates Jacob with the Metatron, the Prince of Countenance.[155] Wolfson suggests that in these latter two views Jacob is accorded features of a divine hypostasis and that they sometimes resemble those associated with the feminine *shekhinah*.[156]

The humble figure of the man in the upper-left medallion does not share any of these features. Yet another tradition, finally, identifies the fourth creature of the Ezekiel vision, the human being, with Jacob, the Patriarch, and Israel, the nation. A *qerovah* about the Throne of Glory composed by Eleazar Qallir, read on Rosh Hashanah, refers to this latter tradition as early as in the sixth or seventh century.[157] The medieval midrashic text *Sekhel Tov* reads as follows: "Rabbi Hiyya, Rabba and Rab Yannai, one says: they stepped up and down on the ladder and left him; the other says: they stepped up and down in order to stay next to Jacob. . . . [In order to see] him whose image is engraved in the upper sphere, they stepped up and saw the fourth creature on the Throne of Glory, whose name is like his, Israel, and then they stepped down and found him sleeping."[158] This tradition was also known to the eleventh-century Sephardi Talmudist Judah ben Barzillai, who wrote a commentary to the *Sefer Yetsirah*.[159] Likewise, Rashi mentioned it as commentary to both Ezekiel 1:5 and the midrash about Jacob's dream.[160] A *selihah* for the third of the Days of Awe between Rosh Hashanah and Yom Kippur, authored by Simon ben Isaac the Great of Mainz (d. c. 1020) refers to the engraved image of Jacob as follows: "[God] looks at the form of the simple (Jacob) engraved on the Throne: to the right a lion . . . to the left a bull . . . the vision of the face of a man . . . the sound of the eagle." The *selihah* is entitled *shevet hakise* ([the Glory] is seated on the Throne) and discusses the Throne of Glory at length. It opens: "[the Glory] is seated on the mighty *(menusse)* Throne up high; it will plead for us before the mighty rock (Lord, *tsur hamitnasse*), the King

on the Throne."[161] The different forms for "mighty" *(menusse, hamitnasse)* are echoed in the wording of the *yotser*'s title *el mitnasse*.

Among the various Pietist scholars, it was Eleazar of Worms who elaborated on this motif. His commentary to the book of Ezekiel discusses the image of Jacob at great length. He starts out with an explanation of "I saw divine visions," the conclusion of the first verse of the book, noting that the chapter alludes to nine different kinds of visions, one of them being "the vision of the man." A few lines down he explicitly mentions the image of Jacob and writes about it in great detail:

> And the man goes first, as it is written (Ez 10:11), "they go in the direction where the head goes." And it is known that the man is the most glorious among the creatures. And the man's head is more glorious than the rest of his limbs, therefore it is on top. And this head is in the countenance of Jacob, our father, may he rest in peace, as it is engraved on the Throne of Glory. About this we read (Lam 2:1): "He has cast from heaven to earth the Glory of Israel"—Israel stands for My Glory. . . . And it is written (Gn 28:13): "and behold, God stood above it [the ladder]"—as on the Throne above and he will go and be seated on the Cherub. And it is written (paraphrasing Nm 7:89): "and he heard the voice speaking to him between the two Cherubs." Jacob is referred to as small and the Cherubs are described as having small faces. And the Holy one blessed be he spoke to Jacob five times. There he is referred to in the book of Ezekiel. The face of the human creature is [that of] Jacob engraved in the Throne. The final letters of the words *the Throne of Glory up high* form the word *Adam*—man. . . . Jacob said: "Am I *(anokhi)* in God's place."[162] The numerical value of "I" equals that of "Throne." Therefore Jacob receives the splendor when the prayer ascends. And it is written (Ex 24:10): "and they saw the God of Israel and under his feet [was something like a pavement made of Sapphire]"—you should read the house of Israel under his feet. "Each of them had a human face (Ez 1:10)"—the equation is well known. The final letters of the words "each of them had a human face" form the word *tamim* (simple); the image of Jacob, the "simple man" (Gn 25:27).[163]

Not only does Eleazar's commentary offer a detailed exploration of the motif of Jacob's image being associated with the face of the man, but not less importantly he links the whole vision of the four creatures and the wheels explicitly with the notions of judgment, penance, and mercy. The association of the penitential system mentioning "the hand underneath their wings" found earlier in the *Commentary to the Siddur* recurs. This observation consolidates the main themes of the images that allude to mystical teachings: "Hands of a man were underneath their wings (Ez 1:8): His hand—the hand of the Holy one blessed be he underneath the wings of the beasts to receive the repentant." The following sentence goes beyond the link to the penitential system and takes us into the realm of prayer:

"[the hand] also receives the prayer and the thanksgiving. . . . And the hands of a man: the hand of the Holy one blessed be he . . . the hands of a man, who appears in the image of Jacob, as it is said underneath their wings, [these words] being terminated [by the letters that form the word] simple *(tam)*, as it is said (Gn 28:27): "and Jacob was a simple man sitting in the tent—'sitting in the tent' this refers to the tent below and to the tent."[164] This paragraph appears almost as a summary of the entire visual message: the human creature as Jacob, the link to penance, and the role of prayer. A few pages later Eleazar associates the notion of mercy with the four creatures: "The eagle has to appear behind the man. When Israel sins, the man puts the yoke of sins upon the bull and judgment will be fulfilled. The [image of the] eagle seeing [indicates] that the Glory will be merciful, [as it is written] 'Like an eagle who rouses his nestlings, gliding down to his young (Dt 32:11).' The Glory immediately looks at the face of the human, the image of Jacob, and has mercy on them . . . (Gn 9:15) 'I will remember my covenant'—Jacob."[165] In Wolfson's words, Jacob is thus "transformed into a mythical depiction of the attribute of mercy," a motif that has particular meaning in the general theme of the image, penance, and judgment.[166]

The simple hooded garment worn by the human figure of Jacob-Israel in our image underscores the repeated references to Jacob as the "simple" man, and in Eleazar's commentary to the book of Ezekiel it takes on a mystical dimension. As early as in the description of the four creatures in the *qerovah* referred to by Qallir, the man appears as "the image of the simple man *(tam)*," taking the words from the book of Genesis that describe Jacob as a simple or mild man sitting in the tents, as opposed to the wild Esau, the hunter.[167] The expression *tam* is frequently explained in rabbinic literature as a hint that Jacob had enjoyed a rabbinic education and had become a scholar.[168] Beyond the notion of Jacob as a simple, honest man, who dwells in the tents, Ashkenazi Pietists of the thirteenth century also mention the motif of Jacob being "small," in the sense of being humble, which is hinted at in the above citation of Eleazar's text.[169] The man in the Leipzig image is shown as a "simple man" by means of his costume, and the book in his hands characterizes him as a scholar.[170] As Jacob he represents the community of Israel, in contrast to Esau the Christian hunter alluded to in the hunting scene in the upper frame.[171] He may also represent the pious and the penitent members of the community. Finally, the brownish garment he wears recalls a statement about Judah the Pious, who was known to have worn sackcloth.[172] This would make Jacob-Israel a representative of the most pious among the people.[173]

The basic arrangement of the four creatures within medallions is indebted to Christian art (fig. 17). This choice, however, was not made randomly. The

appearance of the four creatures as separate beings, but each within a wheel and thus attached to it, fits first of all the halakhic remark about the possibility of drawing each of the creatures separately. The attachment of the creatures to the wheels figures in the imagination of the Ashkenazi Pietists, and Eleazar explains it as follows: "The creatures and the wheels are attached as one body on the lower part [of the Throne] and when the creatures go the wheels go with them."[174] This composition thus not only corresponds well with the halakhah, but the close attachment of the wheels to the creatures can easily be visualized by the Christian model of medallions framing the creatures.

The Leipzig image of the Throne of Glory, where the hand of God receives the repentant, must indeed be indebted to some of these traditions. The iconographic modifications of the Christian formula are guided by several elements of Pietist lore. The notions of the image of Jacob are as manifold and faceted as those associated with the feminine *shekhinah*, but the image of the balance amid the four medallions does not reflect the full range of theological strata in the texts. Unlike the picture of the mystical couple, this image is rendered more naively. It focuses on the issue of penance, and it represents the mystic notion of the Throne in quite a conventional manner rooted in Christian iconography. The designer(s) could well have been aware of the tradition about the fourth creature being identified with the engraved image of Jacob. However, it seems to me that they had no deep knowledge of all the esoteric implications of Throne mysticism, but approached it rather as some sort of midrash, a familiar motif that gave them scope for some imagination. This is even more obvious when we look at the somewhat simplistic use of the initial *el* as an abstract representation of the Godhead receiving the penitent. Although Eleazar ben Judah's discussion of the tetragrammaton in *Sefer Hashem,* one of the most complex of the Pietists esoteric treatises, addresses letter symbolism in relation to the abstract Godhead, the golden letters in the center of the elaborate initial panel are not particularly indebted to the complex speculations in that book.[175] On the other hand, the representation of the Godhead by means of letters seems to indicate that the designer(s) of the image were well aware that there was such a notion in the mystical repertoire of the Pietists.

Let me conclude these observations by citing Abrams's and Farber-Ginnat's summaries of the Pietists' *merkavah* teachings, which argue that there are four basic concepts that dominate these discussions: first, the neoplatonic concept of emanation; second, several structural characteristics typical of the *merkavah* notion, of which Jacob's image is the central one; third among the dominant qualities of the *merkavah* is its being representative of judgment and mercy; fourth, the *merkavah* makes possible the ascent of

"the Crown of Prayer" to the head of the Glory.[176] Apart from the first, which is beyond visualization, even though as a concept it is touched upon in the image of the mystic couple, these concepts all had an impact on our composition: Jacob as the human creature; the Throne of Glory, where God's hand receives the repentant; and the hope that the prayer performed while the image lies open before the eyes of the prayer-leader fulfilling the obligation of many may ascend to the realm of the Glory.

Prayer

The last concept brings us back to the image of the prayer-leader (fig. 10), which also bears a mystical dimension beyond its ritualistic aspects. The imagery is not explicit with regard to this mystical dimension, but in the world of the Qalonymide Pietists prayer was so strongly associated with mystical experience that this cannot be separated from the image with its ritualistic implications. Moreover, even though the composition is not explicit, there are several visual elements that allude, if ever so subtly, to mystical associations. The notion of the Holy one blessed be he, being wrapped as a *sheliah tsibur* certainly added its share.

The role prayer played in Pietist mysticism was first described by Scholem, who argued that the Pietists' form of mysticism in prayer "was not a new form of devotion," but was based on an established tradition. It was, rather, the techniques of mystical exegesis of letter and number symbolism that were new.[177] Later Wolfson discussed the liturgical orientation of Pietist mysticism.[178] Prayer is the very act that enables the believer to visualize the divine Glory, and the link between prayer and mystical experience shines through Pietist writings time and again. Such a visualization can take place only in a proper location, that is—in the absence of the Temple—in the synagogue, where the prayer-leader functions as a representative of the congregation before God.

The portrait of the prayer-leader accompanies the first section of the prayer that requires the presence of ten men. It starts with *shokhen ad merom* (He who dwells on high) and ends with *barkhu* (Bless). *Shokhen ad merom* is based on the *Sefer Yetsirah*, and a medieval addition to a text of the *Hekhalot* genre describes the Metatron reciting this very prayer: "Every day a single angel stands in the middle of the firmament, and begins and says: The Lord is King. And all the hosts of heaven answer after him until they reach [the prayer of] *barkhu*. And when they reach [the prayer of] *barkhu,* a single beast stands in the middle of the firmament, and its name is Israel. And [it] says: 'Bless the Lord who is blessed.' "[179]

Scholem observed that in the Pietist concept it is the mystic's prayer and
its approach to the Throne that is crucial, not the approach of the mystic
himself as in the *Hekhalot* tradition. The Pietist concern for the correct
uttering of phrases in prayer has its roots in this concept.[180] A central ele-
ment in discussions about prayer and mystical experience, finally, is the
intention in prayer and concentration.[181] The ultimate goal of prayer, to-
gether with the penitential system, Pietist asceticism, and mystic contem-
plation, is a vision of the divine Glory. The critical issue in this matter is
the question, to whom the believer's intention is to be directed: to the in-
visible hidden Creator or to the *shekhinah*. We have seen in the discussion
of the *shekhinah* that the prayer is addressed to the latter, who guides the
believer through it, which can then lead to a visualization of the *shekhi-
nah*. On the other hand, the visualized *shekhinah* as the one to whom
prayers are addressed in the first place also figures prominently, especially
in Eleazar's views. The believer's thought, however, should be directed
to the hidden Creator. The Pietists' dealings with all of these issues are
rather ambiguous and numerous references maintain that a complete di-
rection of prayer to the hidden Creator will be possible only in the world
to come, but the different Pietist stances on this matter are not at all clear-
cut. As Wolfson points out, "the . . . theoretical problem of addressing
prayer to an entity that is distinct from God is solved by the blurring of
the ontological difference between the Creator and the image." The visi-
ble Glory is an image in one's mind and as the Creator is omnipresent he
is present in the image, "hence worshiping the image is akin to worshiping
the Creator."[182]

The *Sefer Hasidim* leaves no doubt that it is forbidden to place an icon
in the synagogue, especially near the ark.[183] This brings us back to the
representation of the couple (fig. 7). It is rather unlikely that this image
was perceived by the book's readers as an icon, a *demut* in the sense that
the prohibition in the *Sefer Hasidim* understands it. It is forbidden to put
up a physical object that would function as a "medium" for prayer. The
picture of the couple is not understood that way but is rather a visual to-
ken of the love between God and Israel. When ritual practice is addressed,
as in the image of the balance on the Throne of Glory or the image of
the prayer-leader, no hint is given regarding a visual representation of the
shekhinah. Yet, this basic difference in approach underscores the fact that
the image of the couple is not perceived as an icon. It is a representation of
the worshipper at the stage of visualizing the *shekhinah*, but it is not the
visualized *shekhinah* and not an object of worship. It focuses on the aspect
of the relationship between the worshipper and the *shekhinah*, not on the
worship itself. The fact that even though she is shown frontally her face

appears in profile and that she is addressing the depicted worshipper as well as the viewer of the image adds further credence to this observation.

Even though these are crucial issues in Pietist esoteric teachings about prayer, the image of the prayer-leader does not address them explicitly. The mystical notions of both the *shekhinah* and the Throne take on visual dimensions in the decoration program of the Leipzig Mahzor, but the image of the prayer-leader is concerned, rather, with the practice, the performance of prayer. The mystical dimension of prayer is touched upon only by the sublime representation of the prayer-leader and the association he creates with the aggadic description of the Holy one blessed be he wrapped like a prayer-leader. This prayer-leader "goes down *(yored)* toward the shrine" as a mystic who goes down to the Chariot *(yorde hamerkavah)* and thus takes on a mystic dimension as a vehicle for the believer's address to God in his prayer.[184]

THE IMAGES DISCUSSED IN THIS CHAPTER can be associated with the mystic concepts of the Ashkenazi Pietists. As a matter of fact, they address the ultimate goal of the ritual of prayer: the mystic union with the Glory and the vision of the Throne. They encompass the basic lines of the Pietist concepts: prayer, worship, study, and penitence as the way to lead to a union with the Glory. How, then, are we to imagine their function as they appear on the pages of a communal mahzor? Mysticism, "secret teachings," as the Jewish tradition refers to it seems, at first sight, to appear in stark contrast to the notion of communal prayer. It is surely not expected that the entire congregation assembled for the holiday service engaged in efforts to experience a mystical vision. Esoteric teachings were limited to a few selected scholarly individuals, and during the days of Judah the Pious and Eleazar of Worms they were reserved for oral tradition from teacher to trusted disciple.

This leads us back to the question of why Eleazar eventually chose to put his mystical tradition into writing. As I noted earlier, whatever the case, once he did write down these traditions some process of reception of mystical symbols into broader circles must have begun. Who read Eleazar's texts apart from mystic scholars who had an active interest in them? Communal rabbis, prayer-leaders, and preachers who sought means to offer guidance to a community in dire economic straits and in constant danger of persecution? Perhaps. I am not engaged in a study of the reception of Eleazar's mystical traditions, but it seems to me that what we encounter in these images in some way reflects this very process. Once put into writing these thoughts left the realm of the purely esoteric and became exoteric, and from that point on their diffusion, as minor as it might have been, could not be stopped.

Whereas in Christian devotional books text and image together could function as what Hamburger defines as "vehicles of mystical elevation," this notion does not apply to the Leipzig Mahzor.[185] The Leipzig Mahzor contains the conventional text of the public rite of Worms with all that such a convention implies. It is a large book not intended for private use, but a book that serves the prayer-leader in fulfilling the obligation of prayer for the entire community. It is, first of all, a guidebook, so to speak, for the performative aspects of the rituals of prayer and *piyyut* recitation. As I described earlier, the book is brought into the synagogue and put on the lectern; the prayer-leader "goes down" and takes his place near the shrine; he wraps himself in a *talit* and begins to recite the text spelled out in the book. As all rituals, these acts, the proper performance of which was of utmost importance in the medieval Ashkenazi mentality, have mythic counterparts. We have seen, for example, that some of the rituals depicted on the pages of the Leipzig Mahzor are accompanied by visual renderings of these mythical counterparts: the Giving of the Law on Mount Sinai appears near the initiation ritual (fig. 15) and the Binding of Isaac adjacent to the *shofar* blowing at Rosh Hashanah (fig. 3).[186]

The images discussed in this chapter take the viewer to another level of the mythical counterpart to rituals. The myths they represent are not just myths that reveal the symbolic essence of their respective rituals. They address the essence of the ritual of prayer and its goal, the mystic union with the Glory. The emotional effort on the part of the mystical worshipper in its full intensity is entirely directed toward this goal. The fusion between the performative and the mythic aspects of the ritual comes to completion in these images. The myth depicted is no longer an informative allusion intended to clarify the meaning of this or that action, but is in itself the essence of the performed act.

But what might have been the function of these images? What role do the mystic aspects in their imagery play in the overall message of this cycle that is so much focused on communal life? They seem, first and foremost, to be addressed to the prayer-leader as a reminder of his holy task. Proper praying for those who are immersed in the particulars of mystic teachings is a step toward union with God. The images are not vehicles toward this union, but simply signs to remind the viewer that this union exists in the cultural repertoire of Ashkenazi thought and religious practice. The emotional impact of these images on the medieval Jewish viewer must have been enormous. Theirs is a particularly careful and sumptuous composition. They form the visual highlights of the first volume: the framed image of the prayer-leader followed by two elaborately composed initial panels, the four medallions alluding to the Throne, and the mystic couple. The rest

of the pages are decorated either with ornamental initial panels or un-framed marginal compositions. Even when leafing quickly through the en-tire book, it would have been hard to miss those highlights. These images communicate something of the prayer-leader's total absorption as he looked at these panels while he was reciting the adjacent *piyyutim*.

If performed properly, rituals can have a great emotional impact, a fact that was observed by early sociologists, particularly Émile Durkheim. Fo-cusing on religious rituals, Durkheim argued that their performance trig-gers a whole range of feelings. Among these is the awareness of belonging to a group, which certainly applies to the community of Worms assembled in its synagogue during a holiday service. However, beyond these social aspects of the feelings aroused by the performance of rituals, Durkheim was also aware of a sense of the sacred character of the symbols for which the rituals stand.[187] Contemporary sociologists, such as Randall Collins, extend these basic observations and argue that rituals impact emotionally if certain conditions are fulfilled. The ritual is to be performed in the pres-ence of others; the participants share a mutual focus of attention; and they have a common emotional mood.[188]

Thus the role of the prayer-leader in bringing the ritual of prayer to emotionally successful completion cannot be overestimated. The act of going "down before the Torah shrine fulfilling the obligation of many" underscores the communal character. The prayer is performed by the whole congregation *together;* its members pray while being led by the prayer-leader, who, as the ritual expert, has been chosen to be responsible for the entire group. The images of the mystic couple and the Throne of Glory following his own "portrait"—all standing out visually in comparison to the less dominant marginal depictions—could very well have functioned as reminders of the ultimate goal of prayer. There can be no doubt that the emotions experienced by the pious prayer-leader had an influence on the way he carried out his duties.

Conclusion

THE IMAGERY OF THE LEIPZIG MAHZOR communicates with its viewer at different levels and in manifold ways. The solemn compositions of some of the initial panels with their symbolic, often allegoric language evoke complex theological notions (figs. 7 and 16), whereas in the unframed marginal pictorials the history of the Israelites connects seamlessly with the religious life of the medieval community of Worms (fig. 15). The interplay between the somewhat enigmatic initial compositions with their sophisticated, often multilayered meanings and the marginal narratives seemingly taken from life indicates that the imagery of the Leipzig Mahzor offers a particularly broad coverage of the diverse ways the members of the Worms community defined themselves in terms of their history, their collective memory, their scholarly tradition, their religious customs, and their communal life. These images indeed create a web of associations that the late medieval patron(s), artists, and viewers of the Mahzor would have shared while conceiving, making, and using the book.

We know very little about possible ways of display when the members of the congregation were given opportunities to view any of the images in the Mahzor. On the eve of each holiday the book was brought from its keeper's home to the sacred space of the synagogue. There it was placed on a lectern, most likely open to the page of the *yotser*. Before the services and between them it may have been accessible to the members of the community to contemplate on an open double page with an image. The only person

about whom we can claim with certainty that he would have reflected on the images extensively is the prayer-leader. Reflecting on an image and on the associations it brings to mind would have provided the prayer-leader with the emotional ability to "fulfill the obligation of many" and to represent his community before God. Year after year the prayer-leader was able to reflect on these associations while he was reciting the texts, many of which he would have known by heart. His eyes would thus have been free to gaze at the images during the recitation. These images do not communicate at a didactic level. Rather, they must have created certain moods that would ensure the proper performance of the service. In this the Leipzig Mahzor would have been very different from many lavish medieval books given by spiritual authorities to patrons in need of spiritual guidance.[1]

How can we, then, in conclusion, define the world (view) of the community that wished to represent itself in the decoration program of the Leipzig Mahzor? We have little information about the culture of the Jewish community of Worms in the early fourteenth century, and the insight—as limited as it is—into its members' mentality provided by the pictorials of the Mahzor is all the more valuable. As we do not know the identities of any of the spiritual leaders after 1300, the history of Jewish Worms in those years is somewhat dry and reduced to legal matters and some scattered information about its social institutions. The Leipzig imagery tells us a great deal about the issues that occupied the minds of those who initiated its making, their thoughts and the historical figures they cherished.

The principal hero that emerges in this scenario is Eleazar ben Judah of Worms. In many ways it was his legacy that guided the designer(s) of the decoration to present themselves and their sacred congregation. Eleazar was a key figure in the development of the Worms prayer rite. The work involved in putting the entire rite into written form in one of the most lavish manuscripts that Ashkenazi culture ever knew is in itself indicative of the extraordinary tribute the community of Worms was ready to pay to one of its most outstanding historical figures. That his scholarship would also contribute a great deal to designing its imagery makes a lot of sense. This scholarship was twofold: it was Pietist and embraced ethical stances and mystical teachings, but it was also communal, addressing issues of customs and ritual laws. The Jews of Worms around 1310 viewed Eleazar ben Judah not so much as a charismatic leader of an eccentric religious group, but rather as a communal authority that informed part of their collective memory, and it seems that they adopted the whole of his scholarship as their legacy.

By the time the Leipzig Mahzor was produced, Eleazar had indeed turned into an historical figure. The Mahzor was made some eighty years

after Eleazar's death, and he himself would probably have had strong objections to the idea of illuminating a mahzor.[2] Even Meir of Rothenburg some decades later was opposed to the idea, arguing that illustrations would distract the prayer-leader from his pious intention.[3] By 1310, however, Pietist concerns about book illuminations were no longer considered valid and the decoration of manuscripts had ceased to be a revolutionary innovation. It would thus certainly be wrong to define the Leipzig Mahzor as product of Pietist culture. Notwithstanding such adjustments in relation to Pietist principles of the past, Eleazar's legacy was still instrumental in shaping the mentality of those who were entrusted with the spiritual concerns of the community of Worms. Although these people believed that Eleazar's legacy was their own, they nevertheless chose to address this community's identity through the medium of pictorial communication, even though in some sense it contradicted the Pietist ethics.

Eleazar was not only the major influence in the development of the rite of Worms, but he was also a towering figure in the community's collective memory. By 1310 the Pietist stances evident in the imagery of the Leipzig Mahzor had become part of this collective memory. Moreover, it was this period that saw a complex process of reception of parts of this legacy into the broader framework of Ashkenazi culture. By then Eleazar had become widely known and respected for far more than his Pietist scholarship and communal leadership. Throughout the late Middle Ages and the early modern period his fame went well beyond the district of Worms and the Rhineland. Widely quoted by later rabbinic scholars, his authority in halakhic matters was unquestioned. For example, an early fourteenth-century editor of a liturgical text from the German lands noted several times on the margins that he had consulted an autograph by Eleazar.[4] The *Sefer Haroqeah*, which was not intended as a study text for Halakhists, but must have been written with a general audience in mind, was accepted as a standard work of ritual law and used extensively for generations to come.[5] It was often cited by later rabbis, including Jacob Moelin's student, for example, whose *Sefer Maharil* cites Eleazar's work dozens of times.[6] Another of Moelin's students compiled a short treatise about the customs related to prayer and holiday rituals, now kept in Warsaw, referring to Eleazar on every page.[7] We are thus in the face of a threefold process: the absorption of Pietist elements as part of Eleazar's heritage shaping the specific communal identity of Worms; the reception of Pietist elements in broader circles of Ashkenazi culture; and the emergence of Eleazar as a widely accepted authority on matters of the ritual law and custom. Hence, although I link the imagery of the Leipzig Mahzor to the worldview of the Pietists in general and to that of Eleazar in particular, I do not envision the community

of Worms as a Pietist community in the sense that it adhered to that movement as to a sect.

Modern attempts to clearly define the Pietist legacy after Eleazar's death have proven controversial. At the current stage of research, our knowledge of these matters is obscured in shadow. A central force, a major movement, a seclusive sect, or a group of unrelated eccentrics? We still do not really know what role the Pietists played in Ashkenazi culture. Recent scholarship has challenged earlier views on the wide integration of Pietist ideals and norms into general Ashkenazi culture. Whether Ashkenazi Pietism was a widespread movement, or whether Pietist ideas communicated in the *Sefer Hasidim* went unnoticed, as Haym Soloveitchik suggests, is not for me to decide. The Qalonymide-Pietist legacy that shines through the Leipzig imagery is not a set of radical notions that appear only in the *Sefer Hasidim*. There are many elements, notions, ideas, aggadic traditions, and more that had been part of the earlier Qalonymide tradition and became part of the worldview of the Ashkenazi Pietists, especially in the form that was known to Eleazar of Worms. These concepts were not necessarily specific to the Pietist culture, but they were part of their tradition. Talking about the "Pietist legacy" I do not mean a fully structured, clearly defined ideological program with a "textbook" of only the specific radical elements associated with Judah the Pious, but the wider spectrum of the Qalonymide-Pietist tradition embraced by Judah the Pious, Eleazar of Worms, and others.

The Qalonymide-Pietist legacy in this broader sense can be discerned in the Ashkenazi scholarship of the thirteenth and fourteenth centuries. Judging from quotations in other texts and from extant manuscripts, we do know that the *Sefer Hasidim* was soon widely received.[8] Among those who transmitted Pietist ethics to future generations were several authorities of the thirteenth century, some of whom were Eleazar's students, including the author of the *Sefer Ha'asufot* and Abraham ben Azriel. The role Isaac ben Moses of Vienna and Meir ben Barukh of Rothenburg played in transmitting Pietist ideals is by no means clear. Whereas earlier scholarship approached these two authorities as essentially Pietist, the work of recent historians shows that we are far from being able to fully clarify this issue. About ten years ago Ephraim Kanarfogel reassessed the matter in great detail and offered abundant evidence for a Pietist influence on both scholars.[9] Isaac of Vienna had indeed studied with Judah the Pious and perhaps also with Abraham ben Azriel.[10] He himself was among Meir of Rothenburg's teachers. Both scholars were committed to Tosafist methods, as much as they valued Pietist ideals and as concerned as they might have been with the preservation of the *minhag*. Avraham (Rami)

Reiner recently demonstrated that a Pietist notion about the souls of the righteous being assembled at the Throne of Glory inspired a formula referring to the memory of the deceased that was inscribed on tombstones in Ashkenaz throughout most of the thirteenth century ("may his/her soul be bound in the bond of life"). At the same time Isaac of Vienna uses the formula in his writings. The emergence of a Pietist notion into a generally accepted formula for tombstones is an eloquent demonstration of the nature of this process. Most likely not every family that used the formula on a tombstone was necessarily in full command of the Pietist mystical concepts. However its frequent use is an example of how basic Pietist ideas could shape later Jews' customs and preferences. In this particular case Pietist notions about life after death did certainly influence the way Ashkenazi Jews expressed their hopes for their ancestors' fate.[11] Reiner also observes that the title "Pious," which was very common on tombstones before 1200 and after 1300, appears only very rarely during the entire thirteenth century, suggesting that at this time it was reserved for people who were specifically associated with Pietist circles.[12] This means that the late thirteenth-century Ashkenazi Jews associated certain personalities with an apparently clearly defined group of Pietists and refrained from referring to other people as pious, even though their conduct may have been one of pious life.

There is no question about the influence of scholars such as Isaac of Vienna and Meir of Rothenburg on Ashkenazi culture of the late thirteenth and early fourteenth century, and it soon began to reach beyond the Rhineland, Franconia, and Austria. But when the patron(s) of the Leipzig Mahzor chose to represent the community of Worms by means of a pictorial "portrait," they did not necessarily mean to demonstrate that they considered themselves to be part of this general framework of Ashkenazi culture. Rather, singling out the specific legacy of their own community's scholarship, they chose Eleazar's legacy as a suitable representative of their collective memory. What the author of the *Sefer Ha'asufot,* Abraham ben Azriel, Isaac of Vienna, and Meir of Rothenburg teach us is that much of this legacy, which had a particular place value for the Jews of Worms, also reached the broader circles of Ashkenazi Jewry.

Scholars agree, finally, that the Pietist penitential system is the one element that had more impact on Ashkenazi culture and beyond than any of the other Pietist values and norms. Interest in that system can be observed among French scholars, including Moses of Coucy and Isaac of Corbeil, and my earlier discussion of the divine scales demonstrates that it was also known in southern France.[13] Even later it would be influential in early modern Jewish culture in Poland.[14] More important perhaps is the fact

that Isaac of Corbeil also relied on Eleazar of Worms in discussing the importance of *kavanah* in prayer.[15] The impact of Pietist scholars on the different rites is also remarkable. Eric Zimmer pointed out that some of Judah the Pious's halakhic positions began to influence the Eastern rite after he had settled in Regensburg, and the role Eleazar played for the rite of Worms was mentioned there time and again. To this we can add the fact that the *shir hayihud,* a mystical prayer about the divine unity, perhaps composed by Samuel the Pious, was integrated into Ashkenazi liturgy at some time in the fourteenth century. We have seen, in fact, that it is included in the Leipzig Mahzor, where it was added at some subsequent stage in the latter part of fourteenth century.[16]

In short, not only was Eleazar of Worms's the last of the outstanding figures associated with Worms, one that the Jewish community of that town could feature when shaping its identity, but his legacy proved to be a cornerstone of late medieval Ashkenazi culture. A similar process occurred, as we have seen, in the nineteenth century when the community of Worms made Rashi's presence there 800 years earlier a primary focus of its collective memory, even though he was there only as a student and not as an active scholar. Owing to the great fame Rashi had acquired over the centuries, his presence in Worms even as a mere student became one of the elements that helped shape the cultural identity of that community centuries later. It was the physicality of Rashi's presence—more than any particulars of his scholarship—that seems to have contributed to that feeling of cohesion and belonging among the members of the modern community. All the more so it can be assumed that a similar process must have taken place between Eleazar and the community of Worms a few decades after Eleazar's death and after he had been acknowledged as a seminal authority of Ashkenazi scholarship.

Eleazar's role in shaping the identity of this community and creating cohesion only eighty years after his death must by any means have been more dominant than was the memory of Rashi in the nineteenth century. Evidence for that comes from Yuspe Shammash's *Ma'ase Nisim,* a collection of traditional miracle stories in yiddish from and for the community of Worms written in 1670. It is worth taking a brief look at the aura of rabbinic fame associated with Eleazar in this text: "In Worms there lived an important man, a great teacher of Torah, equaled by few others throughout the world; he authored numerous *ma'arivim* and *yotsrot,* that have been recited in Worms during the holidays." The collection includes the account of the attack on Eleazar's family in 1196, as well as the miraculous story about Eleazar's soul descending from heaven in order to teach Kabbalah to Nahmanides.[17] More striking is that the same collec-

tion also includes a story about Judah the Pious, who was not born in Worms and never lived there.[18] It must have been owing to Eleazar's link with the Pietist legacy of his teacher, of which the Jews of Worms were, to some extent, still well aware in the seventeenth century, that Judah found a place in the collective memory of a community of which he had never been a part.[19]

It is telling that Yuspe Shammash not only relies time and again on the *Sefer Hasidim,* but also highlights Eleazar's work as an author of *piyyutim* in the story about the attack on his family. These two aspects of Eleazar's activity—his contribution to Pietism and his role as a liturgical poet— were thus enshrined in Yuspe's consciousness even centuries later, and they appeared in bold relief in his notion of his community's culture. It is thus not necessarily the Pietist aspects of this legacy as a general feature of Ashkenazi Jewry that is represented in the decoration program of the Leipzig Mahzor, nor is the imagery of the Leipzig Mahzor a mere patchwork of diffused Pietist elements. Rather, much of this imagery is homage to one of the figures that was most instrumental in shaping that community's identity. The fact that the makers of the Leipzig Mahzor chose the Pietist legacy to represent this homage does not make them Pietists, nor does it mean that Yuspe Shammash writing the miracle stories about Judah and Eleazar in the seventeenth century should be identified as a Pietist.

The Pietist legacy as it shines through the imagery of the Leipzig Mahzor was thus not completely detached from its general Ashkenazi context. Students of the Pietists preserved numerous aspects of Judah the Pious's and Eleazar of Worms's scholarship and worldview, and there are abundant signs that indicate that Pietism did not disappear when Eleazar was buried in the "holy sand" of Worms, as this community's cemetery was referred to for centuries. Most of the works of Eleazar's students and followers reflect a process of reception of some elements of Pietist ethical teachings and its approach to law and custom. Moreover, the mystical legacy of the Pietists lived on and the mystical writings of Eleazar, which were copied over and over again during the late Middle Ages, inspired scholars who are called Kabbalists rather than Pietists.

Scholars still grapple with the question of the impact of Ashkenazi Pietism on Sephardi Kabbalah. Echoes of the latter can be found in Central Europe from the second half of the thirteenth century, when it began to merge with Pietist mystical views. Noteworthy among late medieval Ashkenazi mystics are two descendants of Judah the Pious, his grandson Eleazar the Preacher, and his great grandson Moses ben Eleazar in the late thirteenth century.[20] For example, the question of an interaction between the *shekhinah* and the individual soul arose in a controversy between Moses

ben Eliezer and an anonymous author toward the end of the thirteenth century that reflects different levels of Pietist and Kabbalist knowledge on both sides.[21] Likewise, as Kanarfogel shows in great detail, Pietist influence on Isaac of Vienna and Meir of Rothenburg does not concern only legal methods, but also encompasses mystical traditions, and the same is also true for some of their students who were active in the fourteenth century.[22] These traditions shine through these scholars' copious writings, which were accessible to wide circles of Ashkenazi Jewry—another point in question toward attempts to tackle the issue of mystical teachings being spread beyond the small close-knit circles of scholars of mysticism. In the second half of the fourteenth century, Pietist mystical tradition is clearly discernible in the work of Menahem Tsioni, the author of a mystically oriented Torah commentary.[23]

The nature of this continuous transmission of Pietist mystical teachings is not entirely clear. It is telling that even though there is a great deal of manuscript evidence for such texts—which is indicative of the ongoing interest in them—they have not been printed.[24] Keeping esoteric teachings confined to the limits of manuscript culture ensured that they would not fall into the wrong hands and become popularized. However, even though the reception of these traditions was limited to small circles, once a text existed in written form it could become accessible beyond those circles. Kanarfogel discusses numerous instances of influences of Pietist esoteric traditions on scholars all over the German lands and France who never had any direct contact with Pietists.[25] This seems to be quite indicative of the wider circulation of these ideas. In fact, the treatment of mystical subjects on the part of the designer(s) of the Leipzig Mahzor is not uniform in the sense that its imagery reflects different levels of familiarity with esoteric knowledge. The image of the mystic couple (fig. 7) is very sophisticated in its overall concept, which seems to imply that it must have been conceived by a scholar with broad mystical knowledge. It differentiates between the woman's and the man's rank; it offers a great deal of information about the kind of communication between the two; it treats colors, light, and shade in a complex manner indicative of the full meaning of the figures; it creates the highly symbolical architectural framework; and more. The approach to the representation of the Throne of Glory (fig. 16), on the other hand, is much more simplistic in terms of the mystical concepts it reflects, which seems to point to a broader diffusion of such knowledge but at a more superficial level. It shows only one, the lower, part of the Throne; it translates a Christian iconographic formula in a rather straightforward way; and it refers to the Throne not in its full range of mystical implications, but rather as a framework to designate the locale, so to speak, where the reception of the repentant will take place.

Finally, the patron(s) of the Leipzig Mahzor chose to represent them-
selves, their entire community, and its Pietist heritage within the frame-
work of a ritual object. This fact alone demonstrates the role rituals must
have played in their lives as members—and most likely the leaders—of
that community. Problems of a broad versus a narrow definition of ritual
and the danger of a dichotomous view of (medieval) mentality have vexed
ritual theorists for a long time.[26] But Ashkenazi prayer and *piyyut* recita-
tion do not pose a problem at the level of definition. One does not need a
ritual theorist to understand that both phenomena fall into any definition of
ritual, whether narrow or broad. Apart from definition, however, thoughts
about rituals aid tremendously in dealing with the role of the book within
the framework of its society. Questions about the symbolic meaning of
certain aspects of rituals, such as the *talit,* can be understood simply as
iconographic questions. We do not need ritual theory to come to grips
with the symbolic meaning of the *talit.* But when we want to go beyond
iconographic analysis and ask questions about the meaning of the book as
a whole, concerns about the role rituals play in society can offer a key to
the function of the Leipzig Mahzor in the lives of the members of the
community of Worms.

Art historians have often asked questions about the functions of works
of art; we find discourses about the province of a political message in this
or that imagery. Descriptions of liturgical acts and discussions about how
liturgical books and other objects are handled in the performance of these
acts are abundant in art history. But even if we create a path to the icono-
graphic or symbolic meaning of an image and even if we are able to recon-
struct liturgical acts that involve this or that liturgical book, we would still
know very little about how such books—and the ritual they represent—
were able to hold together the communities they served. The Leipzig Mahzor
looked at as a ritual object enables us to tackle such questions.

The images discussed in this book offer insight into all of these issues
and the forgoing chapters put them into a relationship with the liturgical
text, on the one hand, and the mythical or theological aspects of the rituals
performed, on the other. Not always are the images able to convey both
aspects—the how and the why. The image of the prayer-leader (fig. 10)
offers a whole range of information about the performance of liturgical
rituals, the status of the prayer-leader, the theological meaning behind them,
and the role they played in communal life. The image of the divine judgment
(fig. 16), on the other hand, does not tell us anything about how peniten-
tial rituals were performed; rather it functions as a call for penitence and
conveys the meaning of penitence for the salvation of the nation. The Sha-
vuot image (fig. 15) displaying the initiation rite addresses both aspects: it

shows how the ritual was performed and is juxtaposed with the very biblical image that provides the key to the meaning of the rite. Myth and ritual are inseparably intertwined to enter into a powerful marriage.

Anthropologists believe that rituals provide the society that performs them with group solidarity and social cohesion, to maintain social distinctions and categories, to facilitate transitions between passages or stages in life, to underscore a group's values and its worldview, and to maintain cultural cohesion in the face of various kinds of threats.[27] The need for cohesion and for a sharp definition of communal identity was particularly acute under the circumstances in which the Jews of Worms lived. When the rite of Worms crystallized into its distinct form in the late thirteenth and the early fourteenth century, when the Leipzig Mahzor was produced, the community of Worms could very well have faced a certain degree of threat to its identity. Its scholarly fame gone, the economic situation having deteriorated, and security gradually eroding, the Jews of Worms, as any other community, coped with constant Christian pressure to give up their identity. Moreover, the spread of small Jewish communities in the district of Worms must have caused a feeling that the traditional organizational structure of the urban Jewish community was in danger of falling apart. The creation of a loose network of small communities that used the services of the large urban community may also have added its share to an overall feeling for the need of cohesion. Under these circumstances, it seems, the community of Worms fell back on its prayer rite and on its rituals, in order to preserve the fence the notion of the "sacred community" had provided in earlier days. In later decades and centuries this rite was rewritten over and over again and, judging from the richness of the literature that preserved the rite during the seventeenth and the eighteenth centuries, it appears that it must have played a crucial role in carrying the communal identity of the Jews of Worms safely into the early modern period.

Appendix

Glossary

Notes

Index

List of the Decorated Pages

Volume One

The Biblical texts

Fol. 19r:
Samson rendering the lion. The text surrounding the image is a later addition and contains the *haftarah* for Shavuot. The *haftarah* for the Sabbath before Shavuot includes Jud 13, the story of Samson's birth. Hence, another scene of lion rendering is shown in the initial panel of Shavuot (vol. 1, fol. 130v, fig. 15).

Fol. 19v:
Decorative initial panel for the opening of the Song of Songs to be read during Pesah.

Fol. 23r:
Decorative initial panel for the opening of the book of Ruth to be read during Shavuot.

Fol. 27r:
Framed panel showing a prayer-leader in a *talit* before a lectern with a large open book. He is accompanied by two men with funnel hats, one of them holding another open book (see Chapter 4 and figure 10).

Sabbath in the Week of Hanukah

Fol. 27v:
Decorative initial panel for the *yotser* for the Sabbath during the week of Hanukah accompanied by the depiction of a deer on the upper frame.

Special Sabbaths

Fol. 31v:
Decorative initial panel for the *yotser* for *shabbat sheqalim* (Ransom) with a hunting scene on its upper frame. The panel displays the lower part of the divine Throne with the four living creatures (Ez 1), each inhabiting a medallion. Between the creatures, scales are attached to the initial word *el*—God (see Chapter 6 and fig. 16).

Fol. 40r:
Decorative initial panel for the *yotser* for *shabbat zekhor* (Remember) with four medallions inhabited by small heads of men in profile, each wearing a Jewish funnel hat.

Purim

Fol. 46v:
Decorative initial panel for the *yotser* for Purim displaying snakes.

Fols. 51v–52r:
Marginal composition of the Esther story. The narrative runs from left to right and shows Esther, crowned as a queen before Ahasuerus; Haman leading a horse toward Mordechai, who is shown to the very right as a teacher of three young children. On the right-hand page Haman leads Mordechai on horseback; on the right-hand margin Haman and his sons are hanging on a tree. The orientation of the narrative from left to right results from the effort to link the illustrations as closely as possible to the text: the depiction of Queen Esther appears near the word "kingship" in text to the left, and the tree appears near the sentence "and they hanged the sons of Haman."

Special Shabbatot and Great Shabbat

Fol. 53v:
Decorative initial panel for the *yotser* for *shabbat parah* ("Heifer") accompanied by a small marginal depiction of the red heifer.

Fol. 59r:
Decoration for the opening word of the *yotser* for *shabbat hodesh* ("Month") showing the sun and the moon. On the margins two men appear pointing at the sky.

Fol. 64v:
Decorative initial panel for the *yotser* for the Great Shabbat showing a temple-like architectural frame with the couple of the Song of Songs seated beneath it (see Chapter 7 and fig. 7).

Fol. 66v:
Colored initial word of the *qerovah* for the Great Shabbat.

Fol. 68v:
Marginal depiction showing the cleansing of the dishes to be performed between the Great Shabbat and the beginning of Pesah (see Chapter 5 and fig. 8).

Fol. 70v:
Marginal depiction showing the preparation of the *matsot* to be performed between the Great Shabbat and the beginning of Pesah (see Chapter 5 and fig. 9).

Pesah:

Fols. 72v–73r:
Decorative initial panel for the *yotser* for the first day of Pesah accompanied by a marginal composition showing the Crossing of the Red Sea and the Persecution of the Israelites by the Egyptian Army.

Fol. 81r:
Decorative initial panel for the *musaf* service for the first day of Pesah.

Fols. 86r–87r:
Marginal medallions displaying the signs of the zodiaq as decoration of Eleazar Haqallir's poem on dew.

Fol. 90r:
Marginal image showing a man carrying a basket with sheaves on his back as illustration for the counting of the *omer*, a bundle of barley sheaves to be brought to the Temple as sacrifice between Pesah and Shavuot.

Fol. 91r:
Decorative initial panel for the *yotser* for the second day of Pesah.

Shavuot:

Fols. 130v–131r:
Decorative initial panel showing a man attacking a lion for the *yotser* for the first day of Shavuot (see also above, fol. 19r); it is accompanied by a narrative image of the Transmission of the Law on Mount Sinai (130v) and a rendering of the initiation rite for young boys on their first day of schooling on the opposite page (see Chapter 5 and fig. 15).

Fol. 133r:
Simply decorated opening word for the *qerovah* for the first day of Shavuot.

Volume Two

Biblical Texts

Fol. 18r:
Decorative initial panel for the Book of Qohelet (Ecclesiastes) to be read during Sukkot.

Rosh Hashanah

Fol. 26v:
Decorative initial panel *melekh* (King) for the *yotser* for the first day of Rosh Hashanah. It displays a large golden crown and a male figure with a funnel hat blowing the *shofar*. The panel is accompanied by the image of the ram caught in a tree on the outer margin, an allusion to the Binding of Isaac, told in Genesis 22 and read during the Rosh Hashanah service (figure 3).

Fol. 43r:
Architectural frame for part of the Rosh Hashanah service.

Fol. 43v:
Decorative panel for the word "he" referring to God inserted in the text of the prayer *alenu leshabeah* (It is upon us to praise).

Fol. 52r:
Architectural frame for the poem *modim anahnu lekha* (We thank Thee).

Fol. 54r:
Decorative initial panel for the *yotser* for the second day of Rosh Hashanah.

Fol. 66r:
The opening word *ahallelah* (I shall praise the Lord) is accompanied by a marginal rendering of the Binding of Isaac showing the ram caught in a tree on the inner margins, and Abraham, about to slaughter his son, being held back by the arm of an angel on the outer margin (fig. 4).

Fol. 67r:
Marginal image of a naked crowned king riding a lion in allusion to the "king" (Nebuchadnezzar) mentioned in the adjacent text.

Yom Kippur

Fol. 74r:
Architectural frame decorating the *kol nidre* declaration (All vows) at the beginning of the Yom Kippur service.

Fol. 85r:
Architectural frame for the *yotser* for Yom Kippur, *petah* "Open the gates of mercy."

Fol. 104v:
Initial decoration of the opening word of the *qerovah* for Yom Kippur.

Fol. 118v:
Decorative initial panel for one of the penitential prayers for Yom Kippur.

Fol. 129v:
Four large lilies decorate the beginning of the *musaf* of Yom Kippur, *Shoshan* (The lily of the valley, figure 1).

Fol. 138r:
Decoration of the opening word for one of the *piyyutim* of the *musaf* for Yom Kippur.

Fol. 142v
Decoration of the opening word for one of the *piyyutim* of the *musaf* for Yom Kippur.

Fol. 164v:
Decorative initial panel as part of an architectural frame for the *qerovah* of the afternoon prayer of Yom Kippur. On the bottom margin appears the story of Abraham in the furnace of Nimrod (see Chapter 6 and fig. 18).

Fol. 174r:
Architectural frame decorating the beginning of the final portion of the Yom Kippur service.

Sukkot

Fol. 181v:
Decorative initial panel for the *yotser* for the first day of Sukkot accompanied by a man holding an *etrog* and a *lulav* on the outer margin and images of the *behemot* and the *leviathan*, the messianic beasts, on the bottom.

Fol. 184v:
Initial decoration for the *qerovah* for the first day of Sukkot.

Fol. 192v:
Initial decoration for the *yotser* for the second day of Sukkot.

Fol. 193v:
Initial decoration for the *qerovah* for the second day of Sukkot.

Fol. 196r:
Initial decoration for the *yotser* of the Sabbath of the week of Sukkot.

Fol. 198v:
Marginal image of a Levite playing the harp. The image accompanies the *ma'ariv* service for the seventh day of Sukkot, which mentions the Levites playing music.

Fol. 199v:
Decorative initial panel for the *yotser* for the eighth day of Sukkot.

Fol. 203r:
Decorative initial panel for the *musaf* for the eighth day of Sukkot.

Simhat Torah

Fol. 213v:
Decorative initial panel for the *yotser* for Simhat Torah.

Glossary

aggadah The nonlegalistic parts of rabbinic literature; homiletic exegesis, commonly by means of narrative.

amidah Lit. "standing"; a part of the daily prayer consisting of eighteen benedictions (seven on Sabbaths and holidays), also referred to as *shmoneh esreh* (eighteen), or *the* Prayer *(tefillah)*. While reciting the *amidah*, one is required to stand.

aravit (s. also *ma'ariv*) Evening prayer.

Ashkenaz In medieval Jewish understanding, the entire area between Bohemia in the east and England and northern France in the west. To the south it reached the Loire River, the Upper Rhine, and the Alps. In a narrower sense, and throughout this book, Ashekenazi refers to Jews living in the German lands.

etrog A citrus fruit *(citrus medica)* required as one of the "four species" for the Sukkot holiday, together with a branch of a date palm, myrtle leaves, and willow leaves.

haftarot Reading portions from the prophets and hagiographs to be read during Sabbath and holiday services; the *haftarah* is thematically linked to the Torah portion.

halakhah, halakhic The legalistic parts of rabbinic literature; the ritual law.

Hanukah Festival of Lights, an eight-day festival celebrated in December, commemorating the reconsecration of the Temple after it had been defiled by the Seleucids in 167.

lulav A branch of a date palm, required as one of the "four species" used during the Festival of Sukkot, together with the *etrog*, myrtle leaves, and willow leaves.

mahzor In the modern usage, a prayer book for the holidays; in the Middle Ages, a book containing the liturgical embellishments *(piyyut)* commonly added upon the statutory prayers, whereas the statutory prayers were collected in the *siddur*.

midrash A homiletical method of Bible exegesis (stemming from the root *d-r-sh*—to inquire) seeking the broader meaning of a text with the aid of various exegetical tools, going beyond the basic literal explanation *(pshat)*.

minhah Afternoon prayer.

minhag Custom; religious practices that are not required by the ritual law, but are commonly observed in the different communities. In the Middle Ages, Ashkenazi Jews observed a set of customs that were orally transmitted from late antiquity.

Mishnah The oral tradition of rabbinic Judaism; the oral law was put into writing around 200 CE. It consists of six parts *(sedarim)*, each divided into tractates (63 tractates in total).

musaf Lit. "addition"; an additional recitation of prayer during Sabbath and holiday services, commonly recited immediately after the morning prayer.

ofan Lit. "wheel" (the wheels who "raise themselves toward the Seraphim," together with the Holy Beasts); a type of *piyyut* recited as part of the *yotser* complex, embellishing the blessings recited before and after the recitation of *shma Yisrael* (Hear, o Israel: the Lord is our God, the Lord is one).

omer A measurement of barley (an amount of sheaves that need bundling) to be brought as sacrifice to the Temple between the holidays of Pesah and Shavuot.

Pesah Passover festival commemorating the departure of the Israelites from Egypt; an eight-day festival during which it is forbidden to consume leaven.

piyyut (see also *mahzor*) Liturgical hymn; poetic embellishments recited by the prayer-leader in addition to the statutory prayer.

Purim Festival to be celebrated in the early spring commemorating the deliverance of the Jews of Persia from persecution under the reign of Ahasueros.

qerovah A type of *piyyut* embellishing the *amidah* prayer.

qedushta A type of *qerovah*.

Rosh Hashanah The New Year festival celebrated in the fall; it marks the beginning of the high holidays and the Days of Awe.

seder Lit. "order"; the series of prayers to be recited during a certain ceremony, or to a ceremonial meal, most commonly in the context of the Passover meal.

shaharit Morning prayer.

Shavuot Festival of Weeks, celebrated seven weeks after Pesah. It marks the harvest of barley and wheat, and was the first day on which Jews brought first fruits to the Temple. Shavuot commemorates the Giving of the Law to Moses on Mount Sinai.

Simhat Torah Rejoicement of the Torah; celebrated immediately following the Sukkot holiday. On *Simhat Torah* the annual reading cycle of the Torah begins.

Sukkot Festival of Tabernacles commemorating the divine precept of living in small temporary booths for seven days during the journey from Egypt to Israel (Lv 23:42–43).

talit A four-cornered garment worn during the ancient period. Jews were required by the ritual law to attach the ritual fringes *(tsitsit)* to its corners as a reminder of the 613 precepts.

Talmud The main corpus of ritual law. It consists of the Mishnah (see above) and exegetical commentaries to the Mishnah *(gemarah)*. These commentaries were developed in parallel in the Land of Israel (Jerusalem Talmud) and Babylonia (Babylonian Talmud). Over the century the laws of the Babylonian Talmud became dominant in the Jewish communities of Europe and the Middle East.

tsitsit, see *talit*.

Yom Kippur Day of Atonement.

yotser A type of *piyyut* that derives its name from one of the morning blessings to be recited before the *shma Yisrael* (Hear, o Israel: the Lord is our God, the Lord is one). It is the main *piyyut* that embellishes the blessings recited before and after the recitation of *shma Yisrael*.

zulat One of the *piyyutim* of the *yotser* complex, which derives its name from the blessing "There is no God but you *(zulatkha)*. . . ."

Notes

Introduction

1. For on an anthropological perspective on the culture of the Jews in medieval Europe, see Ivan G. Marcus, *Rituals of Childhood: Jewish Acculturation in Medieval Europe* (New Haven: Yale University Press, 1996), 4; his views are to some extent indebted to Clifford Geertz, "Religion as a Cultural System," in *Anthropological Approaches to the Study of Religion*, ed. Michael Banton (New York: Travistock, 1965), 1–46, repr. in Clifford Geertz, *The Interpretation of Cultures: Selected Essays* (New York: Basic Books, 1973), 87–125.
2. The Jewish year starts in the fall with Rosh Hashanah, the New Year. It would thus have made sense to start the first volume with the liturgy for this particular holiday. However, traditionally the first volume of an Ashkenazi Mahzor begins with the winter and spring holidays and the reason for this is unclear. It is possible that the decision to begin the cycle with the Sabbath during the week of Hanukah, celebrated in December, is due to influence by the Christian practice, where the church year begins with Christmas in December. I thank Israel J. Yuval for suggesting this possibility to me.
3. *Machsor Lipsiae: 68 Facsimile Plates of the Mediaeval Illuminated Hebrew Manuscript in the Possession of the Leipzig University Library*, ed. Elias Katz (Hanau/Main: Werner Dausien, 1964), for the provenance of the Mahzor, see 67, 87. For Narkiss's contribution, see 85–109.
4. Bezalel Narkiss, *Hebrew Illuminated Manuscripts* (Jerusalem: Keter, 1984), 51–55 (revised Hebrew edition of the earlier English version, Jerusalem, 1969); Joseph Gutmann, *Hebrew Manuscript Painting* (New York: Georges Braziller, 1978), 23; Kurt Schubert and Ursula Schubert, *Jüdische Buchkunst*

I (Graz: Akademische Druck- und Verlagsanstalt, 1983), 99; Gabrielle Sed-Rajna, *Le Mahzor enluminé: Les voies de formation d'un programme iconographique* (Leiden: E. J. Brill, 1983), 16, 69–71.

5. Art historical attribution has undergone several critical reappraisals in recent decades. For many years stylistic analysis was the main tool used to identify the origins of a work of art. This method has been shown to yield unsatisfying and at times erroneous results, especially for illuminated manuscripts, an observation that has caused some degree of unease in the field. Study of the Leipzig Mahzor indeed confirms the ineffectiveness of stylistic considerations in identifying origins.

6. Hans Belting, *Bild-Anthropologie: Entwürfe für eine Bildwissenschaft* (Munich: W. Fink, 2001), 12.

7. This approach has been pursued to an extreme in Mendel Metzger and Thérèse Metzger, *Jewish Life in the Middle Ages: Illuminated Hebrew Manuscripts of the Thirteenth to the Sixteenth Centuries* (Secaucus: Chartwell Books, 1982); for a critique, see Eliott Horowitz, "The Way We Were: 'Jewish Life in the Middle Ages,'" *Jewish History* 1/1 (1986): 75–90; Katrin Kogman-Appel, *Die Zweite Nürnberger und die Jehuda Haggada: Jüdische Künstler zwischen Tradition und Fortschritt* (Frankfurt/Main: Peter Lang, 1999), 91–95.

8. This thought was further developed in Katrin Kogman-Appel, "Christianity, Idolatry and the Question of Jewish Figural Painting in the Middle Ages," *Speculum* 84/1 (2009): 73–107.

9. Belting, *Bild-Anthropologie*, 50–54.

10. Geertz, *The Interpretation of Cultures*. The first chapter, "Thick Description: Toward a Interpretive Theory of Culture," was not a reprint of an earlier study, but written for this particular volume, 3–32; Robert Wuthnow, *Meaning and Moral Order: Exploration in Cultural Analysis* (Berkeley: University of California Press, 1989); for an overview on the methodological directions in historical anthropology, see Robert Scribner, "Historical Anthropology of the Early Modern Period," in *Problems in the Historical Anthropology of Early Modern Europe*, ed. Robert Scribner and Ronnie Po-Chia Hsia, *Wolfenbüttler Forschungen* 78 (Wiesbaden: Harassowitz-Verlag, 1997), 11–34. As can be learned from Scribner's sketch, it is not necessarily only the methodological point of view taken, but also the field of study, that defines historical anthropology. Social scientists approach cultural phenomena via a quite broad range of methodologies, not limited necessarily to survey research and participant observation, but also relying on theoretical frameworks as well as hermeneutic and phenomenological approaches; for an overview of methodologies employed in cultural analysis, see Wuthnow, *Meaning and Moral Order*, 42–43.

11. See Catherine Bell, *Ritual Theory, Ritual Practice* (New York: Oxford University Press, 1992), chap. 1.

12. Key works were Émile Durkheim, *The Elementary Forms of the Religious Life* (New York: Free Press, 1965) (originally published in French in 1912); Henri Hubert and Marcel Mauss, *Sacrifice: Its Nature and Function* (Chicago: Chicago University Press, 1989) (originally published in French in 1898).

Pioneers of cultural anthropology were Edmund Leach, *Rethinking Anthropology* (London: Athlone, 1961); Victor Turner, *The Ritual Process: Structure and Anti-Structure*, The Lewis Henre Morgan Lectures, 1966 (London: Routledge and Kegan Paul, 1969); Geertz, *The Interpretation of Cultures;* for an overview of anthropological approaches to rituals, see Bell, *Ritual Theory, Ritual Practice.*

13. An application of this approach to the study of *piyyut* commentary can be found in Elisabeth Hollender, *Piyyut Commentary in Medieval Ashkenaz* (Berlin: Walter de Gruyter, 2007), 16, with references to the theoretical background.

14. Geertz, "Thick Description," 21–22; see also Scribner, "Historical Anthropology."

15. Ivan G. Marcus, *Piety and Society: The Jewish Pietists of Medieval Germany* (Leiden: E. J. Brill, 1981), pt. 3; Marcus, "The Devotional Ideals of Ashkenazic Pietism," in *Jewish Spirituality: From the Bible through the Middle Ages,* ed. Arthur Green (New York: Crossroad, 1986), 356–366.

1. Facts about the Leipzig Mahzor

1. The precise measurements of the codices without the binding are $491 \times 363 \times 66$ mm for the first volume, and $485 \times 358 \times 83$ mm for the second one.

2. One of the pages of the Worms Mahzor, National Library of Israel, cod. 4^0781, displays a blessing in Yiddish addressed to the person who brings the book; see Chone Shmeruk, "The Versified Old Yiddish Blessing in the Worms Mahzor," in *The Worms Mahzor, Jewish National and University Library, MS heb.* $4^0781/1$: *Introductory Volume,* ed. Malachi Beit-Arié (Vaduz: Cyelar, 1985), 100–103; see also David Stern, "'Jewish' Art and the Making of the Medieval Prayerbook," *Ars Judaica* 6 (2010): 36.

3. Abraham Berliner, "*Shir Hayihud*: A Literary and Historical Study [in Hebrew]," in *Selected Writings,* vol. 1, (Jerusalem Mossad Harav Kook, 1945), 147–170; Abraham Haberman, *Shirei ha-Yihud ve-haKavod* (Jerusalem: Mossad Harav Kook, 1948), introduction [in Hebrew]; *The Hymn of Divine Unity with the Kabbalistic Commentary of R. Yom Tov Lipmann Muelhausen, Tihingen 1560,* ed. with an introduction by Joseph Dan (Jerusalem: Hebrew University Magnes Press, 1981). The inclusion of the *shir hayihud* in the Leipzig Mahzor as early as the fourteenth or fifteenth century does not say too much about the volume's history, as there is not much known about exactly when the *shir hayihud* became an integral part of the Ashkenazi liturgy. The mere fact that it was integrated, though, says something about the diffusion of Pietist thought into wider circles of Ashkenazi Judaism.

4. I am indebted to Edna Angel, National Library of Israel, for searching these pages from a paleographical point of view. According to her evaluation, the script is typical for the fourteenth century and was used until the early fifteenth.

5. The reason this page would have remained empty is unclear. Perhaps it was intended to contain a decoration or the blessings to be read before the readings. The somewhat orphaned panel of Samson without any clear visual or textual context could hardly have been the first choice of a designer who otherwise worked very thoughtfully, carefully, and meticulously.

6. Bezalel Narkiss, in *Machsor Lipsiae: 68 Facsimile Plates of the Mediaeval Illuminated Hebrew* Manuscript *in the Possession of the Leipzig University Library,* ed. Elias Katz (Hainau/Main: Werner Dausien, 1964), 99–100; Narkiss also counted the image of the prayer-leader on folio 27r (fig. 10) to this group, which I find hard to accept, as it has numerous stylistic counterparts throughout the manuscript and does not betray the hand of the miniaturist who produced the Samson scene. A somewhat different solution was proposed by Gabrielle Sed-Rajna, *Le mahzor enluminé: Les voies de formation d'un programme iconographique* (Leiden: E. J. Brill, 1983), 16, assuming that those images that reflect familiarity with Christian iconography were painted by a Christian artist, whereas those of a clear exegetical background were the work of a highly original Jewish artist ("il s'agit de l'initiative très personelle d'un des peintres"). As a by-product of this division, Sed-Rajna described the program as eclectic.

7. Sarit Shalev-Eyni, *Jews among Christians: Hebrew Book Illumination from Lake Constance* (Turnhout: Harvey Miller, 2010); Daliah-Ruth Halperin, "Illuminating in Micrography: Between Script and Brush—The 'Catalan Micrography Mahzor' MS heb. 8°6527 in the Jewish National and University Library in Jerusalem [in Hebrew]" (PhD diss., Hebrew University of Jerusalem, 2008).

8. Karl Vollers, *Katalog der islamischen, christlich-orientalischen, jüdischen, und samaritanischen Handschriften der Universitäts-Bibliothek zu Leipzig* (Leipzig: Universitätsbibliothek, 1906), vol. 2, 437; for the Manesse Codex (Heidelberg, Universitätsbibliothek, cod. pal. germ. 848), see *Codex Manesse, Die Große Heidelberger Liederhandschrift, Faksimile des Cod. Pal. Germ. 848 der Universitätsbibliothek Heidelberg,* ed. Walter Koschorreck and Wilfried Werner (Kassel: Ganymed, 1981); for a digital version, see http://digi.ub .uni-heidelberg.de/diglit/cpg848/.

9. Katz, *Machsor Lipsiae,* 72.

10. Joseph Gutmann, *Hebrew Manuscript Painting* (New York: Georges Braziller, 1978), 86; Sed-Rajna, *Le mahzor enluminé,* 16; others mention more generally a southern German provenance, Bezalel Narkiss, *Hebrew Illuminated Manuscripts* (revised Hebrew edition of the earlier English version, Jerusalem, 1969; Jerusalem: Keter, 1984), 52; Mendel Metzger and Thérèse Metzger, *Jewish Life in the Middle Ages: Illuminated Hebrew Manuscripts of the Thirteenth to the Sixteenth Centuries* (Secaucus: Chartwell Books, 1982), 303.

11. Judith Raeber, *Buchmalerei in Freiburg im Breisgau: Ein Zisterzienserbrevier aus dem frühen 14. Jahrhundert. Zur Geschichte des Breviers und seiner Illumination* (Wiesbaden: Reichert, 2003), 117–120.

12. St. Gall, Kantonsbibliothek, MS Vadiana 302; for a facsimile edition, see *Rudolf von Ems: Weltchronik, Der Stricker: Karl der Große,* ed. Ellen J. Beer

(Lucerne: Faksimile-Verlag, 1987). I am very grateful to Christoph Mackert for allowing me to read a version of his lecture, given in Leipzig, December 2005.

13. For the Bird's Head Haggadah, see Jerusalem, Israel Museum, MS 180/57; for a facsimile edition, see *The Bird's Head Haggadah of the Bezalel National Art Museum in Jerusalem: Introductory Volume*, ed. Moses Spitzer (Jerusalem: Tarshish Books, 1967); Ursula Schubert, "Die Vogelkopf-Haggada: Ein künstlerisches Zeugnis jüdischen Selbstbewußtseins am Ende des 13. Jahrhunderts," in *Zur Geschichte und Kultur der Juden*, exh. cat. (Nuremberg: Germanisches Nationalmuseum, 1989), 50–53. The Worms Mahzor is now housed in Jerusalem, National Library of Israel, MS heb. $4^{0}781/1$; for a digital version, see http://www.jnul.huji.ac.il/dl/mss/worms/; for the commentary and the attribution to Würzburg, see Malachi Beit-Arié, "The Worms Mahzor: Its History and Its Paleographic and Codicologic Characteristics," in *Worms Mahzor*, 19–20, http://www.jnul.huji.ac.il/dl/mss/worms/pdf/1eng.pdf; for the stylistic considerations regarding both mahzorim, see Aliza Cohen-Mushlin, "The Artistic Style of the Mahzor," in *Worms Mahzor*, 91–92, http://www.jnul.huji.ac.il/dl/mss/worms/pdf/4eng.pdf.

14. Earlier one of the editors of the facsimile edition, namely H. L. C. Jaffé, had attributed the Haggadah to either the Upper Rhine or the Middle Rhine, tending rather to the latter option, "The Illustrations," in *The Bird's Head Haggadah*, 52; for a scribal comparison between the two manuscripts, see M. Spitzer and B. Narkiss, "General Description of the Manuscript," ibid., 22. Narkiss, "The Iconography of the Illustrations," ibid., 92–93, also offered some iconographic parallels. Aliza Cohen-Mushlin, in her contribution to the 1986 commentary of the facsimile edition of the first volume of the Worms Mahzor of 1272, now attributed to Würzburg, discusses various stylistic relationships between that mahzor and the Bird's Head Haggadah. On the same occasion, she also noted that the Leipzig Mahzor, although stylistically related to the Worms Mahzor and the Bird's Head Haggadah, revealed still stronger influences from the Upper Rhine School; "The Artistic Style of the Mahzor," in *Worms Mahzor*, 91, 92. In a recent study on the Bird's Head Haggadah, Marc M. Epstein adopts the attribution to the Middle Rhine, *The Medieval Haggadah: Art, Narrative, and Religious Imagination* (New Haven: Yale University Press, 2011), pt. 1.

15. For a detailed discussion of the text and its attribution to the Worms praying rite, see Katrin Kogman-Appel, "The Leipzig Mahzor and the Medieval Praying Rite of Worms [in Hebrew]," *Kenishta*, forthcoming 2011.

16. Prayer is not necessarily always a ritual; it can be private, spontaneous, and nonformalized. The more prayer receives fixed forms and becomes repetitive, the more it can be approached as ritual. The medieval practice indicates a particularly high degree of ritualization.

17. Lawrence A. Hoffman, *Beyond the Text: A Holistic Approach to Liturgy* (Bloomington: Indiana University Press, 1987), 46.

18. See, e.g., the definitions of the terms *rite, ritual,* and *ritualization* in Ronald L. Grimes, *Ritual Criticism: Case Studies in Its Practice, Essays on Its Theory* (Columbia: University of South Carolina Press, 1990), 9–10, where he

defines rite as the act performed and ritual as "the general idea of which a rite is a specific instance."

19. Some ritual theorists also distinguish between "ritual" and "ceremony"; see, e.g., Roy Rappaport, *Ritual and Religion in the Making of Humanity* (Cambridge: Cambridge University Press, 1999), 38–39. Because there was no such distinction in medieval Judaism, and a ceremony in the modern sense did actually not exist, I use only the term "ritual." This is roughly also a matter of usage in this or that particular language; e.g., Sigmund Freud used the German term *Zeremoniell* to define acts that social scientists using the English language would refer to as rituals; Freud, *Totem und Tabu: Einige Übereinstimmungen im Seelenleben der Wilden und der Neurotiker* (Vienna: Hugo Heller, 1913).

20. Methodology in liturgical research has undergone a great deal of development in recent years. Liturgists were and are primarily concerned with the textual evidence and the emergence of liturgical forms, the attribution of such forms to particular communities, and so on. This approach has been criticized by sociological and anthropological historians in past years as one that neglects the performative and ritual aspects of liturgy, as well as its social, cultural, and communal context; see, e.g., several publications by Hoffman since the 1980s, in *Beyond the Text;* see also Tzvee Zahavy, "The Politics of Piety: Social Conflict and the Emergence of Rabbinic Liturgy," in Hoffman, *Beyond the Text*, 42–68. In the present chapter I return to the liturgical method as a means of attributing the Leipzig Mahzor; Chapter 4 addresses other aspects.

21. The literature on Hebrew liturgy and liturgical poetry is vast and cannot be cited in full here. For a useful concise survey, including a chapter on the literature up to 1993, see Stefan Reif, *Judaism and Hebrew Prayer: New Perspectives on Jewish Liturgical History* (Cambridge: Cambridge University Press, 1993); for a useful recent overview of the main genres of liturgical poetry, see Leon Weinberger, *Jewish Hymnography: A Literary History* (London: Littman Library of Jewish Civilization, 1998). My remarks here are based primarily on the works of Ezra Fleischer, *Hebrew Liturgical Poetry in the Middle Ages* [in Hebrew] (Jerusalem: Hebrew University Magnes Press, 2007, first published in 1975); Israel Ta-Shma, *The Early Ashkenazic Prayer: Literary and Historical Aspects* [in Hebrew] (Jerusalem: Hebrew University Magnes Press, 2003), pt. 1, and Reif, *Judaism and Hebrew Prayer*.

22. As numerous rabbinic texts have it; they will be discussed in Chapter 4.

23. Ezra Fleischer assumed that the formulations were fixed as early as the talmudic period (before c. 600), even if there were different formulae in different communities, "On the Beginnings of Obligatory Jewish Prayer [in Hebrew]," *Tarbiz* 59 (1990): 337–441; this is discussed in more general terms in Fleischer, *Hebrew Liturgical Poetry*, 48; Joseph Heinemann, however, believed that at that time there were several diverging formulae, *Prayer in the Talmud* (Berlin: Walter de Gruyter, 1977), chap. 1; see also, in reaction to and rejecting Fleischer's position, Stefan Reif, "On the Earliest Development of Jewish Prayer [in Hebrew]," *Tarbiz* 60 (1991): 677–681, who believes in an ongoing process of canonization.

24. Ta-Shma, *Early Ashkenazic Prayer*, 29–33; see also Talya Fishman, "Rhineland Pietist Approaches to Prayer and the Textualization of Rabbinic Culture in Medieval Northern Europe," *Jewish Studies Quarterly* 11 (2004): 313–331.
25. For more details, see Ta-Shma, *Early Ashkenazic Prayer*, 4–15.
26. For a useful diagram mapping out the different medieval prayer rites, see Stern, "'Jewish' Art," fig. 3.
27. For a critique of the traditional geographic definition of the Jewish prayer rites, see Hoffman, *Beyond the Text*, chap. 3, arguing that geography is an arbitrary factor in the definition of rites and that the latter should rather be defined socially. The following chapter uses the traditional methodology not necessarily to add another specimen to the manuscripts attributed to the Worms rite, but in order to determine the provenance of the Leipzig Mahzor, whose imagery is then linked to the cultural and social background of this community. In some sense in his attempt to more properly define prayer rites, Hoffman uses similar terms that can be applied to the definition of a community; for more on this, see Chapter 2.
28. Scholars have suggested several reasons for the development of these poetic additions; see, e.g., Simon Eppenstein, "Beiträge zur Geschichte und Literatur im gaonäischen Zeitalter," *Monatsschrift für die Geschichte und Wissenschaft des Judentums* 52 (1908): 467–472; Fleischer, *Hebrew Liturgical Poetry*, 49; Leo Landman, "The Office of the Medieval 'Hazzan,'" *Jewish Quarterly Review*, n. s. 63/3 (1972): 160.
29. Fleischer, *Hebrew Liturgical Poetry*, 41–262.
30. Early medieval Babylonian and later Sephardi scholars also composed *piyyutim*, which, in terms of form, were very similar to Muslim poetry. Sephardi compositions have since gained much fame, especially from the point of view of poetic genres and forms; for details and poetic forms, see Fleischer, *Hebrew Liturgical Poetry*, 289–411.
31. Remnants of this rite remained in Piedmont, where some of the expelled French Jews settled.
32. It would later develop into the modern Polish rite; Daniel Goldschmidt, *Mahzor layamim hanora'im lefi minhage bne Ashkenaz lekhol anfehem kolel minhag Ashkenaz (hama'aravi) minhag Polin uminhag Tsarfat leshe'avar*, vol. 1: *Rosh Hashanah* (Jerusalem: Koren, 1970), introduction, 13–14. A prominent medieval example of the Eastern rite is the Nuremberg Mahzor, of which a digitalized reproduction appears on the Internet site of the National Library of Israel, http://jnul.huji.ac.il/dl/mss-pr/mahzor-nuremberg; a pdf version of Jonah and Abraham Fraenkel's presentation, attributing it to the Eastern rite, "Prayer and *Piyyut* in the Nuremberg Mahzor [in Hebrew]," appears at http://jnul.huji.ac.il/dl/mss-pr/mahzor-nuremberg/pdf/fraenkel_j_a.pdf.
33. For background on Meir bar Isaac, see Fleischer, *Hebrew Liturgical Poetry*, chaps. 6–7; Avraham Grossman, *The Early Sages of Ashkenaz* [in Hebrew] (Jerusalem: Hebrew University Magnes Press, 1989), 292–296; Weinberger, *Jewish Hymnography*, 160–161.
34. For the medieval manuscripts, see Jerusalem, The National Library of Israel, MS heb. $4^0 781$/II of unknown date; for a digital version, see http://www.jnul

.huji.ac.il/dl/mss/worms/b_eng.html; Oxford, Bodleian Library, MS Michael 436, Adolf Neubauer, *Catalogue of the Hebrew Manuscripts of the Bodleian Library* (Oxford: Clarendon Press, 1886), no. 1025; glosses in a manuscript of the *Sefer Maharil* indicating special features of the Worms rite, Oxford, Bodleian Library, MS Opp. 296, Neubauer, *Catalogue*, no. 2368. The early modern compilations include a mahzor in Oxford, Bodleian Library, MS Michael 434–435; a compilation by Judah Liva Kirchheim from c. 1630, *Minhagot Wermaiza: Minhagim wehanhagot sheasaf wehiber Rabbi Yuda Liva Kirchheim*, ed. Israel M. Peles (Jerusalem: Mekhon Yerushalayim, 1987); one by Yuspa Shammash from c. 1650, *Minhagim dekehilat kodesh Wermaiza Lerabbi Yuspa Shammash*, ed. Benjamin S. Hamburger and Itzhak (Eric) Zimmer (Jerusalem: Mekhon Yerushalayim, 1988–1992); a printed edition by Sinai Zekelin Loans from 1714, *Ma'aravot yotsrot zulatot uselihot im hapesukim uminhagim dekehilat kodesh Wermaiza* (Frankfurt/Main: Johann Kellner, 1714); parts of this text is printed also in *Minhagot Wermaiza*, 335–352. These sources were described and analyzed by A. Epstein, "Die Wormser Minhagbücher," in *Gedenkbuch zur Erinnerung an David Kaufmann*, ed. M. Brann and F. Rosenthal (Breslau: Schottlaender, 1900), 288–316.

35. For the details, see Beit-Arié, "The Worms Mahzor: Its History," 29–30; after World War II it was transferred to the National Library of Israel.

36. Daniel Goldschmidt, "The Worms Mahzor [in Hebrew]," *Kiryat Sefer* 34 (1959): 388–396 and 513–522.

37. Beit-Arié, "The Worms Mahzor: Its History," 14, 20.

38. Peles's notes to Kirchheim, *Minhagot Wermaiza*, 114, n. 8; 142, n. 19. Peles observed some cases of specific correspondence between Kirchheim's description of the Worms rite and the second volume of the Worms Mahzor.

39. Goldschmidt, *Mahzor layamim hanora'im*; Daniel Goldschmidt and Jonah Fraenkel, *Mahzor Sukkot, Shemini Atseret Usimhat Torah lefi minhage bne Ashkenaz lekhol anfehem kolel minhag Ashkenaz (hama'aravi) minhag Polin uminhag Tsarfat leshe'avar* (Jerusalem: Koren, 1981); Jonah Fraenkel, *Mahzor Pesah lefi minhage bne Ashkenaz lekhol anfehem kolel minhag Ashkenaz (hama'aravi) minhag Polin uminhag Tsarfat leshe'avar* (Jerusalem: Koren, 1993); Fraenkel, *Mahzor Shavuot lefi minhage bne Ashkenaz lekhol anfehem kolel minhag Ashkenaz (hama'aravi) minhag Polin uminhag Tsarfat leshe'avar* (Jerusalem: Koren, 2000).

40. Fleischer, "Prayer and Piyyut in the Worms Mahzor," in *Worms Mahzor*, ed. Beit-Arié, 36–78.

41. Toward the publication of the facsimile edition of the illuminated pages of the Leipzig Mahzor in 1964, Narkiss consulted Goldschmidt about the text version of the manuscript and reported that Goldschmidt "found [it] . . . to be generally of the 'use of Worms'"; Narkiss, *Machsor Lipsiae*, 92, n. 1. In the early volumes of Goldschmidt's *Mahzor*, he used the Leipzig Mahzor as a source. This direction was given up for the later volumes; Goldschmidt, *Mahzor layamim hanora'im*, 51–52; Fraenkel, *Mahzor Pesah*, introduction, 48, n. 16; Fraenkel, *Mahzor Shavuot*, introduction, 51, n. 330. I am indebted

to Jonah Fraenkel, who read an earlier version of this chapter and confirmed my findings. In our conversation Fraenkel noted that the Leipzig Mahzor was not included in the project, as it had never been examined thoroughly.

42. An inscription on fol. 179r of the first volume indicates the date of the purchase in 1553; see Narkiss, *Machsor Lipsiae*, 89, citing the inscription with a translation into English.

43. Ibid.; Sed-Rajna, *Le mahzor enluminé*, 69–70; Mackert's lecture (see note 12).

44. Fols. 76v, 115r, 156v, and 169v.

45. Neubauer, *Catalogue*, nos. 1031–1032.

46. Vol. 1, fol. 40r of the Leipzig Mahzor, and vol. 1, fol. 22v of the Michael Codex. Distinguishing marks were required in principle since the Fourth Lateran Council in 1215, but they were enforced in different ways and at different times. It was suggested that the funnel hat was among these marks. In Jewish manuscript decoration, however, the Jews did certainly not approach the funnel hat as a defamatory mark, but as a feature to positively designate Jews; for a recent discussion of the funnel hats in Jewish art with references to earlier treatments and sources, see Epstein, *Medieval Haggadah*, 65–67.

47. Vol. 1, fol. 59r of the Leipzig Mahzor, and vol. 1, fol. 42r of the Michael Codex.

48. Vol. 2, fol. 121r.

49. Vol. 2, fol. 181r of the Leipzig Mahzor, and vol. 2, fol. 142v of the Michael Codex.

50. Vol. 2, fol. 213v of the Leipzig Mahzor, and vol. 2, fol. 151v of the Michael Codex.

51. According to the Hebrew sources that describe the 1615 expulsion and the destruction of the synagogue, the Jews crossed the Rhine and moved into the area of the Palatine. After some time they were readmitted to Worms; many of the expelled Jews resettled there and the synagogue was restored; see the account in *Ma'asse Nisim*, printed with English and Hebrew translations in Shlomo Eidelberg, *R. Juspa, Shammash of Wormaisa (Worms): Jewish Life in 17th Century Worms* (Jerusalem: Hebrew University Magnes Press, 1991), 71–74; David Gans, *Tsemah David* (Warsaw: Zvi Bamberg, 1871), 117–178; for details on the persecution, see Christopher R. Friedrichs, "Anti-Jewish Politics in Early Modern Germany: The Uprising in Worms, 1613–1617," *Central European History* 23/2.3 (1990): 91–152.

52. The second volume of this mahzor, finally, includes two other decorations, for which the second volume of the Worms Mahzor served as a model: the gate for the embellishment of *sha'are rahamim* (Gates of mercy) is copied from the parallel in the Worms Mahzor; likewise the flower design for the *piyyut shoshan emeq* (The lily of the valley) is a copy of the same design in the Worms Mahzor. This supports my suggestion that the second volume of the Worms Mahzor was, indeed, also a mahzor of the Worms rite.

53. The following chapters are not meant as a monograph to cover the entire illustration program of the Leipzig Mahzor. Rather, they discuss a selection of

miniatures in depth, examining their contribution in shedding light on the mentality of those who made and used it. For a full list of the decorated pages with short descriptions, see the Appendix; and Katz, *Machsor Lipsiae.*

54. Vol. 1, fol. 53r; vol. 1, fol. 59r; vol. 1, fols. 72v–73r; vol. 2, fol. 181r.
55. Vol. 1, fols. 85–87.
56. Vol. 1, fols. 51v–52r; vol. 1, fol. 73r.
57. Vol. 1, fol. 19r.
58. Vol. 2, fol. 43v.
59. Amsterdam, Joods Historisch Museum, MS B. 166; *The Amsterdam Mahzor: History, Liturgy, Illumination,* ed. Albert van der Heide and Edward van Voolen (Leiden: E. J. Brill, 1989).
60. Oxford, Bodleian Library, MS Mich. 627 and 617; Neubauer, *Catalogue,* nos. 1033, 1035; Sed-Rajna, *Le mahzor enluminé,* 65; Narkiss, *Hebrew Illuminated Manuscripts,* 215.
61. Oxford, Bodleian Library, MS Laud 321, Neubauer, *Catalogue,* no. 2373; Sed-Rajna, *Le mahzor enluminé,* 65–66; Narkiss, *Hebrew Illuminated Manuscripts,* 121.
62. Sächsische Landesbibliothek, MS 46a, and Biblioteka Uniwersytecka, cod. Or. I, 1; Sed-Rajna, *Le mahzor enluminé,* 15–16.
63. The Tripartite Mahzor is split into three volumes, Budapest, Hungarian Academy of Sciences, Kaufmann collection, MS A 384; London, British Library, MS Add. 22413, G. Margoliouth, *Catalogue of the Hebrew and Samaritan Manuscripts in the British Museum* (London: British Museum, 1899–1935), no. 662; Oxford, Bodleian Library, MS Mich. 619, Neubauer, *Catalogue,* no. 2374; for a discussion, see Sarit Shalev-Eyni, "The Tripartite Mahzor [in Hebrew]" (PhD diss., Hebrew University of Jerusalem, 2001).
64. This contradicts Gabrielle Sed-Rajna's assertion of 1983, *Le mahzor enluminé,* indebted to the recensional method of manuscript studies, presenting the Ashkenazi mahzorim each as a representative of a group that follows basically the same iconographic program. Sed-Rajna treated them as a rather homogeneous group, whose members she considered milestones in the evolution of an iconographic program. Although sharing some of the iconographic themes in their basic outline, the iconographic programs are much more diverse than Sed-Rajna's view seems to imply.
65. Sarit Shalev Eyni, "Cosmological Signs in Calculating the Time of Redemption: The Christian Crucifixion and the Jewish New Moon of Nissan," *Viator* 35 (2004): 265–287.
66. For a detailed discussion, see Katrin Kogman-Appel, "The Tree of Death and the Tree of Life: The Hanging of Haman in Medieval Jewish Manuscript Painting," in *Between the Picture and the Word: Essays in Honor of John Plummer,* ed. Colum Hourihane (Princeton: Index of Christian Art; University Park: Pennsylvania State University Press, 2005), 187–208.
67. They have been discussed by Kurt Schubert and Ursula Schubert, *Jüdische Buchkunst I* (Graz: Akademische Druck- und Verlagsanstalt, 1984), 99–100.
68. Shalev-Eyni, *Jews among Christians.*

69. The issue of animal-headed figures, birds' heads, and other alterations of the human face, is one of the most vexed issues in the historiography of medieval Jewish art, and goes beyond the framework of my current interest in the Leipzig Mahzor. Such alterations appear in the majority of illuminated manuscripts from the German lands from the earliest occurrence of book art until the middle of the fourteenth century, when it suddenly and abruptly stops. The most recent, and most interesting, discussion of this phenomenon appears in Epstein, *Medieval Haggadah,* pt. 1, where the faces in the Bird's Head Haggadah are reconsidered. Together with other iconographic elements that facilitate social stratification, Epstein interprets these faces as a means to single out Jews among Gentiles and emphasize numerous positive associations with these faces. Even though Epstein makes it quite clear, both in his book and in private communication (July 2011), that he does not mean to offer an overall explanation of the phenomenon as such, but approaches solely the Bird's Head Haggadah, I would not completely exclude the possibility that the figures of the Leipzig Mahzor share something of the concepts described by Epstein. Given the fact that both manuscripts may have been written by the same scribe, and both may originate in the Middle Rhine area, it is possible that the Leipzig Mahzor's faces represent a somewhat more stylized version of the birds' heads and was influenced by the designers of the Haggadah some ten or fifteen years later. This, however, should be the subject of a separate study. It can be observed, for example, that in the Leipzig Mahzor there is no consistent distinction between Jews and non-Jews: whereas the Egyptian persecutors are shown with their faces covered by armor, and thus no birdlike faces are seen; Nimrod (fig. 18) and Haman (vol. 1, fol. 51v) are shown with the same faces as the Israelites. For full reference to earlier treatments of the zoocephalic figures, see Epstein, ibid.

70. Both Speyer and Worms were burned to the ground during the Palatine succession war in 1689.

2. Worms

1. Ronald L. Grimes, *Ritual Criticism: Case Studies in Its Practice, Essays on Its Theory* (Columbia: University of South Carolina Press, 1990), 13–15; for another attempt to define rituals by a shared set of features, see Roy Rappaport, *Ritual and Religion in the Making of Humanity* (Cambridge: Cambridge University Press, 1999), chap. 2; for a particularly broad definition of ritual, encompassing religious and profane, public and private, established and spontaneous rituals, see Robert Wuthnow, *Meaning and Moral Order: Exploration in Cultural Analysis* (Berkeley: University of California, 1989), chap. 4; for an overview of alternative approaches to the typical characteristics of rituals, see Catherine Bell, *Ritual. Perspectives and Dimensions* (New York: Oxford University Press, 1997), chap. 5.

2. Steven Lukes, "Political Ritual and Social Integration," *Sociology* 9/2 (1975): 289–290.

3. For a discussion of these characteristics and processes of ritualization, see Catherine Bell, *Ritual Theory, Ritual Practice* (New York: Oxford University Press, 1992), 73–74, 88–89, 140–141, 222–223.

4. Examples are Lawrence A. Hoffman, "Life Cycle Liturgy as Status Transformation," in *Eulogema: Studies in Honor of Robert Taft S. J.,* ed. Ephrem Carr et al., *Studia Anselmiana* 110 (1993): 161–163; see also Ivan G. Marcus, *The Jewish Life Cycle: Rites of Passage from Biblical to Modern Times* (Seattle: University of Washington Press, 2004).

5. *Sefer Maharil: Minhagim shel Rabbenu Ya'akov Moelin, Hilkhot yom kippur* 11, ed. Shlomo Spitzer (Jerusalem: Mekhon Yerushalayim, 1989).

6. Mark Searle, "Ritual," in *The Study of Liturgy,* ed. Cheslyn Jones, Geoffrey Wainwright, Edward Yarnold, and Paul Bradshaw (London: SPCK; New York: Oxford University Press, 1992), 51–58, repr. in *Foundations of Ritual Studies: A Reader for Students of Christian Worship,* ed. Paul Bradshaw and John Melloh (Grand Rapids: Baker Academic, 2007), 9–16; for a concise discussion of the functionalist approach and its roots, see Bell, *Ritual. Perspectives and Dimensions,* 27–33.

7. For an overview, see Bell, *Ritual. Perspectives and Dimensions,* 33–46; Bell defined these approaches as structuralist in that they correlate social structures with "structured relationships among symbols," the latter expressing the cultural ideas and values of a society. See also Wuthnow, *Meaning and Moral Order,* chap. 4.

8. Searle, "Ritual," 12.

9. For an excellent recent discussion of the mahzor and the siddur as an early type of Hebrew book, the former's communal nature, and their place in the history of the medieval book, see David Stern, *The Jewish Library: Four Classic Jewish Books and the Jewish Historical Experience* (forthcoming), chap. 3. I am grateful to David Stern for sharing his manuscript with me prior to publication; see also Stern, "'Jewish' Art and the Making of the Medieval Prayerbook," *Ars Judaica* 6 (2010): 23–44.

10. Samson Rothschild, *Aus Vergangenheit und Gegenwart der Israelitischen Gemeinde Worms* (Frankfurt: J. Kaufmann, 1905), fig. 1; for a discussion on the nineteenth-century community of Worms building its historical memory, see Nils Roemer, "Provincializing the Past: Worms and the Making of a German-Jewish Cultural Heritage," *Jewish Studies Quarterly* 12/1 (2005): 80–100.

11. For details and a photograph of the burning synagogue, see Nils Roemer, *German City, Jewish Memory: The Story of Worms* (Waltham: Brandeis University Press 2010), 137–138, 170–177; Ernst Roth, *Die alte Synagoge zu Worms* (Frankfurt/Main: Ner Tamid Verlag, 1961).

12. A focus on geographical definitions of settled areas can be observed in German research marked by an emphasis on patterns of settlement, geo-economic considerations, and cartographic surveying of historical evidence, in what is termed *Kulturraumforschung;* see, e.g., Franz-Josef Ziwes, *Studien zur Geschichte der Juden im mittleren Rheingebiet während des hohen und späten Mittelalters* (Hannover: Hahnsche Buchhandlung, 1995); for a discussion of

the problems of defining boundaries apart from legal or political boundaries (linguistic, religious, cultural), see Anthony Cohen, *The Symbolic Construction of Community* (New York: Routledge, 1985), 12–15.

13. These two approaches, the historical (in terms of describing the key historical events) and the institutional, are the most dominant ones in dealing with medieval Ashkenazi communities; see Abraham Grossman, "The Attitude of Ashkenazi Scholars to Community Authorities [in Hebrew], *Shnaton Hamishpat Ha'ivri* 2 (1975): 175–199; Yosef H. Yerushalmi, *Zakhor: Jewish History and Jewish Memory* (Seattle: University of Washington Press, 1982), chap. 2; Haym Soloveitchik, *Responsa as Historical Sources* [in Hebrew] (Jerusalem: Zalman Shazar Center, 1990), 87–105; Ephraim Kanarfogel, "Unanimity, Majority, and Communal Government in Ashkenaz during the High Middle Ages: A Reassessment," *Proceedings of the American Academy for Jewish Research* 58 (1992): 79–106; Christoph Cluse, "Die Mittelalterliche jüdische Gemeinde als 'Sondergemeinde': Eine Skizze," in *Sondergemeinden und Sonderbezirke in der Stadt der Vormoderne* (Städteforschung A 59), ed. Peter Johanek (Cologne: Böhlau Verlag, 2004), 29–51. Issues of social cohesion, shared values, and cultural boundaries in the sense suggested by Cohen, in *Symbolic Construction of Community*, have only rarely been addressed in Jewish history; for an exception, see Jeffrey Woolf, "'Qehillah qedosha': Sacred Community in Medieval Ashkenazic Law and Culture," in *A Holy People: Jewish and Christian Perspectives on Religious Communal Identity*, ed. Marcel Poorthuis and Joshua Schwartz (Leiden: E. J. Brill, 2006), 217–235. For the early modern period, see also Dean Phillip Bell, *Sacred Communities: Jewish and Christian Identities in Early Modern Germany* (Leiden: E. J. Brill, 2001). For methodological issues in sociological approaches to historical communities, see Alan Macfarlane, Sarah Harrison, and Charles Jardine, *Reconstructing Historical Communities* (Cambridge: Cambridge University Press, 1977), with a focus on statistical data and thus limiting their applicability to medieval communities. For a particularly useful model of group definition, see Mary Douglas, *Natural Symbols: Explorations in Cosmology*, 2nd rev. ed. (New York: Routledge, 1973), chap. 4. Douglas maps out the parameters that enable us to define a group by its structure and its behavioral patterns.

14. The Jewish institutions were surveyed by Ziwes, *Studien*, 73–97; see also Bell, *Sacred Communities*, chap. 6; social structures and organizational systems were discussed by Ivan G. Marcus, "The Political Dynamics of the Medieval German-Jewish Community," in *Authority, Power and Leadership in the Jewish Polity: Cases and Issues*, ed. Daniel J. Eleazar (Lanham, MD: University Press of America, 1991), 113–137; demographic issues in relation to social institutions were studied in recent years by Rainer J. Barzen, aiming at an integration of non-Jewish archival material with Jewish sources, primarily the responsa literature and the so-called *Memorbücher*, lists that commemorate the victims of medieval persecutions, "Zur Siedlungsgeschichte der Juden im mittleren Rheingebiet bis zum Beginn des 16. Jahrhunderts," in *Geschichte der Juden im Mittelalter von der Nordsee bis zu den*

Südalpen—Kommentiertes Kartenwerk, ed. Alfred Haverkamp (Hannover: Hahnsche Buchhandlung, 2002), vol. 1: *Kommentarband*, 55–73; Barzen, "Jewish Regional Organization in the Rhineland: The Kehillot Shum around 1300," in *The Jews of Europe in the Middle Ages (Tenth to Fifteenth Centuries): Proceedings of the International Symposium Held in Speyer, 20–25 October 2002*, ed. Christoph Cluse (Turnhout: Brepols, 2004), 233–242.

15. Recent scholarship presents European Jewry no longer as an isolated minority whose history was primarily determined by persecution and suffering, and shows different degrees of integration of the Jews in the structures of Christian society. See especially Jonathan Elukin, *Living Together, Living Apart: Rethinking Jewish-Christian Relations in the Middle Ages* (Princeton: Princeton University Press, 2007); Robert Chazan, *Reassessing Jewish Life in Medieval Europe* (New York: Cambridge University Press, 2011).

16. It is difficult to apply sociological community theory to medieval communities, as it is largely concerned with modern communities and the role community cohesion plays in industrial and postindustrial societies. See, e.g., Colin Bell and Howard Newby, *Community Studies: An Introduction to the Sociology of the Local Community* (London: Allen and Unwin, 1972); Gerald Suttles, *The Social Construction of Community* (Chicago: University of Chicago Press, 1972); Graham Crow and Graham Allan, *Community Life: An Introduction to Local Social Relations* (New York: Harvester and Wheatsheaf, 1994). Modern communities are often interest groups that link their members by choice, whereas the medieval community, naturally, was significantly less flexible; for a discussion of these questions regarding modern communities, see Cohen, *Symbolic Construction of Community*.

17. "Qehillah qedosha"; more generally defining communities from this angle, see Cohen, *Symbolic Construction of Community*, chap. 1, who points out that the community provides a set of symbols, a cultural vocabulary, but that within this symbolic framework its members enjoy a great deal of flexibility in the use of this vocabulary.

18. For a discussion on the spiritual background of this notion in the medieval German lands in relation to similar Christian ideas about holy cities, see Israel J. Yuval, "Heilige Städte, heilige Gemeinden: Mainz als das Jerusalem Deutschlands," in *Jüdische Gemeinden und Organisationsformen von der Antike bis zur Gegenwart*, ed. Robert Jütte and Abraham B. Kustermann, *Aschkenas, Beiheft* 3 (1996): 91–101.

19. Woolf, "'Qehillah qedosha'," 218. Dean P. Bell approached the early modern Jewish community—the Ashkenazi community in general and the Worms community in particular—from these points of view, in *Sacred Communities*; Bell, "Worms and the Jews: Jews, Magic and Community in Seventeenth-Century Worms," in *Werewolves, Witches, and Wandering Spirits: Traditional Belief and Folklore in Early Modern Europe* (Kirksville, MO: Truman State University Press, 2002), 93–118, where he discusses rituals and magic in the context of the sacred congregation.

20. The role prayer played in shaping a shared tradition and the collective memory of any given community is addressed by Lawrence A. Hoffman, *Beyond*

the Text: A Holistic Approach to Liturgy (Bloomington: Indiana University Press, 1987), 75–79; see also his call for methodologies that go "beyond textual and ritual reconstruction and also encompass questions of public meaning and personal identity," Hoffman, "Reconstructing Ritual as Identity and Culture," in The Making of Jewish and Christian Worship, ed. Paul F. Bradshaw and Lawrence A. Hoffman (Notre Dame, IN: University of Notre Dame Press, 1991), 22–41, esp. 34.

21. For a concise presentation of archival material about the Jewish communities in the German lands, integrating it to some degree with traditional rabbinic sources, see Germania Judaica, vol. 1: Von den ältesten Zeiten bis 1238, ed. I. Elbogen, A. Freimann, and H. Tykocinski (Tübingen: Mohr Siebeck, 1963); vol. 2: Von 1238 bis zur Mitte des 14. Jahrhunderts, ed. Zvi Avneri (Tübingen: Mohr Siebeck, 1968); on the history of Ashkenazi scholarship, see Ephraim E. Urbach, The Tosafists: Their History, Writings and Methods [in Hebrew], rev. ed. (Jerusalem: Mosad Bialik), 1986; originally published in 1954); Avraham Grossman, The Early Sages of Ashkenaz: Their Lives, Leadership and Works, 900–1096 [in Hebrew] (Jerusalem: Hebrew University Magnes Press, 1988); these works describe scholarly production in a conventional approach to cultural history. On recent approaches to Jewish cultural history, see Moshe Rosman, "A Prolegomenon to the Study of Jewish Cultural History," Jewish Studies—Internet Journal 1 (2002): 109–127; for an excellent recent overview of the culture of Ashkenazi Jews, see Ivan G. Marcus, "A Jewish-Christian Symbiosis: The Culture of Early Ashkenaz," in Cultures of the Jews: A New History, ed. David Biale (Westminster: Schocken Books, 2002), 449–518; for a recent summary of the history of medieval Jewish Worms with a focus on martyrdom and remembrance, see Roemer, German City, Jewish Memory, chap. 1.

22. For a detailed examination of sources specifically for the Middle Rhine region, see Ziwes, Studien. On the immigration of Jews to the German lands, see Abraham Grossman, "The Immigration of the Jews to Germany and Their Settlement There during the Ninth and the Eleventh Centuries [in Hebrew]," in Emigration and Settlement in Jewish and General History: A Collection of Essays, ed. Avigdor Shinan (Jerusalem: Zalman Shazar Center, 1992), 109–128; on the early medieval Ashkenazi communities, see also Grossman, "The Jewish Community in Ashkenaz during the 10–11th Centuries [in Hebrew]," in Kehal Yisrael: Jewish Self-Rule through the Ages, ed. Avraham Grossman and Joseph Kaplan (Jerusalem: Zalman Shazar Center, 2004), 57–74; specifically for Worms, see Fritz Reuter, "Die heilige Gemeinde Worms: Zur Geschichte des Oberrheinischen Judentums," in Juden in Deutschland, ed. Michael Matheus, Mainzer Vorträge 1 (Stuttgart: Institut für geschichtliche Landeskunde an der Universität Mainz, 1995), 61–84; Gerold Bönnen, "Jüdische Gemeinde und christliche Stadtgemeinde im spätmittelalterlichen Worms," in Jüdische Gemeinden und ihr christlicher Kontext in kulturräumlich vergleichender Betrachtung von der Spätantike bis zum 18. Jahrhundert, ed. Christoph Cluse, Alfred Haverkamp, and Israel J. Yuval (Hannover: Hahnsche Buchhandlung, 2003), 309–340; Bönnen, "Worms:

The Jews between the City, the Bishop, and the Crown," in Cluse, *The Jews of Europe*, 450–458.

23. See, e.g., in one of the three chronicles reporting the 1096 events, the so-called Mainz Anonymous, *Hebräische Berichte über die Judenverfolgungen während des Ersten Kreuzzugs*, ed. Eva Haverkamp (Hannover: Hahnsche Buchhandlung, 2005), 285.

24. Marcus, "Political Dynamics."

25. Grossman emphasizes this independence in relation to the Babylonian authorities on various occasions; see, e.g., *Early Sages of Ashkenaz*, 106–107; see also Marcus, "Political Dynamics," 115.

26. Israel M. Ta-Shma, *Early Franco-German Ritual and Custom* [in Hebrew] (Jerusalem: Hebrew University Magnes Press, 1999), 13–108; see also some remarks in Ta-Shma, *Early Ashkenazic Prayer* [in Hebrew] (Jerusalem: Hebrew University Magnes Press, 2003), 4–7.

27. For example, *Palestinian Talmud, Yebamot* 12, 12c, and several more instances; for a detailed discussion of the attitude to the *minhag* in the Palestinian Talmud, see Ta-Shma, *Ritual and Custom*, 61–69; see also Daniel Sperber, *Jewish Custom: Sources and History* [in Hebrew] (Jerusalem: Mosad Bialik, 1989), 235–237.

28. A significant part of their work survived in the somewhat later *Sefer Ma'ase Hageonim*, ed. Abraham Epstein and Jacob Freimann (Berlin: Meqitse Nirdamim, 1915).

29. Scholars disagree on the impact the riots had on the subsequent generations. Whereas Robert Chazan, in *European Jewry and the First Crusade* (Berkeley: University of California Press, 1987), suggests that the Rhenish communities recovered fairly quickly, Abraham Grossman, in *Early Sages of Ashkenaz*, 434–440, argues that the massacres led to a severe crisis in scholarship.

30. For details on this process, see Dietmar Willoweit, "Vom Königsschutz zur Kammerknechtschaft: Anmerkungen zum Rechtsstatus der Juden im Hochmittelalter," in *Geschichte und Kultur des Judentums: Eine Vorlesungsreihe an der Julius-Maximilians-Universität Würzburg*, ed. Karlheinz Müller and Klaus Wittstadt (Würzburg: Kommissionsverlag F. Schoningh, 1988), 71–89.

31. Heinrich Boos, *Urkundenbuch der Stadt Worms* (Berlin: Weidmann, 1886), vol. 1, 49, no. 56; Ziwes, *Studien*, 96.

32. Louis Finkelstein, *Jewish Self-Government in the Middle Ages* (New York: Jewish Theological Seminary of America, 1924), 232; Rainer J. Barzen, "'Kehillot Schum': Zur Eigenart der Verbindungen zwischen den jüdischen Gemeinden Mainz, Worms und Speyer bis zur Mitte des 13. Jahrhunderts," in *Jüdische Gemeinden und ihr christlicher Kontext*, 391–404; Barzen, *Takkanot Kehillot Schum: Die Rechtssatzungen der jüdischen Gemeinden von Mainz, Worms und Speyer im hohen und späten Mittelalter* (Hannover: Hahnsche Buchhandlung, 2011). As early as the first part of the twelfth century a rabbinic council was held in Troyes, and apparently the representatives of Mainz, Speyer, and Worms were approached as some sort of general legal authority for the German lands.

33. Earlier scholarship referred to these assemblies as "synods," thus creating a clear parallel to the Christian institution of synods, Heinrich Graetz, *Geschichte der Juden von den ältesten Zeiten bis auf die Gegenwart* (Leipzig: Leiner, 1897), vol. 4, 22; Finkelstein, *Jewish Self-Government,* 25, 35; Eric Zimmer, *Jewish Synods in Germany during the Late Middle Ages, 1286–1603* (New York: Yeshiva University Press, 1978); recently, however, Barzen observed that the notions of the Christian synods and the Jewish assembly have less in common than hitherto assumed, "'Kehillot,'" 392.

34. The term was coined by Charles Homer Haskins, *The Renaissance of the Twelfth Century* (Cambridge, MA: Harvard University Press, 1927); *Renaissance and Renewal in the Twelfth Century,* ed. Robert L. Benson, Giles Constable, and Carol D. Lanham (Cambridge, MA: Harvard University Press, 1982). On influences on Jewish scholarship, see especially Ivan G. Marcus, "The Dynamics of Jewish Renaissance and Renewal in the Twelfth Century," in *Jews and Christians in Twelfth-Century Europe,* ed. Michael A. Signer and John Van Engen (Notre Dame, IN: University of Notre Dame Press, 2001), 27–45.

35. On the Tosafist school of this generation, see Abraham (Rami) Reiner, "Rabbenu Tam and His Contemporaries [in Hebrew]" (PhD diss., Hebrew University of Jerusalem, 2002); Reiner, "From Rabbenu Tam to R. Isaac of Vienna: The Hegemony of the French Talmudic School in the Twelfth Century," in Cluse, *The Jews of Europe,* 273–283.

36. Metz, even though a free town of the Holy Roman Empire, was culturally and linguistically French.

37. For details and a case in point, see Irving A. Agus, *Rabbi Meir of Rothenburg: His Life and His Works as Sources of the Religious, Legal and Social History of the Jews of Germany in the Thirteenth Century* (New York: Ktav, 1970), vol. 1, 51–53.

38. For a careful discussion of the historical background in an attempt to define it to a degree that enables us to determine an approximate date between 1200 and 1225, see Haym Soloveitchik, "Remarks on the Date of the *Sefer Hasidim* [in Hebrew]," in *Culture and Society in Medieval Jewish History: A Collection of Articles in Memory of Haim Hillel Ben-Sasson,* ed. Reuven Bonfil, Menachem Ben-Sasson, and Joseph Hacker (Jerusalem: Zalman Shazar Center, 1989), 383–389. The book now exists in two recensions, one that is based on the first printed edition, Bologna 1538, see *Sefer Hasidim,* ed. Reuven Margaliot (Jerusalem: Mosad Harav Kook, 1957); the other in a manuscript in Parma, *Sefer Hasidim,* ed. Judah Hakohen Wistinetzky and Jakob Freiman (Frankfurt/Main: n.p., 1924); for a comparative database of the different versions and background information, see http://etc.princeton.edu/sefer_hasidim.

39. Their family roots, as reported by Eleazar ben Judah in his *Commentary to the Siddur,* ed. Moshe Hershler (Jerusalem: Mekhon Harav Hershler, 1952), 238, largely correspond to those chronicled in 1054 by Ahima'az ben Paltiel in Capua; for an edition and contextualizing commentary of the latter, see Robert Bonfil, *History and Folklore in a Medieval Jewish Chronicle: The*

Family Chronicle of Ahima'az ben Paltiel (Leiden: E. J. Brill, 2009). The link to the late antique and early medieval Jewish tradition has been discussed by Ivan G. Marcus, "Hierarchies, Religious Boundaries and Jewish Spirituality in Medieval Germany," *Jewish History* 1 (1986): 7–26; Peter Schäfer, "The Ideal of Piety of the Ashkenazi Hasidim and Its Roots in Jewish Tradition," *Jewish History* 4/2 (1990): 9–23, describes parallels to earlier phenomena of religious elitism in Jewish society, especially early medieval circles of *Merkavah* mysticism; Daniel Abrams, "*Ma'aseh Merkabah* as a Literary Work: The Reception of Hekhalot Traditions by the German Pietists and Kabbalistic Reinterpretation," *Jewish Studies Quarterly* 5 (1998): 329–345; see also Bonfil, *History and Folklore*, 42, 236, n. 52.

40. Gershom G. Scholem, *Major Trends in Jewish Mysticism* (Jerusalem: Schocken, 1941), 80–87; Joseph Dan, "The Problem of Martyrdom in the Teachings of the Pietistic Movement [in Hebrew]," in *Holy War and Martyrology in the History of the Jews and in General History* (Jerusalem: Historical Society, 1968), 121–129, repr. in *The Religious and Social Ideas of the Jewish Pietists in Medieval Germany: Collected Essays*, ed. Ivan G. Marcus (Jerusalem: Zalman Shazar Center, 1986), 207–216; see also Marianne Awerbuch, "Weltflucht und Lebensverneinung der 'Frommen Deutschlands,' " *Archiv für Kulturgeschichte* 60 (1978): 53–93.

41. Yitzhak Baer, "The Social and Religious Tendencies of the *Sefer Hasidim* [in Hebrew]," *Zion* 3 (1938): 1–50, repr. in Marcus, *Religious and Social Ideas*, 1–50; Urbach, *The Tosafists*, vol. 1, 394.

42. Haym Soloveitchik, "Three Themes in the *Sefer Hasidim* (pt. 1)," *Association of Jewish Studies Review* 1 (1976): 318–319.

43. At one occasion, for example, he noted that "the custom is a full corpus of teaching," *Sefer Haroqeah*, par. 319, ed. Barukh S. Shneurson (Jerusalem: n.p., 1967).

44. For the most thorough and exhaustive study of interactions between Pietist and Tosafist scholarship, which discusses earlier somewhat dichotomizing views about the two schools in great depth, see Ephraim Kanarfogel, *Peering through the Lattices: Mystical, Magical, and Pietistic Dimensions in the Tosafist Period* (Detroit: Wayne State University Press, 2000), specifically on Eliezer ben Joel, 47–52.

45. Ivan G. Marcus, *Piety and Society: The Jewish Pietists of Medieval Germany* (Leiden: E. J. Brill, 1981), 114, 121; Marcus, "Judah the Pietist and Eleazar of Worms: From Charismatic to Conventional Leadership," in *Jewish Mystical Leaders and Leadership in the 13th Century*, ed. Moshe Idel and Mortimer Ostow (Northvale, NJ: Jason Aronson, 1998), 97–127.

46. *Germania Judaica*, vol. 1, 453; on the legal decisions of the three Rhenish communities, see Barzen, *Takkanot*, Einleitung, chap. 2.

47. This issue was addressed in a paper by Ivan G. Marcus, "The Historical Meaning of *Hasidei Ashkenaz*: Fact, Fiction or Cultural Self-Image?," in *Gershom Scholem's "Major Trends in Jewish Mysticism" 50 Years After: Proceedings of the Sixth International Conference on the History of Jewish Mysticism*, ed. Joseph Dan and Peter Schäfer (Tübingen: Mohr Siebeck,

1993), 103–114, proposing an anthropological-historical approach to the reading of literary narratives in attempts to judge their historicity.

48. The *Sefer Ha'asufot* has never appeared in print; the only extant manuscript copy is kept in the private collection of D. H. Feinberg (New York), formerly Jews' College, MS Montefiori 134, see, e.g., fol. 32r.

49. For example, ibid., fol. 33v, 35r.

50. Very little is known about this scholar in terms of biographical data; for the available information, see Ephraim E. Urbach, *Sefer Arugat Habosem*, vol. 4: *Introduction* (Jerusalem: Meqitse Nirdamim, 1939–1963), 112–127.

51. Pietism as a value played a central role in these scholars' teachings; see, e.g., Isaac ben Moses, who explains that a pious deceased person should not be buried even near a simple righteous person and defines them as different categories, *Or Zarua*, pt. 2, *Hilkhot avelut*, no. 422 (Zitomir: n.p., 1862).

52. Kanarfogel, *Peering through the Lattices*, 115–124 and chap. 5.

53. Joseph Dan, "Ashkenazi Hasidim, 1941–1991: Was There Really a Hasidic Movement in Medieval Germany?," in *Gershom Scholem's "Major Trends in Jewish Mysticism,"* 87–101; see also Sari Halpert, "Elitism and Pietism: An Investigation into the Elitist Nature of the Hasidei Ashkenaz," *Queens College Journal of Jewish Studies* 2 (2000): 1–7, arguing in favor of Pietist elitism, somewhat simplistically neglecting, however, the fact that Pietism was not a uniform mass of scholarship with a fully homogeneous worldview; her study is almost exclusively based on evidence from the *Sefer Hasidim*.

54. Haym Soloveitchik, "Piety, Pietism, and German Pietism: *Sefer Hasidim I* and the Influence of *Hasidei Ashkenaz*," *Jewish Quarterly Review* 92/3–4 (2002): 455–493; see also Soloveitchik, "Pietists and Kibbitzers," *Jewish Quarterly Review* 96/1 (2006): 60–64. In this context Soloveitchik also differentiates between "conventional" Pietism and "German" Pietism, and argues that much of what earlier scholarship defined as German Pietism should actually be associated with conventional Pietism. Using the term "Pietism" here, I am well aware of this distinction, and it will be used to define the legal, ethical, and esoteric traditions associated with scholars such as Samuel the Pious, Judah the Pious, Eleazar of Worms, and some of their students.

55. Bönnen, "Jüdische Gemeinde," esp. 312, n. 10; Ziwes, *Studien*, 76, 112.

56. On the tense situation of the Rhenish Jews between royal and ecclesiastical power, see Berhard Kreutz, "Worms und Speyer im Spannungsgefüge zwischen Bischolf, Adel und Reich um 1300," in *Städtelandschaft–Städtenetz–Zentralörtliches Gefüge: Ansätze und Befunde zur Geschichte der Städte im hohen und späten Mittelalter* (*Trierer Historische Forschungen* 43; Trier: Kliomedia, 2000), 295–347.

57. For an analytical discussion of the privileges and the related policies, see Ziwes, *Studien*, 97–110.

58. These communities include: Stauf, Altleiningen, Lambsheim, Bockenheim, Alzey, Gau-Odernheim, Wachenheim, Bensheim, Heppenheim, Erbach, Weinheim, Ladenburg, Schriesheim, Heidelberg, Eberbach, Mosbach, Waibstadt, and Wimpfen; see Rainer Barzen, "Regionalorganisation jüdischer Gemeinden im Reich in der ersten Hälfte des 14. Jahrhunderts," in *Geschichte der Juden*

im Mittelalter von der Nordsee bis zu den Südalpen, 293–366; Barzen, "Jewish Regional Organization," map 17.

59. For precise data on the distribution of community institutions, see *Geschichte der Juden im Mittelalter von der Nordsee bis zu den Südalpen,* map B 4.1.

60. There may have been more: the evidence from the district of Speyer, e.g., indicates synagogues in four out of nineteen district communities.

61. In the nineteenth century the community of Worms still built its identity on the fame of the distant past. What stood out in the Worms tradition at that time was the fact that Rashi had lived there, which was stylized into one of the most important aspects of the history of Worms's Jewry, together with the commemoration of its persecuted victims; Roemer, "Provincializing the Past." The comparatively rich physical evidence together with a great deal of folklore made Worms, together with Prague and in some competition with it, into one of the outstanding historical Jewish communities.

62. See first Joachim Wach, *Sociology of Religion* (Chicago: University of Chicago Press, 1971), 214–218 (originally published in 1947); for an overview on approaches to ritual experts, see Bell, *Ritual Theory, Ritual Practice,* 130–140; Bell, "The Authority of Ritual Experts," *Studia Liturgica* 23 (1993): 98–120, repr. in *Foundations of Ritual Studies,* 176–198.

63. In general on the importance of ritual as factor shaping group identity, see Bell, *Ritual Theory, Ritual Practice,* 71.

64. Cohen, *Symbolic Construction of Community,* 50–53.

65. In general the Jewish religion has attracted anthropological interest only to a limited degree; for a discussion of some of the reasons for that, see Dalia S. Marx, "The Early Morning Ritual in Jewish Liturgy: Textual, Historical and Theological Discussion of *Birkhot Hashakhar* (The Morning Blessings) and an Examination of Their Performative Aspects" (PhD diss., Hebrew University of Jerusalem, 2005), 219–220, n. 9. Exceptions are Itamar Gruenwald, *Rituals and Ritual Theory in Ancient Israel* (Leiden: E. J. Brill, 2003); Uri Ehrlich, *The Nonverbal Language of Prayer: A New Approach to Jewish Liturgy* (Tübingen: Mohr Siebeck, 2004); Marx, "Early Morning Ritual," pt. 3; the latter three are concerned more with the performative aspects of ritual than with social, communal, or cultural issues. These have been tackled by Hoffman, *Beyond the Text,* chap. 5; Hoffman, "Reconstructing Ritual as Identity and Culture," in *The Making of Jewish and Christian Worship,* ed. Paul F. Bradshaw and Lawrence A. Hoffman (Notre Dame: University of Notre Dame Press, 1991), 22–41; Ivan G. Marcus, *Rituals of Childhood: Jewish Acculturation in Medieval Europe* (New Haven: Yale University Press, 1996). The Jewish life cycle has received somewhat more attention; see, e.g., Hoffman, "Life Cycle"; Harvey E. Goldberg, *Jewish Passages: Cycles of Jewish Life* (Los Angeles: University of California Press, 2003). For more general remarks on Judaism in an anthropological light, see Goldberg (ed.), *Judaism Viewed from Within and from Without: Anthropological Studies* (Albany: State University of New York, 1987); Goldberg, "Coming of Age in Jewish Studies, or Anthropology Is Counted in the Minyan," *Jewish Social Studies,* n.s., 4 (1998): 29–64.

66. Durkheim's work was first published in 1915; for an English version, see *The Elementary Forms of the Religious Life* (New York: Free Press, 1965). For a discussion of Durkheim's approach to rituals from the point of view of rituals and socialization, see Bell, *Ritual Theory, Ritual Practice*, 171; and in more depth, Bell, *Ritual. Perspectives and Dimensions*, 24–26; see also Wuthnow, *Meaning and Moral Order*, chap. 1.

67. Bell, *Ritual Theory, Ritual Practice*, chap. 7. Some sociologists focus on the emotional impact of ritual performed in groups; for an overview, see Erika Summers-Effler, "Ritual Theory," in *Handbook of the Sociology of Emotion*, ed. Jan E. Stets and Jonathan H. Turner (New York: Springer, 2006), 135–153.

68. Lukes, "Political Ritual."

69. Scholars have observed that in closed societies with highly developed hierarchical structures, rituals are most effective in processes of socialization; examples are described in Bell, *Ritual Theory, Ritual Practice*, 177–181. This approach has been criticized based on the view that much more is known about rituals in religious groups and hierarchically structured societies than about those that developed in other social contexts; see Wuthnow, *Meaning and Moral Order*, 110–112. We have seen that the medieval Ashkenazi communities were indeed quite hierarchically structured, and that scholarship was concentrated in quite a narrow social stratum. However, nothing points to a specific connection between the scholars orchestrating the rituals and the degree to which the rituals actually functioned in terms of social cohesion and their effectiveness toward stabilizing community identity. It seems, rather, that factors other than hierarchy played those roles.

70. It is an open question, however, whether rituals encourage social cohesion or, instead, are more likely to occur in societies with a high degree of cohesion; for a discussion, see Wuthnow, *Meaning and Moral Order*, 109.

71. Ibid., and see the references offered there, n. 10; see especially George C. Homans, "Anxiety and Ritual: The Theories of Malinowski and Radcliffe-Brown," *American Anthropologist* 43 (1941): 164–172.

72. Bell, *Ritual Theory, Ritual Practice*, 71–72.

73. Ibid., 123; Jack Goody, "Against 'Ritual': Loosely Structured Thoughts on a Loosely Defined Problem," in *Secular Ritual*, ed. Sally F. Moore and Barbara G. Myerhoff (Amsterdam: Van Gorcum, 1977), 30–31, however, emphasizes the loss of meaning owing to formalization.

3. A Pesah Sermon by Eleazar ben Judah of Worms

1. Israel Davidson, *Thesaurus of Hebrew Poems and Liturgical Hymns from the Canonization of Scripture to the Emancipation* (New York: Jewish Theological Seminary of America, 1924), vol. 1, no. 1082.

2. For a discussion, see Simha Emanuel's introduction to *Drashah Lepesah*, ed. Simha Emanuel (Jerusalem: Meqitse Nirdamim, 2006), 42, referring to a quotation from the *Sefer Pardes* in *Sefer Shibole Haleqet Hashalem—Rabbenu Tsidqiyahu ben Abraham Harofe*, par. 205, ed. Jerusalem 1887.

3. Ibid., 61.
4. Ibid., 45.
5. Ibid., 67–68.
6. Ibid., 72–76; 83–84.
7. Ibid., 86–82; 111–118.
8. Ibid., 84–89.
9. Ibid., 89–111.
10. By this he means Christendom; see, e.g., Rashi on Numbers 24:19 equating Edom with Rome; see also Israel J. Yuval, *Two Nations in Your Womb: Perceptions of Jews and Christians in Late Antiquity and the Middle Ages* (Berkeley: University of California Press, 2006), chap. 1.
11. *Drashah Lepesah,* 123. The Midrash *Avkir* survived as a fragment only and is the subject of a recent dissertation by Amos Geula, "Lost Aggadic Midrashim Known Only from Ashkenazi Sources: *Avkir, Asefa,* and *Deuteronomy Zutta* [in Hebrew]" (PhD diss., Hebrew University of Jerusalem, 2007).

4. *Halakhah* and *Minhag*

1. A terminology for the specifics of ritualization processes was proposed by Ronald A. Grimes, *Beginnings in Ritual Studies* (Washington, DC: University Press of America, 1982), chap. 3. The use of the term "ritualization" here does not do justice to Grimes's terminology, but rather corresponds to what he calls "decorum." Ritualization in Grimes's terms is a biological, natural process, whereas "decorum," defined as "conventionalized behavior," addresses social norms. The term "liturgy" in Grimes's concept is reserved for defining the mode of approaching "the sacred in a reverent, 'interrogative' mood," doing "necessary ritual work . . . waiting 'in passive voice,' and finally being 'declarative' of the way things ultimately are." He describes liturgy as "a symbolic action in which a deep receptivity, sometimes in the form of meditative rites or contemplative exercises, is cultivated." His is not a focus on the process of developing liturgies.
2. Clifford Geertz, "Religion as a Cultural System," in *Anthropological Approaches to the Study of Religion,* ed. Michael Banton (New York: Travistock, 1965), 1–46, repr. in *The Interpretation of Cultures: Selected Essays* (New York: Basic Books, 1973), 87–125.
3. For an extreme approach arguing that rituals can have no meaning at all to their performers, see Frits Staal, "The Meaninglessness of Ritual," *Numen* 26/1 (1979): 2–22. What matters, according to Staal, in the ritual described there, a traditional Vedic ritual performed in Kerala, is the mere performative aspect and the precise way it should be done, with an almost obsessive concern for the rules associated with it. For an argument in favor of the opposite position, underscoring the importance of meaning in the performance of rituals, see Victor Turner, "Ritual, Tribal and Catholic," *Worship* 50 (1976): 504–526.
4. The need to describe such contexts is met by Geertz's thick description, *The Interpretation of Cultures,* 1–30; see also Edmund Leach, "Ritualization in

Man in Relation to Conceptual and Social Development," in *A Discussion on Ritualization in Animals and Man*, ed. Julian Huxley, *Philosophical Transactions of the Royal Society*, series B, 251 (1966): 407; and Steven Lukes, "Political Ritual and Social Integration," *Sociology* 9/2 (1975): 291.

5. *Sefer Haroqeah, Hilkhot Purim*, par. 242, ed. Barukh S. Shneurson (Jerusalem: Otsar Haposqim, 1967).

6. In the Leipzig Mahzor it appears at the beginning of the liturgical section (after the biblical readings ending on the recto side of the same page) and before the beginning of the service for the Sabbath during the week of Hanukah. In other mahzorim *shokhen ad merom* is inserted before the *yotser* only in those cases where the liturgy of a particular holiday begins with the evening prayer and not with the *yotser* of the morning prayer; this is the case in the Worms Mahzor, Jerusalem, National Library of Israel, cod. 4⁰781, http://www.jnul.huji.ac.il/dl/mss/worms/about_eng.html for Pesah and Shavuot, for example; in the Leipzig Mahzor *shokhen ad merom* reappears at these points. This text, in fact, forms the concluding section of the prayer *nishmat kol hai* (The soul of all the living), which is not, itself, included in the Mahzor. It is part of the statutory service for Sabbaths and holidays. The reader's *qaddish* is a short version of the *qaddish* recited repeatedly during the synagogal service, often to mark the transition from one part of the service to another. For the most part it is recited by the prayer-leader.

7. *Sefer Raban, Megillah*, par. *Ein Porsim*, ed. Shlomo Z. Ehrenreich (New York: Grossman, 1958). Elias Katz suggested that the somewhat odd shape of the frame—ten pointed forms defining the picture space—refers to the halakhic requirement of ten men participating in the prayers; *Machsor Lipsiae: 68 Facsimile Plates of the Mediaeval, Illuminated, Hebrew Manuscript in the Possession of the Leipzig University Library*, ed. Elias Katz (Hanau/Main: Werner Dausien, 1964), 74. I shall come back to the frame later in this chapter.

8. The only discussions are a short reference to the *talit* in Abraham Chill, *The Minhagim* (New York: Hermon Press, 1979), 11–23, offering some details from the modern halakhic point of view; and a nonscholarly article by Shlomi Reiskin, "The Wrapping in a *Talit Gaddol* for Young Men [in Hebrew]," *Or Hamizrah* 51/3–4 (2006): 85–105.

9. For a study of the functions of both, with interesting notes on the etymology of the word *"hazan"* in relation to liturgical poetry, see Haim Leshem, "The *Sheliah Tsibur* in Talmudic and Midrashic Literature [in Hebrew]," *Mahanayim* 60 (1961): http://www.daat.ac.il/daat/kitveyet/mahanaim/shlihey-2.htm.

10. *Tosefta, Rosh Hashanah* 2:18, ed. Saul Liebermann (New York: Rabinovitz, 1955–1988); for an English translation of the *Tosefta*, see *The Tosefta Translated from the Hebrew with a New Introduction*, ed. Jacob Neusner (Peabody: Hendrickson, 2002); on various halakhic considerations about what exactly is meant by "fulfill the obligation of many," see Ya'akov (Gerald) Blidstein, *"Sheliah Tsibur:* Character, Functions, and History [in Hebrew]," in *From Qumran to Cairo: Studies in the History of Prayer—Proceedings of*

the *Research Group on the History of Prayer, Institute for Advanced Studies, The Hebrew University 1997* (Jerusalem: Orhot, 1999), 39–44.

11. Blidstein, "*Sheliah Tsibur,*" 43, following up on comments by Ismar Elbogen, *Jewish Liturgy: A Comprehensive History* (Philadelphia: Jewish Publication Society, 1993), 375–381 (originally published in German, Leipzig: G. Fock, 1913).

12. Concerning the age of the *sheliah tsibur,* the rule is that he should be old enough to grow a beard, but it is recommended that he should be older and have demonstrated some wisdom; only when no suitable *sheliah tsibur* is present can a young *bar mitzvah* fulfill the obligation of the congregation; see *Tosefta Hagigah* 1:1, ed. Moshe Zuckermandl (Jerusalem: Wahrmann, 1948); *Babylonian Talmud, Hullin* 24b; for an English version of the Babylonian Talmud, see *The Babylonian Talmud,* ed. Isidore Epstein (London: Soncino Press, 1952). In quotations from the Babylonian Talmud I rely on this version; occasionally a more literal wording has been preferred here. On avoiding errors, see *Mishnah Berakhot* 5:5; on his reputation, see *Babylonian Talmud, Ta'anit* 16b; on issues of descent, see Blidstein, "*Sheliah Tsibur.*"

13. As a teacher, *Mishah Shabbat* 1:3; raising the Torah scroll, *Mishnah Yoma* 7:1; *Mishnah Sotah* 7:7–8; as keeper of *lulavim, Mishnah Sukkah* 4:4; as scourge, *Mishnah Makkot* 3:12; *Tosefta Makkot* 5:2, ed. Zuckermandl.

14. For example, *Teshuvot Rav Natronai bar Hilai Gaon, Orah Hayyim* 42, ed. Yerahmiel Brody (Jerusalem: Mekhon Ofeq, 1994).

15. *Seder Rav Amram Gaon, Seder Shabbatot,* ed. Daniel Goldschmidt (Jerusalem: Mosad Harav Kook, 2004); on the other functions of the *hazan,* see ibid., *Seder Pesah;* ibid., *Shaharit shel Shabbat;* ibid., *Tefillat Shaharit shel Yom Hakipurim;* in the *Tshuvot Hageonim,* finally, we find the first mention of a *hazan* who "fulfills the obligation of many," an expression hitherto used only in conjunction with the *sheliah tsibur, Teshuvot Hageonim,* par. 82 and 109–110, ed. Nahman N. Koronel (Vienna: Joseph Holzwarth, 1871).

16. *Sefer Hiddushe Haramban, Hullin* 24b (Zikhron Ya'akov: Hamerkaz Lehinukh Torani, 1994); Nahmanides's disciple Solomon ibn Adret (d. c. 1310) still abides by this distinction; *Sefer Hiddushe Harashba, Hullin* 24b (Zikhron Ya'akov: Hamerkaz Lehinukh Torani, 1988). For other Sephardi sources, see, e.g., Isaac Alfasi of Fez on *Shabbat* 5a–b; 11b; *Eruvin* 16a; *Megillah* 14a; *Berakhot* 13a–b; 14b; *Rosh Hashanah* 10a; 12a; Alfasi's text is printed in traditional editions of the *Babylonian Talmud;* Maimonides's commentary to the Mishnah; *Perush Hamishnah Larambam, Shabbat* 1:3, ed. David Kappah (Jerusalem: Mosad Harav Kook, 1987); ibid., *Rosh Hashanah* 3:5; 4:9; ibid., *Brakhot* 5:3–4; ibid., *Ta'anit* 2:2; ibid., *Sotah* 5:4.

17. *Rashi* on *Makkot* 22b. As a teacher of children, *Rashi* on *Shabbat* 11a; as a guide for those who read the Torah, ibid.; as the community functionary, *Rashi* on *Shabbat* 35b, 56a, 139a, *Yoma* 24b, 68b, *Sukka* 42b, 51b, and many more. Rashi's text appears in the margins of all traditional editions of the *Babylonian Talmud.*

18. Rashi on *Ta'anit* 16b; see also, *Mahzor Vitry Lerabbenu Simha Mivitry,* par. 89 and 130, ed. Aryeh Goldschmidt (Jerusalem: Otsar Haposqim, 2004).

19. Menahem Ben-Sasson, *The Emergence of the Local Jewish Community in the Muslim World: Qayrawan, 800–1057* [in Hebrew] (Jerusalem: Hebrew University Magnes Press, 1997), 165–168; this view is also shared by Stefan C. Reif, *Judaism and Hebrew Prayer: New Perspectives on Jewish Liturgical History* (Cambridge: Cambridge University Press, 1993), 190.

20. *Sefer Raban, Megillah*, par. *Ein Porsim*.

21. Abraham Grossman, *The Early Sages of Ashkenaz* [in Hebrew] (Jerusalem: Hebrew University Magnes Press, 1988), 274. As Catherine Bell noted, theories about ritual experts tend to be overly occupied with issues of social structures, hierarchy, and power, *Ritual Theory, Ritual Practice* (New York: Oxford University Press, 1992), 131. As we shall see, Ashkenazi society did, indeed, imbue the *sheliah tsibur* with a status he had not enjoyed in any realm before. In some sense, then, this approach does apply to the Ashkenazi circumstances.

22. Reif, *Judaism and Hebrew Prayer*, 169; Reif makes this remark in the context of Jacob ben Judah in England and speaks in general of "that period"; he does not indicate the differences between the Ashkenazi and the French realms (the latter having had a determining influence on England) with regard to the definition and the status of the *hazan*.

23. For details on Meir ben Isaac, see Grossman, *Early Sages of Ashkenaz*, 292–296; for the medieval references, see *Mahzor Vitry*, par. 142, discussed in Grossman, *Early Sages of Ashkenaz*, 293; for references to Meir as *sheliah tsibur*, see, for example, in the Leipzig Mahzor, fol. 151r, and on numerous other occasions; see also Abraham ben Azriel, *Sefer Arugat Habosem*, vol. 1, ed. Ephraim E. Urbach (Jerusalem: Meqitse Nirdamim, 1939–1963), 197; for references to Meir as a poet, see *Arugat Habosem*, vol. 1, 210; as a *hazan*, see ibid., vol. 3 (1962), 423 and 446; on Meir's miraculous powers, see Grossman, *Early Sages of Ashkenaz*, 294.

24. For a discussion of the scant available information on Asher Halevi, see Grossman, *Early Sages of Ashkenaz*, 272–273.

25. Israel Ta-Shma, *The Early Ashkenazic Prayer: Literary and Historical Aspects* [in Hebrew] (Jerusalem: Hebrew University Magnes Press, 2003), 52–53; the consent of the community is relevant for hired *hazanim*, but not in cases where rabbinic authorities—naturally accepted by the public—functioned as *sheliah tsibur*. This was customary especially on high holidays. *Hazanim* were chosen by the consent of the entire congregation. The process of being elected bestowed a special status on the *hazan*, which could not be challenged at a later stage by any individual member of the community; see Mordechai Breuer, "The *Sheliah Tsibur* in Medieval Ashkenaz [in Hebrew]," *Dukhan* 9–11 (1972–1978): 18; see also Blidstein, "*Sheliah Tsibur*," 45–59.

26. Talya Fishman, "Rhineland Pietist Approaches to Prayer and the Textualization of Rabbinic Culture in Medieval Northern Europe," *Jewish Studies Quarterly* 11 (2004): 313–331; see also recently Fishman, *Becoming the People of the Talmud: Oral Torah as Written Tradition in Medieval Jewish Cultures* (Philadelphia: University of Pennsylvania Press, 2001), chap. 6.

27. *Sefer Hasidim*, par. 785, ed. Reuven Margaliot (Jerusalem: Mosad Harav Kook, 1957); *Sefer Hasidim*, par. 480, ed. Judah Hakohen Wistinetzky and Jakob Freimann (Frankfurt/Main: n.p., 1924); for both versions, see http://etc.princeton.edu/sefer_hasidim/manuscripts.php.

28. Isaac ben Moses of Vienna, *Sefer Or Zarua, Hilkhot Tefilah*, par. 114–115 (Zitomir: n.p., 1862), par. 114–116.

29. Private collection of D. H. Feinberg (New York), formerly Jews' College, MS Montefiori 134, fol. 119r.

30. Ibid.; and *Or Zarua, Hilkhot Sheliah Tsibur*, par. 116.

31. It was only during the late Middle Ages that a new distinction began to emerge between the *sheliah tsibur* and the *hazan*, the former referring to scholars who approached the shrine on special occasions and the latter being hired prayer-leaders who received wages; for details on the halakhic issues that emerged from this new practice, see Breuer, "*Sheliah Tsibur*," 14–15; this new distinction is indicative of another change in status, and it appears that around 1400 the *hazan* had been reduced in status to a professional who had not much more to offer than a basic knowledge of the prayers and a fine voice.

32. See, in particular, Israel Ta-Shma, *Early Ashkenazi Custom* [in Hebrew] (Jerusalem: Hebrew University Magnes Press, 1999), 61–74.

33. *Palestinian Talmud, Berakhot* 4–7d; *Ta'anit* 4–67d; for an English version, see *The Talmud of the Land of Israel: A Preliminary Translation and Explanation*, trans. and ed. Jacob Neusner (Chicago: University of Chicago Press, 1982–1994).

34. The *Masekhet Sofrim* is of uncertain date, but scholars assume that it was compiled around the eighth century; see Hermann L. Strack and Günter Stemberger, *Introduction to Talmud and Midrash* (Minneapolis: Fortress Press, 1992), 248; on the *hazan* reading the Torah portion, see *Masekhet Sofrim* for numerous occasions, e.g., 11:4, the Palestinian version of *Masekhet Sofrim* is printed with traditional editions of the Jerusalem Talmud; on a *hazan* conducting the prayers, see *Masekhet Sofrim* 10:6.

35. For more details on the composition of these early poems, see Ezra Fleischer, *Hebrew Liturgical Poetry in the Middle Ages* [in Hebrew] (Jerusalem: Hebrew University Magnes Press, 2007), 55–58 (first published in 1975); quite strikingly, however, Ezra Fleischer in his survey of late antique and medieval liturgical poetry does not make any distinction between the *sheliah tsibur* and the *hazan*.

36. Ta-Shma, *Early Ashkenazic Prayer*, 34.

37. *Midrash Tehillim* 17:5, ed. Solomon Buber (Vilnius: n.p., 1891); for an English version, see *The Midrash on Psalms*, trans. William Braude (New Haven: Yale University Press, 1959). The *Midrash Tehillim* was recently attributed to southern Italy and was well known among and frequently used by Ashkenazi Pietists, Amos Geula, "Lost Aggadic Midrashim Known Only from Ashkenazi Sources: Avkir, Asefa, and Deuteronomy Zutta [in Hebrew]," (PhD diss., Hebrew University of Jerusalem, 2007), 311.

38. This collection appeared in print in Moshe Hershler, "Minhage Wermaiza, Umagentsa, Debe Rashi Urabotav Uminhage Ashqenaz al Haroqeah," *Genuzot* 2 (1985), n. 59, p. 24; for Eleazar of Worms, see *Sefer Haroqeah, Hilkhot*

Sukkot par. 221; for Eliezer ben Joel, see *Sefer Ra'aviah, Hilkhot Lulav,* par. 689, ed. Avigdor Aptowitzer (Jerusalem: Mekhon Harry Fishel, 1964).

39. Ta-Shma, *Early Ashkenazic Prayer,* 34.

40. For example, *Mishnah Peah* 4:3.

41. *Tosefta Baba Metsia* 5:26, ed. Lieberman; *Tosefta Bekhorot* 6:13, ed. Zuckermandl.

42. Numbers 15:38–39; Deuteronomy 22:12.

43. There is a short reference to the blue and white strings of the fringes in *Mishnah Menahot* 4:1; for the blessings, see *Tosefta Berakhot* 6:10; ed. Lieberman; for different types of cloths, see, e.g., *Masekhtot Qetanot, Tsitsit* 1:2; printed in traditional editions of the Babylonian Talmud; for ways of attaching the fringes, see ibid. 1:6; about the rules applying to women, see *Tosefta Qiddushin* 1:10, ed. Lieberman; *Masekhtot Qetanot, Tsitsit* 1:1; for a fringed garment to be worn on Sabbath, see *Babylonian Talmud, Menahot* 37.

44. *Babylonian Talmud, Shabbat* 131a; *Midrash Vayiqra Rabbah* 27:2, ed. Mordechai Margaliot (New York: Jewish Theological Seminary, 1993); for a variant of this motif, see *Midrash Rabbah,* Numbers 14:2 (Vilnius: n.p., 1884; repr. Jerusalem: Ortsel, 1961); see also *Tanhuma Shalah* 15, ed. Solomon Buber (New York: Sefer, 1946).

45. *Babylonian Talmud, Brakhot* 24b–25a; for further details, see Uri Ehrlich, *The Nonverbal Language of Prayer: A New Approach to Jewish Liturgy* (Tübingen: Mohr Siebeck, 2004), 136–139.

46. The particulars of this custom are described and discussed in Ehrlich, *Nonverbal Language of Prayer,* 145–156; see, e.g., the tale of Nakdimon ben Gorion, who "wrapped himself and stood in prayer," *Avot de Rabbi Nathan A* 1:6, ed. Hans-Jürgen Becker and Christoph Berner (Tübingen: Mohr Siebeck, 2006). Ehrlich also remarks on the custom of Roman priests wrapping themselves—including the head—in a toga during religious ceremonies.

47. Babylonian Talmud, *Berakhot* 24b.

48. *She'iltot de Rav Ahai Gaon, Parashat Bahar,* par. 104, ed. Naftali Z. J. Berlin (Jerusalem: Mosad Harav Kook, 1986); ibid., *Parashat Shelah,* par. 127; *Sefer Halakhot Gedolot* 1, *Hilkhot Berakhot* 3, ed. Zeev W. Lifkin (Jerusalem: Mekhon Or Hamizrah, 1992). Among others we also find the reference to *talitot* of scholars, *Teshuvot Hageonim: Geone Mizrah Uma'arav,* ed. Yoel Miller (Bne Braq: Mishor, 1986), 132. Isaac ben Judah ibn Gyyat, *Sha'are Simha: Hilkhot Harits Giat, Hilkhot Evel,* ed. Yitzhak D. Bamberger (Jerusalem: Mekhon Hehatam Sofer, 1998), 215, 225, whose references to the *talit* primarily concern mourning practices; Isaac Alfasi of Fex, *Berakhot* 15a–16a; *Shabbat* 10b; *Halakhot Qetanot, Hilkhot Tsitsit;* his notes in *Baba Metsia* 1a–4b still refer to the *talit* as an object of value.

49. As a result of the question of whether one was obliged to possess a *talit,* a somewhat overanxious preoccupation with the laws concerning the fringes can be observed in the works of some Sephardi and southern French halakhists from the twelfth century on, *Sefer Ha'eshkol, Hilkhot Tsitsit,* ed. Abraham Z. Auerbach (Bne Brak: Sofer Sefer, 2004); *Sefer Ha'ittur, Hilkhot Tsitsit* (Warsaw: n.p., 1903); I am grateful to Amos Geula for discussing these sources with me. Further, Maimonides (d. 1204) elaborates on these

laws, e.g., *Perush Hamishnah Larambam, Sheqalim* 3:2; ibid., *Kelim* 29:1 with explanatory translations into Arabic; *Mishne Torah Hu Hayad Hahazaqah Lerabbenu Moshe ben Maimon, Shabbat* 30:3, ed. Nahum E. Rabinowitz (Jerusalem: Ma'aliot, 1990); for an English version, see *The Code of Maimonides* (New Haven: Yale University Press, 1949–2004); ibid., *Hilkhot De'ot* 5:9; ibid., *Hilkhot Tsitsit*. The tendency to elaborate on the laws of fringes continues in the first half of the fourteenth century in the teachings of later Sephardi and southern French authorities, such as Rabbenu Yeruham, *Sefer Mesharim* (Venice: n.p., 1553); Joshua ibn Shueib, *Drashot Rabbi Yehoshua ibn Shueib,* ed. Zeev Metzger (Jerusalem: Lev Sameah, 1992); or the anonymous *Sefer Hahinukh,* ed. Yitzhak Y. Weiss (Jerusalem: Mekhon Yerushalayim, 1992).

50. *Tosafot, Shabbat* 27b and 32b; for similar discussions, see also *Tosafot, Menahot* 41b; *Arakhin* 2b; *Berakhot* 18a; see also Maimonides, *Mishne Torah, Hilkhot Tsitsit* 3:11. It was only somewhat later that Moses of Coucy, the author of the *Sefer Mitsvot Gaddol* (c. 1250), turned this recommendation into a rabbinic command: "and one is not obliged [to put on] the fringes unless one wears [a garment with] four corners. And we do command [people] to buy a *talit* in order to observe it"; *Sefer Mitsvot Gaddol, Mitsvot Asseh,* par. 26 (Venice: n.p., 1547, repr. Jerusalem: Monson, 1961).

51. *Sefer Raban, She'elot Uteshuvot,* par. 40; about a century or so later Meir ben Yekutiel Hakohen, a student of Meir of Rothenburg and resident of the same town, is still concerned with the changing role of the *talit; Hagahot Maimuniot* on *Mishne Torah Hilkhot Tsitsit* 3:11, ed. Judah Wellesch (Berdichev: Chaim Yaakov Sheftel, 1908); this comments on Maimonides's recommendation to use a *talit,* even though one is theoretically not obliged to do so, *Mishne Torah, Hilkhot Tsitsit* 3:11.

52. Ivan G. Marcus, *Piety and Society: The Jewish Pietists of Medieval Germany* (Leiden: E. J. Brill, 1981), 98–101.

53. Samson of Sens's responsum that points out the difference between the mundane four-cornered mantle and the one used for ritual purposes has not survived and is known only from a quotation in one of the responsa collections of Meir of Rothenburg, *Sefer She'elot Uteshuvot,* par. 287, ed. Prague 1608. The English version follows Marcus, *Piety and Society,* 98. The *chaperon* was a very common hooded cloak, usually much shorter than the *talit.* In the later Middle Ages it was understood rather as headgear than a cloak; the *cotte* was a coat with sleeves; see Ruth Turner Wilcox, *The Dictionary of Costume* (New York: C. Scribner's Sons, 1969), 68, 88.

54. For a more detailed discussion of these Pietist practices, see Marcus, *Piety and Society,* 98.

55. *Babylonian Talmud, Berakhot* 60b.

56. Ibid.

57. Apart from the Babylonian Talmud, it is only in the *Seder Rav Amram Gaon, Berakhot Hashahar,* that this association is made. It is missing in other geonic sources; see, e.g., *Halakhot Gedolot,* 1, *Hilkhot Berakhot* 9.

58. *Mahzor Vitry,* par. 1 and par. 89; similarly also Rashi on *Menahot* 43a; *Siddur Rashi* 3, ed. Shlomo Buber (Berlin: Miqitse Nirdamim, 1912). Similar

associations were drawn in aggadic contexts. One example is *Pesiqta Rabbati*, which not only links the *talit* with phylacteries, but explains that sinners are not worthy of either of them, *Pesiqta Rabbati: A Synoptic Edition of Pesiqta Rabbati Based upon All Extant Manuscripts and the Editio princeps*, 22:5, ed. Rivka Ullmer (Lanham, MD: University Press of America, 2009). *Pesiqta Rabbati* is a midrash for which an Italian provenance was recently suggested, which belongs to a group of midrashim later preserved and transmitted primarily, or in some cases exclusively, in Pietist circles; Geula, "Lost Aggadic Midrashim," 308; Elisabeth Hollender observes that "[*piyyut*] commentaries by Eleazar ben Judah can be identified by their explicit references to *Pesiqta Rabbati* as a hypotext for *piyyutim*," *Piyyut Commentary in Medieval Ashkenaz* (Berlin: Walter de Gruyter, 2008), 49.

59. *Mahzor Vitry*, par. 51.

60. *Sefer Ma'asse Hage'onim*, ed. Abraham Epstein (Berlin: H. Itzikowski, 1910), par. 326–337.

61. It is not entirely clear if this was meant as some sort of embellishment that later became known as an *atarah*, a decorated strip at the side, often with embroidered inscriptions, to be worn over the head. Although this sort of embellishment can be discerned in images of the *talit* from the later fourteenth century, in written records it appears only later.

62. Maimonides, *Responsa*, par. 168, ed. Joshua Blau (Jerusalem: Meqitse Nirdamim, 1986).

63. *Sefer Hasidim*, par. 775, ed. Margaliot.

64. *Midrash Tehillim* 17:5.

65. Geula, "Lost Aggadic Midrashim," 309, 318, 331.

66. *Babylonian Talmud, Rosh Hashanah* 17b; on this formula referring to the authority of the biblical text, see Moshe Halbertal, "Were It Not Written in the Text [in Hebrew]," *Tarbitz* 68/1 (1999): 39–59.

67. The motif of God being wrapped like a *sheliah tsibur* (without mentioning explicitly a *talit*) is discussed occasionally in the context of anthropomorphism, which was also the original concern of Rabbi Yohanan (who is always cited literally in these sources); we find it in North Africa, where Hananel ben Hushiel (d. c. 1055) refers to it. Hananel, whose father had migrated from Italy to Kairouan, is known for his commentary to the Babylonian Talmud, in which he also included numerous elements associated with the Palestinian tradition, *Tshuvot Hageonim*, ed. Jacob Mussafye (Lyck: n.p., 1864), nos. 116–117, pp. 35–36; this version was also cited by Isaac Alfasi on *Rosh Hashanah* 4b; see also the halakhic compilation of Isaac ibn Giyyat in the eleventh century, *Sha'are Simha: Hilkhot Harits Giyyat, Hilkhot Yom Kippur*, par. 95; later in the *Sefer Hamanhig* of Abraham ben Nathan Hayarhi of Lunel, a contemporary of Judah the Pious, who traveled widely, visited the German lands and reported various customs of the Pietists, *Sefer Hamanhig, Hilkhot Ta'anit*, par. 283, ed. Isaac Raphael (Jerusalem: Mosad Harav Kook, 1994); Nahmanides, *Sefer Hamitsvot Larambam im Hasagot Haramban, Shoreshim* 3, ed. Hayim D. Chavel (Jerusalem: Mosad Harav Kook, 1996).

68. *Pesiqta de Rav Kahana, Hahodesh Hazeh* 5:1, ed. Jacob I. Mandelbaum (New York: Jewish Theological Seminary, 1987); for a shorter replication of the motif in *Rosh Hashahah* 17b, see *Midrash Tanhuma Wayar* 9, ed. Buber; for a summary of the provenance of *Midrash Tanhuma* seeking it, as other similar Midrashim in Italy, see Geula, "Lost Aggadic Midrashim," 332, n. 2118; *Tanna debe Eliyahu, Seder Eliyahu zutta,* par. 23, ed. Meir Ish-Shalom (Jerusalem: Wahrmann, 1960), in a section that belongs to a later addition to that text; the *Midrash Tehillim* 27:1 also reports a tradition of God being wrapped in the created light as in a *talit*.
69. *Perush Siddur Hatefilah Laroqeah,* par. 140, ed. Moshe Hershler (Jerusalem: Mekhon Hershler, 1992). For a critique on this edition, which merges three different versions of the commentary into one eclectic text, see Joseph Dan, *Rabbi Judah the Pious* [in Hebrew] (Jerusalem: Hebrew University Magnes Press, 2005), 138.
70. *Sefer Haroqeah, Hilkhot Purim,* par. 242.
71. Daniel Abrams, "*Sefer Shaqud* of Rabbi Samuel ben Rabbi Qalonymos and the Esoteric Teachings of a Student of Rabbi Eleazar of Worms [in Hebrew]," *Asufot* 14 (2006): 217–240; the paper contains the full text of the *Sefer Shaqud;* for the citation on God being wrapped like a *sheliah tsibur,* see par. 11.
72. *Or Zarua, Alfa Beta,* par. 21.
73. *Perush Siddur Hatefillah Laroqeah,* par. 39.
74. *Pesiqta de Rav Kahana, Hahodesh Hazeh* 5:1.
75. Exodus 17:8–16 and *Pesiqta de Rav Kahana, Zakhor,* par. 3; *Pirqe de Rabbi Eliezer* par. 44, ed. David Lurie (Warsaw: n.p., 1852); for an English version, see *Pirkê de Rabbi Eliezer,* trans. and ed. Gerald Friedlander (London: K. Paul. Trench, Trubner, 1916). A somewhat similar tradition is first found in *Masekhet Sofrim* 14:9; it mentions a *hazan* handling the Torah scroll accompanied by two co-worshippers; the three men were supposed to recall the three patriarchs; the same tradition is mentioned later in *Mahzor Vitry,* par. 527.
76. *Sefer Haroqeah, Hilkhot Rosh Hashanah,* par. 203; see also *Sefer Haroqeah, Hilkhot Purim,* nos. 242, 139; a still-later echo is found in the early fourteenth-century Ashkenazi Midrash anthology *Yalqut Shimoni, Beshallah,* par. 264, ed. Dov Hyman et al. (Jerusalem: Mosad Harav Kook, 1973–1977).
77. *Hagahot Maimuniot, Hilkhot Shvitat Assor, Minhage Yom Kippur.*
78. *Sefer Maharil: Minhagim shel Rabbenu Ya'akov Moelin, Tefilat Rosh Hashanah* 1, ed. Shlomo Spitzer (Jerusalem: Mekhon Yerushalayim, 1989).
79. *Minhagim dekehilat kodesh Wermaiza Lerabbi Yuspa Shammash* 136, ed. Benjamin S. Hamburger and Itzhak (Eric) Zimmer (Jerusalem: Mekhon Yerushalayim, 1988–1992), 149; *Minhagot Wermaiza: Minhagim wehanhagot sheasaf wehiber Rabbi Yuda Liva Kirchheim,* ed. Israel M. Peles (Jerusalem: Mekhon Yerushalayim, 1987), 144.
80. Shammash, *Minhagim,* vol. 1, 149, n. 16. It is possible that the first man's gesture is meant to represent the performance of the priestly blessing. Documented as the common prayer posture during the biblical era and the period of the Second Temple, in the mishnaic and talmudic periods the gesture of

raised arms was reserved for the priestly blessings. As Zimmer shows, the gesture was renounced by the Jews in late antiquity after it was adopted by the Christians. Whereas during the early Middle Ages it was customary for descendants of the priests to perform the priestly blessings daily, during the thirteenth century it was done only during holidays. The representation of a member of the community of priestly descent performing the blessing with the antique gesture would thus be an additional emphasis on holiday imagery; for further details, see Zimmer, *Customs*, 78–81, 132–137; see also Ehrlich, *Nonverbal Language of Prayer*, 118–119.

81. Geula, "Lost Aggadic Midrashim," 308.
82. Ibid.
83. *Sefer Haroqeah, Hilkhot Tsitsit*, par. 361.
84. *Midrash Tehillim* 34:2. This particular section may have been an early medieval Ashkenazi addition to the original text; for such additions, see Ta-Shma, *Early Ashkenazic Custom*, 143. Geula attributes the addition to Byzantium, "Lost Aggadic Midrashim," 311; in any event he assumes that early Ashkenazi scholars knew this version of the *Midrash Tehillim*.
85. There was also knowledge of this practice in the Sephardi realm. It is noted explicitly and in detail in the *Sefer Ha'eshkol, Hilkhot Tsitsit*, par. 34, with a direct reference to an edited (not extant) version of the Jerusalem Talmud. This section does not appear in all the versions of the *Sefer Ha'eshkol*; see Geula, "Lost Aggadic Midrashim," 313. The custom is also mentioned in more general terms in the *Sefer Ha'ittur* 75a: "one puts two fringes in the front and two fringes in the back, so that one would be all surrounded by the precepts." It is telling in this context that the *Sefer Ha'eshkol* also mentions the Holy one blessed be he being wrapped like a *sheliah tsibur*, ibid., *Hilkhot Tefilin*, 82v.
86. Geula, "Lost Aggadic Midrashim," 311; for the responsum, see *Teshuvot Ufsaqim me'et Hakhme Ashkenaz Utsarfat*, par. 80, ed. Ephraim Kupfer (Jerusalem: Meqitse Nirdamim, 1973). From the wording of the responsum, it appears that not all Jews followed these customs, and Geula suggests that they may have been controversial and criticized in certain circles. As a matter of fact, the mention in the *Midrash Avkir* could be understood as part of a polemic, Geula "Lost Aggadic Midrashim," 313–314, also offering further thoughts about a possible controversy regarding both customs as early as during the geonic period.
87. *Sefer Ha'asufot*, fol. 108r referring to *Midrash Tehillim* 90:1.
88. *Hagahot Maimuniot, Hilkhot Tsitsit* 3.
89. *Sefer Ra'avia, Hilkhot Lulav*, par. 683; *Sefer Mordekhai, Sukka* 46b, printed together with traditional editions of the Babylonian Talmud.
90. *Or Zarua, Hilkhot Sukka*, 314:3.
91. *Sefer Ra'avia, Masekhet Shabat*, par. 220. This has perhaps to do with an early form of a later Ashkenazi custom of the bridegroom wearing a *talit gaddol* for the first time on his wedding day; for some details, see Reiskin, "*Talit Gaddol*."
92. *Sefer Ha'ittur* 73a.

93. *Or Zarua, Hilkhot Avlut,* par. 421.

94. Later a special *Seder Levishat Talit Gaddol* (sometimes also referred to as *Seder Birkat Tsitsit*) was composed; it includes an examination of the fringes of the *talit gaddol* and the recitation of Psalm 104:1: "Bless the Lord, my soul; Lord my God, you are very great; you are clothed with glory and majesty." The choice of this verse certainly recalls the notion in *Midrash Tehillim* 27:1 of God being wrapped in the light he created, quoting the same verse. Maimonides once refers to "*talit qatan,*" but in a different sense, as a rectangular garment worn by men, *Perush Hamishnah Larambam, Kelim* 20:7.

95. *Sefer Tashbets me'et Rabbenu Shimon bar Tsadoq zatsal, Dine Talit,* par. 262 (Jerusalem: Levin-Epstein, 1962).

96. *Sefer Haparnas* par. 236, ed. Moshe Sh. Horowitz (Tel Aviv: Zohar, 1977). Through Meir's student Asher ben Yehiel, who moved to Toledo, the custom of using a *talit qatan* and a *talit gaddol* eventually also became known in Spain and southern France; see, e.g., *Sefer Kol Bo,* no. 22, ed. Israel Y. Vidavsky (Jerusalem: Mekhon Even Israel, 1997), a text whose assumed author, Aaron of Lunel, may have been familiar with various traditions and customs associated with Meir of Rothenburg. I thank Yudah Galinsky for alerting me to Aaron of Lunel's sources; several discussions by early fourteenth-century Sephardi authorities similarly document the reception of some of Asher ben Yehiel's customs in Iberia and reflect familiarity with Meir's custom of wearing a *talit qatan;* see, e.g., *Hiddushe Haritba, Shabbat* 147a, ed. Mordechai Kleinberg (Jerusalem: Wagshal, 1992); Isaac Abuhav, *Sefer Menorat Hama'or,* chap. 2: *Tefillah, Hilkhot Tsitsit,* ed. Moshe Frankfurt (Jerusalem: Aaron Hasid, 1973), 56. By the time Asher's son Jacob composed his *Arba'a Turim,* Meir's custom was firmly established, *Arba'ah Turim, Orah Hayyim, Hilkhot Tsitsit,* par. 8, ed. Shmuel B. Deutsch (Jerusalem: Mekhon Hama'or, 2007); ibid., par. 24.

97. For an overview of approaches to ritualization processes, see Bell, *Ritual Theory, Ritual Practice,* 88–93. Bell describes the Christian Eucharist in contrast to a regular meal. The Eucharist is performed periodically and with fixed elements; it is not aimed at physical nourishment, ibid., 90.

98. The original context of covering the head with the *talit* is a practice referred to in the sources as "Ismaelite mantling," which had developed as a mourning custom; this is first described in the *Babylonian Talmud Mo'ed Qatan* 24a: "during mourning one has to wrap his head"; the Geonim not only discuss the issue as such, but also consider whether this wrapping is to be performed with a *talit* or a *sudar,* a smaller cloth used as a shawl or headgear, see Zimmer, *Customs,* 192; for later mentions of "wrapping of Ismaelites" in the context of mourning, see, e.g., *Sefer Ra'avia, Hilkhot Evel,* par. 841; *Hagahot Maimuniot, Hilkhot Evel,* 5:19. At some point, the sources seem to indicate that the custom of "wrapping as the Ismaelites" do also became common for prayer.

99. Amsterdam, Joods Historisch Museum, MS B. 166, fol. 171v; *The Amsterdam Mahzor. History, Liturgy, Illumination,* ed. Albert van der Heide and Edward van Voolen (Leiden: E. J. Brill, 1989), pl. IX.

100. Jerusalem, Israel Museum, MS 180/57, fols. 32r, 33v, 38v, 40r; *The Bird's Head Haggadah of the Bezalel Art Museum in Jerusalem,* ed. Moshe Spitzer (Jerusalem: Tarshish Books, 1965–1967).
101. Biblioteca Ambrosiana, MS Fragm. S. O. II. 252, Mendel and Thérèse Metzger, *Jewish Life in the Middle Ages: Illuminated Hebrew Manuscripts of the Thirteenth to the Sixteenth Centuries* (Secaucus: Chartwell Books, 1982), fig. 90.
102. MS 180/94, formerly Sassoon collection, MS 511, p. 23.
103. Budapest, Hungarian Academy of Sciences, Kaufmann collection, MS A 383, fol. 40r, Metzger, *Jewish Life,* fig. 340.
104. Bodleian Library, MS Opp. 776, fol. 20v, Metzger, *Jewish Life,* fig. 196.
105. Floersheim collection, formerly Sassoon collection, MS 511, p. 28, Metzger, *Jewish Life,* fig. 355; the date is not clearly legible and therefore uncertain.
106. New York, Jewish Theological Seminary of America, MS Mic. 8892, fol. 125v, *The Rothschild Mahzor, Florence 1492* (New York: Jewish Theological Seminary of America, 1983), with contributions by Menahem Schmeltzer and Evelyn Cohen, fig. 7 and pl. V. Cohen in her essay on the illustrations attributed the two figures to "Workshop B," which, in 1983, she believed to have worked a generation after Joel ben Simeon, while faithfully copying his style, ibid., 41, 54 n 15. More recently, however, Shlomo Zucker suggested that it was Joel himself who executed the paintings in question; his research indicates that Joel may still have been alive when the Rothschild Mahzor was produced, Shlomo Zucker, *The Moskowitz Mahzor of Joel Ben Simeon: Ashkenazi-Italian Scribe and Illuminator of Hebrew Manuscripts—MS Heb. 4⁰1384,* Jerusalem 2005, XIV. The Rothschild Mahzor was later dated to 1490, instead of 1492, David Wachtel, "How to Date a Rothschild," *Studia Rosenthaliana* 38–39 (2006): 160–168.
107. *Hazanim* had a custom of signing their names at the end of the Worms Mahzor to mark their use of it, fol. 224v; Breuer, "*Sheliah Tsibur,*" 16.
108. *Sefer Maharil, Hilkhot Yom Kippur,* par. 11; see also Breuer, "*Sheliah Tsibur,*" 17.
109. Fishman, "Rhineland Pietist Approaches to Prayer"; see specifically 327, for a quotation from *Sefer Hasidim,* par. 18, ed. Margaliot, a text section that Soloveitchik had put in doubt as being genuinely Pietists, Haym Soloveitchik, "Piety, Pietism, and German Pietism: *Sefer Hasidim I* and the Influence of Hasidei Ashkenaz," *Jewish Quarterly Review* 92/3–4 (2002): 455–93. This is not necessarily true for all the aspects of textual communication; on the attitudes of the Pietists to the book in general, see Colette Sirat et al., *La conception du livre chez les Piétistes ashkenazes du Moyen Ages* (Geneva: Droz, 1996), introduction.
110. Ivan G. Marcus, "Prayer Gestures in German Hasidism," in *Mysticism, Magic and Kabbalah in Ashkenazi Judaism,* ed. Karl Erich Grözinger and Joseph Dan (Berlin: Walter de Gruyter, 1995), 49–50.
111. *Sefer Raban: She'elot Uteshuvot,* par. 42; Ta-Shma, *Early Ashkenazic Prayer,* 30.
112. Ta-Shma, *Early Ashkenazic Prayer,* 33; see also Fishman, "Rhineland Pietist Approaches to Prayer," 326.

113. *Seder Troysh*, par. 10, ed. Meir Z. Weiss (Frankfurt/Main: n.p., 1905).

114. *Perush Siddur Hatefilah Laroqeah*, par. 67.

115. *Mishnah, Berakhot* 1:4.

116. For details on mishnaic and early talmudic controversies on the *piyyut*, see Ruth Langer, *To Worship God Properly: Tensions between Liturgical Custom and Halakhah in Judaism* (Cincinnati: Hebrew Union College Press, 1998), 110–115.

117. For a detailed discussion of the two main sources of geonic criticism against *piyyut*, see ibid., 117–129; see also Reif, *Judaism and Hebrew Prayer*, 182.

118. Ta-Shma, *Early Ashkenazic Custom*, 61–74.

119. For details, see Langer, *To Worship God Properly*, 123–130, with references to earlier scholarship and primary sources.

120. *Hiddushe Haramban, Berakhot* 46a; this view was later adhered to by Nahmanides's student Solomon ibn Adret; *Sefer Hiddushe Harashba, Berakhot* 11a. Interestingly enough we also find reservations in the writings of Asher ben Yehiel and Jacob ben Asher, who after immigrating from Ashkenaz to Iberia adopted the Sephardi position. In the *Arba'a Turim*, e.g., Jacob follows Maimonides's argumentation, *Orah Hayyim, Hilkhot Kriat Shma*, par. 68; for more on the adaptation of Asher Yehiel and Jacob ben Asher to the Sephardi circumstances, see Judah Galinsky, "Ashkenazim in Sefarad: The Rosh and the Tur on the Codification of Jewish Law," *Jewish Law Annual* 16 (2006): 3–23; for a detailed discussion of the Sephardi positions and references to the works of these scholars, see Langer, *To Worship God Properly*, 130–132.

121. Ta-Shma, *Early Ashkenazic Prayer*, 14.

122. In this regard, see also the statistics provided by Hollender, *Piyyut Commentary*, 7.

123. *Teshuvot Rabbenu Gershom Me'or Hagolah*, par. 1, ed. Shlomo Eidelberg (New York: Yeshiva University, 1957); Langer, *To Worship God Properly*, 134.

124. *Shibole Haleqet, Inyan Tefillah*, par. 28, ed. Menahem Z. Hassidah (Jerusalem: n.p., 1969).

125. Langer, *To Worship God Properly*, 136. For concerns among northern French scholars and a discussion that took place there, see Abraham Grossman, *The Early Sages of France: Their Lives, Leadership and Works* [in Hebrew] (Jerusalem: Hebrew University Magnes Press, 1995), 80–81, 91–92; Ta-Shma, *Early Ashkenazic Prayer*, 36, 90–92.

126. Grossman, *Early Sages*, 290–291.

127. *Sefer Hapardes Lerashi, Hilkhot Rosh Hashanah*, par. 130, ed. Hayim J. Ehrenreich (Budapest: Katzburg, 1924); Langer, *To Worship God Properly*, 137.

128. *Mahzor Vitry*, par. 325; for a detailed discussion, see Langer, *To Worship God Properly*, 141–143.

129. On commentaries of *piyyut*, see *Arugat Habosem*, vol. 4: Introduction, chaps. 1–3; and recently Hollender, *Piyyut Commentary*; on *piyyut* and its commentation in rabbinic academies, see ibid., 127.

130. For a detailed study, see Abraham Grossman, "The Role of Prayer in the Teachings of the Ashkenazi Pietists [in Hebrew]," in *Sefer Yeshurun: On the Occasion of the Seventy-Fifth Anniversary of the Yeshurun Association,* ed. Michael Sharshar (Jerusalem: Yeshurun, 1999), 27–56; see also Joseph Dan, "On the Historical Image of R. Judah the Pious [in Hebrew]," in *Culture and Society in Medieval Jewish History: A Collection of Articles in Memory of Haim Hillel Ben-Sasson,* ed. Reuven Bonfil, Menachem Ben-Sasson, and Joseph Hacker (Jerusalem: Zalman Shazar Center, 1989), 389–398.

131. For details, see Fishman, "Rhineland Pietist Approaches to Prayer."

132. Ta-Shma, *Early Ashkenazic Prayer,* 51.

133. For details, see Urbach, *Arugat Habosem,* vol. 4, 92–94; Ivan G. Marcus, "Devotional Ideals of Ashkenazic Pietism," in *Jewish Spirituality from the Bible through the Middle Ages,* ed. Arthur Green (New York: Crossroad, 1986), 360; Daniel Sperber, *Jewish Custom: Sources and History* [in Hebrew] (Jerusalem: Mosad Harav Kook, 1989), vol. 1, 121–124, vol. 2, 95–98; Joseph Dan, "Ashkenazi Hasidim, 1941–1991: Was There Really a Hasidic Movement in Medieval Germany?," in *Gershom Scholem's Major Trends in Jewish Mysticism 50 Years After: Proceedings of the Sixth International Conference on the History of Jewish Mysticism,* ed. Peter Schäfer and Joseph Dan (Tübingen: Mohr Siebeck, 1993), 100; Ta-Shma, *Early Ashkenazic Prayer,* 50–51; Simha Emmanuel, "The Pietistic Polemic about the Version of Prayers [in Hebrew]," *Mekhqare Talmud* 3/2 (2005): 591–625; Fishman, "Rhineland Pietist Approaches to Prayer"; Dan, *Judah the Pious,* 139–140; Israel Ta-Shma, "The Treatise *Sodot Hatefilah* by Rabbi Judah the Pious [in Hebrew]," *Tarbitz* 65/1 (1996): 65–77; most scholars agree that the polemic took place in the vicinity of Judah the Pious, but that Eleazar of Worms was not involved in it; see, however, Moshe Hershler, "*Sodot Hatefilah* by Rabbi Eleazar of Worms, the author of *Haroqeah* [in Hebrew]," *Moriah* 18/1–2 (1992): 5–11.

134. *Sefer Hasidim,* par. 1092, ed. Margaliot; *Perush Siddur Hatefilah Laroqeah,* par. 71. The Leipzig Mahzor, indeed, avoids *piyyutim* that begin with a reference to the Name of God. *Piyyutim* with references to the divine name are common in the Sephardi tradition. Although the text in *Sefer Hasidim* directs religiously that no *piyyut* with any references to God (such as *el* or *elohim*) should be recited, several such poems can be found in Ashkenazi mahzorim.

135. Langer, *To Worship God Properly,* 144.

136. *Sefer Hasidim,* par. 258, ed. Margaliot; *Sefer Haroqeah, Hilkhot Rosh hashanah,* par. 200. According to the *Perush Siddur Tefilah Laroqeah,* par. 3, this does not apply to all the instances of *zulatot:* "From the beginning of *Emet veyatsiv* until the last word of this section *zulatkha,* there are 100 words in correspondence to 100 blessings [to be said during the day]; therefore one is to interrupt the fixed prayer and add the "*zulatot* which the poets composed.'" See, however, Langer, who believes that the Pietist concern in this matter applies to the recitation of *zulatot* in general, Langer, *To Worship God Properly,* 144.

137. Goldschmidt includes the *zulatot–melekh amits we'ayom* (for the first day of New Year) and *ezar na oz limlokh* (for the second day), but notes that in

most congregations it was not recited, *Mahzor Leyamim Nora'im* (Jerusalem: Koren, 1970), vol. 1, 55–57; the Yom Kippur service has no *zulatot* at all.

138. Langer, *To Worship God Properly*, 147.

139. Fol. 217v.

140. See Robert Wuthnow's argument about rituals reaffirming cultural values, *Meaning and Moral Order: Exploration in Cultural Analysis* (Berkeley: University of California Press, 1989), 106–107.

141. This was first discussed by Arnold van Gennep, *The Rites of Passage* (Chicago: University of Chicago Press, 1960; orig. published in 1909), chap. 2; Turner, "Ritual, Tribal and Catholic," 524; Émile Durkheim had created a sharp delineation between the sacred and the profane, an approach that had been heavily criticized for dichotomizing these two notions, in *The Elementary Forms of the Religious Life* (New York: Free Press, 1965; orig. published 1915), 51–57; for a critique, see, e.g., Jack Goody, "Religion and Ritual: The Definitional Problem," *British Journal of Sociology*, 12/2 (1961): 142–164.

142. In his discussion of different kinds of transitions, Turner observed "two major 'models' of human interrelatedness": that of a hierarchically structured society "separating men in terms of 'more' or 'less,' " and that of a society as an unstructured community "of equal individuals who submit together to the general authority of the ritual elders." In some sense this definition seems to apply to the gathering of a congregation on the eve of a holiday for the synagogal service, Victor Turner, *The Ritual Process: Structure and Anti-Structure* (Chicago: Aldine, 1969), 96. For a critique, see Caroline Walker Bynum, "Women's Stories, Women's Symbols: A Critique of Victor Turner's Theory of Liminality," in *Anthropology and the Study of Religion*, ed. Frank Reynolds and Robert Moore (Chicago: Center for the Scientific Study of Religion, 1984), 105–125, repr. in Bynum, *Fragmentation and Redemption: Essays on Gender and the Human Body in Medieval Religion* (New York: Zone Books, 1991), 27–52.

143. This aspect of rituals and the role they play in society was underscored by Turner, "Ritual, Tribal and Catholic," 504–526; and Mary Douglas, *Natural Symbols* (New York: Pantheon Books, 1970), chap. 2.

144. Catherine Bell, "Ritual, Change, and Changing Rituals," *Worship* 63 (1989): 31–41, repr. in *Foundations in Ritual Studies: A Reader for Students of Christian Worship*, ed. Paul Bradshaw and John Mellow (Grand Rapids: Baker Academic, 2007), 167–176.

145. Robert Scribner, "Historical Anthropology of the Early Modern Period," in *Problems in the Historical Anthropology of Early Modern Europe*, ed. Robert Scribner and Ronnie Po-Chia Hsia, *Wolfenbüttler Forschungen* 78 (Wiesbaden: Harrassowitz Verlag, 1997), 18.

146. Bell, *Ritual Theory, Ritual Practice*, 183, relying on the work of James W. Fernandez, "Symbolic Consensus in a Fang Reformative Cult," *American Anthropologist* 67 (1965): 902–929.

147. Philipp Converse, "The Nature of Belief Systems in Mass Publics," in *Ideology and Discontent*, ed. David Apter (New York: Free Press, 1964), 206–261; see also Bell, *Ritual Theory, Ritual Practice*, 182–187.

148. Israel Davidson, *Thesaurus of Hebrew Poems and Liturgical Hymns from the Canonization of Scripture to the Emancipation* (New York: Jewish Theological Seminary of America, 1924), vol. 1, no. 1082.

149. *Tosafot, Zebahim* 95b–97b.

150. The *Sefer Ha'asufot*, fol. 35v, lists a whole range of wooden utensils to be scalded.

151. *Avodah zarah* 5:12; *Zebahim* 11:7.

152. *Babylonian Talmud, Pesahim* 30b.

153. *Babylonian Talmud, Avodah Zarah*, 74b.

154. Sefer Halakhot Gedolot 11, Hilkhot pesah, kol sha'ah, 179.

155. *Teshuvot Rav Natronai, Orah hayyim* no. 125.

156. Isaac Alfasi on *Pesahim* 8b; *Hidushe Haramban, Avodah Zarah* 76a (Jerusalem: Mekhon Hama'or, 2009); *Tosafot, Hullin* 8a.

157. Eliezer ben Nathan, *Sefer Raban, Avodah Zarah* par. 316; Eliezer ben Joel Halevi, *Sefer Ra'avia, Masekhet Pesahim* par. 464; Isaac of Vienna, *Sefer Or Zarua, Pisqe Avodah Zarah*, par. 294; or for Spain their contemporary Yom Tov ben Abraham of Seville, *Hidushe Haritba, Avodah Zarah*, 76a; *Pesahim* 30b; see also *Sefer Hidushe Harashba, Avodah Zarah* 76a.

158. *Ma'asse Roqeah, Hilkhot Hag'alah Velibun*, par. 5 (Jerusalem: Mekhon Torah Mitsion, 1993).

159. *Drashah Lepesah*, ed. Simha Emanuel (Jerusalem: Meqitse Nirdamim, 2006), 72–76.

160. Mendel and Thérèse Metzger discuss this image, which they reproduce in black and white. That is apparently the reason for their interpretation of the metal platter (*askala* in Aramaic) as a wooden board, arguing that wooden dishes cannot be made fit for Pesah, *Jewish Life*, caption to fig. 108. Not only are the depicted platters of metal, but, as noted, in the Middle Ages it was common to scald wooden dishes as well. Following that erroneous interpretation, the Metzgers argued that a Christian artist, who was not fully aware of the halakhic requirements, would have been responsible for this imagery.

161. *Ma'ase Roqeah, Hilkhot Hag'alah Velibun*, par. 4; *Derashah Lepesah, 72*. The precise family relationship between Eleazar and Abraham ben Samuel is not entirely clear, see *Derashah Lepesah, 72* n. 35 in a note by Simha Emanuel, the editor of the sermon. A relative of the Qalonymides by that name was active in Speyer.

162. Shammash, *Minhagim*, par. 73.

163. Israel Yuval, *Two Nations in Your Womb: Perceptions of Jews and Christians in Late Antiquity and the Middle Ages* (Berkeley: University of California Press, 2006), 181, 234–236; with references to *Ma'ase Hagezerot Hayeshanot*, a Crusader chronicle published by Abraham M. Haberman, *Gezerot Ashkenaz Vetsarfat* (Jerusalem: Sifre Ofir, 1971), 95, and *The Life and Miracles of St. William of Norwich*, ed. Augustus Jessopp and Montagu R. James (Cambridge: Cambridge University Press, 1896), 22.

164. Darmstadt, Hessische Landes- und Staatsbibliothek, Cod. Or. 13, fol. 69r.

165. See, e.g., *Arba'a Turim, Orah Hayyim, Hilkhot Pesah*, par. 458.

166. Rainer Barzen, "Zur Siedlungsgeschichte der Juden im mittleren Rheingebiet bis zum Beginn des 16. Jahrhunderts," in *Geschichte der Juden im Mittelalter von der Nordsee bis zu den Südalpen: Kommentiertes Kartenwerk*, ed. Alfred Haverkamp (Hannover: Hahnsche Buchhandlung, 2002), vol. 1: *Kommentarband*, 7.

167. Gerold Bönnen, "Jüdische Gemeinde und christliche Stadtgemeinde im spätmittelalterlichen Worms," in *Jüdische Gemeinden und ihr christlicher Kontext in kulturräumlich vergleichender Betrachtung von der Spätantike bis zum 18. Jahrhundert*, ed. Christoph Cluse, Alfred Haverkamp, and Israel J. Yuval (Hannover: Hahnsche Buchhandlung, 2003), 312; Heinrich Boos, *Urkundenbuch der Stadt Worms* (Berlin: Weidmann, 1886), vol. 2, 317, no. 472.

168. For details, see Franz-Josef Ziwes, *Studien zur Geschichte der Juden im mittleren Rheingebiet während des hohen und späten Mittelalters* (Hannover: Hahnsche Buchhandlung, 1995), 94; on the possible halakhic implications of such a move, see Itzhak (Eric) Zimmer, "Baking Regulations in the Ashkenazi Communities [in Hebrew]," *Zion* 65/2 (2000): 141–162.

169. Shammash, *Minhagim*, par. 75.

170. Yuval, *Two Nations*, chap. 5.

171. For Christian accounts on the host-desecration libels, see Miri Rubin, *Gentile Tales: The Narrative Assault on Late Medieval Jews* (New Haven: Yale University Press, 1999); on the persecutions of 1298, see Friedrich Lotter, "Die Judenverfolgung des 'König Rintfleisch' in Franken um 1298: Die endgültige Wende in den christlich-jüdischen Beziehungen im Deutschen Reich des Mittelalters," *Zeitschrift für historische Forschung* 15/4 (1988): 385–422.

172. For the most significant contribution on this matter, see Yuval, *Two Nations*, chap. 4.

173. Ivan G. Marcus, *Rituals of Childhood: Jewish Acculturation in Medieval Europe* (New Haven: Yale University Press, 1996). In his introduction Marcus sketches relevant patterns of acculturation, 1–17. In the discussion of liminality and rites of passage he is indebted to van Gennep, *Rites of Passage*, and Turner, *Ritual Process*, chap. 3.

174. Moritz Güdemann, *Geschichte des Erziehungswesens und der Cultur der Abendländischen Juden während des Mittelalters und der neueren Zeit* (Vienna: Hölder, 1880–1888); Ephraim Kanarfogel, *Jewish Education and Society in the High Middle Ages* (Detroit: Wayne State University Press, 1992), 23–42.

175. See also Moshe T. Fisher, "Remarks on the Ashkenazi Pietists' Attitude to Education in the Light of the *Sefer Hasidim* [in Hebrew]," *Hagige Giv'ah* 10 (1996): 69–84.

176. Kanarfogel, *Jewish Education and Society*, 79.

177. *Sefer Haroqeah, Hilkhot Shavuot*, par. 296; Ivan G. Marcus, "Honey Cakes and Torah: A Jewish Boy Learns His Letters," in *Judaism in Practice: From the Middle Ages through the Early Modern Period*, ed. Lawrence Fine (Princeton: Princeton University Press, 2001), 122–123; all the elements are given

biblical proof texts, which are all quoted by Marcus, but being left out here, as this is not the central concern of my discussion; the text is discussed in Marcus, *Rituals of Childhood*, 26–28.

178. As observed by Marcus, *Rituals of Childhood*, 74, 81–82, who discusses the parallel functions of the teacher and Moses.

179. Ez 3:3, Marcus, *Rituals of Childhood*, 54–55.

180. Karl E. Grözinger, "Between Magic and Religion: Ashkenazi Hasidic Piety," in *Mysticism, Magic and Kabbalah*, 37, quoting Eleazar ben Judah, *Sode Razia*, Munich, Bayerische Staatsbibliothek, cod. hebr. 81, fol. 218v.

181. *Sefer Ha'asufot*, fol. 67r; for a discussion of the whole section, see Marcus, *Rituals of Childhood*, 29–31.

182. Hamburg, Staats- und Universitätsbibliothek, cod. hebr. 17, fols. 81r–v; Marcus, *Rituals of Childhood*, 30–31.

183. All of these variants are discussed in Marcus, *Rituals of Childhood*, 32, n. 41. The addition appears in New York, Jewish Theological Seminary, MS Mic. 8092, dated 1204.

184. See Judah Galinsky, "The Four *Turim* and the Halakhic Literature of Fourteenth Century Spain [in Hebrew]" (PhD diss., Bar-Ilan University, 1999), 151. I am grateful to Judah Galinsky for discussing these issues with me. The same book has also been identified as *Sefer Hayirah* and attributed to the Catalan scholar Jonah Gerundi; for more background, see ibid. Soloveitchik rejects the claim that the *Sefer Hayirah* is nourished from Pietist thought, "Piety."

185. *Sefer Orhot Hayim*, vol. 2, ed. Moshe Schlesinger, Berlin 1902, par. 3; *Sefer Kol Bo*, par. 74.

186. For a discussion on the Christian iconographic sources of several of the motifs in this image, see Evelyn M. Cohen, "The Teacher, the Father and the Virgin Mary in the *Leipzig Mahzor*," *Proceedings of the Tenth World Congress of Jewish Studies*, Div. D, vol. 2: *Art, Folklore and Music* (Jerusalem: World Union of Jewish Studies, 1990), 71–76.

187. Marcus, *Rituals of Childhood*, 83–101.

188. *Sefer Haroqeah*, no. 296; quoted after Marcus, "Honey Cakes and Torah," 123. The last saying is based on the Jerusalem Talmud, *Ta'anit* 1:6, 64c; *Pesahim* 1:1, 30c; Babylonian Talmud, *Pesahim* 50b; *Bereshit Rabbah*, 49:1.

189. Marcus, *Rituals of Childhood*, 103–112. Also in this respect Marcus underscores several parallels between early pre-Tosafist and monastic culture and Tosafist and scholastic culture. Toward the end of the Middle Ages the initiation rite disappeared as suddenly as it had appeared and was replaced by the early modern Bar Mitsvah ritual, ibid.

190. This is in contradiction to Ta-Shma, *Early Ashkenazic Custom*, 41, where the ritual is described as a mere folkloristic custom; see also Ta-Shma, *Halakhah, Custom, and Reality in Ashkenaz 1000–1350* [in Hebrew] (Jerusalem: Hebrew University Magnes Press, 1996), chap. 6, referring to Eleazar's text and arguing that the latter's description of the rite as a "joy for children" means that it is not a duty and not a custom with the full status of the *minhag*. Eleazar's emphasis on "custom is valid" clearly contradicts this view.

191. As can be learned from a mention in *Sefer Ha'asufot,* fol. 67r; for more on this, see Marcus, *Piety and Society,* 113–114; Marcus, *Rituals of Childhood,* 114.

192. Marcus, *Rituals of Childhood,* 83–101.

193. Turner, *Ritual Process,* 96.

194. David Malkiel, *Reconstructing Ashkenaz: The Human Face of Franco-German Jewry, 1000–1250* (Palo Alto: Stanford University Press, 2009); see also Haym Soloveitchik, "Halakhah, Hermeneutics, and Martyrdom in Medieval Ashkenaz," *Jewish Quarterly Review* 94 (2004): pt. 1, 101, pt. 2, 228.

195. For a discussion of the different approaches, see Bell, *Ritual Theory, Ritual Practice,* 118.

196. Some theories distinguish sharply between tradition as a set of fixed characteristics, usually associated with the written culture of a society, and custom, apparently typical for oral cultures; for a discussion of these approaches, see Bell, *Ritual Theory, Ritual Practice,* 119. This distinction between tradition and custom as separate phenomena does not apply well to the historical circumstances of Ashkenazi Jewry, its tradition and its customs, where written tradition actually challenged the status of orally transmitted customs. According the dichotomous view of tradition and custom, the former would be considered static and fixed, whereas the latter would be dynamic and flexible. In Ashkenazi culture, as in any Jewish realm, both are rather flexible to differing degrees, and the tension between the two was not the result of one being fixed and the other flexible; rather it grew out of a difference in status that the various Jewish societies attached to tradition and custom. The dichotomous view was rejected by Roy A. Rappaport, who realized that literate societies with static traditions do observe customs and oral societies have static, traditional elements, "The Obvious Aspects of Ritual," in *Ecology, Meaning and Religion* (Richmond: North Atlantic Books, 1979), 179–182.

197. For details, see the survey in Catherine Bell, *Ritual Perspectives and Dimensions* (Oxford: Oxford University Press, 1997), chap. 1.

198. Geertz, *The Interpretation of Cultures,* 1–30.

5. Musar

1. These two sections follow 152 paragraphs of apparently different background that were subsequently inserted into the Bologna recension; see Haym Soloveitchik, "Piety, Pietism and German Pietism: *Sefer Hasidim I* and the Influence of *Hasidei Ashkenaz,*" *Jewish Quarterly Review* 92/3–4 (2002): 455–493.

2. Much has been written on Pietist ethics, and the literature is referred to here only selectively; for an anthology of early contributions, see Ivan G. Marcus, *Piety and Society: The Jewish Pietists of Medieval Germany* (Leiden: E. J. Brill, 1981); *The Religious and Social Ideas of the Jewish Pietists in Medieval Germany: Collected Essays,* ed. Ivan G. Marcus (Jerusalem: Zalman Shazar Center, 1986); Joseph Dan, *Rabbi Judah the Pious* [in Hebrew] (Jerusalem: Hebrew University Magnes Press, 2005). Soloveitchik approaches Pietist

ethics in a particularly narrow way, relating only to those elements that are specific to the Pietists, in particular to the *Sefer Hasidim;* see "Piety." On the following pages the notion of Pietist ethics is approached somewhat more broadly.

3. Israel Davidson, *Thesaurus of Hebrew Poems and Liturgical Hymns from the Canonization of Scripture to the Emancipation* (New York: Jewish Theological Seminary of America 1924), vol. 1, no. 3853.

4. For some thoughts on the *aleph-lamed* ligature symbolizing the presence of God in the equivalent image in the Worms Mahzor, see David Stern, "'Jewish' Art and the Making of the Medieval Prayerbook," *Ars Judaica* 6 (2010): 42.

5. See, e.g., Rachel Wischnitzer, "The Moneychanger with the Balance: A Topic of Jewish Iconography," *Eretz Israel* 6 (1960): 23–25, who linked the medallions to Ezekiel and representations of the Evangelists and the scales to the money changers in the Second Temple; on the relation to Christian sources, see also Narkiss's contribution to the commentary volume of the facsimile edition, *Machsor Lipsiae: 68 Facsimile Plates of the Mediaeval Illuminated Hebrew Manuscript in the Possession of the Leipzig University Library,* ed. Elias Katz (Hainau/Main: Werner Dausien, 1964), 31.

6. Gabrielle Sed-Rajna, *Le mahzor enluminé: Les voies de formation d'un programme iconographique* (Leiden: E. J. Brill, 1983), 32; Narkiss's contribution to *The Worms Mahzor, Jewish National and University Library, MS heb. 4°781/1,* ed. Malachi Beit-Arié (Vaduz: Cyelar, 1985), 81; (http://www.jnul. huji.ac.il/dl/mss/worms/a_eng.html). Elias Katz saw the balance as a symbol of God's judgment and the dragons as a representation of the forces of Satan attempting to upset the balance of the scales, *Machsor Lipsiae,* 19.

7. The marginal motif in the Leipzig panel was understood as such by Katz, *Machzor Lipsiae,* 19; on hunting as a metaphor for anti-Jewish persecution in medieval Jewish literature, see Marc M. Epstein, *Dreams of Subversion in Medieval Jewish Art and Literature* (University Park: Pennsylvania State University Press, 1997), 21–22. For a recent recollection of this motif, see Sara Offenberg, "Expressions of Meeting the Challenges of the Christian Milieu in Medieval Jewish Art and Literature [in Hebrew]" (PhD diss., Ben-Gurion University of the Negev, 2008), chap. 4.

8. Epstein argues that the hare was a defamatory Christian symbol for the Jews, translated by the Jews into a positive image of themselves, *Dreams of Subversion,* 27.

9. Kurt Schubert, "Wikkuach-Thematik in den Illustrationen hebräischer Handschriften," *Jewish Art* 12–13 (1986–1987): 251–252.

10. Ibid., 250–251.

11. Israel J. Yuval, "Jewish Messianic Expectations towards 1240 and Christian Reactions," in *Toward the Millennium: Messianic Expectations from the Bible to Waco,* Studies in the History of the Religions 77, ed. Peter Schäfer and Mark Cohen (Leiden: E. J. Brill, 1998), 110, offering references to earlier discussions on Ashkenazi approaches to Messianism.

12. Marcus, *Piety and Society,* chap. 3; Dan, *Judah the Pious,* chap. 6.

13. This process is described in detail by Marcus, *Piety and Society*, 120–28.

14. This was first described in the *Babylonian Talmud, Yoma*, 86a. Much scholarship has been devoted to the roots of the Pietist penitential system; Yitzhak Baer and, following him, Ephraim E. Urbach argued that this system echoes some aspects of medieval Christian penitential doctrine, Yitzhak Baer, "The Social and Religious Tendencies of the *Sefer Hasidim* [in Hebrew]," *Zion* 3 (1938): 18; Ephraim E. Urbach, *The Tosafists: Their History, Writings and Methods* [in Hebrew], rev. ed. (Jerusalem: Mosad Bialik, 1986), vol. 1, 394 (orig. published 1954). Recent scholarship sees the Pietist system rather in continuation of late antique rabbinic concepts; for an overview of the debate, see Talya Fishman, "The Penitential System of Hasidei Ashkenaz and the Problem of Cultural Boundaries," *Journal of Jewish Thought and Philosophy* 8 (1999): 201–205; whereas most scholarship of the 1970s and 1980s abandoned the earlier suggestion of Christian input, Fishman revisited the question of Christian influence, focusing on new evidence. The specific Pietist terminology was developed in its final form only in Eleazar of Worms's *Sefer Haroqeah*, ed. Barukh S. Shne'urson (Jerusalem: n.p., 1967), *Hilkhot Tshuvah*, par. 1–15; see Marcus, *Piety and Society*, 48–49; it is based, however, on the discussions of Samuel the Pious, *Sefer Hayir'ah*, included as par. 1–13 of *Sefer Hasidim*, ed. Judah Hakohen Wistinetzky and Jakob Freimann (Frankfurt/Main: n.p., 1924); and Judah the Pious, in *Sefer Hasidim*, par. 37–43 of the same edition; for an analysis, see Marcus, *Piety and Society*, 44–49.

15. Marcus, *Piety and Society*, 75–78; chap. 8.

16. Urbach, *Tosafists*, vol. 1, 394 and n. 38; see also Martha Keil, "Rituals of Repentance and Testimonies at Rabbinical Courts in the 15th Century," in *Papers of the Workshop "Oral History in the Middle Ages,"* ed. Gerhard Jaritz (Krems: Medium Aevum Quodidianum; Budapest: Central European University, 2001), 159–170.

17. Ibid., 128; Fishman, "Penitential System," 201.

18. *Sefer Haroqeah*, nos. 1–16; 25–28, no. 19; 29.

19. *Perush Siddur Hatefilah Laroqeah*, par. 382, ed. Moshe Hershler (Jerusalem: Mekhon Hershler, 1992).

20. *Babylonian Talmud, Pesahim* 119a.

21. *Sefer Ha'asufot*, private collection of D. H. Feinberg (New York), formerly Jews' College, MS Montefiori 134, fols. 150v–153v.

22. *Sefer Arugat Habosem*, ed. Ephraim E. Urbach (Jerusalem: Meqitse Nirdamim, 1939–1963), vol. 2, 109. For the poem, see Davidson, *Thesaurus*, vol. 1, no. 7880; this *piyyut* was written by Menachem ben Makhir and was recited according to the Eastern rite on the Sabbath between Rosh Hashanah and Yom Kippur, see *Minhagim dekehilat kodesh Wermaiza Lerabbi Yuspa Shammash*, ed. Benjamin S. Hamburger and Itzhak (Eric) Zimmer (Jerusalem: Mekhon Yerushalayim, 1988–1992), no. 151, n. 1.

23. *Arugat Habosem*, vol. 1, 212, citing *Babylonian Talmud Pesahim* 119a; for the poem, see Davidson, *Thesaurus*, vol. 2, 464, no. 66.

24. *Arugat Habosem*, vol. 1, 99–100; for the poem, see Davidson, *Thesaurus*, vol. 1, no. 4742.

25. Judah Galinsky, "The Four *Turim* and the Halakhic Literature of Fourteenth-Century Spain [in Hebrew]" (PhD diss., Bar-Ilan University, 1999), 151.

26. *Sefer Kol Bo*, ed. Israel J. Vidavsky (Jerusalem: Mekhon Even Israel, 1997), par. 66, vol. 1, 266.

27. Ibid.

28. Ibid., 267–272.

29. Davidson, *Thesaurus*, vol. 1, 3204; Daniel Goldschmidt, *Mahzor Layamim Hanora'im Lefi Minhage Bne Ashkenaz Lekhol Anfehem Kolel Minhag Ash-kenaz (Hama'aravi), Minhag Polin, Uminhag Tsarfat Leshe'avar*, vol. 2: *Yom Kippur* (Jerusalem: Koren, 1970), 606. For an English translation of the *piyyut*, see *High Holyday Prayer Book*, ed. and trans. Philip Birnbaum (New York: Hebrew Publishing Company, 1951), 918.

30. Vered Tohar, "Abraham in the Furnace: Phenomenology of a Literary Theme in the Literature of the Jewish People [in Hebrew]," (PhD diss., Bar-Ilan University 2004); Tohar, "Abraham in the Fiery Furnace" [in Hebrew], in *Encyclopedia of the Jewish Story*, ed. Yoav Elstein, Avidav Lipsker, and Rella Kushlevsky (Ramat Gan: Bar-Ilan University Press, 2004), vol. 2, 9–33; and recently Tohar, *Abraham in the Fiery Furnace: A Rebel in a Pagan World* (Ramat Gan: Bar-Ilan University Press, 2010).

31. Joseph Gutmann, "Abraham in the Fire of the Chaldeans: A Jewish Legend in Jewish, Christian and Islamic Art," *Frühmittelalterliche Studien* 7 (1973): 342–352.

32. The Sephardi imagery forms, as I have shown elsewhere, part of a traditional exegetical concept that governs the pictorial narratives from Catalonia and Aragon. This concept was part of the traditional worldview of the particular patrons of these Haggadah manuscripts, Katrin Kogman-Appel, *Illuminated Haggadot from Medieval Spain: Biblical Imagery and the Passover Holiday* (University Park: Pennsylvania State University Press, 2006), chaps. 6 and 7.

33. For background on these images, see Gutmann, "Abraham in the Fire," 342–352; on some of the Ashkenazi examples, see Katrin Kogman-Appel, *Die zweite Nürnberger und die Jahuda Haggada: Jüdische Illustratoren zwischen Tradition und Fortschritt* (Frankfurt/Main: Peter Lang, 1999), 63–69.

34. *Babylonian Talmud, Baba Batra* 15a; for an English version of the Babylonian Talmud, see *The Babylonian Talmud*, ed. Isidore Epstein (London: Soncino Press, 1952).

35. Ps 79:9; 103:8; 145:8; Mic 7:19; Hos 6:2.

36. Davidson, *Thesaurus*, vol. 1, no. 8307; Goldschmidt, *Mahzor Layamim Hanora'im*, vol. 1: *Rosh Hashanah*, 112–121; Benjamin Bar-Tiqva, "The Ten Trials of Abraham in the Light of the *Piyyut* [in Hebrew]," in *The Tradition of the Piyyut*, ed. Benjamin Bar-Tiqva and Ephraim Hazan (Ramat Gan: Bar-Ilan University Press, 2000), vol. 2, 127–143; Tohar, "Fiery Furnace," 19.

37. *Pirqe de Rabbi Eliezer* par. 29, ed. David Lurie (Warsaw: n.p., 1852); for an English version, see *Pirkê de Rabbi Eliezer*, ed. and trans. Gerald Friedlander (London: K. Paul. Trench, Trubner, 1916).

38. Oxford, Bodleian Library, MS Laud 321, fol. 278r; Sed-Rajna, *Le mahzor enluminé*, fig. 47.

39. Oxford, Bodleian Library, MS Michael 627, fol. 128v.

40. Jacob Azuelos, "The Meaning of the Name 'Ur Chasdim' in Genesis 11:27–31 according to Literature from the Second Temple Period and the Midrash [in Hebrew]," *Beit Mikra* 45/3 (Spring 1980): 268.

41. *Midrash Bereshit Rabbah* 38:13, ed. Yehuda Theodor and Hanokh Albeck (Jerusalem: Wahrmann, 1997); for an English version, see *Genesis Rabbah: The Judaic Commentary to the Book of Genesis—A New American Translation*, ed. Jacob Neusner (Atlanta: Scholars Press, 1985).

42. *Yalqut Shimoni al Hatorah Lerabbenu Shim'on Hadarshan*, ed. Dov Hyman, Yitzhak. N. Lerrer, and Yitzhak. Shiloni, par. 77 (Jerusalem: Mosad Harav Kook, 1973–1977); it was composed shortly after 1300, perhaps in Frankfurt, by Simon the Preacher, see Hermann L. Strack and Günter Stemberger, *Introduction to Talmud and Midrash* (Minneapolis: Fortress Press, 1992), 384; *Sefer Zikhronot Hu Divre Hayamim Leyerahmiel*, ed. Eli Yassif (Ramat Aviv: Tel Aviv University, 2001), 123–124, 131–135; this book was written a few years later by an otherwise unknown author, Eleazar ben Asher, apparently not a scholar, but an educated bibliophile; for background, see the introduction by Yassif, ibid., 11–68.

43. Aviva Schussman, "An Iraq Judaeo-Arabic Version of the *Ma'aseh Avraham*: Some Literary and Linguistic Features," in *Genizah Research after Ninety Years: The Case of Judaeo-Arabic—Papers Read at the Third Congress of the Society of Judaeo-Arabic Studies* (Cambridge: Cambridge University Press, 1992), 126–136; Bernard Mehlman, "A Literary Examination of *Maaseh Avraham Avinu Alav Hashalom*," *Annual of Rabbinic Judaism* 2 (1999): 103–125.

44. They were published in *Bet Hamidrash*, ed. Alfred Jellinek (Leipzig: Vollrath, 1853), vol. 1, 25–34; vol. 2, 118–119; vol. 5, 40–41. Not much is known about the literary relationships among these versions or their chronology, as only the last, the longest of the three, has been the subject of a modern study, Mehlman, "Literary Examination."

45. References to the catapult appear in Islamic representations of the story, both visual and literary; see Gutmann, "Abraham in the Fire," 349.

46. *Sefer Gematriot, Liqutim* 6 (Jerusalem: Jacob I. Stahl, 2005); for an earlier facsimile edition of a manuscript, see *Sefer Gematriot Lerabbi Yehuda Hehasid*, ed. Israel Ta-Shma and Daniel Abrams (Los Angeles: Cherub, 1998).

47. For a detailed discussion of the events and their historical significance, see Jonathan Riley-Smith, "The First Crusade and the Persecution of the Jews," *Studies in Church History* 21 (1984): 51–72; Robert Chazan, *European Jewry and the First Crusade* (Berkeley: University of California Press, 1987). On the impact of the massacres on later Jewish historical consciousness and Jewish-Christian relations, see Chazan, *In the Year 1096: The First Crusade and the Jews* (Philadelphia: Jewish Publication Society of America, 1996); for a detailed overview of different waves of persecutions in medieval Ashkenaz, see Jörg. R. Müller, "Judenvervolgungen- und Vertreibungen zwischen Nordsee und Südalpen im hohen und späten Mittelalter," in *Geschichte der Juden*

im Mittelalter von der Nordsee bis zu den Südalpen—Kommentiertes Karten-werk, ed. Alfred Haverkamp (Hannover: Hahnsche Buchhandlung, 2002), vol. 1: *Kommentarband*, 189–222.

48. Published first by Adolf Neubauer and Moritz Stern, *Hebräische Berichte über die Judenverfolgungen während der Kreuzzüge* (Berlin: Verlag Leonhard Simion, 1892); for a later edition, see *Sefer Gezerot Ashkenaz Vetsarfat*, ed. Abraham M. Habermann (Jerusalem: Tarshish, 1945), 24–104; for English translations, see Shlomo Eidelberg, *The Jews and the Crusaders* (Madison: University of Wisconsin Press, 1977); for a recent critical edition with a translation into German and discussion, see *Hebräische Berichte über die Judenverfolgungen während des Ersten Kreuzzugs*, ed. Eva Haverkamp (Hannover: Hahnsche Buchhandlung, 2005); see also, Chazan, *European Jewry*, appendix.

49. David Malkiel, *Reconstructing Ashkenaz: The Human Face of Franco-German Jewry, 1000–1250* (Palo Alto: Stanford University Press, 2009), 89–94.

50. Shmuel Shepkaru, *Jewish Martyrs in the Pagan and the Christian Worlds* (New York: Cambridge University Press, 2006), 214–229.

51. See, e.g., the contributions of Shlomo Eidelberg, "The Solomon bar Simson Chronicle as a Source of the History of the First Crusade," *Jewish Quarterly Review* 49 (1959): 282–287, repr. in *Medieval Ashkenazic History: Studies in German Jewry in the Middle Ages*, ed. Shlomo Eidelberg (New York: Hermon Press, 1999), 21–27; Ivan G. Marcus, "From Politics to Martyrdom: Shifting Paradigms in the Hebrew Narratives of the 1096 Crusade Riots," *Prooftexts* 2 (1982): 42–43; Chazan, *European Jewry*, and a critical review by Marcus in *Speculum* 64 (1989): 685–688; Jeremy Cohen, "The Persecutions of 1096—from Martyrdom to Martyrology: The Sociocultural Context of the Hebrew Crusade Chronicles [in Hebrew]," *Zion* 59 (1994): 169–208; Cohen, *Sanctifying the Name of God: Jewish Martyrs and Jewish Memories of the First Crusade* (Philadelphia: University of Pennsylvania Press, 2004); Robert Chazan, *God, Humanity, and History: The Hebrew First Crusade Narratives* (Berkeley: University of California Press, 2000); Friedrich Lotter, "'Tod oder Taufe': Das Problem der Zwangstaufen während des Ersten Kreuzzugs," in *Juden und Christen zur Zeit der Kreuzzüge*, ed. Alfred Haverkamp (Stuttgart: Jan Thorbecke Verlag, 1999), 110; Malkiel, *Reconstructing Ashkenaz*, chaps. 3 and 4. For short summaries of the historicity controversy, see Cohen, *Sanctifying*, 43–47, and Malkiel, *Reconstructing Ashkenaz*, 76–77. On the diversity of the three Chronicles, finally, see Robert Chazan, "The Mainz Anonymous: Historiographic Perspectives," in *Jewish History and Jewish Memory: Essays in Honor of Yosef Hayyim Yerushalmi*, ed. Elisheva Carlebach (Waltham: Brandeis University Press, 1998), 54; on the relationship among the texts, see Anna Sapir Abulafia, "The Interrelationship between the Hebrew Chronicles of the First Crusade," *Journal of Semitic Studies* 27 (1982): 221–239, and recently, Eva Haverkamp, *Hebräische Berichte*, Einleitung.

52. See, e.g., Cohen's interesting analysis of the Chronicles, which, in his view, depict "the discourse or meaning of those events as it took shape in . . .

Jewish society." Cohen takes into consideration not only the "ideological and cultural baggage" the Chronicles are packed with, but also what one can assume were guilt feelings of those who survived the massacres, the slaughtering, and the suicides, and reported them, *Sanctifying*, 55–60. Avraham Grossman reads them as an expression of the anxiety among Ashkenazi spiritual leaders facing movements of conversion, both deliberate and forced, "The Roots of *Qiddush Hashem* in Early Ashkenaz [in Hebrew]," in *The Sanctity of Life and Martyrdom*, ed. Yeshayahu Gafni and Aviezer Ravitzky (Jerusalem: Zalman Shazar Center, 1993), 99–130, esp. 121–127.

53. For a discussion of the prayer, *av harahamim* (Merciful Father), and a translation into English, see Chazan, *European Jewry*, 145. Many of the poems were published in *Gezerot*.

54. For a collection of articles on martyrdom in antiquity, see *Die Entstehung der jüdischen Martyrologie*, ed. Jan Willem van Henten, Boudewijn Dehandschutter, and Johannes van der Klaauw (Leiden: E. J. Brill, 1989). For details on the three youths, see Shepkaru, *Jewish Martyrs*, 7–11.

55. *Babylonian Talmud, Berakhot* 61b. For rabbinic attitudes to martyrdom and the relevant accounts in rabbinic literature, see Shepkaru, *Jewish Martyrs*, chap. 3.

56. *Babylonian Talmud, Avodah Zarah* 18a.

57. Simha Goldin, *The Ways of Jewish Martyrdom* (Turnhout: Brepols, 2008), 61–62.

58. *Midrash Bereshit Rabbah* 15:7.

59. Grossman, "Roots of *Qiddush Hashem*," 109–119; see also Lena Roos, *"God Wants It!" The Ideology of Martyrdom in the Hebrew Crusade Chronicles and Its Jewish and Christian Background* (Turnhout: Brepols, 2006), 72–75; Cohen, *Sanctifying*, 21, with references to sources. Shepkaru also argues that "Byzantine Jewry's greatest contribution to the evolution of Jewish martyrdom, in my opinion, is the reversal of the rabbinic restrictions on voluntary death." Byzantine Jews, Shepkaru observes, brought the sacrificial symbol into the discourse and, more importantly, laid the groundwork for the "justification for active forms of self-oblation," Shepkaru, *Jewish Martyrs*, chap. 4, esp. 107.

60. Cohen, *Sanctifying*, 62; see also Shepkaru, *Jewish Martyrs*, 163–164. In Iberia passive martyrdom occurred only occasionally, whereas active martyrdom is hardly ever mentioned, Avraham Grossman, "The Sanctifying of the Name of God in the Eleventh and Twelfth Centuries: Between Ashkenaz and the Islamic Lands [in Hebrew]," *Peamim* 75 (1998): 27–46.

61. An example is Avraham Grossman, *The Early Sages of Ashkenaz: Their Lives, Leadership and Works, 900–1096* [in Hebrew] (Jerusalem: Hebrew University Magnes Press, 1988), chaps. 8–9, dealing with the generation of scholars just before 1096 in Mainz and Worms.

62. This question was addressed earlier by Jacob Katz, *Exclusiveness and Tolerance: Studies in Jewish-Gentile Relations in Medieval and Modern Times* (New York: Behrmann House, 1961), chap. 7; Grossman, "Sanctifying," 31–32; Grossman, "Between 1012 and 1096: The Cultural and Social Back-

ground of the Sanctification of the Name in 1096 [in Hebrew]," in *Jews Facing the Cross: The Persecutions of 1096 in History and Historiography*, ed. Yom Tov Assis et al. (Jerusalem: Hebrew University Magnes Press, 2000), 61–64; Cohen, *Sanctifying*, 14, and chap. 3; Haym Soloveitchik, "Halakhah, Hermeneutics, and Martyrdom in Medieval Ashkenaz (Part I of II)," *Jewish Quarterly Review* 94/1 (2004): 105–108. Recent research revisited the role the conversion of the Jews played in Christian theology. It had long been taken for granted that attempts to persuade Jews to convert was one of the dominant factors in the relationship between Christians and Jews, but some recent scholars have raised questions about how dominant the notion of conversion really was. This was considered, however, primarily in the context of Sephardi society, see Harvey Hames, "Reason and Faith: Inter-religious Polemic and Christian Identity in the Thirteenth Century," in *Religious Apologetics: Philosophical Argumentation*, ed. Yossef Schwartz and Volkhard Krech (Tübingen: Mohr Siebeck, 2004), 267–284. The whole issue may also shed light on the question of whether the killings in Germany were indeed the result of refused conversion, or whether baptism often was perhaps not an option at all, as suggested by Malkiel and Shepkaru. Traditionally it has been assumed that Jewish conversion was more frequent in Iberia, and that Ashkenazi Jews were more determined to resist Christian pressure, hence the acts of martyrdom; this position was recently challenged by Kenneth Stow, "Conversion, Apostasy and Apprehensiveness: Emicho of Flonheim and the Fear of Jews in the Twelfth Century," *Speculum* 76 (2001): 911–933. On conversion in Ashkenaz, forced and voluntary, see, recently, Chaviva Levin, "Jewish Conversion to Christianity in Medieval Northern Europe Encountered and Imagined, 1100–1300" (PhD diss., New York University, 2006).

63. This was argued by Haym Soloveitchik, "Between Arabia and Edom," in *The Sanctity of Life and Martyrdom*, ed. Yeshayahu Gafni and Aviezer Ravitzky (Jerusalem: Zalman Shazar Center, 1993), 149–152; Ivan G. Marcus, "From '*Deus vult* to the 'Will of the Creator:' Extreme Religious Ideologies and Historical Reality in 1096 and the Pietist Movement in Germany [in Hebrew]," in Assis et al., *Jews Facing the Cross*, 92–100; see, however, Jeremy Cohen's comments, *Sanctifying*, 57; and Shepkaru, *Jewish Martyrs*, chap. 7.

64. Marcus, "From Politics to Martyrdom," 43; on the Chronicles as stories about the martyrs' heroism, see Chazan, *European Jewry*, 217, arguing, however, that the impact of the Chronicles later on was more limited than some modern scholars assume, ibid., chap. 5. Goldin describes the literary structure of the Chronicles and analyzes how it may have functioned in the process of turning active martyrdom into an ideal, *Martyrdom*, 130–162. For a summary of the relevant scholarship, see Cohen, *Sanctifying*, 33–43.

65. Ivan G. Marcus, *Rituals of Childhood. Jewish Acculturation in Medieval Europe* (New Haven: Yale University Press, 1996), 6–7.

66. Marcus, "From Politics to Martyrdom," 43 and n. 9 with a reference to Alan Mintz, *Hurban: Responses to Catastrophe in Hebrew Literature* (Syracuse:

Syracuse University Press, 1984), 96; see also Robert Chazan, "The Early Development of *Hasidut Ashkenaz*," *Jewish Quarterly Review* 75/3 (1985): 205; Marcus, *Rituals*, 7; Shepkaru, *Jewish Martyrs*, 173–174. Grossman, "Roots of *Qiddush Hashem*," 111 refers to a case in 10th-c Otranto, having been compared to the Temple offerings.

67. This was discussed first by Shalom Spiegel, "*Aggadot* on the Binding of Isaac: A *Piyyut* about the Slaughter of Isaac and His Resurrection by R. Ephraim of Bonn [in Hebrew]," in *Alexander Marx Jubilee Volume, on the Occasion of his Seventieth Birthday* (New York: Jewish Theological Seminary of America, 1950), 471–547 (for an English version, see *The Last Trial. On the Legends and Lore of the Command to Abraham to Offer Isaac as a Sacrifice: The Akedah* (New York: Jewish Lights Publishing, 1967); and somewhat later by Yitzhak Baer, "The 1096 Persecution [in Hebrew]," *Sefer Asaf*, ed. Moshe D. Cassuto (Jerusalem: Mosad Harav Kook, 1953), 126–140; Grossman, "Roots of *Qiddush Hashem*," 115; Elisabeth Hollender and Ulrich Berzbach, "Einige Anmerkungen zu biblischer Sprache und Motiven in Piyyutim aus der Kreuzzugszeit," *Frankfurter Judaistische Beiträge* 25 (1998): 67–68; Lotter, "'Tod oder Taufe,'" 134–143; Goldin, *Ways of Jewish Martyrdom*, chap. 13; Shulamit Elizur, "The Binding of Isaac: In Mourning or in Joy? The Influence of the Crusades on the Biblical Story and Related *Piyyutim* [in Hebrew]," *Et Hada'at* 1 (1997): 15–36; recently also Shepkaru, *Jewish Martyrs*, 174–177.

68. See the synoptic juxtaposition in *Hebräische Berichte*, 335, 337.

69. The idea that Abraham touched Isaac's throat and that the latter's soul disappeared for some time appears as early as in late antique and early medieval midrashim as a commentary to the fact that Isaac is not mentioned in Genesis between the scene on Mount Moriah and the arrival of Rebecca; see, e.g., *Pirqe de Rabbi Eliezer*, chap. 31. Later the descriptions say more explicitly that Isaac was hurt, see, e.g., *Yalqut Shim'oni*, ed. Dov Heiman et al. (Jerusalem: Mosad Harav Kook, 1973), vol. 1, par. 101; on the midrashic tradition, see Spiegel, "*Aggadot*," 484–491. For a short discussion about how the iconography of the Binding of Isaac is informed by the notion of martyrdom, see Ephraim Shoham-Steiner, "Pharaoh's Bloodbath: Medieval European Jewish Thoughts about Leprosy, Disease, and Blood Therapy," *Jewish Blood: Reality and Metaphor in History, Religion, and Culture*, ed. Mitchell Hart (New York: Routledge, 2009), 110.

70. Shepkaru, *Jewish Martyrs*, 167–168.

71. For a discussion of this genre and examples, see Elizur, "The Binding of Isaac."

72. Davidson, *Thesaurus*, vol. 1, 2101 and 3603.

73. For a modern publication of many lesser-known *aqedot*, see *Leqet Piyyute Selihot Me'et Paytane Ashkenaz Vetsarfat*, ed. Abraham Fraenkel and Daniel Goldschmidt (Jerusalem: Meqitse Nirdamim, 1993).

74. Davidson, *Thesaurus*, vol. 1, 8492; for the full text, see Abraham Haberman, "The *Piyyutim* by Rabbi Ephraim of Bonn [in Hebrew]," *Yedi'ot Hamakhon Lekheker Hashira Ha'ivrit* 7 (1958): 266–268, see verse 31. The story about

Isaac actually being killed and visiting Paradise was linked to active martyrdom as early as in 1950 by Spiegel, *"Aggadot,"* 491; for a translation into English, see Spiegel, *The Last Trial,* 139–152.

75. *Babylonian Talmud, Sanhedrin* 74a.

76. *Avodah zarah* 54a.

77. Haym Soloveitchik, "Religious Law and Change: The Medieval Ashkenazic Example," *Association of Jewish Studies Review* 12 (1987): 205–221; Soloveitchik, "Halakhah, Hermeneutics, and Martyrdom," 80; see also Lotter, "Tod oder Taufe," 143–144.

78. The halakhic attitudes toward active martyrdom are subject to modern controversy, see Grossman, "Sanctifying," 38–41; Grossman, "Roots of *Qiddush Hashem*"; Israel Ta-Shma, "The Attitude of Ashkenazi Halakhists to Aggadic Sources: Suicide and the Killing of Others as Sanctification of the Name [in Hebrew]," in Assis et al., *Jews Facing the Cross,* 150–157; Ephraim Kanarfogel, "Halakhah and *Metziut* (Realia) in Medieval Ashkenaz: Surveying the Parameters and Defining the Limits," in *The Jewish Law Annual* 14 (2003): 193–224; Soloveitchik, "Halakhah, Hermeneutics, and Martyrdom"; David Berger, "Jacob Katz on Jews and Christians in the Middle Ages," in *The Pride of Jacob: Essays on Jacob Katz and His Work,* ed. Jay M. Harris (Cambridge, MA: Harvard Center for Jewish Studies, 2002), 44–54.

79. Soloveitchik, "Halakhah, Hermeneutics, and Martyrdom," 79.

80. Commentary to the *Babylonian Talmud, Avodah Zarah* 18a; for more details, see Chazan, *European Jewry,* 156–157; Soloveitchik, "Religious Law and Change;" Soloveitchik, "Halakhah, Hermeneutics, and Martyrdom;" Cohen, *Sanctifying,* 21–22.

81. Soloveitchik, "Religious Law and Change," 210, n. 8.

82. For more on the Tosafist attitudes, see Shepkaru, *Jewish Martyrs,* 232–235.

83. *Babylonian Talmud, Gittin* 57b.

84. For a thorough discussion of these and the role they played in thirteenth-century halakhic statements, see Soloveitchik, "Halakhah, Hermeneutics, and Martyrdom."

85. This distinction is made very clearly in Grossman, "Roots of *Qiddush Hashem,*" 115–119.

86. This is discussed at length in Soloveitchik, "Halakhah, Hermeneutics, and Martyrdom."

87. Goldin, *Ways of Jewish Martyrdom,* 236–237.

88. Urbach, *Tosafists,* 173–183; see recently also Matania J. Ben-Ghedalia, "The Historical Background of *Sefer Even Ha'ezer* [in Hebrew]" (MA thesis, Touro College, 2002).

89. Eliezer ben Nathan, *Sefer Hazikhronot,* in *Hebräische Berichte,* 263.

90. See especially *Gezerot,* 96; Susan Einbinder translated excerpts of one of these *piyyutim* and discussed it, see "Martyrs in the Rhineland: Rabbi Eliezer b. Nathan (Raban), *O God, Insolent Men,*" in *Reading the Middle Ages: Sources from Europe, Byzantium, and the Islamic World,* ed. Barbara H. Rosenwein (Ontario: Broadview Press, 2006), 286–289.

91. *Sefer Zekhirah,* in *Gezerot,* 115–136.

92. Urbach, *Tosafists,* 199–207. See also Matania J. Ben-Ghedalia, "The Rabbinic Sages of Speyer in the Era of the First Crusade: Their Lives, Leadership, and Works at the End of the Eleventh Century and the Beginning of the Twelfth Century [in Hebrew]" (PhD Diss., Bar-Ilan University, 2007), 71, describing the role these scholars played in promoting active martyrdom. He considers them as part of what he identifies as the Worms-Cologne school, which he believes was particularly instrumental in promoting active martyrdom.

93. Eliezer's original statement did not survive and is known only from later citations from the thirteen and fourteenth centuries; for a detailed discussion, see Kanarfogel, "Halakhah and *Metziut,*" 211–216. For a citation see Urbach, *Tosafists,* 288.

94. *Leqet Piyyute Selihot,* 57; Elizur, "The Binding of Isaac."

95. For a discussion of such myths and the role they played in both active and passive martyrdom, see recently also Roos, *"God Wants It!,"* chap. 4.

96. Kanarfogel, "Halakhah and *Metziut,*" 206–216. Maimonides, who, as all the other Sephardi authorities, objected to active martyrdom, also refers to them, *Mishne Torah Hu Hayad Hahazaqah.* Book 1: *Sefer Hamada: Hilkhot Yesode Hatorah* 5:4 (Jerusalem: Ma'aliot, 1990); for an English version, see *The Code of Maimonides,* ed. and trans. Jacob J. Rabinowitz (New Haven: Yale University Press, 1949); Kanarfogel, "Halakhah and *Metziut,*" 206, n. 42. On Maimonides's standpoint, see also Soloveitchik, "Halakhah, Hermeneutics, and Martyrdom," 81; on a comparative approach to references in Ashkenaz, Iberia, and the Islamic lands, see Soloveitchik, "Between Arabia and Edom." On Sephardi positions, see also Cohen, *Sanctifying,* 21.

97. As emphasized by Shepkaru, *Jewish Martyrs,* 8–9. On the three youths as prototypical martyrs, see Ernst Haag, "Die drei Männer im Feuer nach Dan. 3, 1–30," *Trierer Theologische Zeitschrift* 96/1 (1987): 20 n. 2; Jan Willem van Henten, "Das jüdische Selbstverständnis in den ältesten Martyrien," in *Die Entstehung des jüdischen Martyrologie,* 131, n. 7. For a discussion on later versions of the story of Abraham, and in particular the *Ma'ase* in their relation to the idea of martyrdom, see Abraham Gross, *Spirituality and Law: Courting Martyrdom in Christianity and Judaism* (Lanham, MD: University Press of America, 2005), 33–37.

98. *Midrash Bereshit Rabbah* 15:7.

99. It is only in the later phase of the late antique period that occasionally Abraham is described as "going down into the furnace," which implies active involvement, *Midrash Devarim (Deuteronomy) Rabbah* 9:4, ed. Shaul Lieberman (Jerusalem: Wahrmann, 1965); *Midrash Vayikra (Leviticus) Rabbah* 11:7, *Midrash Vayiqra Rabbah* 27:2, ed. Mordechai Margaliot (New York: Jewish Theological Seminary, 1993); the same applies to the three youths in Babylon, *Babylonian Talmud, Pesahim* 53b; *Sifre Devarim* 1:306, ed. Eliezer Finkelstein (New York: Jewish Theological Seminary, 1993); *Shmot (Exodus) Rabbah* 14, *Midrash Shmot Rabbah: Parashot* 1–14, ed. Avigdor Shinan (Tel Aviv: Dvir, 1984).

100. *Midrash Tanhuma, Lekh Lekha* 2 (Warsaw: n.p., 1875); for the role *Midrash Tanhuma* may have played in Pietist scholarship, see Amos Geula, "Lost Ag-

gadic Midrashim Known Only from Ashkenazi Sources: Avkir, Asefa, and Deuteronomy Zutta [in Hebrew]" (PhD diss., Hebrew University of Jerusalem, 2007), 332, n. 2118.

101. *Midrash Tehillim* 28:2, ed. Solomon Buber (Vilnius: Re'em, 1891).

102. Joseph Dan, "The Problem of Martyrdom in the Teachings of the Pietistic Movement [in Hebrew]," in *Holy War and Martyrology in the History of the Jews and in General History* (Jerusalem: Historical Society of Israel, 1968), 121–129, repr. in *The Religious and Social Ideas of the Jewish Pietists in Medieval Germany: Collected Essays*, ed. Ivan G. Marcus (Jerusalem: Zalman Shazar Center, 1986), 207–216; see also Dan, *Rabbi Judah the Pious*, chap. 5.

103. This was first argued by Gershom G. Scholem, *Major Trends in Jewish Mysticism* (Jerusalem: Schocken, 1941), 80–87; and was followed by Dan, "The Problem of Martyrdom;" see also Marianne Awerbuch, "Weltflucht und Lebensverneinung der 'Frommen Deutschlands,'" *Archiv für Kulturgeschichte* 60 (1978): 53–93.

104. Elliot R. Wolfson, "Martyrdom, Eroticism, and Asceticism in Twelfth-Century Ashkenazi Piety," in *Jews and Christians in Twelfth-Century Europe*, ed. Michael Signer and John Van Engen (Notre Dame, IN: University of Notre Dame Press, 2001), 171–221.

105. Chazan, "*Hasidut Ashkenaz*," 205, argues that the Chronicles reflect "strikingly parallel patterns of thought," patterns that can also be observed in later Pietism. The observation that the Pietists were perhaps ambivalent toward active martyrdom does not exclude the possibility that they developed other values that were prominent in Ashkenazi Jewish culture at the end of the eleventh century, which were also apparent in the Chronicles.

106. Dan, "The Problem of Martyrdom," 122; Marcus, *Piety and Society*, 150–151, n. 57; Chazan, "*Hasidut Ashkenaz*."

107. Ben-Ghedalia, "Rabbinic Sages of Speyer," 63–64.

108. *Hebräische Berichte*, 395; for discussions, see Cohen, *Sanctifying*, chap. 7; Shmuel Shepkaru, "Death Twice Over: Dualism of Metaphor and Realia in 12th Century Hebrew Crusading Accounts," *Jewish Quarterly Review* 93/1–2 (2002): 217–256, with further thoughts about medieval doubts regarding martyrdom.

109. Matania Ben-Ghedalia goes as far as to make an attempt to draw a clear line and to differentiate between the behavior of the Qalonymides and that of the Tosafists of what he defines the Worms-Cologne school. In his opinion it was among the latter that active martyrdom was performed most often, whereas the Qalonymides did not in particular tend to kill themselves and others. He fails to mention, however, that Qalonymos ben Meshullam, according to the Chronicle of Solomon bar Samson, did kill his son after all; Ben-Ghedalia, "Rabbinic Sages of Speyer," 64.

110. Eleazar of Worms, introduction to *Sodot Hatefilah;* this text is extant only in manuscript sources; for a printed version of this particular section, see Joseph Dan, *The Esoteric Theology of Ashkenazi Hassidism* (Jerusalem: Hebrew University Magnes Press, 1968), 15–17; see also Avraham Grossman,

"The Immigration of the Qalonymos Family from Italy to Germany: Observations on the Beginnings of Medieval Jewish Settlement in Germany [in Hebrew]," *Zion* 40 (1975): 154–185; the English version follows Chazan, "*Hasidut Ashkenaz*," 201; see also Grossman, *Early Sages of Ashkenaz*, 436, on the observation that many survivors are found among the Qalonymos family.

111. Urbach, *Tosafists*, 192. Unlike the communities of Mainz and Worms, that of Speyer was better protected. Its leadership involved several members of the Qalonymos family who had left Mainz after a fire in 1084 and had settled in Speyer, where they received a privilege from Bishop Rüdiger; for details, see *Germania Judaica*, vol. 1: *Von den ältesten Zeiten bis 1238*, ed. I. Elbogen, A. Freiman, and H. Tykocinsky (Tübingen: Mohr Siebeck, 1963), 330; and more recently Werner Transier, "Speyer: The Jewish Community in the Middle Ages," in *The Jews of Europe in the Middle Ages (Tenth to Fifteenth Centuries): Proceedings of the International Symposium Held in Speyer, 20–25 October 2002*, ed. Christoph Cluse (Turnhout: Brepols, 2004), 435–447.

112. Shepkaru, *Jewish Martyrs*, 230; see also Roland Goetschel, "Le martyre juif à l'époque de la première croisade et chez le Pietistes juifs d'Allemagne," in *Sainteté et martyre dans les religions du livre (Problemes d'histoire du Christianism* 19), ed. Jacques Marx (Brussels: Université de Bruxelles, 1989), 128; Gross, *Spirituality and Law*, 37–49; Peter Schäfer, "Jews and Christians in the High Middle Ages: The *Book of the Pious*," in Cluse, *The Jews of Europe*, 29–42.

113. For some details, see Jeremy Cohen, "Between Martyrdom and Apostasy: Doubt and Self-Definition in Twelfth-Century Ashkenaz," *Journal of Medieval and Early Modern Studies* 29/3 (1999): 454.

114. *Sefer Hasidim*, par. 1862, ed. Wistinetzki and Freimann; the English translation follows Chazan, *European Jewry*, 143–144, and Shepkaru, *Jewish Martyrs*, 232.

115. This is reported in two of the Chronicles, the Mainz Anonymous, and Solomon bar Samson, *Hebräische Berichte*, 351.

116. Shepkaru, *Jewish Martyrs*, 232; and Ben-Ghedalia, "Rabbinic Sages of Speyer," 70.

117. *Sefer Hasidim*, par. 1365, ed. Wistinetzki and Freimann. This story was discussed by Matania Ben-Ghedalia, "Martyrdom in the Doctrines of Rabbi Judah he-Hasid and His Circle: A Reconsideration," paper delivered at the Fifteenth World Congress of Jewish Studies, August 65, 2009; Ben-Ghedalia suggests that it is the difference in halakhic attitudes of the Pietists and the Tosafists that accounts for their divergent positions with regard to (active) martyrdom, and that it was their halakhic point of view that led them to promote passive martyrdom, rather than active self-affliction, Ben-Ghedalia, "Rabbinic Sages of Speyer," 66–67.

118. *Gezerot*, 161–167.

119. Ibid., 168–170; Davidson, *Thesaurus*, vol. 2, 83; *Ma'aravot yotsrot zulatot uselihot im hapesukim uminhagim dekehilat kodesh Wermaiza* (Frankfurt/Main: n.p., 1714). Part of this text is printed in *Minhagot Wermaiza: Min-*

hagim wehanhagot sheasaf wehiber Rabbi Yuda Liva Kirchheim, ed. Israel M. Peles (Jerusalem: Mekhon Yerushalayim, 1987), 335–352, and quoted here from this edition, for the mention of Eleazar's Erfurt eulogy, see 336.

120. Self-afflictions are mentioned in a poem by Solomon ben Abraham, *Gezerot,* 171; and in the *Memorbuch* of Erfurt, in *Das Martyrologium des Nürnberger Memorbuches,* ed. Siegmund Salfeld (Berlin: Verlag Leonhard Simion, 1898), 12. Recently Rainer Barzen examined the manuscript sources for the *Memorbücher* and revealed some regrettable inaccuracies in Salfeld's edition with regard to spelling, formulaic openings of the different sections, and others; see Rainer Barzen, "Regionalorganisation jüdischer Gemeinden im Reich in der ersten Hälfte des 14. Jahrhunderts," in Haverkamp, *Geschichte der Juden im Mittelalter von der Nordsee bis zu den Südalpen,* 295–297.

121. For discussions of Eleazar's careful wording, see Shepkaru, *Jewish Martyrs,* 244–245.

122. *Perush Haroqeah al Hatorah,* Gen. 22 (New York: Yoel Klugmann, 1986); on the attribution of this text, doubting Eleazar of Worms's authorship, see Joseph Dan, "The *Commentary on the Torah* by Eleazar ben Judah of Worms [in Hebrew]," *Kiryat Sefer* 59/2–3 (1984): 644–645.

123. For the *piyyut,* see Davidson, *Thesauarus,* vol. 1, no. 2101. The same title was also chosen, as wc have seen, for an *aqedah* by Meir ben Isaac, the famous eleventh-century prayer-leader of Worms. As noted, this poem was among those that, according to Shepkaru, prepared the way for turning the Binding of Isaac into a paradigm of active martyrdom, Shepkaru, *Jewish Martyrs,* 167–168; for Abraham ben Azriel's commentary, see *Arugat Habosem,* vol. 3, 325–328.

124. *Arugat Habosem,* vol. 3, 288–289, and Urbach's remarks in the introduction vol. 4, 181–182.

125. Vol. 2, 120r; Davidson, *Thesaurus,* vol. 1, no. 4626; Goldschmidt, *Mahzor Layamim Hanora'im,* vol. 2: *Yom Kippur,* 538.

126. *Arugat Habosem,* vol. 3, 337–339.

127. Judah L. Weinberger, "A New Lament for the Blois Martyrs by Abraham ben Samuel of Speyer," *Proceedings of the American Academy for Jewish Research* 44 (1977): 39–47.

128. See, e.g., Goldin, *Ways of Jewish Martyrdom,* 231.

129. Soloveitchik, "Religious Law and Change," 210, n. 8.

130. *Hebräische Berichte,* 331. This report appears in both the Chronicle of Eliezer of Mainz and that of Salomon bar Samson, and the texts mention that the victims awaited the enemy in the court while wrapped in fringed *talitot.* It is possible that they wrapped themselves, because they were awaiting their death, as some sort of ritualized sacrifice. If the attitude of these victims was one of passive martyrdom, their use of the *talit* as ritual object, instead of as a mere reminder of the precepts, is thus not surprising.

131. Malkiel, *Reconstructing Ashkenaz,* 99–102, and his earlier discussion "Vestiges of Conflict in the Hebrew Crusade Chronicles," *Journal of Jewish Studies* 52 (2001): 327–328; see also Abraham Gross, *Struggling with Tradition: Reservations about Active Martyrdom in the Middle Ages* (Leiden: E. J. Brill, 2004), 14.

132. *Sefer Tosafot Hashalem* 1:262, ed. Yaakov Gellis (Jerusalem: Mekhon Harry Fishel, 1982). The text is quoted in English in Gross, *Struggling with Tradition*, 29, based on *Rabotenu Ba'ale Hatosfot al Hamisha Humshe Torah* (Warsaw: n.p., 1877, 30); and Israel J. Yuval, *Two Nations in Your Womb: Perceptions of Jews and Christians in Late Antiquity and the Middle Ages* (Berkeley: University of California Press, 2006), 159.

133. As suggested by Yuval, *Two Nations*, 159; and Gross, *Struggling with Tradition*, 29. See, however, Goldin, *Ways of Jewish Martyrdom*, 231; and Soloveitchik, "Halakhah, Hermeneutics, and Martyrdom," 102, who believe that these were rare exceptions.

134. *Hisquni—Perushe Hatorah Lerabbenu Hizqia bar Manoah* Genesis 9:5, ed. Haim D. Chavel (Jerusalem: Mosad Harav Kook, 1981); Goldin, *Ways of Jewish Martyrdom*, 232.

135. Commentary to Ecclesiastes 7:15; Sara Japhet and Robert Salters, *Perush Rabbi Shmuel ben Meir Lekohelet* (Jerusalem: Hebrew University Magnes Press, 1985); Goldin, *Ways of Jewish Martyrdom*, 232.

136. See, e.g., Gross, *Struggling with Tradition*, 42–44; such emotionally grounded reservations, Gross argues, were not necessarily typical for outstanding rabbis or juridical authorities but they did exist within Jewish society. Similarly, Malkiel addresses the question of despair and fear of death that the persecuted Jews of Mainz, for instance, must have felt when facing death. Grounded on the fact "that all human beings fear death," he also considers the effect of social pressure within a group of Jews who must have known each other fairly well, in a situation of mortal danger, Malkiel, *Reconstructing Ashkenaz*, 103–104.

137. *Yam shel Shlomo*, vol. 3: *Babba Kamah* 8:59 (Jerusalem: Mekhon Even Israel, 1996). Unfortunately, none of Solomon Luria's references can be verified. One of them, a reference to Isaac of Dampierre from the twelfth century, is, according to Soloveitchik, erroneous, as the latter's uncle Rabbenu Tam is known to have approved of active martyrdom. Even though, as we have seen, the attribution of this position is not ascertained, this led Soloveitchik to the somewhat arbitrary assumption that Isaac himself must have approved of it as well, "Religious Law and Change," 210–211, n. 8.

138. See, e.g., an anonymous commentary from the thirteenth or the fourteenth century, now in Moscow, Russian State Library, Ms. Guenzburg 615, fol. 108r; Hamburg, Staats- und Universitätsbibliothek, cod. hebr. 17/2, fol. 160v–161r. This commentary was mentioned above in the context of the initiation ritual, chap. 4, as one of the sources that describe the ritual. The manuscript is dated 1318.

139. See, e.g., the way Ephraim of Bonn describes the Würzburg massacres of 1147; Shepkaru, *Jewish Martyrs*, 218–222.

140. For Eleazar of Worms's description of the Erfurt persecution, see *Gezerot*, 161–167; *Memorbuch*, 12–13; Shepkaru, *Jewish Martyrs*, 244–245.

141. Meir ben Barukh of Rothenburg, *Teshuvot, Pesaqim, Uminhagim*, ed. Yitzhak Z. Cahana (Jerusalem: Mosad Harav Kook, 1957–1962); vol. 2, 54; Yuval, *Two Nations*, 186, n. 109.

142. Shepkaru, *Jewish Martyrs,* 255.
143. This wave of persecutions has received significantly less attention in histori-
cal research than the 1096 events; for a detailed discussion, see Friedrich
Lotter, "Die Judenverfolgung des 'König Rintfleisch' in Franken um 1298:
Die endgültige Wende in den christlich-jüdischen Beziehungen im Deutschen
Reich des Mittelalters," *Zeitschrift für historische Forschung* 15/4 (1988):
385–422. For a discussion of Christian accounts of the host desecration libel,
see Miri Rubin, *Gentile Tales: The Narrative Assault on Late Medieval Jews*
(New Haven: Yale University Press, 1999), 48–57.
144. The painting disappeared from the walls of the church about twenty years
ago. During the 1980s it was photographed by Dr. Joachim Hahn, who put
the images on the Internet, http://www.alemannia-judaica.de/roettingen_
juedische_geschichte.htm. See also *Jüdisches Leben in Bad Kissingen,* ex-
hibit catalog, ed. Hans-Jürgen Beck and Rudolf Walter (Bad Kissingen:
Rötter Druck und Verlag, 1990), 14; and the website of the municipality
of Röttingen, http://www.tauberperle.de/historie/histor02.html. My letter
with a query to the former parish priest of Röttingen, Michael Etzel, re-
ceived the following reply: "Zum Verbleib des Bildes kann ich nur so viel
sagen, dass es vor Jahren auf Betreiben verschiedener Seiten aus der
Pfarrkirche in Röttingen entfernt wurde und an einen sicheren Platz ge-
bracht wurde, wo es nicht mehr einsehbar ist . . . Ich kann nicht nachvoll-
ziehen, warum man vor Jahren die Entfernung des Bildes erzwungen hat
und jetzt wieder vermehrt nach dem Bild fragt, angeblich zu Forschungsz-
wecken. Meines Erachtens wäre es ein Stück Fairness, wenn die ganze Sache
endlich zur Ruhe käme," letter of November 8, 2005. In late 2011, Dr. Hahn
discovered that the painting is now kept in the depot of the Diocese of
Würzburg. I am indebted to Dr. Hahn for various attempts to obtain further
information.
145. Lotter, "'König Rintfleisch,'" 395–396, referring to Rudolph of Schlett-
stadt, *Historiae memorabiles,* ed. E. Kleinschmidt (Cologne: Böhlau Verlag,
1974), 58–62; for more background on the *Historiae,* see Friedrich Lotter,
"Das Judenbild im volkstümlichen Erzählgut um 1300: Die 'Historiae
memorabiles' des Rudolf von Schlettstadt," in *Herrschft, Kirche, Kultur:
Beiträge zur Geschichte des Mittelalters—für Friedrich Prinz zum 65. Ge-
burtstag,* ed. Georg Jenal and Stephanie Haarländer (Stuttgart: Hiersemann,
1993), 431–445; Miri Rubin, "Rudolph of Schlettstadt, O.P.: Reporter of
Violence, Writer on Jews," in *Christ among the Medieval Dominicans,* ed.
Kent Emery and Joseph Wawrykow (Notre Dame, IN: University of Notre
Dame Press, 1998), 283–292; Rubin, *Gentile Tales,* 51–54; on the massa-
cre, see also *Germania Judaica,* vol. 2: *Von 1238 bis zur Mitte des 14.
Jahrhunderts,* ed. Zvi Avneri (Tübingen: Mohr Siebeck, 1968), 719; *Memor-
buch,* 29.
146. *Memorbuch,* 67; *Germania Judaica,* vol. 2, 867; Friedrich Lotter, "Hostien-
frevelvorwurf und Blutwunderfälschung bei den Judenverfolgungen von
1298 ('Rintfleisch') und 1336–1338 ('Armleder')," in *Fälschungen im Mit-
telalter: Internationaler Kongress der Monumenta Germaniae Historica,*

München, September 1986, pt. 5 (Hannover: Hahnsche Buchhandlung, 1988), 556, n. 57, n. 88, listing the sources; Lotter, "'König Rintfleisch,'" 402.

147. These burnings are documented in *Memorbuch*, 49, 50, 54–55, 67; see also *Germania Judaica*, vol. 2, 49 n, 1, 56, 268, 480, 588, 815–816 n. 10.

148. *Memorbuch*, 29, 30, 37; the *Memorbuch* mentions Eichstätt only as a place where Jews were killed without specific details, but burnings in Eichstätt were mentioned in Christian sources, see *Germania Judaica*, vol. 2, 192, n. 4; on other locations in Middle Franconia, see ibid., 356, 582–583, 909.

149. Lotter, "'König Rintfleisch,'" 411, n. 92, referring to a Christian source in the *Annales Osterhovenses*, in *Monumenta Germaniae Historica, Scriptores*, vol. 17, 552, http://bsbdmgh.bsb.lrz-muenchen.de/dmgh_new; *Memorbuch*, 32–36; *Germania Judaica*, vol. 2, 598, n. 2, with references to Christian and Jewish sources, especially the *piyyutim* composed to commemorate the victims.

150. Lotter, "'König Rintfleisch,'" 407, n. 71; *Memorbuch*, 39–43; *Germania Judaica*, vol. 2, 707.

151. Lotter, "'König Rintfleisch,'" 409, referring to Rudolf von Schlettstatt, *Historiae memorabiles*, 58–62.

152. *Memorbuch*, 37; *Germania Judaica*, vol. 2, 372, 593, 731; Rubin, *Gentile Tales*, 53, refers to Rudolph of Schlettstadt's account of the burning of the Jews of Möckmühl.

153. Lotter, "Hostienfrevelvorwurf," 558–559; Shepkaru, *Jewish Martyrs*, 256–259.

154. Gross, *Struggling with Tradition*, 22–23.

155. Shepkaru, *Jewish Martyrs*, 257.

156. *Sefer Tashbets*, par. 415 (Lemberg: n.p., 1858); the translation follows Shepkaru, *Jewish Martyrs*, 258, which is based on the version in *Teshuvot, Pesaqim Uminhagim*, vol. 2, par. 59; see also Michael Fishbane, *The Kiss of God: Spiritual and Mystical Death in Judaism* (Seattle: University of Washington Press, 1994), 52–60, discussing the influence of Meir's dictum on later rabbinic authorities.

157. Urbach, *Tosafists*, 521.

158. Eric Zimmer, "The Persecutions of 1096 as Reflected in Medieval and Modern *Minhagim* Books [in Hebrew]," in Assis et al., *Jews Facing the Cross*, 157–170.

159. *Gezerot*, 161–167; *Memorbuch*, 4, 20; *Germania Judaica*, vol. 1, 99, and vol. 2, 534.

160. *Germania Judaica*, vol. 2, 161, n. 2, with reference to Christian sources.

161. Numerous judges enthroned in similar poses appear, e.g., in the Heidelberg copy of the Sachsenspiegel, Heidelberg, Universitätsbibliothek, cpg 164, http://diglit.ub.uni-heidelberg.de/diglit/cpg164.

162. The victims are listed in *Memorbuch*, 49–50; for further sources, see Lotter, "'König Rintfleisch,'" 412.

163. As reported in Rudolf of Schlettstadt's chronicle, *Historiae memorabiles*, 47; Lotter, "Hostienfrevelvorwurf," 557, n. 91; Lotter, "'König Rintfleisch,'" 408.

164. *Historiae memorabiles,* 49; Lotter, "'König Rintfleisch,'" 396. On the Paris incident, see Rubin, *Gentile Tales,* 40–47.

165. The *Memorbücher* mention several proselyte martyrs in Augsburg (or, perhaps, Würzburg, 1264), and in Weissenburg, Alsace (1270), whose stories were also modeled after Abraham. Described as former monks who gave up idolatry and broke their idols, their fate could easily be compared to that of Abraham; see *Memorbuch,* 8, 22, 150; *Germania Judaica,* vol. 2, 874. The Augsburg victim was commemorated in liturgical poems, Davidson, *Thesaurus,* vol. 1, no. 3263, and vol. 3, 86, no. 604; they were both published in *Gezerot,* 186–190.

166. See, e.g., in the commentary in the margins of the third volume of the Tripartite Mahzor from. c. 1322, Oxford, Bodleian Library, MS Mich. 619, fol. 68v; and Oxford, Bodleian Library, MS Opp 172, fols. 24v–25r. I am indebted to Elisheva Baumgarten for pointing out these sources to me.

167. *Pirke de Rabbi Eliezer,* chap. 24, 174–175, stresses Nimrod's qualities as a "mighty hero" and "a mighty hunter"; see *Targum Onqelos* Genesis 10:9; for an English version, see *Targum Onqelos to Genesis,* ed. and trans. Bernard Grossfeld (Wilmington, DE: Michael Glazier Books, 1988). Rashi refers to him time and again as a hunter, Rashi on Genesis 10:9; Leviticus 26:14; for an English text of Rashi's Bible commentary, see Morris Rosenbaum and Abraham M. Silbermann, *Pentateuch with Targum Onkelos, Haphtarot and Rashi's Commentary* (Jerusalem: Silbermann, 1973); the *Babylonian Talmud Eruvin* 53a mentions that the name Nimrod is rooted in the word *marad*— "to be rebellious"; *Midrash Bereshit Rabbah* 42:4 and 44:2, characterizes him as a liar.

168. *Ma'ase Avraham Avinu,* 1b.

169. Ibid., 2b.

170. For the sources and their discussion, see Robert Chazan, "The Blois Incident of 1171: A Study in Jewish Intercommunal Organization," *Proceedings of the American Academy of Jewish Research* (1968): 13–31; for more recent discussions, especially of the poetical laments, see Susan Einbinder, *Beautiful Death: Jewish Poetry and Martyrdom in Medieval France* (Princeton: Princeton University Press, 2002), chap. 2; to the list of laments, Judah L. Weinberger adds another one by Abraham ben Samuel, Judah the Pious's older brother, "A New Lament"; its wording recalls in many respects that of the laments of Ephraim and Hillel.

171. This recalls one of the stories in the 1096 Chronicles: Isaac ben David of Mainz, who, after having been baptized, sought penance and took his children to the synagogue, slaughtered them in front of the Torah shrine, and burned their bodies and himself together with the synagogue. The Chronicles report his story as an act of burnt offering and self-sacrifice, the destroyed synagogue being equated to the destroyed Temple; *Hebräische Berichte,* 347; for a thorough analysis of the accounts, see Yuval, *Two Nations,* 145–150; Malkiel, "Vestiges of Conflict," 340, stressing the inner conflict reflected in the story; see also Joseph (Jeffrey) Woolf, "The Synagogue in Ashkenaz: Image and Halakhah [in Hebrew]," *Kenishta* 2 (2003): 9–30, showing that in

Ashkenaz and France the synagogue was equated with the Temple; this is not a new notion, but, as Woolf demonstrates, it receives extra stress in these realms. In this context, Woolf also discusses the sacrificial character of the slaughter of 1096.

172. Julius Aronius, *Regesten zur Geschichte der Juden im fränkischen und deutschen Reich bis zum Jahre 1273* (Berlin: Verlag Leonhard Simion, 1902), no. 529.

173. As Susan Einbinder demonstrates, in some of the accounts about Jews being burned, the bodies of some of the martyrs are described as incombustible. Einbinder sees here an attempt to "elevate the scholar-rabbi to the post of ideal martyr," Einbinder, *Beautiful Death*, chap. 2, esp. 50–59.

174. Yuval, *Two Nations*, 150–160. For further comments on the significance of fire, see Shepkaru, *Jewish Martyrs*, 256–258.

175. Examples are found in Darmstadt, Universitäts- und Landesbibliothek Cod. Or. 13, fol. 202v; Sed-Rajna, *Le mahzor enluminé*, fig. 46; the Tripartite Mahzor, Oxford, Bodleian Library, MS Mich. 619, fol. 5v, showing only the ram caught in a tree; Sed-Rajna, *Le mahzor enluminé*, fig. 42; the Laud Mahzor, Oxford, Bodleian Library, MS Laud Or. 321, fol. 184r; Sed-Rajna, *Le mahzor enluminé*, fig. 44; Oxford, Bodleian Library, MS Reggio 1, fol. 159v.

176. Both Sed-Rajna, *Le mahzor enluminé*, 16, and Joseph Gutmann, "The Sacrifice of Isaac in Medieval Jewish Art," *Artibus et Historiae* 16 (1987): 67–89, suggested that this second artist was a Christian. The sword in Abraham's hand seems, indeed, to support that assumption.

6. Sod

1. For some details, see Ephraim Urbach, *Sefer Arugat Habosem*, vol. 4, introduction [in Hebrew] (Jerusalem: Meqitese Nirdamim, 1963), 72–73; and more recently, Talya Fishman, "Rhineland Pietist Approaches to Prayer and the Textualization of Rabbinic Culture in Medieval Northern Europe," *Jewish Studies Quarterly* 11 (2004): 328–329.

2. See the discussion by Ephraim Kanarfogel, *Peering through the Lattices: Mystical, Magical, and Pietistic Dimensions in the Tosafist Period* (Detroit: Wayne State University Press, 2000), 25, with references to further scholarship.

3. Israel Davidson, *Thesaurus of Medieval Hebrew Poetry* [in Hebrew] (New York: Jewish Theological Seminiary, 1955), vol. 1, no. 8891.

4. *Mishnah Yadayim* 3:5; for an English version of the Babylonian Talmud, see *The Babylonian Talmud*, ed. Isidore Epstein (London: Soncino Press, 1952); Arthur Green, "The Song of Songs in Early Jewish Mysticism," *ORIM: A Jewish Journal at Yale* 2/2 (1987): 50–53; for a discussion of rabbinic interpretations of the Song of Songs, see Gerson D. Cohen, "The Song of Songs and the Jewish Religious Mentality," in *Samuel Friedland Lectures, 1960–1966* (New York: Jewish Theological Seminary, 1966), 1–22; Michael Fishbane, *The Kiss of God: Spiritual and Mystical Death in Judaism* (Seattle: University of Washington Press, 1994), chap. 1; Arthur Green, *Keter: The*

Crown of God in Early Jewish Mysticism (Princeton: Princeton University Press, 1997), chap. 9.

5. For the allegorical interpretation of the Song of Songs, see, e.g., Ivan G. Marcus, "The Song of Songs in German Hasidism and the School of Rashi: A Preliminary Comparison," in *The Frank Talmage Memorial Volume*, ed. Barry D. Walfish (Waltham: Brandeis University Press, 1993), vol. 1, 181–189; Sara Japhet, "The Literal Meaning of the Song of Songs: On Rashi and His Followers as Interpreters of the Literal Meaning," in Sara Japhet, *Collected Studies in Biblical Exegesis* [in Hebrew] (Jerusalem: Hebrew University Magnes Press, 2008), 135–156; on allegorical interpretations vs. literal explanations of the Song of Songs, see Japhet, "Description of the Body and Images of Beauty [in Hebrew]," in *Papers on the Interpretations of the Bible and the Quran in the Middle Ages Presented to Haggai Ben-Shammai*, ed. Meir Bar Asher, Simon Hopkins, Sarah Stroumsa, and Bruno Chiesa (Jerusalem: Mekhon Ben Zvi, 2007), 133–162, repr. in Japhet, *Collected Studies*, 54–84; for a list of medieval commentaries on the Song of Songs, see Barry D. Walfish, "Annotated Bibliography of Jewish Commentaries to the Song of Songs [in Hebrew]," in *The Bible in the Light of Its Commentators: Collective Volume in Memory of Sara Kamin*, ed. Sara Japhet (Jerusalem: Mosad Bialik, 1994), 518–571; Ephraim E. Urbach, "Homilies of the Sages, Origen's Interpretation of the Song of Songs, and the Jewish-Christian Debate [in Hebrew]," *Tarbiz* 30 (1971): 148–170, repr. in Ephraim E. Urbach, *From the World of Sages: A Collection of Studies* (Jerusalem: Hebrew University Magnes Press, 2002), 514–536; see also Moshe Halbertal and Avishai Margalit, *Idolatry* (Cambridge, MA: Harvard University Press, 1992), 92.

6. Sarit Shalev-Eyni, "The Tripartite Mahzor [in Hebrew]" (PhD diss., Hebrew Unversity of Jerusalem, 2001), 117, referring to the commentaries that appear in the margins of the Tripartite Mahzor, Budapest, Library of the Hungarian Academy of Sciences, Kaufmann collection, MS A 384, fol. 104v; the Nuremberg Mahzor, London, private collection of David and Jemimah Jeselsohn, 68v, http://jnul.huji.ac.il/dl/mss%2Dpr/mahzor%2Dnuremberg/; and another commentary, Budapest, Library of the Hungarian Academy of Sciences, Kaufmann collection, MS A 400, fol. 96r. See also the recent, more detailed discussion of the commentaries by Sara Offenberg, "Expressions of Meeting the Challenges of the Christian Milieu in Medieval Jewish Art and Literature [in Hebrew]" (PhD diss., Ben-Gurion University of the Negev, 2008), 59–61.

7. Examples are the Worms Mahzor, Jerusalem, National Library of Israel, Ms. heb. 4° 781/1, fol. 72v; http://www.jnul.huji.ac.il/dl/mss/worms/about_eng .html, with references to the literature; the Laud Mahzor, Oxford, Bodleian Library, MS Laud 321, fol. 61v, Gabrielle Sed-Rajna, *Le mahzor enluminé: Les voies de formation d'un programme iconographique* (Leiden: E. J. Brill, 1983), fig. 13; Darmstadt, Hessische Landes- und Hochschulbibliothek, cod. Or. 13, fol. 65v, Sed-Rajna, *Le mahzor enluminé*, fig. 14; Hamburg, Staats- und Universitätsbibliothek, cod. Levi 37, fol. 169v.

8. For earlier discussions of the couple imagery as a visual allegory of divine love, see Sarit Shalev-Eyni, "Iconography of Love: Illustrations of Bride and Bridegroom in Ashkenazi Prayerbooks of the Thirteenth and Fourteenth Century," *Studies in Iconography* 26 (2005): 27–57; Shalev-Eyni, "Come with Me from Lebanon, My Bride [in Hebrew]," *Rimonim* 6–7 (1999): 6–20; Ruth Bartal, "Medieval Images of 'Sacred Love': Jewish and Christian Perceptions," *Assaph* 2 (1996): 93–110.

9. Shalev-Eyni, "Iconography of Love," 28; on the wedding diadem, see Naomi Feuchtwanger, "The Coronation of the Virgin and of the Bride," *Jewish Art* 12–13 (1986–1987): 213–224.

10. This was stressed by Shalev-Eyni, who discusses the representation of the groom as a Jewish man, enabling the artist to adhere to the literal meaning and to "avoid the visual depiction of God's image, as it was presented in the Christian model of the couple in the form of the cruciform-haloed Christ," Shalev-Eyni, "Iconography of Love," 40; see also Irmi Dubrau, "Iconographic Images of Lovers in Illuminated Ashkenazi Mahzorim: Toward an Interpretive Reading of Medieval German Esotericism," *Kabbalah* 24 (2011): 214–215.

11. For a recent discussion, see Elisheva Revel-Neher, "Seeing the Voice: Configuring the Non-Figurable in Medieval Jewish Art," *Ars Judaica* 2 (2006): 7–24. Recently, however, Evelyn M. Cohen described an Italian manuscript from 1432 that surprisingly includes several fully anthropomorphic depictions of God, "Illustrating the Bible in Fifteenth-Century Italy: Scenes from a Hebrew Manuscript," *Materia Giudaica* 13/1–2 (2008): 153–157; currently not enough is known to come to terms with this discovery and the background of these very unusual images.

12. Bezalel Narkiss, "The Illumination of the Worms Mahzor: Description and Iconographical Study," in *The Worms Mahzor, Jewish National and University Library, MS heb. 4⁰781/1. Introductory Volume*, ed. Malachi Beit-Arié (Vaduz: Cyelar, 1985), 64, for a digital version, see http://www.jnul.huji.ac.il/dl/mss/worms/pdf/3eng.pdf.

13. *Babylonian Talmud, Berakhot* 6a.

14. Yair Lorberbaum, *Image of God: Halakhah and Aggadah* [in Hebrew] (Tel Aviv: Schocken, 2004), 30.

15. For more on this, see ibid., 56.

16. *Moreh Hanevuhim*, pt. 1, chap. 46, trans. and ed. Michael Schwarz (Tel Aviv: Tel Aviv University Press, 2002); for an English version, see Maimonides, *Guide for the Perplexed*, trans. Shlomo Pines (Chicago: University of Chicago Press, 1963).

17. These traditions are often based on the anthropomorphic descriptions in the Song of Songs; for more background, see, e.g., Rachel Elior's introduction [in Hebrew] to her edition of *Hekhalot Zutrati, Mekhqare Yerushalayim Bemahshevet Israel*, suppl. vol. 1 (1982); Elior, "The Uniqueness of the Religious Phenomenon in Hekhalot Literature: The Figure of God and the Limits of Its Perception [in Hebrew]," in *Early Jewish Mysticism*, ed. Joseph Dan, *Jerusalem Studies in Jewish Thought* 1–2 (1987): 13–64, with references to earlier literature. For general background on Heikhalot literature and its

modern study, see Ra'anan Boustan, "The Study of Hekhalot Literature: Between Mystical Experience and Textual Artifacts," *Currents in Biblical Research* 6/1 (2007): 130–160. Earlier scholarship has dated the beginning of Hekhalot literature to the second century; recent scholarship, however, tends to postdate it to the sixth or seventh, see Boustan, ibid.

18. Lorberbaum, *Image of God;* see, earlier, David Stern, "*Imitatio Hominis:* Anthropomorphism and the Character(s) of God in Rabbinic Literature," *Prooftexts* 12 (1992): 151–174; Moshe Halbertal, "Would It Not Be Written in the Bible [in Hebrew]," *Tarbiz* 68/1 (1999): 39–59; Alon Goshen-Goldstein, "The Body as Image of God in Rabbinic Literature," *Harvard Theological Review* 87/2 (1994): 171–195, who goes as far as to claim that there is no other than an anthropomorphic position to be found in tannaitic literature; Lorberbaum disagrees with this latter view and argues that reservations concerning anthropomorphism can be found in early rabbinic sources, *Image of God,* 27. For a full survey of past research on this matter, see ibid., chap. 1.

19. For more details, see Moshe Halbertal, "Of Pictures and Words: Visual and Verbal Representations of God," in *The Divine Image: Depicting God in Jewish and Israeli Art,* exh. cat. (Jerusalem: Israel Museum, 2006), 7–13.

20. On Maimonides referring to aggadic anthropomorphism as an expression of popular thought, see Lorberbaum, *Image of God,* 33–34.

21. Saadia Gaon wrote about this in Arabic in his *Book of Beliefs and Opinions,* an English translation of which was published by Samuel Rosenblatt (New Haven: Yale University Press, 1948); in the Middle Ages a Hebrew paraphrase of this work was known in Europe, *Sefer Ha'emunot Wehade'ot,* which was never printed in its entirety; for a manuscript, see Vatican, Biblioteca apostolica, cod. heb. 266.

22. These references are summarized in Ephraim Kanarfogel, "Varieties of Belief in Medieval Ashkenaz: The Case of Anthropomorphism," in *Rabbinic Culture and Its Critics: Jewish Authority, Dissent, and Heresy in Medieval and Early Modern Times,* ed. Daniel Frank and Matt Goldish (Detroit: Wayne State University Press, 2008), 117–119.

23. Kanarfogel, "Varieties of Belief," 137. See also, more recently, Kanarfogel, "Anthropomorphism and Rationalist Modes of Thought in Medieval Ashkenaz: The Case of R. Yosef Bekhor Shor," in *Jahrbuch des Simon-Dubnow-Instituts: Simon Dubnow Institutes Yearbook* 8 (2009) [Schwerpunkt: *Science and Philosophy in Early Modern Ashkenazic Culture: Rejection, Toleration, and Appropriation*], ed. Gad Freudenthal, 119–138.

24. On this matter see Halbertal, "Of Pictures and Words."

25. Gershom G. Scholem, *Major Trends in Jewish Mysticism* (Jerusalem: Schocken, 1941), 80–87; Elliot R. Wolfson, *Through a Speculum That Shines: Vision and Imagination in Medieval Jewish Mysticism* (Princeton: Princeton University Press, 1994), 194–195; in Moshe Idel's view this tension is particularly strong in the writings he attributes to Nehemiah ben Solomon the Prophet, who will be referred to in more detail below, Moshe Idel, "A Commentary by R. Nehemiah ben Solomon, the Prophet on the *Piyyut–'el na le'olam tu'arats'*

and Remarks on the Particulars of the Teachings of a Forgotten Ashkenazic Scholar [in Hebrew]," *Moreshet Israel* 2 (2006): 5–41.

26. Joseph Dan, *The Esoteric Theology of Ashkenazi Hasidism* [in Hebrew] (Jerusalem: Mosad Bialik, 1968), 106; on the reception of the Hebrew paraphrase of Saadia's work among the Pietists, see ibid., 22–24

27. Among the numerous examples, see *Mishnah Avot*, chap. 3.

28. On the esoteric teachings about the *kavod* among Ashkenazi Pietists, see Scholem, *Major Trends*, 107–118; Scholem, *Origins of the Kabbalah* (Princeton: Princeton University Press, 1987), 180–187; Dan, *Theology*, esp. 104–168; Dan, "The Hidden *kavod* [in Hebrew]," in *Religion and Language: Papers in General and Jewish Philosophy*, ed. Moshe Halamish and Asa Kasher (Tel Aviv: University Publications, 1982), 71–78; Asi Farber-Ginat, "The Concept of the Merkabah in Thirteenth-Century Jewish Esotericism: 'Sod Ha-'Egoz' and Its Developments [in Hebrew]" (PhD diss., Hebrew University of Jerusalem, 1986), 401–432; see also the various articles referred to in this chapter discussing specific issues.

29. *Perush Siddur Hatefilah Laroqeah*, par. 326, ed. Moshe Hershler (Jerusalem: Mekhon Hershler, 1994); Daniel Abrams, "'The Secret of All the Secrets': The Approach to the Glory and the Intention in Prayer in the Writings of Rabbi Eleazar of Worms and Its Echoes in Other Texts [in Hebrew]," *Da'at* 34 (1995): 64–65. On the human appearance of the *shekhinah* on the Throne of Glory, see also Elliot R. Wolfson, "Metatron and Shi'ur Qomah in the Writings of Haside Ashkenaz," in *Mysticism, Magic and Kabbalah in Ashkenazi Judaism*, ed. Karl Erich Grözinger and Joseph Dan (Berlin: Walter de Gruyter, 1995), 69, n. 43; Wolfson also discusses texts that identify the *shekhinah* with the Metatron and imply an angelic appearance for the *shekhinah*, ibid., 70; see also Annelies Kuyt, "The Haside Ashkenaz and Their Mystical Sources: Contnuity and Innovation," in *Jewish Studies in a New Europe: Proceedings of the Fifth Congress of Jewish Studies in Copenhagen 1994 under the Auspices of the European Association for Jewish Studies*, ed. Ulf Haxen, Hanne Trautner Kromann, and Karen Lisa Goldschmidt Salamon (Copenhagen: De Kongelige Bibliotek, 1998), 462–471.

30. These remarks follow the observations made by Abrams, "Secret," 66–67; and Elliot R. Wolfson, "Sacred Space and Mental Iconography: *Imago Templi* and Contemplation in Rhineland Jewish Pietism," in *Ki Baruch Hu: Ancient Near Eastern, Biblical and Judaic Studies in Honor of Baruch A. Levine*, ed. Robert Chazan, William W. Hallo, and Lawrence H. Schiffman (Winona Lake: Eisenbrauns, 1999), 602–605.

31. Urbach, *Arugat Habosem*, vol. 4: introduction, 74–81; see also Dan, *Theology*, chap. 1, esp. 32–34; Joseph Dan, "Rabbi Eleazar of Worms' *Sefer sha'are hasodot hayihud weha'emunah* [in Hebrew]," *Temirim* 1 (1972): 141–156; Wolfson, "Metatron," 62.

32. For the early thirteenth-century Pietists, the reflection of the Divine Glory was an imagined image, a mental visualization, and certainly nothing they expected to find physically depicted in an illuminated manuscript. Figural representations did not exist in the cultural realm of the Pietists. A

century later, when the Leipzig Mahzor was produced, figural representation was a common phenomenon among Ashkenazi Jews, and even in those circles that preserved aspects of the Qalonymide-Pietist legacy as the designer(s) of the Leipzig Mahzor, figural representation was apparently not an issue.

33. For details on the rabbinic notion of the *shekhinah*, see Peter Schäfer, *Mirror of His Beauty: Feminine Images of God from the Bible to the Early Kabbalah* (Princeton: Princeton University, 2002), chap. 4.

34. Gershom G. Scholem, *Von der mystischen Gestalt der Gottheit: Studien zu Grundbegriffen der Kabbala* (Zürich: Rhein Verlag, 1962), chap. 4, 135–192; Peter Schäfer, "Tochter, Schwester, Braut und Mutter: Bilder der Weiblichkeit Gottes in der frühen Kabbala," *Saeculum: Jahrbuch für Universalgeschichte* 49/2 (1998): 259–279; and Schäfer, *Mirror of His Beauty*; Arthur Green, "Shekhinah, the Virgin Mary, and the Song of Songs: Reflections on a Kabbalistic Symbol in Its Historical Context," *Association of Jewish Studies Reviews* 26/1 (2002): 1–52.

35. Dalia-Ruth Halperin, "The Hidden Couple: An Unexecuted Underdrawing in the Catalan Micrography Mahzor," in *Between Judaism and Christianity: Art Historical Essays in Honor of Elisheva (Elisabeth) Revel Neher*, ed. Katrin Kogman-Appel and Mati Meyer (Leiden: Brill, 2009), 358; Dubrau, "Iconographic Images of Lovers."

36. Moshe Idel, *Kabbalah and Eros* (New Haven: Yale University Press, 2005), 1–2. This applies to the esoteric-theosophical schools, whereas in ecstatic Kabbalah, represented by Abraham Abulafia, e.g., erotic imagery does not play a particular role; for more on this distinction, see ibid., 9.

37. Schäfer, *Mirror of His Beauty*, 9, see also 86–88.

38. Idel, *Kabbalah and Eros*, 125.

39. *Midrash Mishle* 22:29, ed. Baruch Vissatzky (New York: Jewish Theological Seminary, 1990), 150; Scholem, *Gestalt*, 148; Daniel Abrams, "The *Shekhinah* Praying before the Holy one blessed be he: A New Source of the Theosophic Approach among the Ashkenazic Pietists and Their Attitude to Secret Teaching [in Hebrew]," *Tarbiz* 63/4 (1994): 509; see also Schäfer, *Mirror of His Beauty*, 95.

40. See, e.g., Ephraim E. Urbach, *The Sages: Their Concepts and Beliefs* (Jerusalem: Hebrew University Magnes Press, 1979), 646–647.

41. Idel, *Kabbalah and Eros*, 26–31; Idel argues that this view can be traced back only to Gershom Scholem's later writings.

42. *Habahir* 115, ed. Daniel Abrams (Los Angeles: Cherub Press, 1994); Schäfer, *Mirror of His Beauty*, 123. The *Sefer Habahir* refers to the potencies not as *sefirot*, but as *ma'amarot*—utterances; according to the *Mishnah Avot* 5:1 the world was created by means of ten utterances.

43. *Habahir* 43; Scholem, *Gestalt*, 157; Schäfer, *Mirror of His Beauty*, 130. Quotations in English are either my own or follow Schäfer's version (which are based on Scholem's German version, *Das Buch Bahir: Ein Schriftdenkmal aus der Frühzeit der Kabbala auf Grund der kritischen Neuausgabe von Gerhard Scholem* [Berlin: n.p., 1923] with a few alterations.

44. *Shir Hashirim Rabbah* 3, 11:2, ed. Eleazar Halevi Grünhut (Jerusalem: Ktav-yad wasefer, 1995); for an English version, see *Midrash Rabbah: Song of Songs*, trans. Maurice Simon (London: Soncino Press, 1939). For a careful reading of this text, see Schäfer, *Mirror of His Beauty*, 84–85; Scholem, *Gestalt*, 158.

45. Green, "The Song of Songs."

46. Green, "Shekhinah," 15.

47. As far as they are relevant for the *Sefer Habahir*, they are discussed briefly by Schäfer, *Mirror of His Beauty*, 123–125; however, see Scholem, *Gestalt*, 158, who argues that this element of erotic love between the Godhead and the feminine *shekhinah* is not yet dominant in the *Sefer Habahir*, which, in his opinion, describes primarily the father–daughter bond.

48. Schäfer, *Mirror of His Beauty*, 124.

49. See primarily the work of Farber-Ginat, "Concept of the Merkabah," e.g., 101–123; Daniel Abrams, *The Female Body of God in Kabbalistic Literature* [in Hebrew] (Jerusalem: Hebrew University Magnes Press, 2004); Moshe Idel, *Ben: Sonship and Jewish Mysticism* (London: Continuum, 2007), chap. 4, focusing on the sexualization of the divine son.

50. See, e.g., *Habahir*, 146, about a king's children going astray and their mother feeling remorse; for a discussion, see Schäfer, *Mirror of His Beauty*, 132; Idel identifies the woman as the *kneset Israel*, on the grounds that in the later developments of this motif, the mother is explicitly mentioned as *kneset Israel*; *Kabbalah and Eros*, 138–139.

51. Schäfer, *Mirror of His Beauty*, 131.

52. *Habahir* 36, 137–138; Schäfer, *Mirror of His Beauty*, 131.

53. Green, "Shekhinah," 12–13. Green emphasizes that Ashkenazi scholarship continued the tradition of allegorical interpretation only in terms of communal aspects of divine love. In this realm, Green argues, there was no place for individual love. It appears that our image challenges this assumption.

54. For a discussion of the parable from this point of view, see Abrams, *Female Body of God*, 33–34.

55. Joseph Gikatilla, *Sha'are Orah*, chap. 1, ed. Joseph Ben Shlomo (Jerusalem: Mosad Bialik, 1981); Green, "Shekhinah," 25; Abrams, *Female Body of God*, 30–31.

56. Abrams, *Female Body of God*, 29–45; according to Abrams, as early as in the *Sefer Habahir* the *shekhinah* approaches the male Jew erotically. Green, "Shekhinah," 34–35, argues that the sexual aspects appear only in the God-head–*shekhinah* relationship.

57. Abrams, *Female Body of God*, 6, 27.

58. Schäfer, *Mirror of His Beauty*, 132.

59. Scholem, *Gestalt*, 156, 163. For the entire concept of the *shekhinah*, Scholem saw Gnostic roots, but he did not exclude some influence of the Christian notion of *Ecclesia*—the Christian community—as *corpus Christi*. On the hypostasized *kneset Israel* in rabbinic thought, see Idel, *Kabbalah and Eros*, 26–31.

60. *Shekhinah:* Schäfer, *Mirror of His Beauty,* 132; *Kneset Israel:* Idel, *Kabbalah and Eros,* 138–139.
61. *Zohar* 3:74a; for a recent English version, see *The Zohar. Pritzker Edition,* trans. Daniel C. Matt (Stanford: Stanford University Press, 2004).
62. Daniel C. Matt, "David ben Yehudah Hehasid and His *Book of Mirrors,*" *Hebrew Union College Annual* 51 (1980): 146, 162.
63. Idel, *Kabbalah and Eros,* 139, 140, 141.
64. Schäfer, *Mirror of His Beauty,* 8.
65. *Midrash Alfa Betot* 2, in *Bate Midrashot,* ed. Solomon and Abraham Wertheimer (Jerusalem: Mosad Harav Kook, 1940–1943), 424.
66. Textual sources are discussed in Elliot R. Wolfson, "The Mystical Significance of Torah Study in German Pietism," *Jewish Quarterly Review* 84/1 (1993): 43–77, esp. 61, n. 69; 63.
67. Schäfer, *Mirror of His Beauty,* 121–128.
68. Ibid., 129; this, as Schäfer points out in detail, is in contradiction to the rabbinic view that both the written and the oral Torah were transmitted on Mount Sinai. Wolfson describes this process of transition from "merely a literary expression used in a metaphorical context" to a "living symbol that names one of the divine potencies," Elliot R. Wolfson, "Female Imaging of the Torah: From Literary Metaphor to Religious Symbol," in *From Ancient Israel to Modern Judaism: Intellect in Quest of Understanding—Essays in Honor of Marvin Fox,* ed. Jacob Neusner, Ernest S. Frerichs, and Nahum M. Sarna (Atlanta: Brown Judaic Studies, 1989), 285–291.
69. Dan, *Theology,* 18, 29; Wolfson, "Torah Study," 65. This may indicate that the notion of the feminine *shekhinah* existed in Iberia prior to the composition of the *Sefer Habahir,* which would counter Schäfer's claim that it is an independent novelty of the latter, Schäfer, *Mirror of His Beauty,* 236.
70. Wolfson, "Female Imaging," 293–297.
71. *Zohar* 1:22a–22b; this section is not included in the new translation, which reflects an attempt to reconstruct an early recension of the text; I therefore rely on the earlier translation by Harry Sperling, Maurice Simon, and Paul P. Levertoff (London: Soncino Press, 1934). It is somewhat strange that it is the *right* part of the man's body that is rendered dark, whereas the left half is exposed to light. This contradicts the usual convention of the right side representing good. Changing the sides, however, would have resulted in an illogical light source in the background of the image, which would have been atypical for early fourteenth-century practice. As the couple appears, the man is seated to the woman's left, another indicator of their difference in rank. The treatment of light and shade in our image has an interesting parallel in one of the Creation mosaics in the narthex of San Marco in Venice in the rendering of the angel personifying the first day of Creation, the separation of light and darkness. As Penny Jolly argues, this is based on Augustine's view about the origin of evil. The bi-colored angel represents the struggle between the good and the fallen angels, Penny Howell Jolly, *Made in God's Image: Eve and Adam in the Genesis Mosaics at San Marco, Venice* (Berkeley: University of California Press, 1997), 16.

72. Joseph Dan, "The Language of the Mystics in Medieval Germany," in Grözinger and Dan, *Mysticism, Magic and Kabbalah*, 26.

73. On this circle, see first Yehuda Liebes, "The Angels of the Voice of the *Shofar* and Jeshua Sar Hapanim [in Hebrew]," in Dan, *Early Jewish Mysticism*, 171–195. A concise listing of these texts has been made by Moshe Idel, "Some Forlorn Writings of a Forgotten Ashkenazi Prophet: R. Nehemiah ben Shlomo ha-Navi," *Jewish Quarterly Review* 95/1 (2005): 183–196; see also Idel, "A Commentary."

74. Several scholars have argued that the *Sefer Habahir* is indebted to Ashkenazi influence. Gershom Scholem believed that bahiric materials traveled from the East via Ashkenaz to Provence, where the treatise was written—or edited—in its final form. He based this conclusion on a statement made by a Castilian Kabbalist, Isaac ben Jacob of Soria, around 1260, that the *Sefer Habahir* originated in Palestine and reached Europe via the tradition of the Ashkenazi Pietists, Scholem, *Origins of the Kabbalah*, 41; Abrams, in the commentary to his edition of the *Sefer Habahir*, chap. 1, 14–16, observes several strata, among them Ashkenazi Pietist influence on the final text, thus providing firmer evidence than does Isaac ben Jacob's account; see also Daniel Abrams and Asi Farber-Ginat, *The Merkavah Commentaries by R. Eleazar of Worms and R. Jacob ben Jacob Hakohen* (Los Angeles: Cherub Press, 2004), introduction [in Hebrew], 12.

75. Moshe Idel, "Commentaries of the Forty-Two Lettered Name by Rabbi Nehemiah ben Shlomo the Prophet and the *Sefer Hahokhmah* attributed to Rabbi Eleazar of Worms [in Hebrew]," *Kabbalah* 14 (2006): 198.

76. This was already pointed out by Scholem, *Origins of the Kabbalah*, 103.

77. Idel, "Commentary," 35, n. 189; Idel, "Rabbi Nehemiah ben Solomon the Prophet and Manuscript BL 752 [in Hebrew]," in *Lectures by New Fellows of the Israeli Academy of Sciences: Newsletter Kislev 2008*, 6–10, http://www.academy.ac.il/data/egeret/88/EgeretArticles/M_Idel.pdf.

78. Idel, "Forty-Two Lettered Name," 226.

79. On David ben Judah's text, see *The Book of Mirrors: Sefer Mar'ot ha-Zoveot by R. David Ben Yehudah he-Hasid*, ed. Daniel C. Matt (Chico, CA: Scholars Press, 1986); Matt,, "David ben Yehudah," 129–172. I am grateful to Zeev Gries for pointing these sources out to me.

80. Wolfson, "Torah Study." On the Torah and the divine names, see also Moshe Idel, "The Concept of Torah in the *Hekhalot* and Its Evolution in the Kabbalah [in Hebrew]," *Jerusalem Studies in Jewish Thought* 1 (1981): 23–49.

81. Wolfson, "Torah Study," 67, based on a text in a manuscript in the former Sassoon collection, ms. 290, fol. 585; see also Idel, "The Concept of Torah," 42, n. 53.

82. Wolfson quotes two texts by Eleazar of Worms, the *Commentary to Prayer* as it appears in Paris, Bibliothèque nationale de France, cod. hébr. 772, fol. 163v; and in the *Sefer Hashem*, London, British Library, MS Add. 27199, fol. 203v; "Torah Study," 68–69.

83. *Midrash Tanhuma, Pequde* 4 (Warsaw: n.p., 1875); the translation follows Wolfson, "Female Imaging," 279–280.

84. Wolfson, "Torah Study," 63.
85. Paris, Bibliothèque nationale de France, cod. hébr. 772, fol. 629; Wolfson, "Torah Study," 72.
86. *Drashah Lepesah*, ed. Simha Emanuel (Jerusalem: Meqitse Nirdamim, 2006), 68; on the symbolic form of the Temple, see Elisabeth Revel-Neher, *L'arche d'alliance dans l'art juif et chrétien du second au dixième siècles: Le Signe de la Rencontre* (Paris: Association des amis des études archéologiques byzantino-slaves et du christianisme oriental, 1984); Revel-Neher, *Le témoinage de l'absence: Les objets du sanctuaire a Byzance et dans l'art juif du XIe au XV siècle* (Paris: de Boccard, 1998); Katrin Kogman-Appel and Shulamit Laderman, "The Creation in the Sarajevo Haggadah and Its Hermeneutical Background," *Studies in Iconography* 25 (2004): 89–128; Katrin Kogman-Appel, "The Temple of Jerusalem and the Hebrew Millennium in a Thirteenth-Century Jewish Prayer Book," in *Jerusalem as Narrative Space*, ed. Gerhard Wolf and Annette Hofmann (Leiden: Brill, forthcoming 2011).
87. Joseph (Jeffrey) Woolf, "The Synagogue in Ashkenaz: Image and Halakhah [in Hebrew], *Kenishta* 2 (2002): 9–30.
88. *Drashah Lepesah*, 68; Zohar 2:143a–b; Green, "The Song of Songs," 60–61. In numerous allegorical commentaries on the Song of Songs (and other biblical books, as well) "Lebanon" is understood as a reference to the Temple; for a short overview on this issue from the classical Midrash to the Middle Ages, followed by a thorough analysis of the attitude of the Tosafists, see Sara Japhet, "'Lebanon' in the Transition of the *Derash* to *Peshat*: Sources, Etymology and Meaning (with special attention to the Song of Songs)," in *Emanuel: Studies in the Hebrew Bible, Septuagint and Dead Sea Scrolls in Honor of Emanuel Tov*, ed. Shalom M. Paul et al. (Leiden: Brill, 2003), 707–724; Eleazar also knew of this reading; Eleazar of Worms, *Perush Haroqeah al Hamegillot, Shir Hashirim* 4:16 (Bne Brak: Yoel Klugmann, 1985).
89. *Sefer Hahokhmah* 11, in *Perush Haroqeach al Hatorah* (Bne Brak: Yoel Klugmann, 1986), vol. 1, 25; the English version partly follows Elliot R. Wolfson, "The Image of Jacob Engraved upon the Throne: Further Reflection on the Esoteric Doctrine of the German Pietists," in *Along the Path: Studies in Kabbalistic Myth, Symbolism, and Hermeneutics*, ed. Elliot R. Wolfson (Albany: SUNY Press, 1995), 1–62, esp. 42. For the association of this text with Nehemia the Prophet, see Idel, "Forty-Two Lettered Name," 212–222.
90. Moshe Idel, "Gazing at the Head in Ashkenazic Hasidism," *Journal of Jewish Thought and Philosophy* 6 (1997): 285.
91. Haym Soloveitchik argues that although Ashkenazi Pietists frequently use midrashim in their teachings, four "basic leitmotifs" are lacking in their works. According to Soloveitchik, the Midrash appears to be "filtered by Hassidic mentality"; one of these missing leitmotifs is the notion of *kneset Israel* as a hypostasis. He observes that the term *kneset Israel* can be found only rarely in Pietist writings and concludes that the Pietists did not think in terms of the Jewish people as a nation. This goes together with a limited sense for the past and anything else that involves communal responsibility. The Pietists do refer to particular communities, or aspects of communal life,

but not to the nation as such; Soloveitchik, "The Midrash, *Sefer Hasidim* and the Changing Face of God," in *Creation and Re-Creation in Jewish Thought: Festschrift in Honor of Joseph Dan on the Occasion of His Seventieth Birthday,* ed. Rachel Elior and Peter Schäfer (Tübingen: Mohr Siebeck, 2005), 165–177. Soloveitchik's observations concern primarily the *Sefer Hasidim,* but not Eleazar of Worms's scholarship. There are yet further feminine notions associated by the Pietists with the *shekhinah;* the famous image of Jacob engraved on the Throne of Glory is occasionally feminine, see Wolfson, "The Image of Jacob," 3, 26; and the Metatron, the Prince of Countenance can also be associated with the female *shekhinah,* see Wolfson, "Metatron," 70–76.

92. Dubrau, "Iconographic Images of Lovers"; for further background on crowns and diadems, see Green, *Keter,* chaps. 10–14; Moshe Idel, *Kabbalah: New Perspectives* (New Haven: Yale University Press, 1988), 191–197. On this issue, see also Idel arguing that the image of the diadem *(atarah)* on the head of the Godhead is one of those elements that demonstrate the tension between anti-anthropomorphism and anthropomorphism in the writings of Nehemiah, "Commentary," 24–25. Dubrau's analysis does not offer any clear definition of the bridegroom or of other crucial elements of the composition.

93. *Perush Haroqeah al hamegillot,.*

94. For a critical edition of the Hebrew text, a translation into German, and a commentary, see Hanna Liss, *El'azar Ben Yehuda von Worms: Hilkhot ha-Kavod. Die Lehrsätze von der Herrlichkeit Gottes. Edition, Übersetzung, Kommentar* (Tübingen: Mohr Siebeck, 1997).

95. Urbach, *Arugat Habosem,* vol. 4, introduction, 74, observed that Eleazar's approach to anthropomorphism stands out in sharp contrast to that of other circles, such as the author of the *Commentary to the Forty-Two Lettered Name of God,* where clear signs of anthropomorphism can be found. Eleazar went so far as to openly critique other circles in this matter. It is possible, however, that by the early fourteenth century this contrast was no longer perceived by later readers. Wolfson discusses this issue, *Speculum,* 194; his remarks, however, predate Idel's attribution of some of the texts associated with Eleazar to Nehemia the Prophet and should therefore be reconsidered. Wolfson argues that despite Eleazar's "untiring efforts to rid the Divine of anthropomorphism," some anthropomorphic speculations can still be found in his texts.

96. Idel, "Manuscript BL 752," 6.

97. Idel, "Commentary," 37.

98. Ibid., 40–41.

99. See Zeev Gris, "The Early Kabbalistic Commentaries on the Song of Songs [in Hebrew]," *Mar'eh* 1 (2006): 18–24.

100. Green, "Shekhinah," 12–13. For a possible esoteric layer in rabbinic interpretations of the Song of Songs, see Shaul Lieberman, "*Mishnat Shir Hashirim,*" in Gershom G. Scholem, *Jewish Gnosticism, Merkabah Mysticism and Talmudic Tradition* (New York: Jewish Theological Seminary, 1960), appendix

D, 118–126. For a recent critique on this thesis, see Lorberbaum, *Image of God*, 56, n. 95; on the question of mystical traditions in relation to the Song of Songs, see Marc (Menachem) Hirshman, *Mikra and Midrash: A Comparison of Rabbinics and Patristics* [in Hebrew] (Tel Aviv: Hakibbutz Hame'uhad, 1992), 66–67; see also Green, "The Song of Songs," 52–53.

101. Scholem, *Gestalt*, 158; Schäfer, *Mirror of His Beauty*, 84, 131.

102. *Habahir* 117, 201–203; for the reference to Akiva, see *Mishnah Yadayim* 3:5; Schäfer, "Weiblichkeit," 263.

103. Gikatilla's commentary was never printed; it survives in Paris, Bibliothèque nationale de France, cod. heb. 790.

104. Ezra's commentary has traditionally been attributed to Nahmanides and appears under his name in Chavel's edition of Nachmanides's writings, *Kitve Rabbenu Moshe ben Nahman*, ed. Hayyim D. Chavel (Jerusalem: Mosad Harav Kook, 1982). The English version is taken from Seth Brody's translation: *Rabbi Ezra Ben Solomon of Gerona, Commentary and the Song of Songs and Other Kabbalistic Commentaries* (Kalamazoo, MI: Medieval Institute Publications, 1990), 25–27.

105. For a discussion of the theme of salvation and liberation of the Land of Israel in these commentaries, see Gries, "Commentaries." For general background on early kabbalistic commentaries, see Shifra Asulin, "The Mystical Commentary of the Song of Songs in the Zohar and Its Background [in Hebrew]" (PhD diss., Hebrew University of Jerusalem, 2006), 2–17.

106. For discussions of the sexual aspects of the female *shekhinah*, see Abrams, *Female Body of God*, chaps. 2–3; Schäfer, *Mirror of His Beauty*, 121, Green, "Shekhinah," 34–35; Green argues that the sexual aspects associated with the notion of the female *shekhinah* are all related to the bond between the Godhead (or the upper male potencies) and the *shekhinah* and do not apply to any other type of relationship.

107. Ezra of Gerona, *Commentary on the Song of Songs;* for the English version, see Brody, *Commentaries*, 39–40. For further discussion, see Haviva Pedaya, *Vision and Speech: A Study of the Jewish Mystical Experience* [in Hebrew] (Los Angeles: Cherub Press, 2002), 165–168, 198–200. Similarly, Idel discerned an interest in the union between God and human intellect in Abraham Abulafia's discussion of the Song, Idel, *Kabbalah: New Perspectives*, 206, and Asulin, "Commentary," 7–8.

108. This commentary was first published by Michael Grajwer, who attributed it to Nahmanides, *Die kabbalistischen Lehren des Moses Nachmanides in seinem Kommentare zum Pentateuch* (Breslau: T. Schatzky, 1933), 59–63; a few years later it was published from a different manuscript and in a different version by Gershom G. Scholem, "Traditions of Rabbi Jacob and Rabbi Isaac, the Sons of Rabbi Jacob Hakohen (Sources for the History of Kabbalah before the Appearance of the *Zohar*)," *Mada'e Hayahadut* 2 (1937): 227–230; in his later discussion, however, Scholem refers to the earlier publication, *Gestalt*, 166, with partial translation into German. On links to Ashkenazi thought, see Idel, *Ben*, 234; and also Wolfson, "The Image of Jacob," 14 n. 95, with further references to relevant literature.

109. *Perush Haramban al Hatorah*, ed. R. Haim D. Chavel (Jerusalem: Mekhon Harav Kook, 1969), Genesis 24:1, 132–133; for the English version, see Ramban (Nahmanides), *Commentary on the Torah*, trans. Charles B. Chavel (New York: Shilo, 1971–1976).

110. Green, "Shekhinah," 34–36; Abrams, *Female Body of God*; Asulin, "Commentary."

111. *Zohar* 2:135a; for a discussion, see Scholem, *Gestalt*, 178–191.

112. Asulin, "Commentary," 77–82.

113. Marcus, "The Song of Songs," 46; this line of interpretation was also taken up by Joseph of Shushan, a Castilian Kabbalist of the late thirteenth century, Asulin, "Commentary," 14–17.

114. Schäfer, *Mirror of His Beauty*, 149.

115. Ann Matter, *The Voice of My Beloved: The Song of Songs in Western Medieval Christianity* (Philadelphia: University of Pennsylvania Press, 1990).

116. Origen, *Commentarii in Canticum Canticorum*, in the Latin translation by Rufinus of Aquilaea (fourth century), see Wilhelm Baehrens, *Origines Werke*, vol. 8, *Die Griechischen Christlichen Schriftsteller der ersten drei Jahrhunderte* 22 (Leipzig: Teubner, 1925), prologue, 61. Origen's two texts on the Song of Songs have survived only as fragments, and most of our knowledge is based on Latin translations and Western references to them. The parallels to rabbinic views are striking, see Matter, *Song of Songs*, 27; for further literature on Origen in relation to Jewish interpretations of the Song of Songs, see ibid., 41, n. 2.

117. For exegetical traditions that focus on Mary, see Matter, *Song of Songs*, 151–167.

118. *The Golden Legend*, ed. and trans. William G. Ryan (Princeton: Princeton University Press, 1995), vol. 2, 80.

119. Matter, *Song of Songs*, 156; 58–85.

120. Philippe Verdier, *Le Couronnement de la Vierge. Les origines et les premiers développements d'un thème iconographique* (Montreal: Institut d'études médiévales,and Paris: J. Vrin 1980, 17.

121. For more background, see Matter, *Song of Songs*, 123–133.

122. Jeffrey Hamburger, *The Rothschild Canticles: Art and Mysticism in Flanders and the Rhineland, circa 1300* (New Haven: Yale University Press, 1990), 70–73.

123. New Haven, Yale University Library, Beinecke Rare Book Library, MS 404; Hamburger, *Canticles*, 84.

124. Hamburger, *Canticles*, 3.

125. Such a poem survived, e.g., in a Bavarian manuscript from 1408, Augsburg, Universitätsbibliothek, Cod. III 1. oct. 1, fols. 146v–148r; Karin Schneider, *Deutsche mittelalterliche Handschriften der Universitätsbibliothek Augsburg: Die Signaturengruppen Cod.I.3 und Cod.III.1.* (Wiesbaden: Harrassowitz, 1988), 370–371.

126. Hamburger, *Canticles*, 85, discussing yet further, later variations of this.

127. Schäfer's proposition that the feminine *shekhinah* owes its existence to Christian influence is based on, among other things, the observation that the *Sefer*

Habahir is the first source to approach the *shekhinah* in terms of a female persona, *Mirror of His Beauty,* 236; this is his main argument for rejecting Scholem's theory of Gnostic roots for the feminine *shekhinah*, Scholem, *Gestalt,* chap. 4. Abrams and Idel trace earlier hints of an understanding of the *shekhinah*; Abrams focuses on a section in the *Midrash Mishle*, a text that may be located in early medieval Palestine and in a Ashkenazi reference to that section from the twelfth century, *Female Body of God,* 26; Idel traces feminine traits in the rabbinic notion of the *shekhinah, Kabbalah and Eros,* 30–31. For a more thorough and detailed critique of Scholem's Gnosis theory, see Idel, *Kabbalah: New Perspectives,* 30–32, see also Green, "Shekhinah."

128. Idel, *Kabbalah and Eros,* 46 refers to Schäfer's and Green's suggestions as a "simple reductionist approach." For more subtle constructs of the Jewish-Christian cultural exchange, see Ivan G. Marcus, "Jews and Christians Imagining the Other in Medieval Europe," *Prooftexts* 15/3 (1995): 209–211; Marcus, *Rituals of Childhood: Jewish Acculturation in Medieval Europe* (New Haven: Yale University Press, 1996), introduction; or Israel Yuval's methodology employed in his *Two Nations in Your Womb: Perceptions of Jews and Christians in Late Antiquity and the Middle Ages* (Berkeley: University of California Press, 2006).

129. Schäfer, *Mirror of His Beauty,* 156.

130. See Hermann of Tournai, as discussed in ibid., 154.

131. As pointed out by Yehudah Liebes in his critique of Schäfer's book, "Is the Virgin to Be Equated with the *Shekhinah*? [in Hebrew]," *Pe'amim* 101–102 (2005): 303–313. Liebes does not in principle reject the possibility that the feminine *shekhinah* might also—among other possibilities—be indebted to awareness of the cult of Mary and influenced by it. But he does not accept the idea that it was predominantly the Christian cult that led to the emergence of the feminine *shekhinah*.

132. Idel, *Kabbalah and Eros,* 48.

133. Philippe Verdier, "Suger a-t-il été en France le créateur du theme iconographique du couronnement de la Vierge?" *Gesta* 15/1–2 (1976): 227.

134. For more background on the role played by the Song of Songs in Christian theology, see Matter, *Song of Songs.* The leading figure in this line of interpretation of the Song of Songs was Honorius of Autun; see Valerie I. J. Flint, "The Commentaries of Honorius Augustodunensis on the Song of Songs," in *Ideas in the Medieval West: Texts and Their Contexts* (London: Variorum, 1988), 196–211. In this spirit the Sulamite in Song of Songs 7:1 was interpreted as *Synagoga*, which in Honorius's view is directed at the hope for Jewish conversion; see Jeremy Cohen, "*Synagoga conversa*: Honorius Augustodunensis, the Song of Songs, and Christianity's 'Eschatological Jew,'" *Speculum* 79/2 (2004): 309–340. Some scholars see here a polemical dialogue between Christian and Jewish theologians, each side making its claims for a proper understanding of the Song, see Ephraim E. Urbach, "The Homiletical Interpretations of the Sages and the Expositions of Origen on Canticles, and the Jewish Christian Disputation," *Scripta hierosolymitana*

22 (1971): 247–275; Reuven Kimmelman, "Rabbi Yochanan and Origen on the Song of Songs: A Third-Century Jewish-Christian Disputation," *Harvard Theological Review* 73 (1980): 567–595; Sara Kamin demonstrated that the Jewish medieval commentaries on the Song of Songs are part of a polemical dialogue, "Rashi's Commentary to the Song of Songs and the Jewish-Christian Polemical Dialogue [in Hebrew]," *Shnaton Lamiqra Weheqer Hamizrah Haqadum* 7–8 (1983–1984): 218–248; this issue is part of a scholarly discourse on the question of whether Rashi's biblical exegesis was polemical, see the controversy between Abraham Grossman, "Rashi's Commentary to Psalms and Jewish-Christian Polemics [in Hebrew]," in *Studies in Bible and Education,* ed. Dov Rappel (Jerusalem: Touro College, 1996), 59–74, and Daniel J. Lasker, "Rashi and Maimonides on Christianity," in *Between Rashi and Maimonides: Themes in Medieval Jewish Law, Literature and Exegesis,* ed. Ephraim Kanarfogel and Moshe Sokolov (New York: Yeshiva University Press, 2010), 3–22; as to the interpretation of the Song of Songs, scholars assume that in reaction to the Christian understanding of the couple as Mary and Christ, medieval Jewish exegetes emphasized that the love motif refers to God and Israel. For a discussion of how the polemical dialogue may have affected medieval iconography of illustrations of the *piyyut,* see Offenberg, "Challenges," chap. 1, with a thorough comparison between the Jewish and Christian imageries, pinpointing the different turns Jewish iconography took to make the point; this implies, e.g., an understanding of the brooch as hinting at the yellow badge worn by Jews in France; Shalev-Eyni, "Iconography of Love," 39; although in principle my interpretation of the couple does not contradict the possibility that it was meant to address polemical issues, I am in doubt about this particular interpretation of the brooch, which was a common item in medieval realia frequently seen in medieval manuscript painting; the reading of the brooch as a means to turn the defamatory meanings of the yellow badge into a sublime symbol does not correspond with the understanding of the woman as the *shekhinah.*

135. Wolfson, *Speculum,* 3–4.

136. Ibid., 44–45.

137. *Zohar* 1:13a.

138. Whereas the older translation by Sperling and Simon uses all these terms, Matt's recent version is more consistent and uses most often "image." For different cases, see *Zohar* 1:1a ("sign" in Sperling and Simon, *Zohar;* "image" in Matt, *Zohar*); 1:2b ("likeness" in Sperling and Simon; "paradigm" in Matt); 1:6b ("image of a lion"); 1:53b ([changing] "forms" in Sperling and Simon; "transforming" in Matt).

139. Scholem, *Gestalt,* 173.

140. *Sefer Hamar'ot Hatsov'ot* 152, 8, ed. Daniel C. Matt (Chico, CA: Scholars Press, 1982); see also Matt, "David ben Yehudah," n. 242.

141. Wolfson, *Speculum,* 199, n. 43.

142. In his *Sefer Hahokhmah,* introduction, Eleazar explained that he did so for the lack of students. We know of several students who studied with Eleazar, but apparently they were not entrusted with esoteric traditions, perhaps be-

cause they did not belong to the Qalonymos clan. The still-unanswered question is why Eleazar, certainly aware that putting these teachings into writing would not preserve them as a secret tradition, still preferred to compose texts instead of transmitting these teachings to students orally, even if they were not from the Qalonymos family. For further thoughts on these matters, see Joseph Dan, "The Book of the Divine Name by Rabbi Eleazar of Worms," *Frankfurter Judaistische Beiträge* 22 (1995): 27–60.

143. Matt, "David ben Yehudah," 162.

144. For some details, see Dan, *Theology*, 254–256.

145. On the reception of Kabbalist thought, see now Boaz Huss, *Like the Radiance of the Sky: Chapters in the Reception History of the Zohar and the Construction of Its Symbolic Value* [in Hebrew] (Jerusalem: Mekhon Ben Zvi, 2008).

146. Davidson, *Thesaurus*, vol. 1, 178, no. 3853.

147. Wolfson, *Speculum*, 18–19.

148. *Orhot Hayyim, Hilkhot Avodah Zarah* 7, ed. Moshe Schlesinger (Berlin: Zvi Hirsch, 1902).

149. On late antique Jewish approaches to Ezekiel's vision, see David J. Halperin, *The Faces of the Chariot: Early Jewish Responses to Ezekiel's Vision* (Tübingen: Mohr Siebeck, 1988); for a recent summary on the links to medieval mysticism, see Abrams and Farber-Ginat, *Merkavah Commentaries*, introduction, 9–11; see also, Farber-Ginat, "Concept of the Merkabah."

150. Leon Weinberger, *Jewish Hymnography: A Literary History* (London: Littman Library of Jewish Civilization, 1998), 6. *Ofan* poems deal with the chariot throne, and they are an embellishment of the benediction of the *shema*.

151. *Targum Pseudojonathan* Genesis 28:12, *Targum Pseudo-Jonathan of the Pentateuch: Text and Concordance*, ed. Ernest G. Clarke (Hoboken: Ktav, 1984); *Genesis Rabbah* 68:12; for a discussion of the rabbinic background, see Shamma Friedmann, "Image, Likeness, and Impression [in Hebrew]," *Sidra* 22 (2007): 89–152; see also David Stern, *Parables in Midrash: Narrative and Exegesis in Rabbinic Literature* (Cambridge, MA; Harvard University Press, 1991), 110–113.

152. Discussed in detail by Rachel Neis, "Embracing Icons: The Face of Jacob on the Throne of God," *Images* 1 (2007): 36–54.

153. These traditions are discussed in detail by Wolfson, "The Image of Jacob."

154. Halperin, *Chariot*, 121; Wolfson, "The Image of Jacob," 8.

155. Wolfson, "Metatron," 81–92; Wolfson, "The Image of Jacob," 19–20.

156. Discussed in detail in Wolfson, "The Image of Jacob," 29–59.

157. *Wehayyot asher henah merubaot lakise*, Davidson, *Thesaurus*, vol. 2, p. 185, no. 189; Wolfson, "The Image of Jacob," 8. It is included in the Leipzig Mahzor, vol. 2, fol. 240r.

158. *Midrash Sekhel Tov*, ed. Samuel Buber (Jerusalem: Zikhron Aharon, 2008), 141; see also Wolfson, "The Image of Jacob," 8.

159. *Perush Sefer Yetsirah*, ed. Solomon J. Halberstam (Berlin: Itzikowski, 1895), 43; see Wolfson, "Metatron," n. 118.

160. Rashi on Ezekiel 1:5; on *Hullin* 91b; Wolfson, "The Image of Jacob," 9.

161. Davidson, *Thesaurus*, vol. 4, 417, no. 313; for the full text, *Seder Haselihot eminhag Polin werov Haqehilot Be'erets Israel*, ed. Daniel Goldschmidt (Jerusalem: Mosad Harav Kook, 1965), no. 67. I am indebted to Sara Offenberg for pointing this source out to me.

162. Alluding to Genesis 50:19, the words of Joseph.

163. *Perush Hamerkavah* Ezekiel 1:1–10.

164. Ibid., Ezekiel 1:8.

165. Ibid., Ezekiel 1:10; Eleazar ben Judah's views on the Chariot, the Throne, and Jacob's image have also been discussed in detail by Farber-Ginat, "Concept of the Merkabah," 418–432, who compares them with those of pre-zoharic Kabbalists in Iberia. She also goes into detail about the neoplatonic roots of these views.

166. Wolfson, "The Image of Jacob," 54.

167. Davidson, *Thesaurus*, vol. 2, 185, no. 189; Daniel Goldschmidt, *Mahzor layamim hanora'im lefi minhage bne Ashkenaz lekhol anfehem kolel minhag Ashkenaz (hama'aravi) minhag Polin uminhag Tsarfat leshe'avar*, vol. 1: *Rosh Hashanah* (Jerusalem: Koren, 1970), vol. 1, 217; Wolfson, "The Image of Jacob," 8.

168. Genesis Rabbah 63:9–10, *Genesis Rabbah. The Judaic Commentary to the Book of Genesis. A New American Translation*, ed. Jacob Neusner (Atlanta: Brown Judaic Studies, 1985), vol. 2, 360–361.

169. According to Nehemia the Prophet it was owing to Jacob's humility in this world that his face was engraved in the Throne, see Israel Weinstock, "*Alphabeta de Metatron* and its commentaries [in Hebrew]," *Temirin* 2 (1982): 70; for a discussion of the section and its attribution to Nehemia, see Moshe Idel, "The Anonymous Commentary to '*Alphabeta de Metatron*': Another Treatise to Be Attributed to R. Nehemia ben Solomon the Prophet," *Tarbiz* 76 (2007): 259–261.

170. Bezalel Narkiss, "Introduction to the Mahzor Lipsiae," referred to the book as reminiscent of a Christian model showing the four evangelists, in *Machsor Lipsiae. 68 Facsimile Plates of the Mediaeval Illuminated Hebrew Manuscript in the Possession of the Leipzig University Library*, ed. Elias Katz (Hanau/Main: Werner Dausien, 1964), 94; on the iconographic tradition of Jewish scholars shown with books, see Mendel Metzger, *La Haggada enluminée. Étude inconographique et stylistique des manuscrits enluminés et décorés de la Haggada du XIIIe au XVIe siècle* (Leiden: E. J. Brill, 1973), 171–178.

171. One of the sources quoted by Wolfson, "The Image of Jacob," 25–26, infers a feminine gender to the image of Jacob. Wolfson interprets this in relation to the association of Jacob with the community of Israel. If Israel is referred to in the image for the Great Sabbath, the mystical couple (fig. 7), the male figure in the current image can correspondingly be identified as male *kneset Israel*.

172. Ivan G. Marcus, "The Political Dynamics of the Medieval German-Jewish Community," in *Authority, Power and Leadership in the Jewish Polity. Cases and Issues*, ed. Daniel J. Eleazar (Lanham, New York and London: University

Press of America, 1991), 134, n. 39, quoting a manuscript in New York, Jewish Theological Seminary, MS Mic 1885, *Sefer Sodot Aher.*

173. Intriguing is the somewhat monklike appearance of the human creature. In some way he even recalls representations of Francis of Assisi. Both figures, Francis and Jacob, address simple piety. It is possible that this notion is polemicized here, but this is beyond the scope of this chapter.

174. *Perush Hamerkavah,* Ezekiel 1:19; Farber-Ginat, "Concept of the Merkabah," 421.

175. Dan, "Divine Name."

176. *The Merkavah Commentaries,* introduction.

177. Scholem, *Major Trends,* 100.

178. Wolfson, *Speculum,* 200.

179. *Sefer Yetsirah* (Jerusalem: Otiyot, 1994), chap. 1; on the addition to the *Hekhalot* text, see *Synopse zur Hekhalot-Literatur,* ed. Peter Schäfer (Tübingen: Mohr Siebeck, 1981), no. 296; this version appears in only one of the manuscripts that are listed in Schäfer's synopsis (Budapest, Hungarian Academy of Sciences, MS Kaufmann 238); the translation follows Daniel Abrams, "Special Angelic Figures: The Career of the Beasts of the Throne-World in 'Hekhalot' Literature, German Pietism, and Early Kabbalistic Literature," *Revue des études juives* 155/3–4 (1996): 368.

180. Scholem, *Major Trends,* 100.

181. Issues of intention in particular formed the core of the Pietists' mystical dealings with prayer. Research on this aspect of Pietism is extremely rich, and the literature can be cited here only selectively; see, e.g., Scholem, *Major Trends,* 100–103; Georges Vajda, *L'amour de dieu dans la théologie juive du moyen age* (Paris: J. Vrin, 1957), 154–155; Ivan G. Marcus, *Piety and Society: The Jewish Pietists of Medieval Germany* (Leiden: E. J. Brill, 1981), 117–118; Joseph Dan, "The Emergence of Mystical Prayer," in *Studies in Jewish Mysticism,* ed. Joseph Dan and Frank Talmage (Cambridge: Association for Jewish Studies, 1982), 85–120; Dan, "*Pesaq ha-Yirah veha-Emunah* and the Intention of Prayer in Ashkenazi Hasidic Esotericism," *Frankfurter Judaistische Beiträge* 19 (1991–1992): 185–215; Dan, "Prayer as Text and Prayer as Mystical Experience," in *Torah and Wisdom: Essays in Honor of Arthur Hyman,* ed. Ruth Link-Salinger (New York: Shengold, 1992), 33–47; Ivan G. Marcus, "The Devotional Ideals of Ashkenazic Pietism," in *Jewish Spirituality from the Bible through the Middle Ages,* ed. Arthur Green (New York: Crossroad, 1986), 356–366; Moshe Idel, "Intention in Prayer and the Beginning of Kabbalah: Between Ashkenaz and Provence [in Hebrew]," in *Ben Porat Yosef: Studies Presented to Rabbi Joseph Safran,* ed. Bezalel and Eliyahu Safran (Hoboken: Ktav, 1992), 5–14; Abrams, "Secret," 61–81; for a concise summary, see also Joseph Dan, *Rabbi Judah the Pious* [in Hebrew] (Jerusalem: Hebrew University Magnes Press, 2005), chap. 9.

182. Wolfson, *Speculum,* 198–199; thus in some sense the "mental image functions iconically, that is, one worships the image as if it were an iconic representation of the Deity."

183. *Sefer Hasidim,* par. 480, ed. Judah Hakohen Wistinetzky and Jakob Freimann (Frankfurt/Main: n.p., 1924), par. 1625.
184. For background on the descent to the Chariot, see Eliot Wolfson, "'*Yeridah la-merkavah*' Typology of Ecstasy and Enthronement in Ancient Jewish Mysticism," in *Mystics of the Book: Themes, Topics, and Typologies,* ed. Robert A. Herrera (New York: Peter Lang, 1993), 13–44; Annelies Kuyt, *The 'Descent' to the Chariot: Towards a Description of the Terminology, Place, Function and Nature of the Yeridah in Hekhalot Literature* (Tübingen: Mohr Siebeck, 1995). For thoughts about the descent to the Chariot and the prayer-leader going "down" to the shrine, see Itamar Gruenwald, "The Song of the Angels, the *Qedushah* and the Composition of the *Heikhalot* Literature," in *Jerusalem in the Second Temple Period: Abraham Schalit Memorial Volume,* ed. Aharon Oppenheimer et al. (Jerusalem: Yad Ben Zvi, 1980), 459–481. Zeev Weiss, "The Location of the *Sheliah Tsibbur* during Prayer," *Cathedra* 55 (1990): 8–21, on the other hand, examined the expressions "went down to the *tevah*" and "passed before the *tevah*" and argues that a change in terminology took place once platforms were built in ancient synagogues. At the same time, however, permanent shrines were also added to the synagogue furniture, and the mobile ark was no longer put on the platform, as Weiss seems to infer. That the terminology has to do with the placement of the ark was suggested by Jeffrey Hoffman, "The Ancient Torah Service in Light of the Realia of the Talmudic Era," *Conservative Judaism* 42 (1989/1990): 41–45. For the influence of *Merkavah* mysticism on Ashkenazi Pietism, see Peter Schäfer, "The Ideal of Piety of the Ashkenazi Hasidim and Its Roots in Jewish Tradition," *Jewish History* 4/2 (1990): 9–23.
185. See the wording chosen by Hamburger, *Canticles,* 7.
186. The subject matter of these images would certainly also call for links to mystic thought. However, at least in the image of the initiation rituals, there is no clear visual sign of it. But there can be no doubt that Torah study has a great deal of mystical significance, and this has been discussed by both Wolfson, "Torah Study," and Ivan G. Marcus, "Honey Cakes and Torah: A Jewish Boy Learns His Letters," in *Judaism in Practice: From the Middle Ages through the Early Modern Period,* ed. Lawrence Fine (Princeton: Princeton University Press, 2001), 115–130.
187. Émile Durkheim, *The Elementary Forms of the Religious Life* (New York: Free Press, 1965, orig. published 1915), 247.
188. Randall Collins, *Interaction: Ritual Chains* (Princeton: Princeton University Press, 2004), chap. 2.

Conclusion

1. There are numerous illuminated books for which this has been argued; for one example out of many, see William Diebold's reading of the Carolingian Bible in San Paolo fuori le mura, "The Ruler Portrait of Charles the Bald in the S. Paolo Bible," *Art Bulletin* 76/1 (1994): 6–18.

2. This becomes clear from a statement about art in the realm of the synagogue, *Sefer Hasidim*, par. 1625, ed. Judah Hakohen Wistinetzky and Jakob Freimann (Frankfurt/Main: n.p., 1924); for a discussion, see Kurt und Ursula Schubert, *Jüdische Buchkunst* (Graz: Akademische Druck- und Verlagsanstalt, 1984), 71.

3. R. Meir ben Barukh of Rothenburg, *Sefer sha'are teshuvot maharam bar barukh zal*, no. 97, ed. Moshe A. Bloch (Jerusalem: n.p., 1968), 134. For an English translation, see Vivian B. Mann (ed.), *Jewish Texts on the Visual Arts* (New York: Cambridge University Press, 2000), 110–111.

4. Oxford, Bodleian Library, MS Can. Or. 86, Adolf Neubauer, *Catalogue of the Hebrew Manuscripts in the Bodleian Library* (Oxford: Clarendon Press, 1886), no. 1103; for a discussion, see Simha Emanuel, *The Lost Halakhic Books of the Tosafists* [in Hebrew] (Jerusalem: Mosad Bialik, 1993), 125–126.

5. On the readership of the *Sefer Haroqeah*, see Ephraim E. Urbach, *The Tosafists: Their History, Writings and Methods* [in Hebrew] (Jerusalem: Mosad Bialik, 1986) (revised edition of the original 1954 version), 393.

6. *Sefer Maharil*, ed. Shlomo Y. Spitzer (Jerusalem: Mekhon Yerushalayim, 1989), *Hilkhot yom kippur* 11, e.g., for the earlier discussion of public mahzorim.

7. Warsaw, University, Wydzial Orientalistyczny, MS 258, fols. 334r–337r.

8. See, e.g., Joseph Dan, *The Esoteric Theology of Ashkenazi Hasidism* [in Hebrew] (Jerusalem: Mosad Bialik, 1968), 251.

9. Ephraim Kanarfogel, *Peering through the Lattices: Mystical, Magical, and Pietistic Dimensions in the Tosafist Period* (Detroit: Wayne State University Press, 2000), 115–124 and chap. 5.

10. Urbach, *Tosafists*, 437; Urbach, *Sefer Arugat Habosem* (Jerusalem: Meqitse Nirdamim, 1939–1963), vol. 4: Introduction, 112.

11. Avraham (Rami) Reiner, "From 'Paradise' to 'the Bonds of Life': Blessings for the Dead on Tombstones in Medieval Ashkenaz [in Hebrew]," *Zion* 76 (2011): 5–28.

12. Reiner, "'A Tombstone Inscribed': Titles Used to Describe the Deceased in Tombstones from Würzburg between 1147–1148 and 1346 [in Hebrew]," *Tarbiz* 78/1 (2009): 142–144.

13. For some more recent discussions, see Talya Fishman, "The Penitential System of Hasidei Ashkenaz and the Problem of Cultural Boundaries," *Journal of Jewish Thought and Philosophy* 8 (1999): 201; Kanarfogel, *Lattices*, 61–92; see also the work of the French scholar Solomon ben Samuel, who had studied with the Pietists in Speyer, Kanarfogel, *Lattices*, chap. 2.

14. Edward Fram, "German Pietism and Sixteenth and Early Seventeenth Century Polish Rabbinic Culture," *Jewish Quarterly Review* 96 (2006): 50–59.

15. Kanarfogel, *Lattices*, 81–92.

16. Not much is known about this poem and the precise time of its integration into the general liturgy; for some background, see Abraham Berliner, "*Shir Hayihud*: A Literary and Historical Study [in Hebrew]," in *Selected Writings*, vol. 1 (Jerusalem: Mosad Harav Kook, 1969), 147–170; Abraham Haberman,

Shirei ha-Yihud ve-haKavod (Jerusalem: Mosad Harav Kook, 1948), introduction [in Hebrew]; *The Hymn of Divine Unity with the Kabbalistic Commentary of R. Yom Tov Lipmann Muelhausen Tihingen 1560* [in Hebrew], ed. Joseph Dan (Jerusalem: Hebrew University Magnes Press, 1981).

17. *Ma'asse Nisim,* nos. 6 and 7, in Shlomo Eidelberg, *R. Juspa, Shammash of Wormaisa (Worms): Jewish Life in 17th Century Worms* (Jerusalem: Hebrew University Magnes Press, 1991), offering a Hebrew and an English translation of the Yiddish original. For a digital version of a print from 1767, see http://sammlungen.up.uni-frankfurt.de/jd/urn/urn:nbn:de:hebis:30:2–4382.

18. Ibid., no. 8; this story appears in the Hebrew section only, 71.

19. Dean Phillip Bell points at the role these stories (and in particular those about magical practices) must have played in the historical memory of the Jews of Worms and the definition of their community, "Worms and the Jews: Jews, Magic, and Community in Seventeenth-Century Worms," in *Werewolves, Witches, and Wandering Spirits: Traditional Belief and Folklore in Early Modern Europe,* ed. Kathryn A. Edwards (Kirksville, MO: Truman State University Press, 2002), 93–116.

20. On Eleazar the Preacher, see Daniel Abrams, "A Commentary to the *Sefer Yetsirah* by Rabbi Eleazar the Preacher [in Hebrew]," *Ale Sefer* 19 (2001): 69–87; on Moses the Preacher's work, see Dan, *Esoteric Theology,* 67, 251.

21. Dan, *Esoteric Theology,* 253–254.

22. Kanarfogel, *Lattices,* chap. 5. Kanarfogel's interest lies not so much in coming to terms with the reception of Pietist scholarship, but, rather, with an all-embracing portrayal of Tosafism.

23. *Sefer Tsioni,* ed. Amnon Gross, n.d. 2005. On Menahem Tsioni's debt to both Ashkenazi Pietism and Sephardi Kabbalah, see Heidi Laura, "Collected Traditions and Scattered Secrets: Eclecticism and Esotericism in the Works of the 14th Century Ashkenazi Kabbalist Menahem Ziyyoni of Cologne," *Nordisk Judaistik: Scandinavian Jewish Studies* 20/1–2 (1999): 19–44.

24. Indeed, much of modern research into Pietist mystical traditions is based on the study of manuscript sources. Some of the texts have been printed in recent years, but many remain unprinted even today. Early prints of Pietist mystical texts are not extant. This can also be confirmed from lists of printed books compiled in early modern Hebrew print shops, especially in Italy; see, e.g., Peretz Tishby, "Hebrew Incunabula, Italy (Hebrew)," *Kiryat Sefer* 57 (1983): 805–857; 60 (1986): 865–962; 62 (1988–1998): 361–401; 63 (1990–1991): 603–636; 64 (1992–1993): 689–726; Tishby, "Hebrew Incunabula (3), Italy: Bologna," *Ohev Sefer* 1 (1987): 29–39.

25. Kanarfogel, *Lattices,* chap. 4, esp. 191.

26. These dilemmas have been discussed in a particularly clear and concise way by Jack Goody, "Against 'Ritual': Loosely Structured Thoughts on a Loosely Defined Problem," in *Secular Ritual,* ed. Sally F. Moore and Barbara G. Myerhoff (Amsterdam: Van Gorcum, 1977), 25–35.

27. This summary is based on Mark Searle, "Ritual," in *The Study of Liturgy,* ed. Cheslyn Jones, Geoffrey Wainwright, Edward Yarnold, and Paul Bradshaw (Oxford: Oxford University Press, 1992), 51–58, repr. in *Foundations of Rit-*

ual Studies: A Reader for Students of Christian Worship, ed. Paul Bradshaw and John Melloh (Grand Rapids, MI: Baker Academic, 2007), 9–16, esp. 11, who relies on Clifford Geertz, "Religion as a Cultural System," in *Anthropological Approaches to the Study of Religion*, ed. Michael Banton (New York: Travistock, 1965), 1–46, repr. in *The Interpretation of Cultures: Selected Essays* (New York: Basic Books, 1973), 87–125.

Index